To my family for their love and patience

"Every provocative subject has a body and a soul.
Your camera only captures the body, while your interpretation of light captures its soul"

Chapter Summary

❏ Introduction: Why I Wrote this Book

I wrote this book to teach the interested photographer to understand the simplified Zone System of light measurement. This book is intended as a platform to learn the more advanced concepts of photographic exposure.

This section needs to be read by all readers.

❏ Chapter 1— Glossary and Explanation of Terms

In this chapter we review terms and techniques such as tone, incident light, reflected light, simple and complex subjects, the 18% gray card, concept of zones and so on.

This section needs to be read by all readers.

❏ Chapter 2 — Assignments to "Normally Expose" Simple Subjects with Different Tones

In this chapter we perform five assignments that will be the basis for the entire book. By photographing a black card and a white card, we will notice that the camera will erroneously produce a gray image tone from each of these subjects. The rest of the chapter is based on developing techniques to correct these image tones.

This chapter needs to be read by all readers and performing these assignments will help the reader to understand the practical concepts of the Zone System.

❏ Chapter 3 — The Single Tone Metering Technique to Photograph a Complex Subject

In this chapter we learn the technique of breaking a subject down to its simple subject components. Once this is done, we can then determine the correct exposure **for one of these tones and use this exposure to photograph the entire subject**. The wisdom behind this *simplified* technique is that **"if one part of a complex subject is properly exposed, then all other parts will be properly exposed."**

This chapter is ideal for those photographers who are interested in a quick and easy-to-understand method of photographing a complex subject by using their camera. For many photographers, this chapter is all you need to know to take correctly exposed pictures.

❏ Chapter 4 — The Multiple Tone Metering Technique to Photograph a Complex Subject

In this chapter, which is an extension of the previous chapter, we will learn how to determine the Subject Brightness Range (SBR) and explore different ways that the film accommodates a complex subject. You will also learn how to previsualize the final image tones.

The Confused Photographer's Guide to Photographic Exposure and the Simplified Zone System

Bahman Farzad

The Confused Photographer's Guide to
Photographic exposure and the
Simplified Zone System

Fourth edition.
Library of Congress Catalog Card
Number: 99-094626
ISBN: 0-9660817-1-4

Published by:

Confused Photographer's Guide Books
PO Box 660014
Birmingham
Alabama
35266

Phone:1.205.877.3282
e-mail: **info@spotmetering.com**
URLs:
http://www.simplifiedzonesystem.com
http://www.spotmetering.com

Edited by Linda Voychehovski
Design and production by Bahman
Farzad
1 2 3 4 5 6 7 8 9 10

Nikon™, Canon™, Minolta™, Sony™,
Pentax™, Olympus™, Kodak™, Federal
Express™, Tiffen™, Adobe™, Fuji™,
Ilford™, eBay™, and their products are
Trade Marks of their respective
companies.

This chapter is for those photographers who want to learn more advanced features of the Zone System of light measurement using a spotmeter.

❏ Chapter 5 — Alternative Light Measurement Techniques and Related Examples

This chapter covers odds and ends that include incident light measurement techniques, exposure without an exposure meter and many examples of "standard" and "not so standard" exposure situations such as scenics, portraits, fireworks, lightning, and moonlit landscapes.

This chapter covers other types of exposure with or without a meter. Reading of this chapter is highly recommended to the interested photographer.

❏ Chapter 6 — What is the Zone System?

In this chapter we discuss the concept of zones as it applies to our everyday life. We then discuss the make-up of a time zone and its relationship with a "photographic" zone.

This chapter, although interesting, is for the curious photographer. If you are not curious, you can skip it.

❏ Appendices

In this section I have provided you with a Neutral Density Filter table, a quick review of color theory and color correction, and an introduction to Digital Photography and Spotmetering.

❏ Camera Cheat Sheets

In this section I have provided you with manual spot metering / partial metering exposure cheat sheets for some of the popular digital and film (35mm / medium format) electronic cameras.

❏ Index

GALLERY

The Confused Photographer's Guide to Photographic Exposure and the Simplified Zone System

What is covered in this book?

❏ Chapter 1 — Glossary and Explanation of Terms

Let's review the terms that you need to know:

❏ Chapter 2 — Assignments to Normally Expose Simple Subjects With Different Tones

❑ Chapter 6 — What is the Zone System?

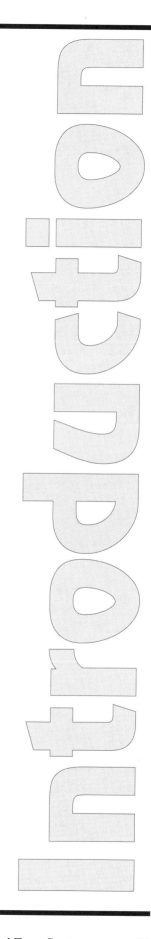

Why I wrote this book (Please read this!)

For many years I have searched for an easy-to-understand, logical, practical, and systematic approach to light measurement. Although I considered myself an advanced photographer, many light measurement books lost me on their first few pages.

Something needed to add up and at least for me, it just did not. It was not until the mid 1970s that I picked up a free booklet published by the late California photographer and educator Glen Fishback to promote Pentax spotmeters and the Glen Fishback School of Photography. By reading the book a few times, thanks to his teaching technique, I started to understand the idea. That booklet gave me the basis for what is commonly called the Tone or Value-Range system of light measurement. After learning and practicing this technique, I reached a point where I could read and understand other books about the subject.

Unfortunately the problem that I was facing in the 1970s, persists in the new millennium. Regardless of all the books available, I still feel that none of them satisfies the everyday photographer who is interested in learning the subject. This conclusion is proven to me at the beginning of every term that I teach this subject. I see many eager students who complain about the same problem.

These days, the newer cameras and their metering systems have become more computerized and sophisticated. They offer more choices for metering the subject than ever before. The flip side of this is that the cameras have become so complicated that they themselves need to be operated by an expert. In my experience, most photographers do not know how to use many features of their cameras. The most interesting thing about the advanced technology is that it still uses the same basic idea of light measurement that has been used for decades. If you do not believe this, just pick up your $2,000 top-of-the-line film camera, load it up with a roll of color slide film and take pictures of snow, white sand, or a black piece of cardboard. I promise that you will be disappointed. *Cameras today, as cameras of decades ago, cannot differentiate between exposing black or white subjects!* What you get with any of the above simple subjects is a gray image. *This property also applies to **all** digital cameras.*

Many newer and more expensive cameras now offer built-in spotmetering capability. The sad part about this is that only a handful of people know how to use this powerful feature effectively. The reason for this is that because reflective light measurement (the method that your camera uses), even with a built-in spotmeter, is not a mechanical process. The readings of the meter must be interpreted and perhaps adjusted before the picture is taken. This interpretative skill can be used with cameras with different formats and films because the skill is in the photographer's head rather than in a certain brand of camera. A successful photographer's knowledge of light measurement must be independent of the camera that he or she uses.

The next question is how a person can learn to use the light metering equipment properly. Although the answers are there, they are not readily available.

I am hoping that the interested photographer will start learning with this book! This book is written especially for the beginner and intermediate photographer who is interested in the understanding of exposure and control of light.

Compared to this book, other books currently on the market have the following drawbacks for a beginner:

1) They are too mathematical and scare people away. In this book, I have no formulas or mathematical equations. The only math you need to understand and apply the concept is the ability to count the number of fingers on your hand and to be able to multiply and divide by 2.

2) They are mainly written for larger format cameras. An average photographer does not have the opportunity of seeing and working with a view camera. The techniques that you will learn in this book are basic and applicable to whichever camera and metering system that you use.

3) Current books mainly use the black and white negative as the primary medium. The major drawback of the black and white negative is that it takes a skilled person to judge its correct density and contrast. Many photographers lack the skill and necessary equipment to do this. Also, black and white photography usually requires access to a darkroom!

In this book none of these drawbacks will be of your concern! We will be using slide film instead of the negative. This eliminates the majority of the problems arising when using a negative. The following is a quick comparison:

 a) Unlike the black and white film, slide film is positive film. You need not be an expert to judge your exposure errors.

 b) Once the film is exposed, you can take the film to the processing lab. You do not have to worry about any darkroom work.

 c) Unlike black and white film, slide processing is tightly controlled. You will also be certain that, unlike with the negative, no one will second guess your exposure. **With slide film, "What You Take Is What You Get."**

 d) Unlike black and white film, slide film is not very forgiving. It quickly reminds you of your exposure errors by darkened lowlights or washed-out highlights (we will learn about this later). Please understand that once you have learned this technique, you can apply it to a black and white as well as to a color negative. **Slide film is designed to get you started, to give you discipline, and to keep you on the right track.**

4) Current books cover the entire system of light measurement, including film development and printing. An average photographer is usually not interested in the entire package. **In this book I plan to improve the light measurement skills that affect your picture** *before you release the shutter.*

5) Most books currently on the market look at light measurement strictly through the Zone System. In this book you will learn the techniques of light measurement including the Zone System. The fact is that there is no one method of light measurement or equipment that works well under all different situations.

6) Almost all books use pictures to teach the beginner the difference between the tones and how every tone relates to standard tones. **In this book I use computer generated tones to illustrate this concept. In my experience, the novice photographer grasps the idea quicker if examples and illustrations include manufactured tones than actual tones produced by a photograph.**

For properly exposing your subject under different lighting situations, you need to be able to use the type of metering system that yields the best results. At times, when you have an emergency in the middle of nowhere, you must be able to use your camera without *any* metering system. It could be sunny, overcast or simply a moonlit landscape. I will also be covering these techniques in this book. My objective is to teach you, the interested photographer, the joy of light measurement, through practical and easy-to-understand methods. This will give you control over the final quality of the image. I assume that you know nothing about the subject of light measurement, or that your knowledge is minimal. Otherwise you would not be reading this book. In writing this book, I have made a few assumptions about you.

I assume that you are familiar with handling your camera, such as changing the shutter speed and/or aperture settings to take a picture. Consequently, I will not cover the elementary ideas of the camera. There are many good books already published on this subject.

I have also assumed that you are not happy with your pictures and that you are searching for a method that will enable you to control the final look of your image. On the subject of light metering equipment, I will be covering them all! These include: 1) Your camera's meter, 2) An exposure meter used as a reflective meter, 3) An exposure meter used as an incident meter and finally, 4) A spotmeter.

In Chapters 2 and 3, your primary equipment will be your camera. You can learn the idea of light measurement by simply using the meter in your manual camera. If you have an automatic camera, use its manual override feature. **Automatic cameras without a manual override do not lend themselves to exposure manipulation, which is what you will be doing, and cannot be used for this purpose.**

If you want to buy a camera, buy a manual one or a camera that can be operated in the manual-exposure mode. Basic cameras that can be manually operated include: Pentax K1000 (old), Pentax ZX-M, Nikon FM-10, and Canon Rebel series (with partial metering). More expensive cameras with spotmetering feature (for spotmetering please see section 4.4) include Pentax *ist (extremely simple to operate), Pentax ZX-5N, Pentax PZ1P, Minolta Maxxum 5, Minolta Maxxum 7, Minolta STsi, Nikon N70, Nikon N6006 (old), Nikon N8008s (old), and Olympus OM-4. Higher-end cameras with true spotmetering (have a distinct spot frame/circle visible to the eye) in the viewfinder include Nikon F4 (old), Nikon N90 (old), Minolta Maxxum 9, Pentax MZ-S, Canon 1n, and Canon EOS 3. Older cameras can be purchased online from **ebay.com**.

If you intend to purchase a serious Digital Camera (D-Slr), it is well worth to look into cameras such as Pentax *ist-D, Canon 5D, 10D, 20D, and 30D, Nikon D50, D70, D80, or D200. Although all the cameras with a spotmetering (Partial Metering) will work, however, my personal preference is with those cameras having a distinct spot circle such as Pentax *ist-D or Canon 30D.

Please note that you <u>do not</u> need to have a camera with a spotmetering feature in order to learn the Zone System of light measurement, however, spotmetering (Partial Metering) is the ultimate tool for the Zone System applications and makes exposure determination of distant subjects (tones) possible.

1 On-camera reflective meter

46 degrees full angle of coverage for a normal 50mm lens

Some cameras also have a built-in, narrow-angled spotmeter (partial coverage angle of 4 to 7 degrees) with a 50 mm lens

Normal exposure

18% gray card

2 Off-camera exposure meter used as an incident meter

F - 16 1/60

3 Off-camera exposure meter used as a reflective meter

F - 16 1/60

4 Pentax Digital Off-camera reflective spotmeter

18% gray card

1 Degree angle of measure (acceptance)

Spot Frame (Circle)

15

Exposure Value (EV)

1/3 EV Divisions

Diagram illustrating four types of light metering equipment that will be discussed in this book.

If you have an off-camera spotmeter such as Pentax Digital or Standard Spotmeter, this book will teach you their correct application. An off-camera spotmeter (works very much like the meter in your camera but has a very narrow angle of measurement) will prove very useful in the advanced stages of this book. To summarize, when you take a picture, you should be able to set the *camera's aperture, shutter speed and the ISO to anything that you wish.* **If your camera prevents you from performing any of these functions, do not buy it since it limits the scope of your participation in creating the final image.**

Please make sure that you read Chapter 2 thoroughly because it provides the basis for all that you will learn in the coming chapters.

When you are reading this book and find that you do not understand the material, most likely you have skipped over something along the way. This book is like a chain. If you miss one step, there is a good chance that you will not understand the rest.

You must also remember that this is a slow-paced book, especially written for the beginner. You will notice that certain topics are *covered* more than once. **Sometimes the topic is repeated in the same chapter, most likely in the summary or in the review of the previous chapter. If an idea is important, the chances are that you will see it explained more than once. Please understand, the majority of my students learn by repetition.**

For some of you, depending on your experience and expectations from this book, Chapters 2 and 3 may be all that you need to learn! For those of you who are interested in learning all the details of this system, you will need to read and understand the rest of the book. To absorb this subject properly, you must take your time while reading about it. Do not read the subject one night and expect to master the technique the next day. The idea, although simple, takes time to absorb and to apply correctly. Very much like learning to drive a stick shift car, it is essential that you should keep on using the technique so that it becomes like second nature to you. If you ever become confused and start thinking backwards, that is, "opening-up" the aperture instead of "closing it down," do not worry, it is a part of the learning process and it happens to everybody. With a little bit of practice, you will put it behind you. The five simple assignments that are given in Chapter 2 set the tone for understanding the Zone System of reflective light measurement. Please remember, you must read and understand the entire chapter before performing these assignments. To save you time, money, and to achieve exposure and processing consistency, you must perform all of these assignments on the same roll of slide film. These simple assignments, as dull as they may look, are necessary if you want to understand the subject. Performing these assignments will also give you a foothold and help you to understand the subject more quickly

DIGITAL FOOTNOTES:

If you do not use a digital camera, please ignore digital footnotes in this book. These footnotes are _intended to serve as a basic guide_ for those who are using a _Manual_ digital camera.

Acknowledgments

One can not write a book about the Zone System and not mention some of its pioneers, inventors, and educators who have carried the torch for more than a century. These include Hurter & Driffield (1890). Weston Electrical Instrument Company (1932) for inventing the first exposure meter and applying the concepts of image densities as applied to subject Brightness Range of a scene (1935-1938) upon which the foundations of the Zone System were built. John Davenport (1940) whose two articles paved the way for work done by Ansel Adams and Fred Archer's version of the Zone System (early 1940s). Minor White and Richard Zakia for streamlining Adams' system and making it more practical. Asahi Pentax Co. by introducing the off-camera spotmeter in 1960 and for the first time in the history of the Zone System made exposure determination of distant and scenic subjects/tones possible. Glen Fishback and Phil Davis who further simplified the system for smaller cameras and allowed more photographers than ever to enjoy the concept and practical applications of the Zone System.

I would like to thank the computer industry for bringing us PCs, word processors, spell checkers, laser printers and graphic packages like Corel Draw! and its CD-ROM Clip art. I could not have done it without them.

I would like to thank my family for their support and patience while I was glued to the computer for about four years every night until early hours of the morning. I would also like to thank my students at the University of Alabama at Birmingham (Special Studies) who encouraged me, challenged me, and provided me with the fuel and the energy to write this book. My special thanks to Linda Voychehovski who corrected most of the text, helped me with the ideas, as well as keeping me on track to fulfill my original pledge of simplicity. Finally, I would like to thank my daughter Parastoo "Paris" Farzad, a graduate of RIT for catching and correcting many of my last minute mistakes.

About thirty years ago when I was eagerly searching for answers to my exposure questions, a small book by Glen Fishback helped me to understand the concept of seeing and interpreting light. It gave me confidence and changed my vision forever. I hope this book does the same for you.

The teaching philosophy used in this book:

Clarity, Simplicity, and Repetition

GALLERY

Glossary and explanation of terms

What will you learn in this chapter?

In this chapter we review such terms and techniques as tone, incident light, reflected light, simple and complex subjects, the 18% gray card, the concept of zones and so on.

Please Note: This section must be read by all readers.

Let's become familiar with the basics

1) The Camera

2) The Film

3) What do we mean by a tone?

4) Incident and reflected light

5) What is a "STOP?"

6) Film sensitivity, ISO (ASA)

7) A Simple Subject

8) A Complex Subject

9) 18% Standard Gray Card

10) **Normal exposure** versus **correct exposure** and **desired exposure**

11) The Reference Tone

12) How to choose a Reference Tone

13) What is a Zone?

14) Exposure Consistency

15) The Rule of Equivalent Exposures

1.1. The Camera

Although most of you know what a camera is, the following is a review of its basic functions:

A camera is a device that is used to record the image of a subject on some type of recording medium that is generally called film. Today's cameras have two major components:

1) The lens that controls the amount of light entering the camera by opening and closing of the aperture.

2) The body that generally accommodates:

a) The shutter speed mechanism that also controls the amount of light entering the camera,

b) Dials to change the sensitivity of the film (ISO) and

c) A built-in exposure meter to measure the amount of the light that exposes the film.

One can buy a serious camera with a normal lens for as little as $250. The upper limit of this can run into thousands of dollars. If you are interested in the creative aspects of photography and you want to control the exposure of your images, you must use a manual camera or a camera that can be manually adjusted. With these cameras, you can set the shutter speed, aperture and the film speed (ISO) to anything that you wish. If a camera prevents you from changing any of these

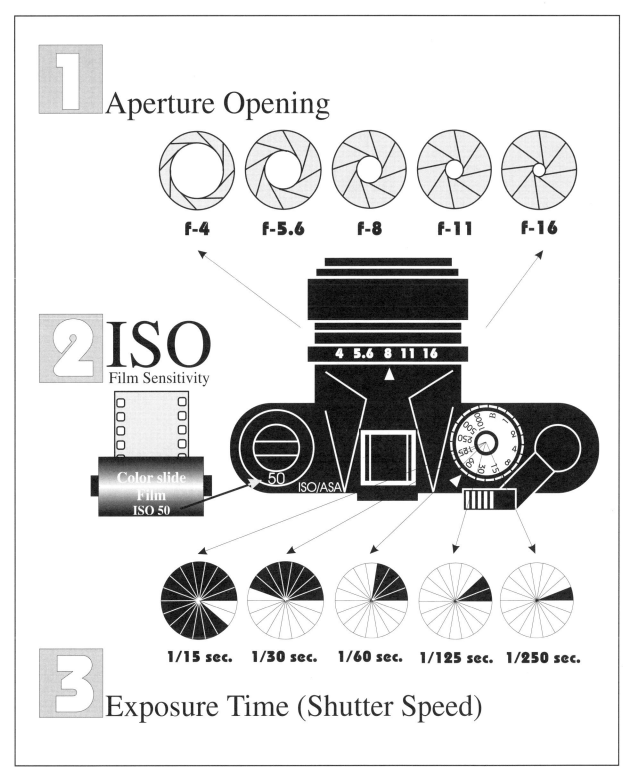

1 Aperture Opening

f-4 **f-5.6** **f-8** **f-11** **f-16**

2 ISO
Film Sensitivity

Color slide Film ISO 50

50 ISO/ASA

1/15 sec. **1/30 sec.** **1/60 sec.** **1/125 sec.** **1/250 sec.**

3 Exposure Time (Shutter Speed)

Diagram 1.1.0

Diagram illustrating the three main components of a camera.

three functions, do not buy it. If you have one of these cameras, sell it or exchange it for the one that does.

The following are my recommendations. Older cameras with a distinct spot metering frames can be purchased inexpensively from http://www.ebay.com.

❏ A Manual body or a body that can be "M"anually operated. The list includes: Pentax ZX-5N, Pentax *ist, Pentax PZ1p, Olympus IS3, Canon EOS A2/E, Minolta Maxxum 5, Minolta Maxxum 7, Minolta STsi, Nikon N6006, Nikon N70, and Nikon N8008s. More expensive (professional) cameras with true spotmetering (a distinct spot frame) include: Nikon N90/90s, Nikon F4, Pentax MZS, Minolta Maxxum 9, and Canon EOS 3.

❏ Two separate zoom lenses with the zoom power of 80 to 200 mm telephoto and a wide angle lens of 28 to 70 mm would be ideal for the beginner.

DIGITAL FOOTNOTE:

PLEASE NOTE: Most of the techniques you learn in this book can be easily applied to the more serious digital cameras entering the market. Before you buy a digital camera please make *absolutely sure* that in the "M"anual mode you can set the aperture opening and the exposure time (shutter speed) to any combination that you wish. As I mentioned before, the most popular digital Slr (D-Slr) cameras include Pentax *ist-D, Canon 5D, 10D, 20D, and 30D. Nikon Models include D50, D70, D80, and D200.

Summary of choosing a camera:

1) Your camera's metering system **must** be able to operate in the manual mode "M". A true spot metering camera with a distinct (outlined spot frame/circle visible in the viewfinder) is a plus.

2) You **must** be able to set the shutter speed and aperture opening to anything that you wish.

3) You **should** be able to set the ISO of the film camera to anything that you wish. The ISO of many digital cameras can be set at 100 through 3200.

4) Two zoom lenses, 28mm to 70mm and 80 to 200 mm provide you with plenty of lens power. Dividing these numbers by 1.5 provides you with the equivalent mm range (approx.) for many of today's D-Slrs.

5) *Please note that you do not need a camera with spotmetering feature to learn the Zone System of light measurement*, however, since it enables accurate exposure determination, it is a must tool for the serious Zone System photographer

GALLERY

1.2. The Film

Film, by definition, is a light sensitive material that captures the subject's image. There are two common types of film that are currently in use. Negative films include color as well as black-and-white. Positive film includes color slide (also referred to as color reversal or transparency) film. For most parts of this book, we will be using a daylight-balanced color slide film. Using a color slide film has the following advantages over the negative for the beginner.

1) With the color slide film, **"What You Take is What You Get."** Color slide film consistently maintains the integrity of your original exposure.

2) Color slide film requires a one-step standard process, i.e., the film enters a tightly monitored processor from one end and exits from the other. During this standard process, no one will second guess your original exposure! With negative film, the lab first processes the negative and then prints the negative on paper. It is during the second step that your exposure is second guessed by a technician or a machine. This makes the result of your exposure inexact and unpredictable.

3) Color slides are easy to judge even by the untrained and the inexperienced photographer. To judge slide film, all one needs is a light box, a white sheet of paper, a slide projector, or a $5 slide viewer. This enables the novice to catch his or her exposure errors and correct them quickly. To judge a black and white or color negative, one needs a few years of experience, and in the case of the color negative, one needs to imagine every color backwards or in terms of its complement. Simply stated, it is very hard to judge a negative (especially a color negative) without having access to a negative scanner or other very specialized and expensive equipment.

To get started, I recommend that you find yourself a professional processing lab. These labs usually charge a little more, but will provide you with consistent processing. Of the many slide films that lend themselves to a two-hour (E6) processing are Fuji's Fujichrome 50 (Velvia), Kodak Ektachrome 64, Kodak Elite 100, Agfachrome 100 and so on.

DIGITAL FOOTNOTE:

If you own a Manual digital camera such as Canon 10D, 20D, or 30D, Nikon D70, D80, or D200, or Pentax *ist D, you can apply many of the techniques discussed in the book. Digital displays on the back of a camera work very much like looking at slide film on a light box. If you do not have a ***Manual*** digital camera, ***please ignore*** these footnotes.

In Digital Photography, light passing through lens is focused on a photo-sensitive electronic chip called a Charged Coupling Device (CCD). The CCD using a process called digitization, converts light impulses into electrical impulses. The digitized signals are then recorded and preserved in a reusable memory often referred to as "digital film." The digital film comes in variety of shapes, and sizes and its capacity at this writing can go up to 8GB (8,000,000,000 characters).

A sample of standard color negative, black and white negative, and color slide films from different manufacturers. These films are capable of recording up to 36 images on each roll.

Diagram 1.2.0

CompactFlash USB Card Reader photographed with a 2GB memory card

Photographed side-by-side (for scale) are a .5GB (512 MB) SecurDisk Memory Card and a 2BG CompactFlash memory card

DIGITAL FOOTNOTE:

Photographed is a 2GB digital film (CompactFlash Memory card) used by many of today's cameras. This film measures approximately 4.3cmX3.7cm (3mm thick) is capable of recording about 500 Hi-resolution JPG images with a 6 MegaPixel camera (2000X3000 in pixel dimensions) to produce a perfect 8X12 color print @ 250 DPI or an 11X16 inch print @ 182 DPI using a printer such as Epson Stylus Photo Printer 2200.

These images are usually transferred to your computer using a USB (Universal Serial Bus) port and a card reader. They can also be transferred directly to your computer using your camera's USB connection. In both cases, the card will appear as your next available drive letter (D:, E:, F:, or G:, etc.). In this case, a COPY command can be used to copy your images to your hard drive or to a CD/DVD burner for editing or permanent storage.

Please note that the approximate pixel dimensions for a 6 MegaPixel camera is 2000X3000, for a typical 8 MegaPixel camera is 2310X3465, for a 10 MegaPixel camera is 2582X3875, and for a 12.8 MegaPixel camera is 2921X4381.

The most asked question is: What MegaPixel camera produces an image whose quality equals the 35mm camera?

Assuming we use an ISO 100 film with a resolution of 100 lines/mm, the equivalent is 10,000,000 pixels or a 10 MegaPixel camera.

1.3. What do we mean by a tone?

A subject tone can be defined as its lightness or darkness. In this book we will be discussing two kinds of tones:

1) A subject tone.

2) An image tone.

1.3.1. A Subject Tone

A subject tone can be defined as the subject's degree of grayness. If the subject has color, imagine taking away its color; what remains is its tone.

Absence of any tone makes a subject bright (light gray/white). The presence of a tone makes it dark (dark gray/black).

A white wall or a white piece of paper (lightly shaded) has almost no tone, whereas black velvet is dense (heavily shaded). That is why it looks black.

If you choose a colored subject like the blue sky, **simply take away its color and imagine it in black and white.** The tone of a blue sky at times could approximate what we call a medium gray, i.e., it is neither black nor white.

In this introductory book, we have five main categories for a tone. The tone is either black, dark gray, medium gray, light gray or white. In this book, gray, black or white surfaces are defined as subjects that have only gray density (no color).

Any colorful subject can be considered as painted gray tones. If you wonder what the "gray tone" of a colored subject looks like, take away its color and imagine the subject in black and white.

1.3.2. An image tone

An image tone can be defined the tone on the slide film or negative film that corresponds to the tone or the tones of a subject. Subject tones and image tones for slide film are illustrated in Diagram 1.3.1-1.3.2.

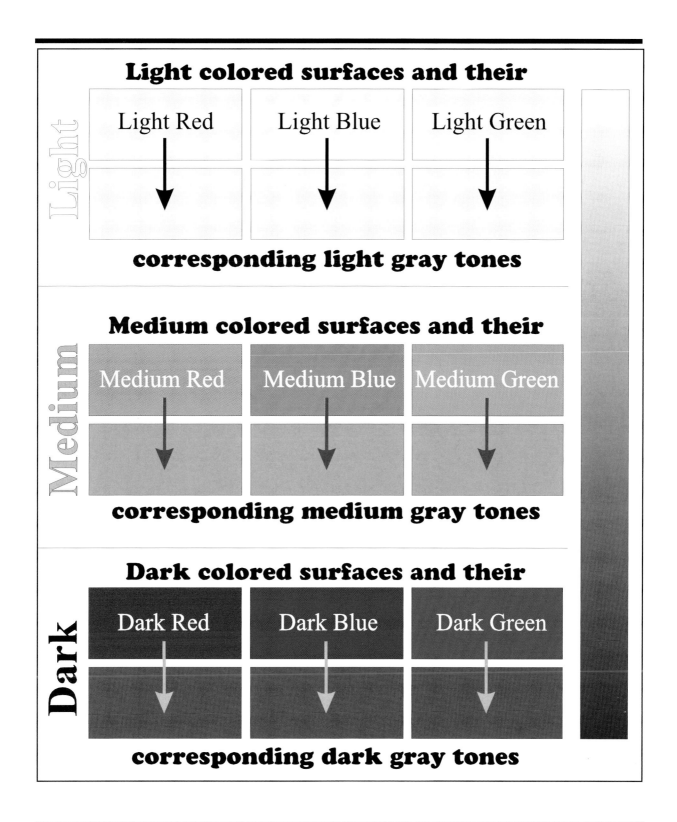

Light colored surfaces and their

Light Red Light Blue Light Green

corresponding light gray tones

Medium colored surfaces and their

Medium Red Medium Blue Medium Green

corresponding medium gray tones

Dark colored surfaces and their

Dark Red Dark Blue Dark Green

corresponding dark gray tones

Color versus Tone illustration

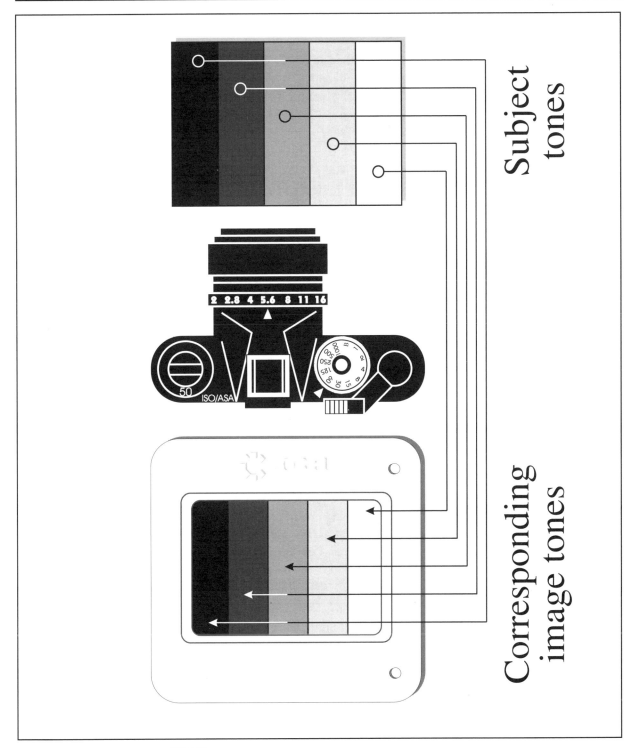

Diagram 1.3.1-1.3.2

Diagram illustrating Subject Tones and their corresponding Image Tones as are captured on slide film.

1.4. Incident and Reflected Light

The light we get from the sun or any other light source is called **incident** light. It is light that strikes, or falls upon, a subject. Light that bounces off a surface after the incident light has fallen on it is called **reflected** or reflective light (please see Diagram 1.4.0). In the Zone System, we use this reflective property to find the proper exposure of a subject.

What enables us to see is the reflectivity of subjects or surfaces. Without this property, even with all the light that surrounds us, we would be living in total darkness. If you do not believe this, just look at the sky on a clear, moonless night. There is as much sunlight above as there is on a clear day. Unlike Earth, outer space has no reflective particles such as air, pollution, dust, or water vapor. Therefore, we cannot see the lighted space in the same way that we see our blue sky.

The reflectivity of a subject is measured in percentages. A highly reflective material such as white paint, white paper, or white cloth reflects more than 70% of the light. Consequently, white or lightly colored clothing keeps us cool in the summer.

Materials with low reflectivity, such as black velvet or dull black paint, reflect less than 4% of the light. The light that is not reflected by the surface will help to heat up the black or dark subject. This is the main reason people wear dark clothing in the winter.

If you are one of the people who is scared of the term "percentages," you do not need to be. This is an example that I am sure you will understand. Assume you deposit $100 in your savings account. Also assume that the bank pays a yearly interest of 5% on saving accounts. This means you collect $5 (5% of $100 is $5) interest at the end of every year from the bank. If the bank pays an annual interest of 18%, then your annual interest would be $18 (18% of $100 is $18). The interest you collect at the end of the year is very much like the light that is reflected from the surface. Your original $100 is the equivalent of 100 rays of light that fall on a surface. A 5% reflective surface will only reflect 5 of them, and an 18% reflective surface will reflect 18 of them.

Another example is to throw 100 balls from a tall building on a hard pavement. Since most of the balls would bounce back. The hard pavement in this case represents a white surface that reflects most of the light.

Now let's throw the same number of balls on a pavement covered with thick, hot, and sticky tar. Chances are most of the balls will stick to the pavement and would not bounce. The pavement with hot sticky tar represents a black surface that absorbs most of the incident light and reflects very little of it.

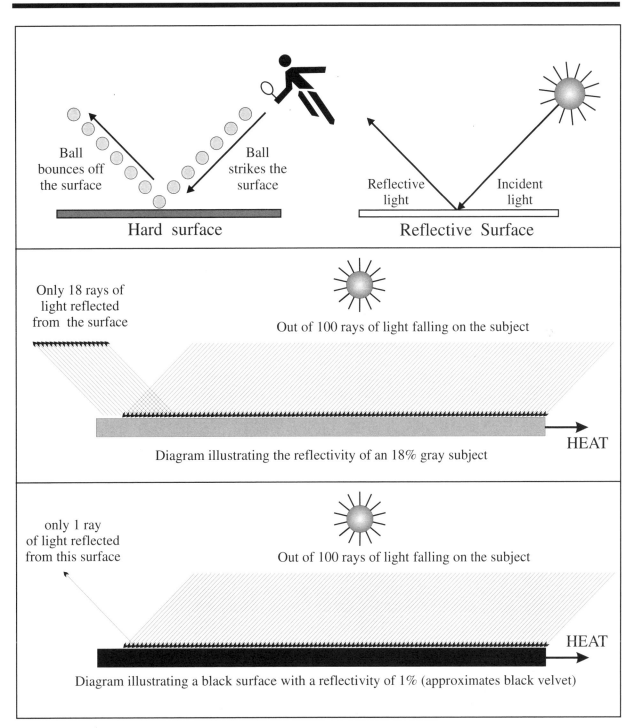

Ball bounces off the surface

Ball strikes the surface

Hard surface

Reflective light

Incident light

Reflective Surface

Only 18 rays of light reflected from the surface

Out of 100 rays of light falling on the subject

HEAT

Diagram illustrating the reflectivity of an 18% gray subject

only 1 ray of light reflected from this surface

Out of 100 rays of light falling on the subject

HEAT

Diagram illustrating a black surface with a reflectivity of 1% (approximates black velvet)

Diagram 1.4.0

Diagram illustrating incident and reflected light for different tones.

1.5. What is a STOP?

A stop is one _full_ **click** of the **shutter speed** (exposure time) or **aperture opening**. For the list of **standard** shutter speeds or **standard** aperture openings that are one full click apart, please see Diagrams 1.5.1 and 1.5.2. *The most important property of a STOP is its ability to double or half the amount of light that reaches the film.*

To avoid confusion, in this book*, change of exposure is generally achieved by changing the aperture opening (f-stop) and not by changing the shutter speed*.

1.5.1 The aperture opening

The aperture opening determines how much light gets into the camera. The larger the opening, the more light enters the camera. To indicate the degree to which the lens is open, numbers such as 1.4, 2, 2.8, 4, 5.6, 8, 11, 16, and 22 can be seen on many older lenses.

In the newer cameras, these numbers can be found in the viewfinder (what you look through) of your camera. In this book, these numbers are prefixed by [f-]. For example, an aperture opening of 5.6 is referred to as f-5.6. The only thing that a beginner should be aware of is that the _larger_ the number, the _smaller_ the aperture opening. Simply stated, the _numbers_ and the _aperture opening_ have an _inverse_ (reverse) relationship. In our illustration, f-4 (smallest number) has the largest opening and f-16 (largest number) has the smallest opening. Please make sure you understand this (see diagram 1.5.1). The most important thing about these numbers is that they are one STOP away from one another, i.e., f-5.6 is one STOP away from its two neighboring aperture openings of f-8 and f-4. Another piece of information that may interest you is that for each STOP the area of the aperture opening doubles or halves, depending on the direction in which it is moved. For example closing the aperture down from f-1.4 to f-2 reduces the area of the aperture by one half (the amount of light entering the camera is halved). By the same token, if you open the aperture from f-8 to f-5.6, the area of the aperture opening doubles; so does the amount of light passing through the lens.

In newer electronic cameras (and some older cameras) one may see 1/2 stop divisions. These are half-way between the standard aperture openings. For our examples above, these include 1.7, 2.3, 3.4, 4.7, 6.7, 9.5, 13.5 and 19. To simplify the illustrations and accommodate photographers with older cameras, we will be using full aperture numbers like f-5.6, f-8, and f-11.

Section 1.5.1 Summary:

Aperture openings of a lens are indicated by 2, 2.8, 4, 5.6, 8, 11 and 16 on many lenses. Each of these numbers are separated by ONE STOP from its neighboring number. Each stop, depending on how you look at these numbers, doubles or halves the amount of light that enters the camera. For example f-11 lets in twice as much as f-16 but half as much light as f-8. With the newer cameras, these numbers are shown only internally in the viewfinder or externally on the camera's main LCD panel.

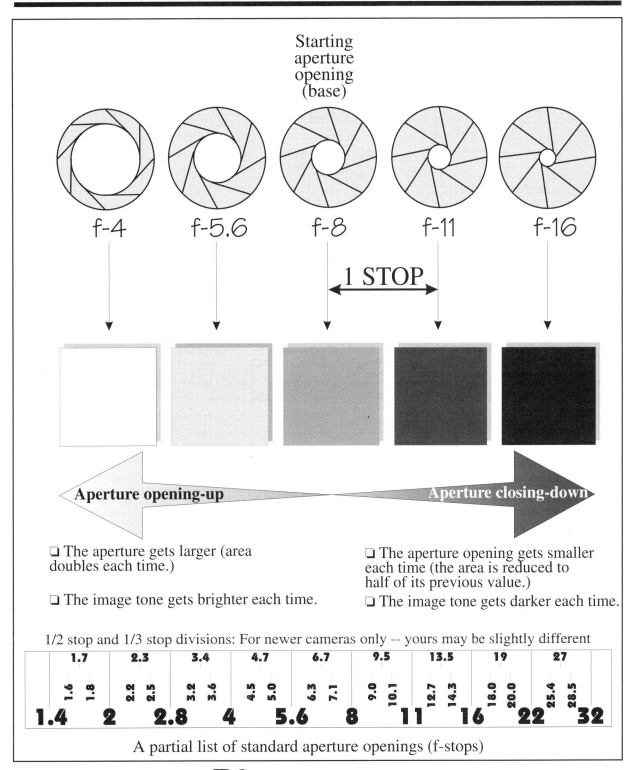

Starting aperture opening (base)

f-4 f-5.6 f-8 f-11 f-16

1 STOP

Aperture opening-up

Aperture closing-down

❑ The aperture gets larger (area doubles each time.)

❑ The image tone gets brighter each time.

❑ The aperture opening gets smaller each time (the area is reduced to half of its previous value.)

❑ The image tone gets darker each time.

1/2 stop and 1/3 stop divisions: For newer cameras only -- yours may be slightly different

| 1.7 | 2.3 | 3.4 | 4.7 | 6.7 | 9.5 | 13.5 | 19 | 27 |

1.6 1.8 2.2 2.5 3.2 3.6 4.5 5.0 6.3 7.1 9.0 10.1 12.7 14.3 18.0 20.0 25.4 28.5

1.4 2 2.8 4 5.6 8 11 16 22 32

A partial list of standard aperture openings (f-stops)

Diagram 1.5.1

Diagram illustrating the effects of opening-up and closing-down the aperture by 1 stop on the final image tone for a slide film *given that the shutter speed remains constant.*

1.5.2 The exposure time (Shutter speed)

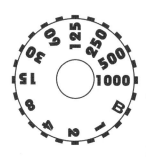

Exposure time is the measure of time, usually in fractions of a second, that the shutter stays open and exposes the film. Standard shutter speeds are 1, 1/2, 1/4, 1/8, 1/15, 1/30, 1/60, 1/125, 1/250, 1/500, and 1/1000 second. For some cameras, this range extends from 30 sec. [30"] to 1/8000 sec. In many books, including this one, these notations are sometimes simplified by eliminating the "1/" portion. ***In this book I will be using both notations***. Chances are that on your camera the same speeds are indicated as 1, 2, 4, 8, 15, 30, and so on. As with the aperture opening, the only thing that a beginner should be aware of is that with this kind of notation, the *larger the number, the smaller the amount of light reaching the film*. These numbers and the exposure times have inverse (reverse) relationships.

In our examples, [1000] (1/1000th of a second) has the shortest and [1] (1 second) has the longest exposure time. Make sure you understand this. Like aperture openings, each of these numbers is one STOP away from its neighboring numbers: i.e., 500 is one STOP away from 1000 as well as being one STOP away from 250. Another piece of information that may interest you is that for each STOP, depending on the direction in which the settings are changed, the exposure time doubles or halves. For example, when changing the exposure time from 1/500 sec. to 1/1000 sec., the exposure time is halved and so is the amount of light entering the camera. By the same token, changing the exposure time from 1/500 sec. to 1/250 sec. doubles the exposure time (so it doubles the amount of light entering the camera). On many newer electronic cameras you will see numbers such as 45, 90, 180, 360, 720, and so on. These numbers are 1/2 stop exposure times. For example, 1/90 is half a stop between 1/60 and 1/125 sec. In order to support many millions of older cameras and to keep things simple, we will stick with standard exposure times (shutter speeds) such as 1/15, 1/30, 1/60 etc.

Bulb Setting "B"

For many cameras a "B" on a shutter speed dial indicates "Bulb" and signifies the longer than standard exposure time that can be controlled by the photographer. Subjects requiring long exposure times (from a minute to several hours) include moonlit scenes, tracing stars, lightening, and fireworks. To keep the shutter open for an extended period one can use a cable release which can be locked in position.

Section 1.5.2 Summary:

Shutter speed (exposure time) of a camera is represented by series of numbers signifying the amounts of time (generally in fractions of a second) that the shutter remains open. Typical practical exposure times in seconds are 1, 1/2, 1/4, 1/8, 1/15, 1/30, 1/60, 1/125, 1/250, 1/500, and 1/1000. The exposure time for some of the professional digital cameras extends from 30 seconds [30"] to 1/16000th of a second.

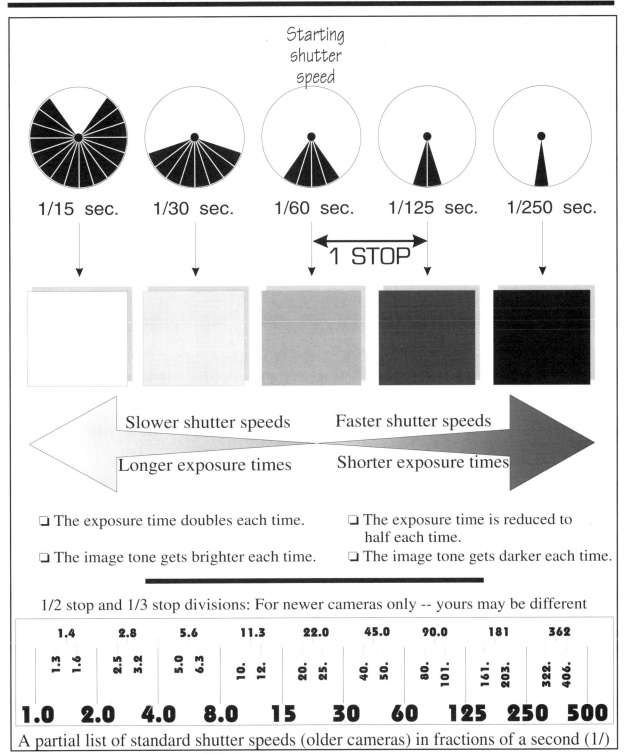

Starting shutter speed

| 1/15 sec. | 1/30 sec. | 1/60 sec. | 1/125 sec. | 1/250 sec. |

1 STOP

Slower shutter speeds / Faster shutter speeds

Longer exposure times / Shorter exposure times

❑ The exposure time doubles each time.

❑ The image tone gets brighter each time.

❑ The exposure time is reduced to half each time.

❑ The image tone gets darker each time.

1/2 stop and 1/3 stop divisions: For newer cameras only -- yours may be different

| 1.4 | 2.8 | 5.6 | 11.3 | 22.0 | 45.0 | 90.0 | 181 | 362 |

1.3 1.6 2.5 3.2 5.0 6.3 10. 12. 20. 25. 40. 50. 80. 101. 161. 203. 322. 406.

| 1.0 | 2.0 | 4.0 | 8.0 | 15 | 30 | 60 | 125 | 250 | 500 |

A partial list of standard shutter speeds (older cameras) in fractions of a second (1/)

Diagram 1.5.2

Diagram illustrating the effects of exposure time on image tone production for slide film. *If the aperture remains constant,* the longer the exposure, the lighter the image tone. The shorter the exposure, the darker the image tone. In the above illustration, the **black** areas of the wheel represent the exposure time. Please note that each time slice is 1/250 sec.

1.6. What is Film Speed?

Film speed is a measure of the film's sensitivity to light and is measured in ISO. **ISO** stands for **I**nternational **O**rganization for **S**tandards (on older cameras, **ASA** stands for **A**merican **S**tandards **A**ssociation). ISO is a combination of the old American ASA and German DIN, separated by a "/". For example, ISO 100 film is marked as 100/21°. In this book we will be only using the first part of this number, i.e., 100. On some films, the first part of ISO appears as a part of the film's name, such as Ektachrome 100 Plus. On professional films you may also see the film speed (ISO) to be indicated as EI 100 where EI stands for Exposure Index. For your purposes, EI and the first part of ISO are identical. If you can not find the ISO on the box, look inside. It is always printed on the film's container.

As far as ISO numbers go, the *larger* the number, the *more sensitive* the film is, and the *less* light is needed to take a picture. Similarly, the *smaller* the number, *the less sensitive* the film is, and the more light is needed to expose the picture properly.

ISO 25 film (such as Kodak's Kodachrome-25) is considered to be a low speed film. ISOs 50 to 100 are considered to be medium speed. ISOs of 200 and 400 are called high speed and ISOs of 800 and more (up to 3200) are considered as ultra high speed. If you are photographing a picnic or a soccer game on a sunny afternoon, you would use a medium speed film, such as ISO 64. However, if you are photographing an indoor football game or ice skating where you have a low light situation combined with a moving subject, you can use a higher speed film such as ISO 400, 800, 1600 or even 3200. The ISO numbering system is very much like the numbers on your shutter speed dial. It doubles (or halves) every time. Therefore, **there is one stop of difference** between, say, 400 and 800 ISO films.

If we start with the ISO 25 film and double this number each time, we will get the ISOs for most of the popular films such as 50, 100, 200, and 400, etc. Diagram 1.6.0 shows some of the ISOs that are currently used in photography.

If you look at the film speed dial on your camera, you will see small index lines or dots between the ISO numbers. For the newer cameras, these numbers are built into the camera's memory. These index lines stand for 1/3 stop increments between ISO numbers. For example, the two lines or dots between 50 and 100 stand for 64 and 80.

Like shutter speed and aperture settings, ISO can be adjusted to manipulate your exposure.

DIGITAL FOOTNOTE:

In the Manual Mode, the ISO of Pentax *ist D (D-Slr) can be set to 200, 400, 800, 1600, and 3200 (Custom Function). Many of the newer digital cameras such as Nikon D80, Nikon D200, Canon 20D and 30D have 100 as their lowest ISO. The most versatile Professional camera as far as the ISO goes is Canon 5D that can be set to as low as 50 and as high as 3200.

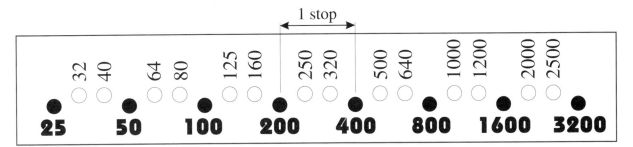

A partial list of ISOs in 1/3 stop increments

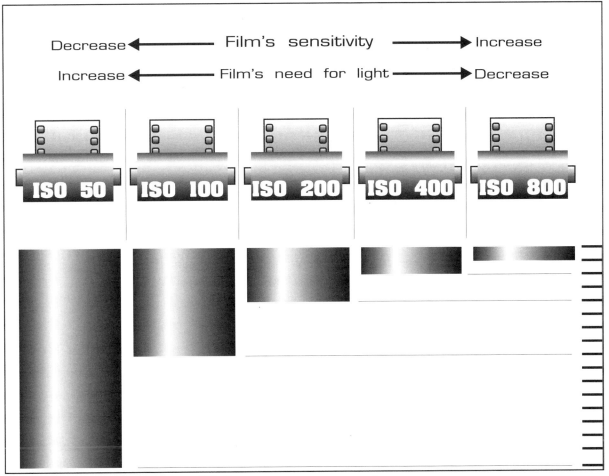

Diagram 1.6.0

ISO (film sensitivity or film speed) illustration

A film's ISO can be graphically represented by water tanks that are of different capacities. The volume of the container which is proportional to the ISO of the film represents the film's need for light. In this illustration, as the film's ISO is halved, its need for light is doubled.

1.7. A Simple Subject

A simple subject is a subject that in our definition has only one tone. Examples of a simple subject include a white piece of paper, snow, a painted wall under uniform light, a uniformly colored mat board, and portions of the blue sky.

If you look at the Diagram 1.7.0, you will see three simple subjects (tones) with different reflectivities. These subjects are very much like the cloth that is used to make a quilt before they are sewn together. At the lower half of the page, you will see the diagram for three plastic utensils, a knife, a fork and a spoon. These objects resemble our three simple subjects because they are in their simplest form. Another property of these utensils (very much like the three simple subjects) is that they are separate from one another; that is, they are not glued together. This enables us to pick one up without disturbing the others.

Associating **simple subjects** (what you photograph) with **simple objects** (utensils) will help you to better understand the techniques used to expose a subject.

How does one pick up one of these utensils with one hand? It is simple. First you must decide which utensil you are interested in, then grab hold of the handle and pick it up.

Please Note:

Since we will be extending the technique of properly exposing a simple subject to photograph a complex subject, learning to photograph a simple tone is perhaps the most important objective of this book. Without this knowledge, one cannot expect to excel in the art and science of light measurement.

A Practical Tip!

The most practical way to determine whether a subject is simple or complex is to look through your camera and move the spotmetering circle (frame) within the boundaries of the tone that you think represents a simple subject. If the reading of your meter remains the same (i.e., the needle stays in the middle / Exposure Index indicates the same exposure reading) the subject is simple, if it does not (i.e., it changes as you move the camera), the subject is complex. If with the above tip I totally lost some of you, don't worry. Please read on.

1 Simple subjects
(things being photographed)

Three uniform surfaces representing three (3) simple subjects

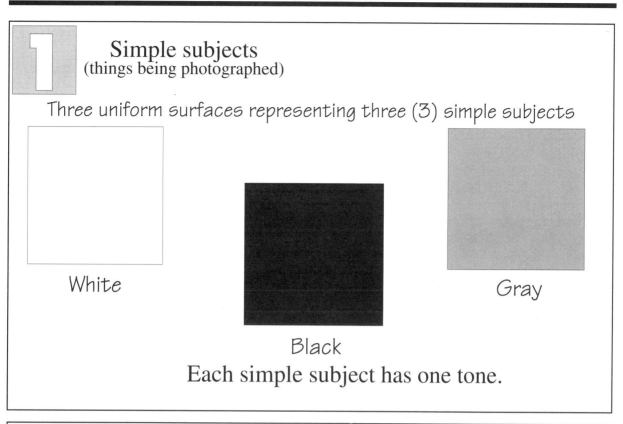

White

Black

Gray

Each simple subject has one tone.

2 Simple objects
(things we use to illustrate the concept)

Knife

Spoon

Fork

Each simple object has one handle.

Diagram 1.7.0

Diagram illustrating simple subjects and their association with simple objects

Practical examples of a simple subject

Although most of these surfaces do not qualify as true simple tones, for practical applications, when the majority of these subjects are viewed from far away as a group, they can be approximated to a simple subject.

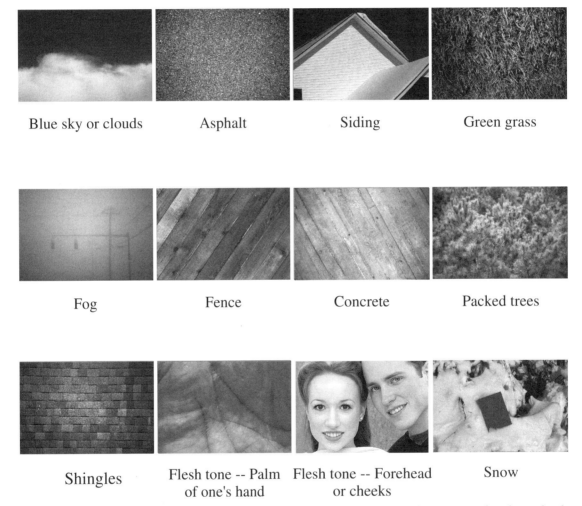

Blue sky or clouds Asphalt Siding Green grass

Fog Fence Concrete Packed trees

Shingles Flesh tone -- Palm of one's hand Flesh tone -- Forehead or cheeks Snow

The most practical way to determine whether a subject is simple or complex is to look through your camera and move the spotmetering circle (frame) within the boundaries of the tone that you think represents a simple subject. If the reading of your meter remains the same (i.e., the needle stays in the middle / Exposure Index indicates the same exposure reading) the subject is simple, if it does not (i.e., it changes as you move the camera), the subject is complex. If I totally lost you, please read on. We will be covering this in Sections 1.7, 1.10, and 3.2.

Images for section 1.7.0

1.8. A Complex Subject

By our definition, a complex subject is a subject that is made up of two or more simple subjects (tones). In other words, by combining (sewing, gluing, stapling, screwing, etc.) two or more simple subjects together, we get a complex subject.

Since it takes two or more simple subjects to create a complex subject, by the same logic, any complex subject can be visually divided (broken down) into two or more simple subjects.

Throughout this book, we will be using this important property to determine a complex subject's "correct" exposure.

As shown in Diagram 1.8.0, the three simple subjects that we used in the previous section are sewn together to form a quilt. A quilt, by our definition, is a complex subject. To see a complex subject in real life, just look around.

On the bottom of the Diagram 1.8.0, the same three utensils that we used in the previous illustration are screwed together to form a complex object. Unlike the simple objects discussed previously, these utensils are dependent on one another. This means if you move one of them from one location to another, the others will follow.

How does one move this complex object with one hand? It is simple. There are three choices: Choose any of these three handles, grasp the handle and move the *__entire__* object.

1. A complex subject
(subject being photographed)

Three simple subjects sewed together to make a quilt.
The quilt is considered to be a complex subject.

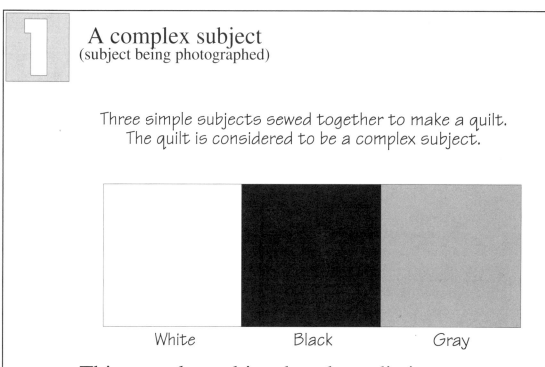

White Black Gray

This complex subject has three distinct tones.

2. A complex object
(what we use to illustrate the concept)

Three simple objects screwed together to make a complex object

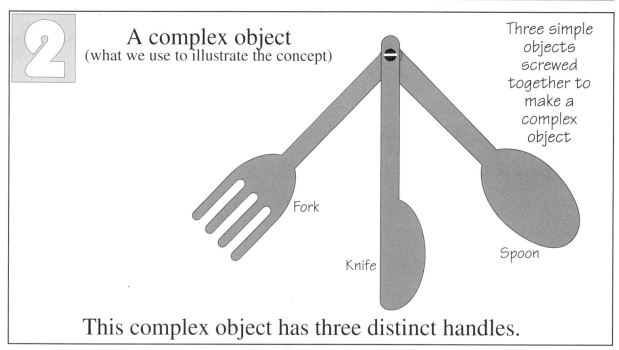

Fork

Knife

Spoon

This complex object has three distinct handles.

Diagram 1.8.0

Diagram illustrating complex subjects and their association with complex objects.

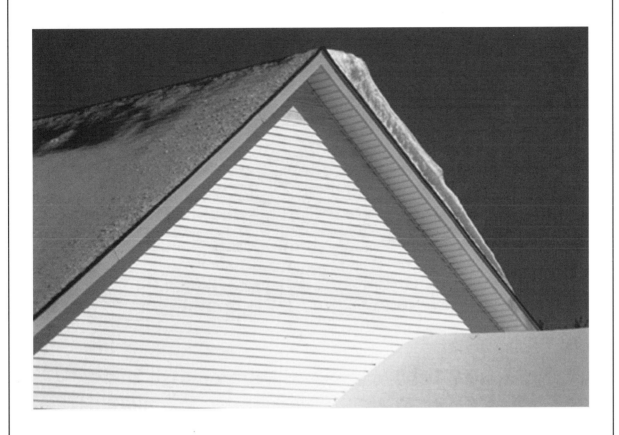

A complex subject

This snow-covered rooftop is an example of a complex subject. Some of the tones creating this subject include the dark gray (blue) sky, the black roof top, the white snow and the white siding.

Image for section 1.8.0

1.9. The Standard 18% Gray Card

Let's assume you want to measure the width of a house in yards. To do this, you can use a yardstick and obtain an approximate measure. In this process, a yard is the unit of our measurement. Since in photography we will be reproducing tones, we must have some type of standard for comparing and measuring tones. The most widely accepted standard in exposure determination and tone reproduction is called the 18% gray tone. An 18% gray card can be purchased from a camera store. Make sure, if possible, that the card is made of plastic and not cardboard. The cardboard ones have a short life, they get dirty quickly, and they can cause unwanted glare.

What 18% reflectivity means is that if 100 rays of light hit the card's surface, only 18 of them will reflect and the rest (other 82) will heat up the gray card!

Where this magic 18% number comes from, no one knows for sure. Why it is 18% and not another number is anybody's guess. In the literature of the 1950s and the 60s, the 18% number has been loosely associated with the average reflectivity of the planet earth as well as the reflectivity of an average subject, none of which should concern you.

What we must care about is that the 18% gray tone is exactly in the middle of our black and white tones.

By our definition, in the Zone System of light measurement, the 18% gray card is recognized to have a tone that is <u>halfway</u> between black and white tones. This tone, for the lack of other standards, has been chosen by most camera and lightmeter manufacturers to represent the tone of an average subject.

The 18% gray tone, as we will see later on, is the foundation of the Zone System of light measurement.

Diagram 1.9.0
Surface with an approximate reflectivity of 18%

1.10. The "normal exposure" versus the "correct exposure" and the "desired exposure"

A) The "normal exposure" —

What your meter thinks the exposure should be: Another term that we need to learn is what is meant by the term **"normal exposure."** This is when you point your camera at a subject and you change the aperture and/or shutter speed until the **camera shows you what it thinks to be the best exposure for your subject**. In some cameras, this is indicated when the needle is in the middle or when a needle aligns with another needle. In newer cameras, LED (Light Emitting Diodes/ digital display) indicators may turn on or LCD (Liquid Crystal Display/ digital display) arrows point to the center indicating the exposure balance. In this book, we will use the needle in the middle diagram to graphically illustrate the "normal exposure." Please refer to your camera manual to learn about yours.

One of the most important points about the "normal exposure" is that it would not necessarily produce what the photographer's eye sees.

B) The "correct exposure" —

The exposure that produces what your eye sees (well, almost!): The correct exposure of a subject produces an image that is close to what the eye sees. **As we will be finding out shortly, the "normal" exposure indicated by your camera does not necessarily produce the correct image, i.e., the "normal exposure" and the "correct exposure" can be different**. The major objective of this book is to teach you how to use the "normal exposure" as a starting point (platform) in order to find the "correct exposure."

C) The "desired exposure" —

This is the exposure that in your opinion would produce the best image for a given film and subject: In certain situations, some photographers are not happy with either of the above exposure techniques. In cases like this, the photographer, for artistic or other reasons, wants to produce an image that is technically neither "normal" nor "correct." Under these circumstances, the photographer thinks that the "desired exposure" would produce an image that he or she feels comfortable with. This includes overexposing a subject by two stops to lighten-up its tones or underexpose it by one stop to get darker tones or more saturated colors.

To simplify things, in this book, unless specified, the terms "correct exposure" and "desired exposure" are identical.

In the first three chapters of this book, we will be discussing the light measurement techniques mostly through the eyes of a camera's meter, although any other reflective metering instrument such as a spotmeter (a narrow angled reflective meter) and a broad angle reflective meter can also be used.

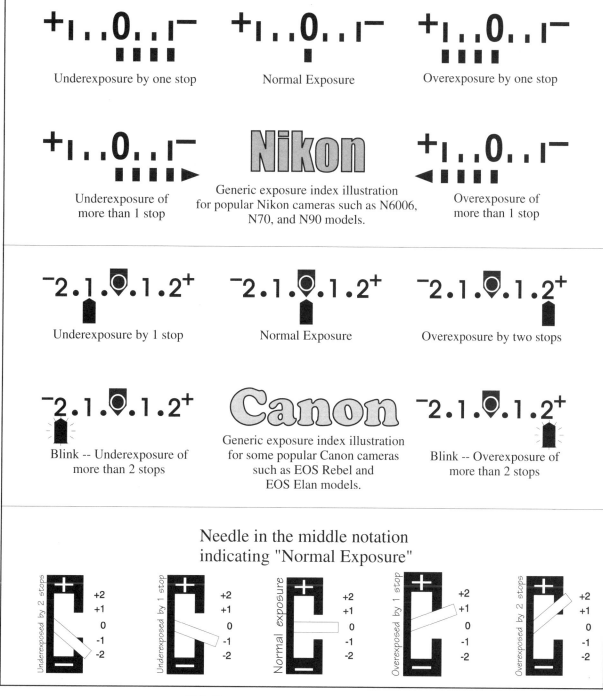

+|..0..|−
Underexposure by one stop

+|..0..|−
Normal Exposure

+|..0..|−
Overexposure by one stop

+|..0..|−▶
Underexposure of more than 1 stop

Nikon
Generic exposure index illustration for popular Nikon cameras such as N6006, N70, and N90 models.

◀+|..0..|−
Overexposure of more than 1 stop

−2.1.◉.1.2+
Underexposure by 1 stop

−2.1.◉.1.2+
Normal Exposure

−2.1.◉.1.2+
Overexposure by two stops

−2.1.◉.1.2+
Blink -- Underexposure of more than 2 stops

Canon
Generic exposure index illustration for some popular Canon cameras such as EOS Rebel and EOS Elan models.

−2.1.◉.1.2+
Blink -- Overexposure of more than 2 stops

Needle in the middle notation indicating "Normal Exposure"

Underexposed by 2 stops +2 +1 0 -1 -2

Underexposed by 1 stop +2 +1 0 -1 -2

Normal exposure +2 +1 0 -1 -2

Overexposed by 1 stop +2 +1 0 -1 -2

Overexposed by 2 stops +2 +1 0 -1 -2

Diagram 1.10.0

Diagram illustrating the exposure index for some of the newer cameras. The objective of this illustration is to teach the photographer what to look for in the viewfinder or on the LCD screen and how to recognize the camera's normal exposure. In this book we will be using the "needle in the middle" notation to indicate the "normal exposure."

1 When the "normal exposure" is the same as the "correct exposure"

The above subject was "normally exposed" using the camera's built-in meter. The exposure was 1/60 @ f-4 with an ISO 100 Kodak Ektachrome slide film.

The above subject was "correctly exposed" using the exposure of 1/60 @ f-4 with an ISO 100 Kodak Ektachrome slide film. As you notice, this "correct exposure" was also the same as the "normal exposure" that was indicated by your camera. This happened because the subject had a medium tone (not too bright and not too dark). As you can see, both of these images are identical.

2 When the "normal exposure" is NOT the same as the "correct exposure"

The above subject was "normally exposed" using the camera's built-in meter. The exposure was 1/125 @ f-16 with an ISO 100 Kodak Ektachrome slide film. In this case, the camera thought it was creating the best image. The meter was wrong!

The above subject was "correctly exposed" using an exposure of 1/125 @ f-5.6 with an ISO 100 Kodak Ektachrome slide film. In this case the photographer's skill overrode the erroneous camera's "normal exposure" to obtain this image. You will be learning these techniques later on in this book.

Images for section 1.10.0

When photographing an 18% gray card and the camera indicates a normal exposure (needle is in the middle), your "normal exposure" is also the "correct exposure." **This is the only time when one is sure that the "normal" exposure and "correct" exposure settings are the same. As we will be learning shortly, in real life, the "normal" exposure and "correct" exposure are not necessarily the same.**

Under these conditions, the photographer must use his or her skills to override camera's settings in order to produce the "correct" or the "desired" image tone. If you are a little confused, please read on! Converting the "normal exposure" to the "correct" or "desired" exposure is what this book is all about!

1.11. The Reference Tone

Let's pretend that when you release the shutter, you pick up the subject and carry it through the lens to the back of the camera and record it on the film. Picking up a subject and moving it from one medium to another is similar to picking up a stool with one hand and moving it from one room to another. To pick up a stool, one must look for a handle. **Let's define a handle as a section of the stool that one can grasp in order to move it to another location. Let's also refer to this part as the reference point of the stool.** In the previous example in which three utensils were bolted together, the choice was simple because we had three handles to choose from. With the stool, although the handles are not as obvious, if you look hard enough, you can find more than one component that you can use to pick it up with.

When photographing a subject (very much like picking up a stool), first you must select a simple tone that you can use as a handle. Let's call this a **Reference Tone**. By definition, this is a simple tone that is **"visually grabbed"** by the photographer. Once this is done, he or she uses this tone as a handle to pull the entire subject through the lens to the back of the camera and then record its proper image on film.

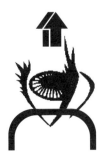

Since the **simple subject has only one tone**, this tone will also become its *only* Reference Tone. Therefore, the tone of the simple subject is the only "handle" that we can use to pick up the subject with. **To choose a Reference Tone for a complex subject, we must visually break the subject down into two or more simple subjects (tones). Once this is done, then theoretically, any one of these simple tones can become a Reference Tone that can be used as a handle.** As is shown in Diagram 1.11.0, the symbol for the Reference Tone is an eye with a handle. Consequently, when you see this symbol, the tone sticking to it will be the subject's Reference Tone.

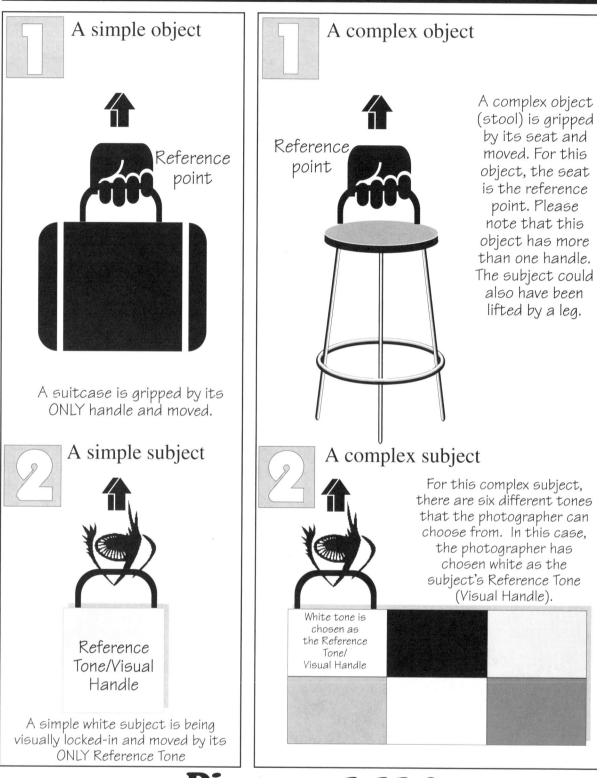

A simple object

Reference point

A suitcase is gripped by its ONLY handle and moved.

A complex object

Reference point

A complex object (stool) is gripped by its seat and moved. For this object, the seat is the reference point. Please note that this object has more than one handle. The subject could also have been lifted by a leg.

A simple subject

Reference Tone/Visual Handle

A simple white subject is being visually locked-in and moved by its ONLY Reference Tone

A complex subject

For this complex subject, there are six different tones that the photographer can choose from. In this case, the photographer has chosen white as the subject's Reference Tone (Visual Handle).

White tone is chosen as the Reference Tone/ Visual Handle

Diagram 1.11.0

Diagram illustrating Reference Tones for simple and complex subjects.

1.12. How does one choose a Reference Tone?

When photographing a subject, choosing a Reference Tone is very much like choosing a section of the stool that you can lift the stool with.

As the stool can be picked up by its seat or legs, theoretically, any complex subject can be picked up by any of the tones that make up the subject. **In practice, any complex subject has handles that are more logical. When using slide film, these are usually chosen from the medium or brighter tones of the subject**. These tones are easier to handle than darker tones.

*The only **exception** to this is that the Reference Tone cannot be the point source of light like the sun, a candle flame or a lamp that is illuminating your subject.*

Another factor to consider is that the **Reference Tone should be selected from the *most important* part of your subject**. For example, in portrait photography, the most logical tone to be used as the Reference Tone is the skin tone of the subject.

How to choose a Reference Tone

1) Choose the Reference Tone from the *most important area* of the subject.

2) If your subject does not have a "most important area," and you are using slide film, choose tones that are medium gray or brighter — If possible, avoid areas whose tones are darker than medium gray.

3) Although the sun, a lamp, or the flame of a candle can be photographed in a scene, you MUST avoid using these as a Reference Tone since they are simply too hot to handle!

1.13. What is a Zone?

Of all the terms we discussed, perhaps you are least familiar with this term as it applies to photography. Although the term "zone" will be covered in detail in Chapter 6, the following example will give you a solid foundation for a better understanding of this term.

Perhaps the most familiar application of the zone concept is the North American Time Zones. These zones extend from Nova Scotia (Canada) to California. As shown in Diagram 1.13.0, we have divided the "time" in North America into five 1-HOUR divisions or areas. This extends from the earliest (Atlantic Time Zone) to the latest (Pacific Time Zone) with the **Central Time Zone in the middle.** Assume that the time in Birmingham Alabama (Central Time) is 6:00 a.m. By examining the illustration, the time in New York state would be 7:00 a.m. and time in California would be 4:00 a.m. If we use the Central Time as our base of reference, then:

By adding 2 hours to Central time we get Atlantic time.

By adding 1 hour to Central time we get Eastern time.

By adding 0 hour to Central time we get Central time.

By subtracting 1 hour from Central time we get Mountain time.

By subtracting 2 hours from Central time we get Pacific time.

In this important example, our unit was "TIME" and we divided it into five 1-HOUR divisions or "ZONES."

In photography, the measure of the brightness of a subject is its "TONE." Since our complex subject can have many tones, we can divide these tones into many divisions called "ZONES." As with Time-Zones, each of these "Tone Zones" will be "ONE STOP" away from each other.

If the last paragraph left you confused, that was intentional. Even if you do not understand it, I want you to think about it. The subject of zones will be covered extensively in the following chapters.

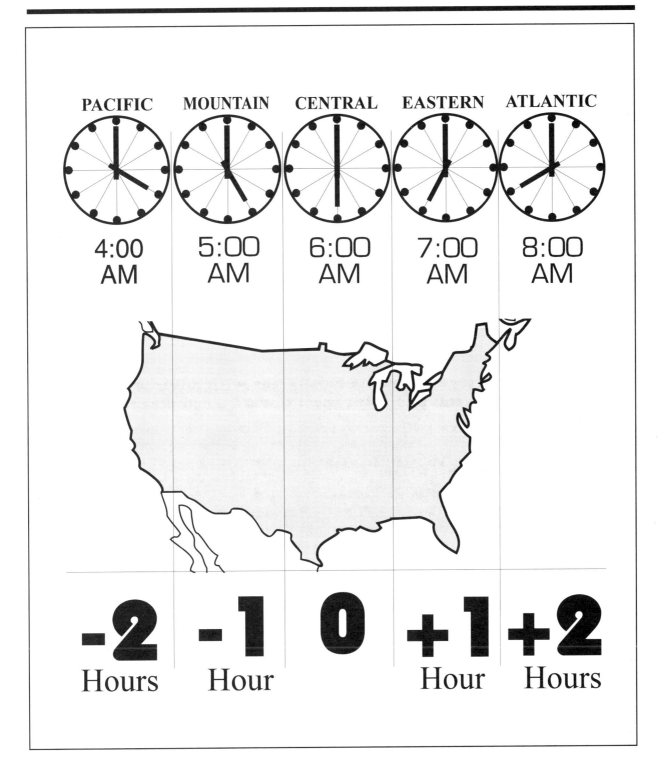

Diagram 1.13.0

Diagram illustrating five North American Time Zones
(Approximate. For illustration purposes only!)

1.14. Exposure consistency — The ultimate goal of the serious photographer

If I ask you whether you would be interested in a parachute that only opens most of the time or to fly a plane whose engine cuts off occasionally, or to use a scuba diving gear that could supply oxygen to the diver most of the time, there would be no takers.

When I tell my students "assume that you are on your last frame and you have the chance of making 1,000,000 dollars if you take a correctly exposed picture of a given subject," many of them take the offer without any hesitation. However, when I tell them "if you mess up the exposure, you will be shot," nobody wants to do it. The unskilled photographer is smart enough to know that they cannot trust their life to a meter that cannot be trusted every time.

This example, though extreme, illustrates the shortcoming of your camera's metering system. Perhaps you have realized that when you took a picture of a scene, the scene looked different in the final print. To illustrate this point, you can perform the following experiments:

1) Take three brand name cameras with different metering systems and point them toward a complex subject.

Although in some instances you may get the same "normal exposure" readings from each camera, there is no guarantee that the indicated exposure will produce a correct image. With this experiment, there is also a good chance that you may end up with three different exposure readings from the same *complex subject*. In this case which one of these exposures is technically correct? Although there is a possibility that one of them is correct, no one knows for sure. We can now conclude that with a *complex subject*, these three cameras provide you with *inconsistent* and/or *misleading* exposures readings.

2) Now point the same three cameras toward a *simple* subject.

If their metering systems work correctly, all three would indicate *approximately* the same "*normal exposure*." Although the "normal exposure" does not necessarily produce the correct image tone, however, if this exposure reading is *wrong*, then all three cameras are *consistently* showing the *wrong exposure.* If it is *correct,* then all three cameras are *consistently* showing you the *correct exposure. In this book, we will be using the consistency* characteristics of our cameras or spotmeters from a simple subject to find their normal exposure. *The next step is to convert (change) this "normal exposure" to a "correct exposure" that produces the correct or desired image tone*. Later on, we can expand the technique to cover a variety of complex subjects.

Section 1.14 Summary:

Techniques that are discussed in this book will enable you to produce consistent results and teach you the skill to previsualize the final image. Previsualization is the art and science that enables you to predict and control the tones of your final image.

Since there is not a single camera in the world that by itself (without your help) can provide you with the "correct exposure" every time, remember: **A photographer is very much like a painter. He or she uses a camera instead of a paint brush and film instead of a canvas. As what gets painted on the canvas very much depends on the skill and the taste of the painter, what gets registered on a film very much depends on the skill and the taste of the photographer. It is the** *mind of the skilled photographer* **that overrides the dials of a camera to capture what** *he or she wants to see,* **where it is the camera that overrides the mind of the unskilled and gives them what "it" wants them to see.**

1.15. The Rule of Equivalent Exposures

When you are exposing a subject and you have determined its **correct** or **normal** exposure, there are many other exposures that will expose the film with the same amount of light.

Assume your exposure from a subject is 1/1000 sec. @ f-1.4. For many films, the following shutter speed/aperture combinations, result in identical exposures. This means if for one of these exposures "the needle is in the middle," or "the pointer/index mark is under 'O' in the middle of '+' and '-' signs in the viewfinder of your camera," then the needle will stay in the middle for the rest of these exposures (please see illustration 1.10.0).

Shutter speed/aperture pairs producing identical exposures							
The following row illustrates eight consecutive exposure times in _increasing_ order							
1/1000	1/500	1/250	1/125	1/60	1/30	1/15	1/8
f-2.8	f-4	f-5.6	f-8	f-11	f-16	f-22	f-32
The above row illustrates eight consecutive aperture openings in _decreasing_ order							

As you notice, for every STOP **decrease** in the aperture opening, the exposure time **increases** by one STOP.

Using your camera, experiment and build your own set of equivalent exposures and make sure that you understand the concept. In this book, this property will be extensively used with your camera as well as with off-camera exposure meters and spotmeters.

If you are confused, please note that a one Dollar bill is worth the same as four Quarters, ten Dimes, twenty Nickels, hundred Cents, and many other combinations.

In this example each of the above combinations adds up to exactly one Dollar. By the same token, **_each exposure combination_** illustrated in the above table exposes the film with exactly the same amount of light.

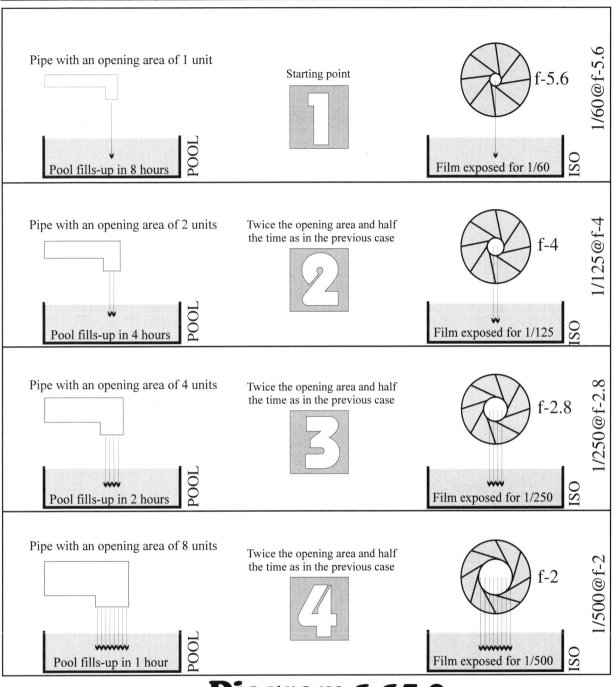

Illustration 1 — Starting point
Pipe with an opening area of 1 unit
Pool fills-up in 8 hours — POOL
f-5.6 — Film exposed for 1/60 — ISO
1/60 @ f-5.6

Illustration 2
Pipe with an opening area of 2 units
Twice the opening area and half the time as in the previous case
Pool fills-up in 4 hours — POOL
f-4 — Film exposed for 1/125 — ISO
1/125 @ f-4

Illustration 3
Pipe with an opening area of 4 units
Twice the opening area and half the time as in the previous case
Pool fills-up in 2 hours — POOL
f-2.8 — Film exposed for 1/250 — ISO
1/250 @ f-2.8

Illustration 4
Pipe with an opening area of 8 units
Twice the opening area and half the time as in the previous case
Pool fills-up in 1 hour — POOL
f-2 — Film exposed for 1/500 — ISO
1/500 @ f-2

Diagram 1.15.0

An illustration of equivalent exposures

In this example, the pipe in illustration #2 discharges twice as much water as in illustration #1. The pipe in illustration #3 discharges twice as much water as in illustration #4 and so on. The same logic applies to the aperture opening. The aperture opening of f-8 lets in twice as much light as f-11 and the aperture opening of f-5.6 lets in twice as much light as f-8.

In the water example, *in each case*, the pipe discharges *exactly* the same amount of *water in a given time* to *fill up the pool*. In the camera example, *each exposure (shutter speed/aperture opening combination)* will allow *exactly* the *same amount* of *light* to *expose the film*.

GALLERY

The Confused Photographer's Guide to Photographic Exposure and the Simplified Zone System

Assignments to Normally Expose Simple Subjects with Different Tones

What will you learn in this chapter?

In this chapter we will perform five experiments that will be the basis for the entire book. By photographing a black card and a white card, we will notice that the camera will erroneously produce a gray image tone from each of these subjects. The rest of the chapter is based on developing techniques to correct these image tones.

Please Note: This chapter must be read by all readers, and performing these assignments will help the reader to understand the practical foundations of the Zone System.

How to prepare for these assignments:

In these assignments, you will be simply taking a picture of a gray card, a black surface, and a white surface. It will only take a few minutes to complete.

<u>IMPORTANT</u>

Before starting, please read through section 2.16. To save you time and money, you need to perform all five assignments under the same lighting conditions, within a short time frame and on the same roll of film. It is very important for you to know what to expect from these assignments.

Before starting on these, make sure:

1) It is a sunny morning or afternoon with no clouds in the sky. This is necessary for exposure consistency.

2) You have your normal, 50mm lens on your camera. If you do not have a 50mm lens, any fixed lens would do. Please avoid zoom lenses. They are less accurate than fixed lenses and may produce inconsistent results.

3) Your camera's ISO is set to the film's ISO (In my case it is 64).

4) You are using slide film (*do not use negative film*)!

5) Wear something that is not too bright or too dark (a medium tone would do)! White clothing, under certain lighting conditions, could affect the exposure and produce inconsistent results.

2.1. Assignment #1: Normally exposing a standard 18% gray card

1) Select an eye level spot on a *uniformly shaded* wall (about 5 feet high).

2) Use a few pushpins around the 18% gray card to secure it to the wall. *Make sure the card is situated so that there is no glare on it.*

3) Place the camera about 12 inches away from the card. Make sure all that you see in a viewfinder is the gray tone of the card. If the lens's minimum distance is greater than 12 inches and the image is blurred, it does not matter.

4) Set your aperture to f-8 and change the shutter speed until your camera shows a normal exposure. If your needle is a little off, change the aperture from f-8 a little until it shows a normal exposure, that is, the needle is in the middle.

5) Shoot the picture.

6) Record the frame number, the exposure and the subject type on a piece of paper. Just for illustration purposes, assume normal exposure settings of 1/60 @ f-8 (your reading may be different).

After you have processed your slides, examine the gray image that was created on this slide. **This gray tone is what we call the "image of the 18% gray card" or the "18% gray image tone." This image tone is the most important tone in photography and is the foundation of our Zone System of light measurement.** This assignment is illustrated in Diagram 2.1.0.

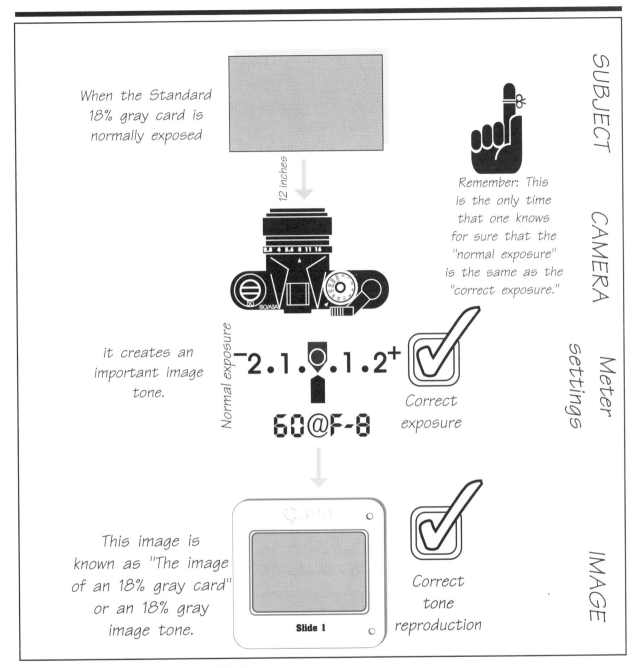

When the Standard 18% gray card is normally exposed

SUBJECT

12 inches

CAMERA

Remember: This is the only time that one knows for sure that the "normal exposure" is the same as the "correct exposure."

it creates an important image tone.

Normal exposure

⁻2.1.◉.1.2⁺

60@F-8

Meter settings

Correct exposure

This image is known as "The image of an 18% gray card" or an 18% gray image tone.

Slide 1

IMAGE

Correct tone reproduction

Diagram 2.1.0

Assignment #1- Normally exposing a gray card

Diagram showing how the meter in your camera measures the "normal exposure" from a standard 18% gray card and produces its correct image tone on the slide film. The tone we produced on this slide is the foundation of the Zone System and is the most important tone in photography.

2.2. Assignment #2: Normally exposing a black mat board

1) Select an eye level spot on a **uniformly shaded** wall (about 5 feet high), as you did in the previous experiment.

2) Use a few pushpins to secure the black board to the wall. Make sure the card is situated so that there is no glare on it.

3) Place the camera about 12 inches away from the black board. **Make sure that all you see in the viewfinder is the black tone of the board**. No part of the wall should appear in your viewfinder. If the lens's minimum distance is greater than 12 inches and the image is blurred, it does not matter. Keep your distance dial exactly the same as the previous assignment.

4) Keep your shutter speed the same as Assignment #1 and change the aperture until the camera shows a **normal exposure.**

5) Using these settings, shoot the picture.

6) Record the frame number, the exposure and the subject on a piece of paper. Just for illustration purposes, assume our normal exposure was at 1/60 @ f/4 (your reading may be different).

After you have processed your slides, inspect the image tone that you just created on this slide. To your surprise, it will look gray. In practice, its image tone will approximate the tone we captured in Assignment #1. Here, the camera's "normal exposure" created a wrong image tone for our black subject. The assignment is illustrated in Diagram 2.2.0.

DIGITAL FOOTNOTE:

If you are **not** using a digital camera please skip over this! **_Please note that this illustration also applies to Section 2.1._**

After you have transferred your images to your PC, by changing its Image Mode convert your image to Grayscale (black and white). If you use Photoshop photo editing software, click on the foreground image (your gray image) with the Eyedropper tool. Then click on Foreground Color Box, the following readings will appear. Your numbers **_should be close_** to R:128 (Red), G:128 (Green), and B:128 (Blue) where 128 is the **middle** of a 256 point Grayscale with 000 (black) as darkest and 255 (white) as the brightest tone that can be displayed on your monitor's screen . Please note that the semi-circle on the left is positioned exactly in the middle of the black and white tones. If your numbers are much lower than 128, say 103, please refer to Appendix C.7 on page 249.

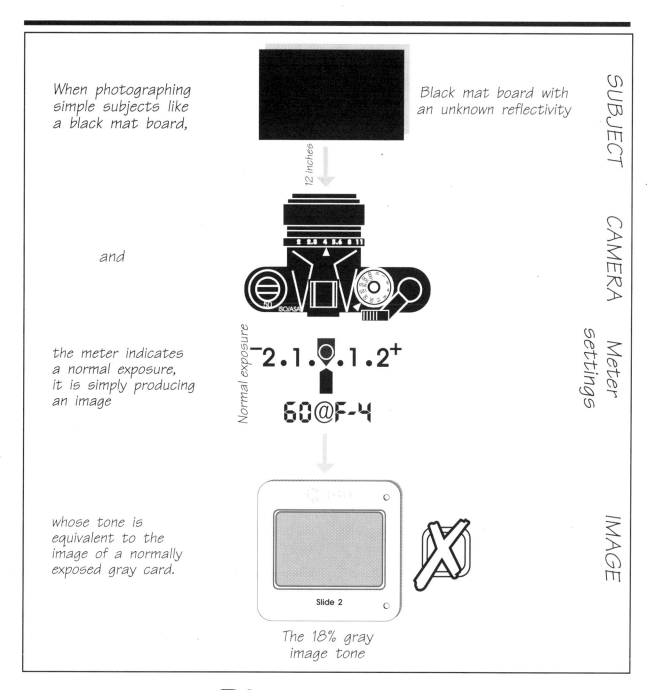

When photographing simple subjects like a black mat board,

Black mat board with an unknown reflectivity

SUBJECT

CAMERA

12 inches

and

2 2.8 4 5.6 8 11

50 ISO/ASA

Meter settings

the meter indicates a normal exposure, it is simply producing an image

Normal exposure

⁻2.1.●.1.2⁺

60@F-4

whose tone is equivalent to the image of a normally exposed gray card.

IMAGE

Slide 2

The 18% gray image tone

Diagram 2.2.0

Assignment #2 - Normally exposing a black surface

Diagram showing how the meter in your camera produces the standard gray image tone from simple subjects such as a black mat board. In this case, the meter in your camera indicates a normal exposure but produces the wrong tone. When you are photographing a simple subject and your meter indicates a normal exposure, it is simply creating an 18% gray image tone on the film. **This tone is independent of the tone of the original subject.**

2.3. Assignment #3: Normally exposing a white mat board

1) Select an eye level spot on a *uniformly shaded* wall (about 5 feet high), as you did in the previous experiment.

2) Use a few pushpins to secure the white board to the wall. Make sure the card is situated so that there is no glare on it.

3) Place the camera about 12 inches away from the white board. Make sure that all you see in the viewfinder is the white tone of the board. *No part of the wall should appear in your viewfinder*. If the lens's minimum distance is greater than 12 inches and the image is blurred, it does not matter. Keep your distance dial exactly the same as the previous assignment.

4) Keep your shutter speed the same as Assignment #1 and change the aperture until the camera shows a *normal exposure*.

5) Using these settings, shoot the picture.

6) Record the frame number, the exposure and the subject on a piece of paper. Just for illustration purposes, assume our normal exposure was at 1/60 @ f/16 (your reading may be different).

After you have processed your slides, look at the image tone that you just created on this slide. *To your surprise, it will look gray.* In practice, its image tone will approximate the tone we created in Assignment 1 and 2. Here, the camera's "normal exposure" created a wrong image tone for our white subject.

DIGITAL FOOTNOTE:

If you are not using a digital camera please skip over this!

After you have transferred your images to your PC, by changing its Image Mode convert your image to Grayscale (black and white). If you use Photoshop photo editing software, click on the foreground image (your gray image) with the Eyedropper tool. Then click on Foreground Color Box, the following readings

will appear. Your numbers *should be close* to R:128 (Red), G:128 (Green), and B:128 (Blue) where 128 is the *middle* of a 256 point Grayscale with 000 (black) as darkest and 255 (white) as the brightest tone that can be displayed on your monitor's screen . My numbers with my camera were slightly higher (132 instead of 128). Please note that the semi-circle on the left is positioned exactly in the middle of the black and white tones. If your camera reads a lower number than 128, say 103 or 111, please refer to Appendix C.7 on page 249.

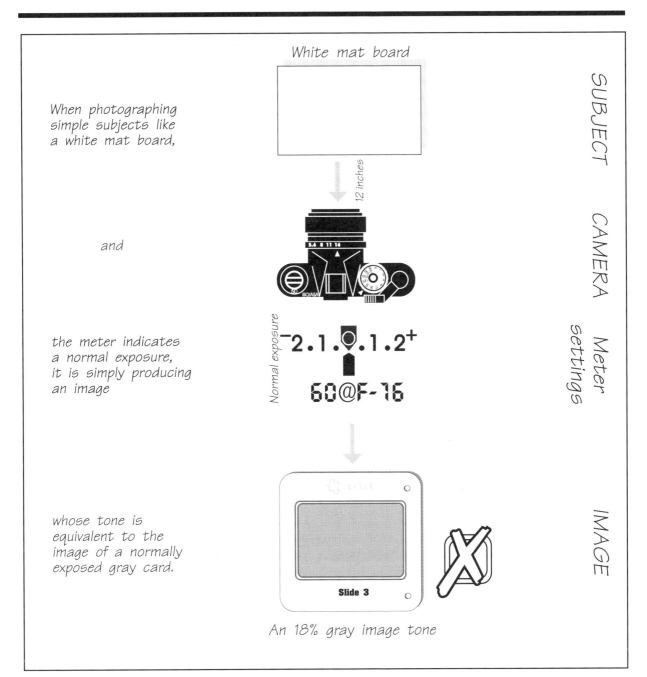

When photographing
simple subjects like
a white mat board,

and

the meter indicates
a normal exposure,
it is simply producing
an image

whose tone is
equivalent to the
image of a normally
exposed gray card.

White mat board

12 inches

Normal exposure
⁻2.1.◉.1.2⁺
60@F-16

SUBJECT CAMERA Meter settings IMAGE

Slide 3

An 18% gray image tone

Diagram 2.3.0

Assignment # 3 - Normally exposing a white surface

Diagram showing how the meter in your camera produces the standard gray tone image from simple subjects such as a white mat board. In this case, the meter in your camera indicates a normal exposure but produces the wrong tone.

When you are photographing a simple subject and the meter in your camera indicates a normal exposure, it is simply creating an 18% gray image tone from your subject. **The tone produced is independent of the tone of the original subject.**

2.4 The Federal Express (FedEx) Story

Federal Express Company (FedEx) is the world's largest express transportation company and carries more than two million packages daily. Many of these packages are delivered overnight to hundreds of destinations in the US. For many years, until the volume became overwhelming, all packages from different cities, irrespective of their final destination, were flown to Memphis, Tennessee, to FedEx's Superhub. From there, the packages were sorted and placed on a plane and flown to their appropriate destinations (except all packages whose final destination was Memphis)! Diagrams 2.4.1 and 2.4.2 illustrate the similarities between your meter's operation and that of FedEx's original operations.

2.5. Let's relate the FedEx's centralized process to the conclusions of our assignments.

When sending a package from one city to another, the package always ended up in Memphis before it was shipped to its final destination. For many years, Memphis was the base for the FedEx operations in the same way that the 18% gray image tone is the base for your meter's operation.

When you point the reflective meter in your camera **at any simple subject** and the meter in your camera shows a normal exposure, it is simply creating an 18% gray image tone.

For the original FedEx, Memphis was considered to be the city where all packages must change planes to reach their final destination.

For your camera, 18% gray base can be considered as a point through which *all image tones must pass* before reaching their final destination. *The only difference is that your camera does not know where these tones are coming from and where they are going to*. The final destination of any gray tone at the gray base must be determined by the skilled photographer. Photographers having the knowledge of light measurement, know what the original tone looks like and they use their skill to create the correct image tone on film.

 The original operation of the FedEx Company

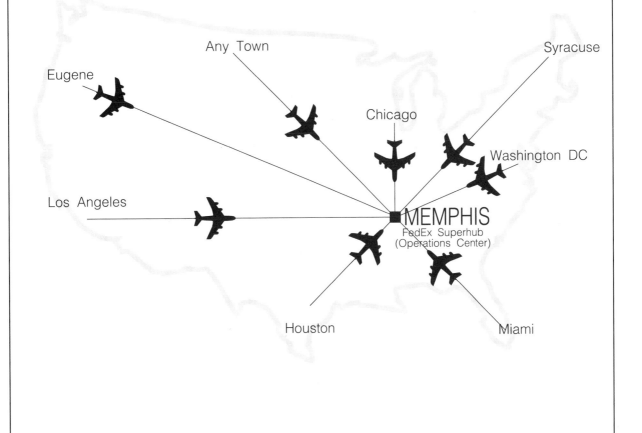

Diagram 2.4.1

Similarities between two operations:
The FedEx versus your camera's meter

Irrespective of the city of the origin, all packages ended up in Memphis every night before they were shipped to their final destination.

The operation of your camera's meter

Black · Dark Gray · Middle Gray · Light Gray · White · Any simple Tone

SUBJECT

Normal exposure · Normal exposure · Normal exposure · Normal exposure · Normal exposure · Normal exposure

18% Gray image tone (base)

IMAGE

Diagram 2.4.2

Similarities between two operations: The FedEx versus your camera's meter

For these simple subjects, when your meter indicates a normal exposure, it is simply creating an image whose tone is 18% gray. **When a simple subject is normally exposed, the tone of the image will always be independent of the original tone of the subject.**

Summary of what we have learned so far

When we normally expose any simple subject, the resulting image tone will always be equivalent to that of a normally exposed 18% gray card. *This is because your meter is designed to do so.* This gray image tone is the base for your meter, the same way Memphis is the base for the FedEx's operation.

The question that a FedEx employee at Memphis asks is "Where does this package go from here?"

The question that is asked by a skilled photographer at the 18% gray image tone is "Where does this image tone go from here?"

If you are confused about gray image making nature of your camera's meter, and you would like something to remember it by, perhaps memorizing this helps. My students seem to like it!

There are three things that are for sure:

1) Death

2) Taxes

3) An 18% gray image tone from a normally exposed simple subject.

As cliché as it sounds, this can help you to remember this important property. Just make sure you do not leave out a single word.

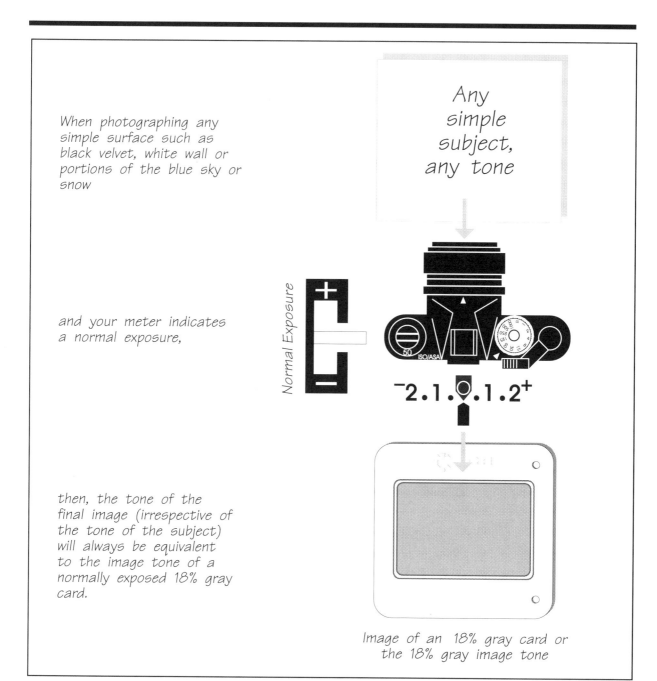

When photographing any simple surface such as black velvet, white wall or portions of the blue sky or snow

Any simple subject, any tone

Normal Exposure

and your meter indicates a normal exposure,

⁻2.1.●.1.2⁺

then, the tone of the final image (irrespective of the tone of the subject) will always be equivalent to the image tone of a normally exposed 18% gray card.

Image of an 18% gray card or the 18% gray image tone

Chapter 2: An illustrative summary

Conclusions for assignments #1, #2 and #3

When photographing a simple subject like snow, a white wall, the blue sky or sand and your camera indicates a normal exposure, it is creating an image whose tone is equivalent to that of a normally exposed 18% gray card. This image is generally called the 18% or standard gray image tone.

2.6. The gray-making property of the meter; is it good or bad?

This is what we have learned so far: **When photographing any simple subject and the camera indicates a "normal exposure," the camera's meter is creating an 18% gray image tone.** In this situation we have two choices:

1) We can shoot the picture as is. Depending on the reflectivity of the tone that we are photographing, the final picture may or may not be correctly exposed. This is what most people do, and always end up with a gray image. To do this, one does not need to have any special skills.

2) Look at the subject tone and by manually lightening or darkening the image tone in the camera, create a similar tone on the film. The procedure of changing the image tone to match its original subject tone is called "manually overriding" the normal exposure readings.

When I teach this subject and say that it is good to be at the 18% gray base, some students look at me and say, "This is crazy!" "It doesn't make any sense!" or "What is so good about it?" My standard answer is "Yes, it is crazy" and "Yes, it doesn't make any sense." **However, since you are stuck with this property, what you can do is to know and understand it so that you can use it skillfully in producing a correct image tone.**

The disadvantage of this gray-making feature of the meter is that it *may not* provide us with the *correct image tone* from a simple subject.

The advantage of this feature is its *predictability*, i.e., *you always know exactly where you stand with it.* When *normally* exposing a simple subject, *the image tone is always 18% gray*. This consistency provides us with a solid and predictable base that we can use as a foothold or a base in our journey to produce the final image.

As was demonstrated in cases like Assignments 2 and 3, this starting 18% gray image tone is not our final destination. The trick is that if we can manually brighten or darken this gray image tone so that it approximately matches our subject's tone, then we have made it.

When photographing any simple subject and the meter indicates a normal exposure, all your camera is doing is creating an image whose tone is the same as that of a **normally/correctly** exposed 18% gray card (see Assignment #1). **Your camera's meter does this** *because it is designed to do so*. **The tone of the resulting image will** *always* **be** *independent* **of the** *original tone* **of the subject. Please read, understand and memorize these lines. Unless you understand this concept, you will not be able to use the Zone System of light measurement to improve your exposure skills.**

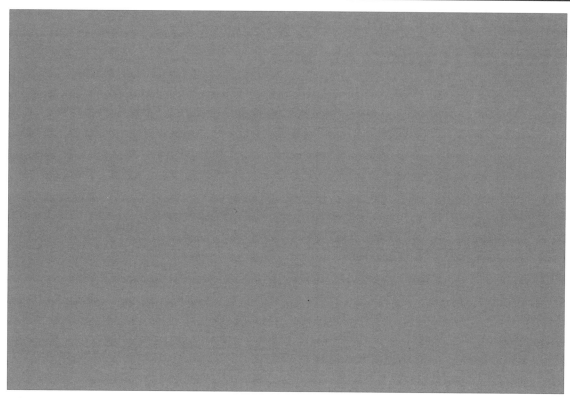

These two pictures illustrate the gray-making property of the meter. If the subject is uniform enough (e.g., it approximates a simple subject), the resulting *image tone* from normally exposing the subject will *always* be 18% gray.

Images for section 2.6.0

2.7. Changing one shade of gray (tone) to another: The Standard Gray Paint Factory

In the next three pages (Diagrams 2.7.1, 2.7.2 and 2.7.3) you will see illustrations for the Standard Gray Paint Factory. This factory, as the name implies, specializes in producing standard gray paint (perhaps with a reflectivity of 18%).

Occasionally, orders come in for white or black paints. Unfortunately, since the production of this factory is geared toward making gray paint, these orders are routed through the normal gray paint producing channels until the paint reaches the quality control area. In this department the inspector examines the paint and sends it through the manual reprocessing section.

In the manual reprocessing section, to make the gray paint black, most of the *white* pigment is *extracted* (removed) from the gray paint and what is left will look darker or "more black."

To turn the gray paint into white, more *white* pigment is *added* to it and the resulting paint becomes more white.

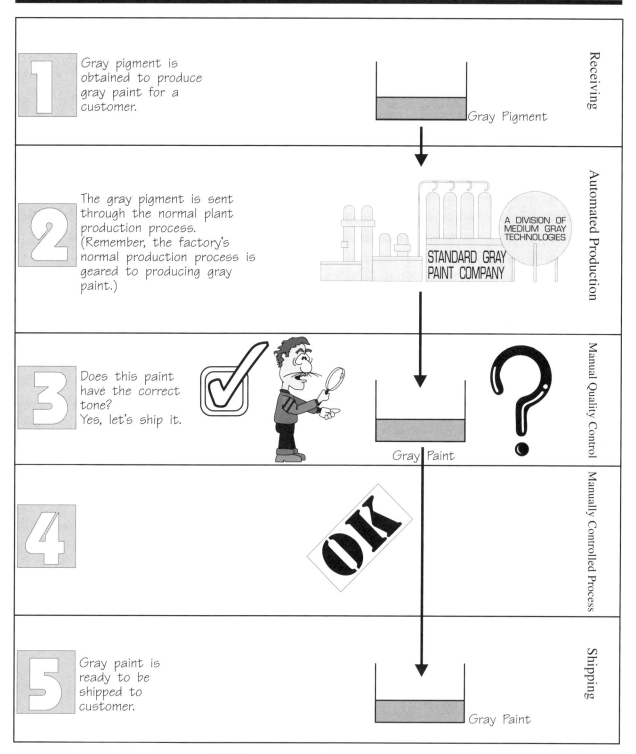

1 Gray pigment is obtained to produce gray paint for a customer.

Gray Pigment

Receiving

2 The gray pigment is sent through the normal plant production process. (Remember, the factory's normal production process is geared to producing gray paint.)

A DIVISION OF MEDIUM GRAY TECHNOLOGIES

STANDARD GRAY PAINT COMPANY

Automated Production

3 Does this paint have the correct tone? Yes, let's ship it.

Gray Paint

Manual Quality Control

4 OK

Manually Controlled Process

5 Gray paint is ready to be shipped to customer.

Gray Paint

Shipping

Diagram 2.7.1

Normal production process at the Standard Gray Paint Company

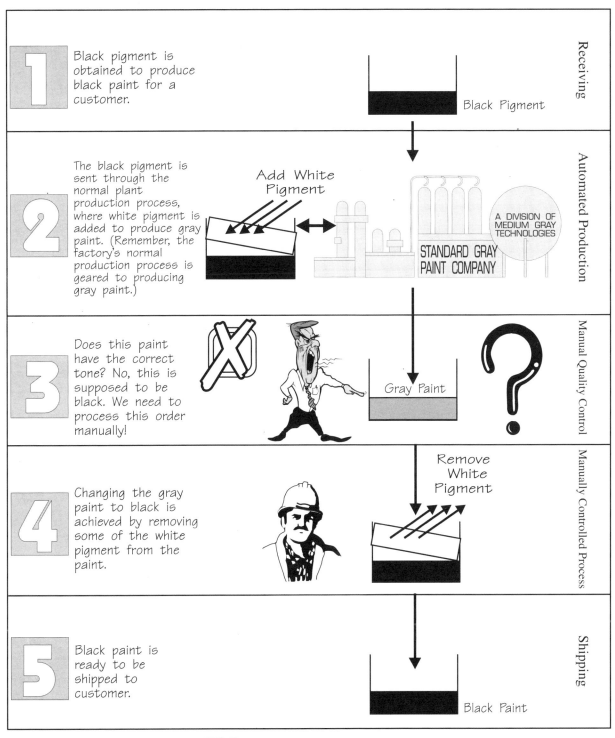

1 Black pigment is obtained to produce black paint for a customer.

Black Pigment

Receiving

2 The black pigment is sent through the normal plant production process, where white pigment is added to produce gray paint. (Remember, the factory's normal production process is geared to producing gray paint.)

Add White Pigment

STANDARD GRAY PAINT COMPANY

A DIVISION OF MEDIUM GRAY TECHNOLOGIES

Automated Production

3 Does this paint have the correct tone? No, this is supposed to be black. We need to process this order manually!

Gray Paint

Manual Quality Control

4 Changing the gray paint to black is achieved by removing some of the white pigment from the paint.

Remove White Pigment

Manually Controlled Process

5 Black paint is ready to be shipped to customer.

Black Paint

Shipping

Diagram 2.7.2

Production problems at the Standard Gray Paint Company

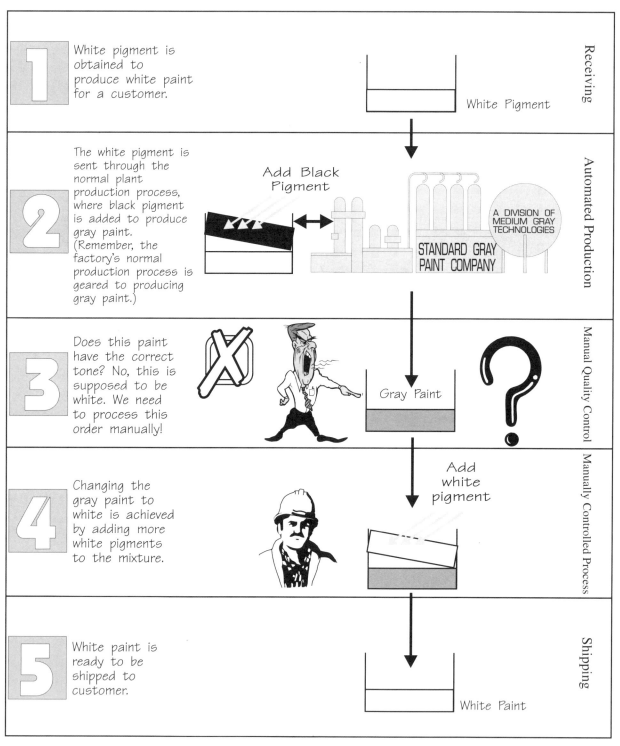

1 White pigment is obtained to produce white paint for a customer.

White Pigment

Receiving

2 The white pigment is sent through the normal plant production process, where black pigment is added to produce gray paint. (Remember, the factory's normal production process is geared to producing gray paint.)

Add Black Pigment

A DIVISION OF MEDIUM GRAY TECHNOLOGIES

STANDARD GRAY PAINT COMPANY

Automated Production

3 Does this paint have the correct tone? No, this is supposed to be white. We need to process this order manually!

Gray Paint

Manual Quality Control

4 Changing the gray paint to white is achieved by adding more white pigments to the mixture.

Add white pigment

Manually Controlled Process

5 White paint is ready to be shipped to customer.

White Paint

Shipping

Diagram 2.7.3

Production problems at the Standard Gray Paint Company

2.8. The standard gray paint factory and how it relates to the meter in your camera

Since the gray paint is a combination of black and white paint, it can be converted to any other shade of gray by increasing or decreasing its white content. What this means is that if we start with some gray paint and add white pigment to it, the tone of the gray paint turns into a brighter shade of gray. By using the same logic, if we start with the same gray paint and take away some of its white, the gray turns to a darker shade of gray.

We can apply the same logic to the gray tone that is produced by our camera.

Since any gray paint is a combination of black and white, this 18% gray image tone is also a combination of black and white. Therefore its tone can be changed to brighter or darker shades of gray by increasing or decreasing its white content, the light that it is exposed to.

2.8.1. Changing the 18% gray image tone into darker shades of gray by decreasing its white content

The standard 18% gray image can be changed to darker shades of gray by decreasing its white content. The reduction of the white content of this tone can be achieved by decreasing the amount of light entering the camera.

This can be done by closing-down the aperture or using shorter exposure times than the normal exposure. An example of this is closing-down the aperture from f-4 to 5.6 or changing the shutter speed from 1/30 to 1/60 sec.

2.8.2. Changing the 18% gray image tone into brighter shades of gray by increasing its white content

The increase in the white content of this 18% gray image tone can be achieved by increasing the amount of light entering the camera. This can be done by opening-up the aperture or using longer exposure times (slower shutter speeds) than the normal exposure. An example of this is opening-up the aperture from f-11 to f-8, *or* changing the shutter speed from 1/125 to 1/60 sec.

2.9. What does the term "middle" mean in photography?

Although the term "middle" could mean different things to different people, in photography it has a special meaning. The easiest way that I can explain it without losing you in mathematical details is to give you an example of 5 familiar consecutive shutter speeds. These speeds can be found on the speed dials of many newer cameras. As you can see in the illustration, I chose 1/125, 1/250, 1/500, 1/1000 and 1/2000 sec. Now let's assign these shutter speeds to your fingers. Please look at the Diagram 2.9.0.

The logic of explaining the term "middle" is important and will be used shortly to build other shades of gray for our Simplified Zone System.

Question: Use your shutter speed dial to find one set of shutter speeds that 1/30 sec. is the middle of.

Answer: By looking at the dial, *one stop* away from 30 is *15* and *60;* therefore the pair of 1/15 and 1/60 is one of our answers. These numbers could also have been obtained by *dividing* and *multiplying* the number 30 by 2. Other answers include 1/8 and 1/125, 1/4 and 1/250 and so on.

Question: Use your shutter speed dial to find one set of shutter speeds that 1/125 sec. is the middle of.

Answer: By looking at the dial, one stop away from 125 is 60 and 250, therefore the pair of 1/60 and 1/250 is one of our answers. These numbers could also have been obtained by *dividing* and *multiplying* the number 125 by 2 (approximate).

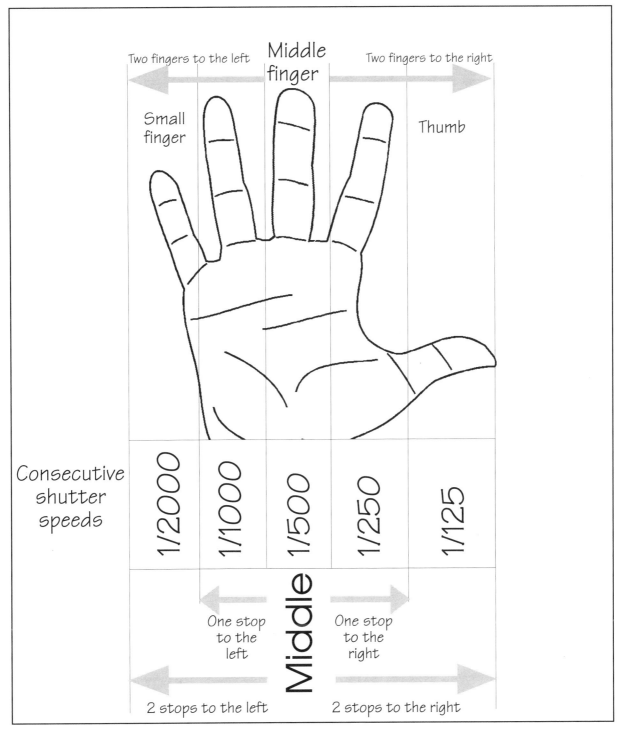

Diagram 2.9.0

Diagram illustrating the photographic "middle"

2.10. Creating other Standard Tones of Gray: Controlling the brightness of the image for a simple subject

The next question you might ask is *by how much* you need to brighten or darken the gray tone. **"How much" is the million dollar question**. When correcting the tone, the worker in the Standard Gray Paint Factory used some kind of chart as a guide. The chart suggested the quantity of white pigment to be added or to be removed from the gray paint to produce the desired tone. We can apply the same technique to our camera.

By the Zone System definition, the tone of the standard 18% gray card is in the middle of black and white subject tones. As you remember in the previous section, we could always start with a given shutter speed and find the other shutter speeds that were one stop away from it. This was done by multiplying and dividing the given shutter speed by 2. For example, when we selected the shutter speed of 500 and divided it by 2, we got 250. When we multiplied it by 2 we got 1000. According to our definition of "middle," 500 was the photographic middle of 1000 and 250. So far so good.

Now we can use the same type of logic for our 18% gray card. As was mentioned before, the 18% gray card is also known as "middle gray." *Let's find out what this card is the middle of!* By multiplying 18 by 2, we get 36. By dividing 18 by 2, we get 9. Now we have one number on each side of 18%. We can arrange these three numbers as follows:

	9%	18%	36%	

Now let's go one step further and find the two neighboring numbers for 9% and 36%. By dividing 9 by 2, we get 4.5; by multiplying 36 by 2, we get 72. Inserting these two new numbers in the above table gives us the following:

4.5%	9%	18%	36%	72%

Surfaces with these tones are of special interest to us since they represent shades of gray that are one or two stops away from our base, the 18% gray tone. As you can see, 18% gray is in the middle of 72% white and 4.5% black, as well as in the middle of 9% dark gray and 36% light gray. We can refer to these tones as our *Extended Standard Shades of Gray*. Diagram 2.10.1 shows these Extended Standard Shades of Gray. The printed shade of gray represents their approximate tones. At first the 18% gray card was our only standard tone. Now we have created 4 other standard tones. The most important property of these 5 subject tones is that they are *one stop* away from one another. **This means we can easily reproduce their image tones by opening or closing the aperture by one or two stops from the normal exposure.** As you remember, when a *simple subject* is *normally exposed*, its image tone will *always* be *18% gray*. As you can see in Diagram 2.10.1, the idea of 5 fingers and 5 corresponding tones is an easy way of remembering their relationship with one another. The 18% gray "middle" gray is assigned to the "middle" finger. In the next section, we will discuss how these tones are used to enhance our exposure skills.

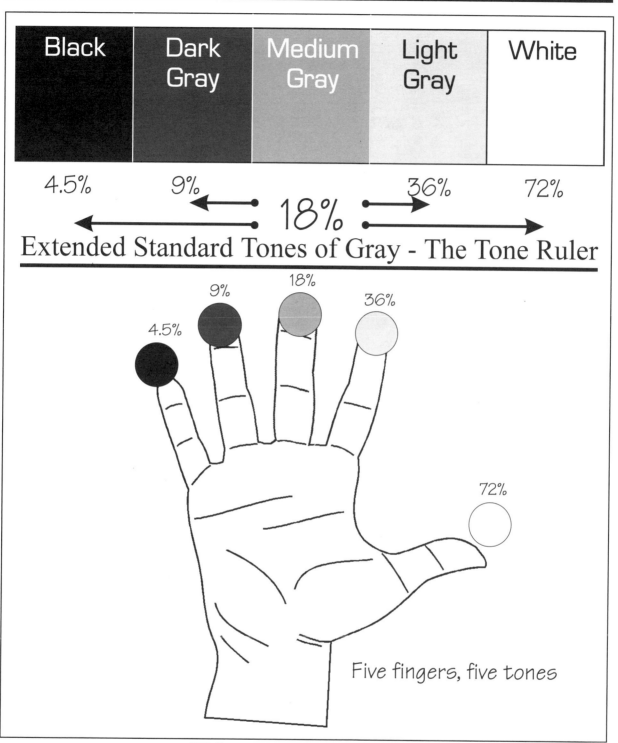

Black	Dark Gray	Medium Gray	Light Gray	White

4.5% 9% 18% 36% 72%

Extended Standard Tones of Gray - The Tone Ruler

18%

Five fingers, five tones

Diagram 2.10.1

By dividing and multiplying the number "18" by 2, we created four more standard tones. As you can see, the 18% reflective gray (middle gray) tone is in the middle of the 9% reflective (dark gray) and 36% reflective gray (light gray) tones. The 18% reflective gray (middle gray) tone is is also is in the middle of the 4.5% reflective (black) and 72% reflective (white) tones.

Extended Standard Subject Tones

4.5%

A 4.5% gray is an extra dark gray and for all practical purposes is black. This is not the darkest black we can get, but it is convenient for our purposes. In this book we refer to this also as 4.5% black. Examples: Dark, new blue jeans, black cloth.

9%

A 9% gray is considered dark gray. Examples: Moist earth, clean asphalt, ultra blue sky.

18%

A 18% gray is called "medium gray" or "standard 18% gray." Examples: Beach, wet brown sand, medium blue sky.

36%

A 36% gray is considered light gray and has a tone whose value is close to the Caucasian skin tone. Other examples include: A beach of dry brown sand and concrete.

72%

A 72% gray can be called extra light gray and for all practical purposes is white. To distinguish it from other whites, we also refer to this as 72% white. The paper that this text is printed on has an approximate reflectivity of 72%.

Diagram 2.10.2

2.11. A quick experiment to show that our standard subject tones are one stop away from one another

Each page of the following five pages represent subject tones with *approximate* reflectivities of 4.5%, 9%, 18%, 36% and 72%.

Set your camera to manual mode with aperture set to f-8. Place this book with the 18% medium gray page in a shadowed area and by _changing the shutter speed_ find its normal exposure. Your camera should be about ten inches away from the page and it doesn't matter if the page looks blurred. Also make sure that all you see in the viewfinder is the shadowed area (no white borders)!

Let's assume your normal exposure from the 18% medium gray page is 1/60 @ f-8

If you take a normal exposure reading from the 4.5% black page, your normal exposure would be *approximately* 1/15 @ f-8.

If you take a normal exposure reading from the 9% dark gray page, your normal exposure would be *approximately* 1/30 @ f-8.

If you take a normal exposure reading from the 36% light gray page, your normal exposure would be *approximately* 1/125 @ f-8.

If you take a normal exposure reading from the 72% white page, your normal exposure would be *approximately* 1/250 @ f-8.

You can see for yourself that the normal exposure for each page is approximately one stop away from the next.

You could have also obtained the same results if you had changed the aperture instead of the shutter speeds. In this specific example, your apertures would have been f-4 @ 1/60 for the 4.5% black page, f-5.6 @ 1/60 for the 9% dark gray page, f-11 @ 1/60 for the 36% light gray page, and f-16 @ 1/60 for the 72% white page. For those of you who have a spotmeter, point your spotmeter at each page and record each page's EV reading. As you will notice, each page will be *approximately* one EV away from the previous one.

An important Note:

Due to variations in mechanical reproduction (i.e., the way this book is printed), you may not get all the expected results. Hopefully these shades of gray would be close enough so that they help you to understand the idea behind this exercise.

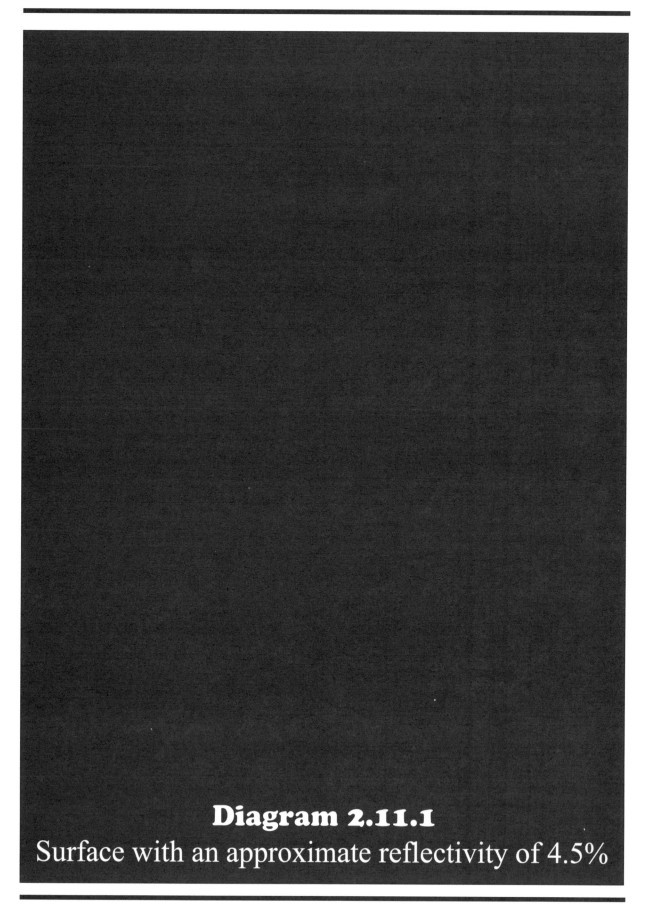

Diagram 2.11.1
Surface with an approximate reflectivity of 4.5%

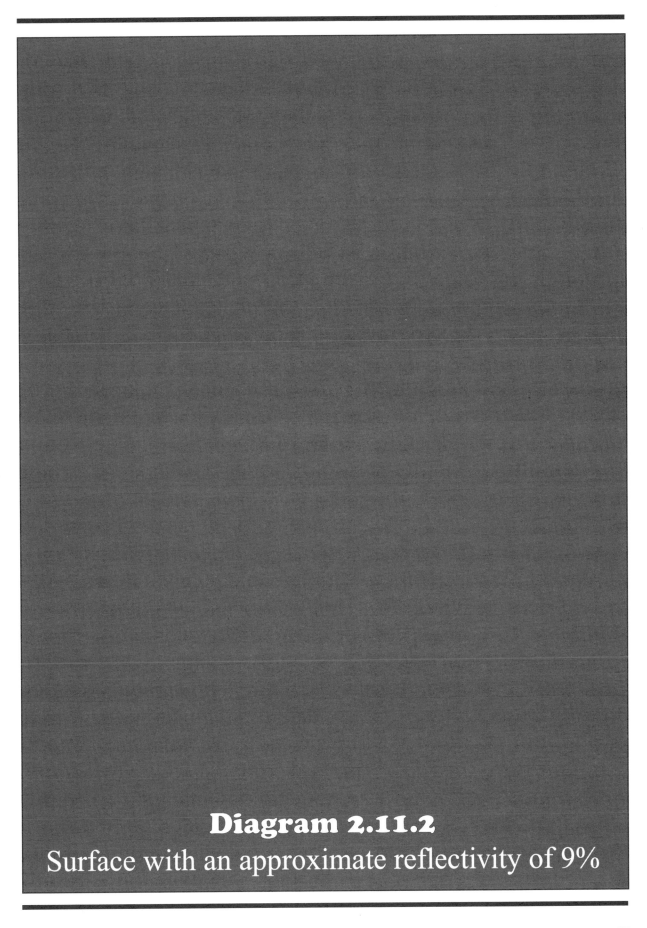

Diagram 2.11.2
Surface with an approximate reflectivity of 9%

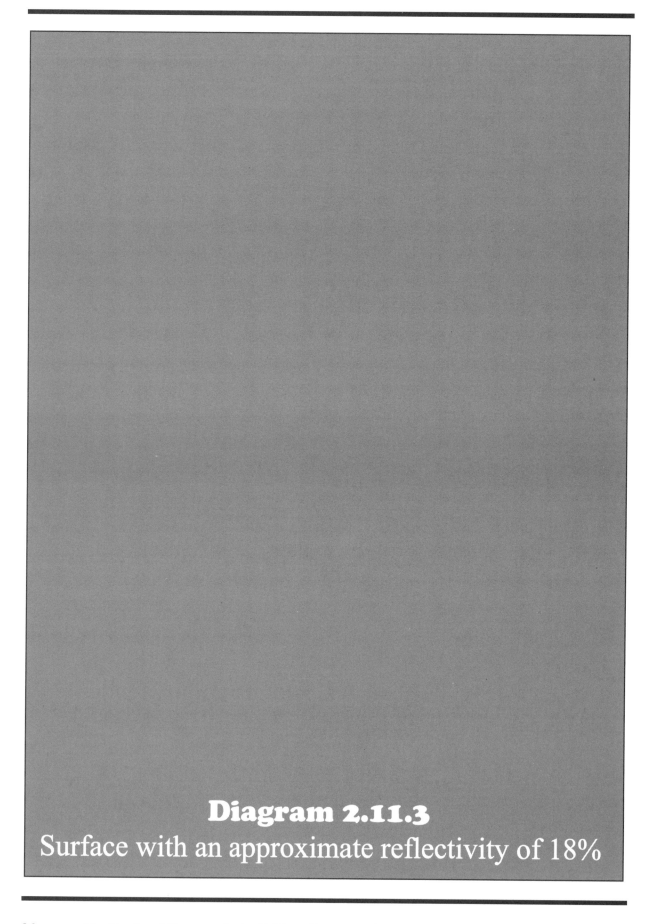

Diagram 2.11.3
Surface with an approximate reflectivity of 18%

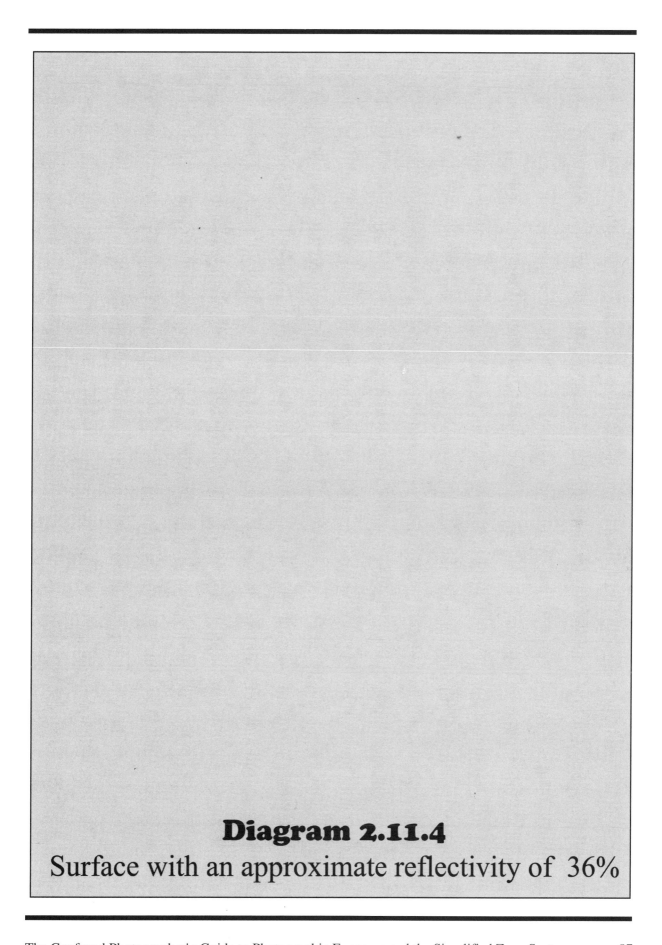

Diagram 2.11.4
Surface with an approximate reflectivity of 36%

Diagram 2.11.5
Surface with an approximate reflectivity of 72%

Observation #2 of the Simplified Zone System (Conclusions from Standard Gray Paint Factory):

Since the 18% gray image tone is a combination of black and white tones, it can be changed to any other shade of gray by increasing or decreasing its white content.

1) Brightening this 18% gray image tone: We can turn this 18% gray image tone to lighter (brighter) shades of gray by increasing its white content. Brightening of this image tone can be achieved by opening-up the aperture or using slower shutter speeds (longer exposure times). Examples include changing the aperture from f-5.6 to f-4 or changing the shutter speed from 1/125 to 1/60 sec.

2) Darkening this 18% gray image tone: We can turn this 18% gray image tone to darker shades of gray by decreasing its white content. Darkening of this image tone can be achieved by closing-down the aperture or using faster shutter speeds (shorter exposure times). Examples include changing the aperture from f-5.6 to f-8 or changing the shutter speed from 1/125 to 1/250 sec.

2.12. Changing (converting) one standard tone to another

Although all sections of this book are important, this section is perhaps the most important of all. It is important because we will use what we have learned so far to change the grayness of the 18% image tone. We will be able to convert this 18% gray image to darker or lighter shades of gray in a systematic manner. The following three items are the tools for this tone manipulation and we will review them just in case you have forgotten. If you haven't, please skip the rest of this page.

1) First Observation of the Zone System: When you are photographing a simple subject and the meter indicates a "normal exposure," it is simply producing an 18% image tone on the film. *This tone is independent of the original tone of the subject.*

2) Second Observation of the Zone System: Since the gray image is a combination of black and white tones, by controlling the amount of white in the gray, we can change its tone to any other shade of gray. What this enables us to do is to take the 18% gray image tone that is the result of the normal exposure and by controlling its white content, turn it into any other standard shades of gray.

3) Starting with the 18% gray card, we created 4 other standard shades of gray: These are: 4.5%, 9%, 36% and 72%. Each of these new shades of gray is 1 or 2 stops (full clicks) away from the 18% gray base.

Now let's put 1, 2 and 3 to some practical use and correct the wrong tones that we obtained in Assignments 2 and 3.

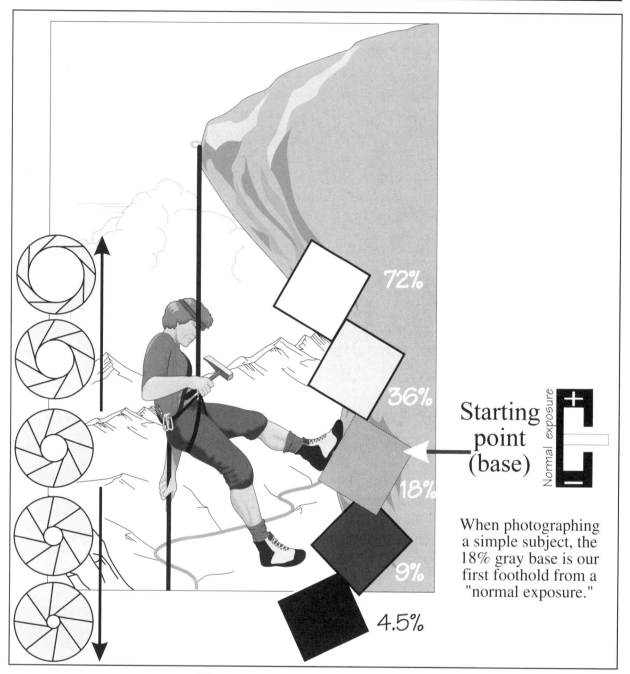

72%

36%

Starting
point
(base)

18%

Normal exposure

When photographing
a simple subject, the
18% gray base is our
first foothold from a
"normal exposure."

9%

4.5%

Diagram 2.12.0

A climber can climb up and down the mountain, as a photographer can create brighter or darker image tones from the 18% gray image base. This gray image base was generated when you exposed a simple subject using the camera's normal exposure settings. To go up (brighten the image tone) a photographer can open-up the aperture, say, from f-5.6 to f-4. To go down (darken the image tone), a photographer can close-down the aperture, say, from f-5.6 to f-8. Where to go from this 18% gray image base would entirely depend on your taste, judgment, objective and skill as a photographer.

2.13. Correcting the black image tone in Assignment #2

As you remember, in this assignment you photographed a simple black surface and you ended up with an 18% gray image tone. The normal exposure (in my case) for this surface was 1/60 @ f-4. So far so good. ***At this point we know two things: First, the subject tone is black and second the image tone is 18% gray.*** This wrong image tone must be corrected. To correct this, we must darken the 18% image tone so that it becomes black and approximately resembles the tone of the original subject. The closest tone we have to the black mat board on our standard shades of gray is the 4.5% black. To change the 18% gray image tone to 4.5% black image tone we need to take away an exact amount of whiteness from it. In our camera, this is achieved by closing-down the aperture by 2 stops (4.5% is exactly 2 stops away from 18%). The new exposure can be 1/60 @ f-8 (f-8 is 2 stops away from f-4). This is our final setting and will create a 4.5% black image on the slide. This is illustrated in Assignment #4.

2.14. Properly exposing a black mat board by manually overriding the normal exposure settings -- Assignment #4

1) In the same spot as your previous assignments, in a uniformly shaded area, use a few pushpins to secure the black mat board to the wall.

2) Place the camera about 12 inches away from the black board. Make sure all that you see in the viewfinder is the black tone of the board. Avoid glare and make sure that no part of the wall appears in your viewfinder. If the lens's minimum distance is more than 12 inches and the image is blurred, it does not matter. Keep your distance dial exactly the same as the previous assignment.

3) Keep your shutter speed the same as in Assignment #2 and change the aperture until the camera shows a normal exposure. It is now creating an 18% gray image tone on the slide film. For the sake of illustration, assume this exposure is 1/60 @ f-4.

4) Compare the black mat board with the 5 standard tones of our Tone Ruler. The closest tone to the black mat board would be the 4.5% black tone. Now we have to convert the gray image tone that was created in step 4 into a 4.5% black image tone. To turn a gray tone into black, we must manually override the setting and take away the gray image's whiteness by two stops. This is done by closing down the aperture by two stops from the normal exposure. The new exposure would be 1/60 @ f-8 (yours may be different).

5) Using these new settings, shoot the picture. As before, record the frame number, the normal exposure, and the overridden exposure on a piece of paper.

6) After you have processed your slides, look at the image tone that you just created on this slide. The slide will be properly exposed and it will have a 4.5% black image tone. This assignment is graphically illustrated in Diagram 2.14.0.

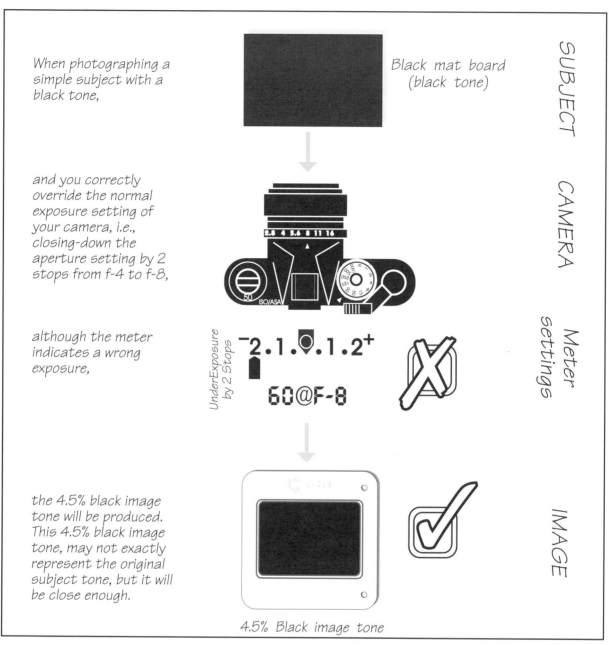

When photographing a simple subject with a black tone,

and you correctly override the normal exposure setting of your camera, i.e., closing-down the aperture setting by 2 stops from f-4 to f-8,

although the meter indicates a wrong exposure,

the 4.5% black image tone will be produced. This 4.5% black image tone, may not exactly represent the original subject tone, but it will be close enough.

Black mat board (black tone)

SUBJECT

CAMERA

Meter settings

UnderExposure by 2 Stops

¯2.1.◉.1.2⁺

60@F-8

IMAGE

4.5% Black image tone

Diagram 2.14.0

Assignment #4: Photographing a black surface using a manual override technique to create a 4.5% image tone.

Diagram showing how to override the meter in your camera to produce a properly exposed tone. The normally exposed gray image was manually underexposed by two stops to produce this 4.5% black image tone. For the final exposure, the meter shows a wrong exposure setting but produces the correct image tone.

If you look closely enough, 1/60 sec. @ F-8 is the standard gray card's correct exposure. (Assignment #1).

2.15. Correcting the white image tone in Assignment #3

As you remember, in this assignment you photographed a simple white surface and you ended up with an 18% gray image tone. The normal exposure (in my case) for this surface was 1/60 @ f-16. So far so good. *At this point we know two things: First, the subject tone is white and second the image tone is 18% gray.* This wrong image tone must be corrected. To correct this, we must lighten (brighten, whiten) the 18% image tone so that it becomes white and approximately resembles the tone of the original subject. The closest tone we have to white mat board on our Tone Ruler is 72% white (extra light gray). To convert the 18% gray image to the 72% white tone, we need to add an exact amount of whiteness to this tone.

In our camera, this is achieved by opening-up the aperture by 2 stops (72% is exactly 2 stops away from 18%). The new exposure can be 1/60 @ f-8 (f-8 is 2 stops away from f-16). This is our final setting and will create a 72% white image tone on the slide. This is illustrated in Assignment #5.

2.16. Properly exposing a white mat board by manually overriding the normal exposure settings -- Assignment # 5

1) In the same spot as your previous assignments, use a few pushpins to secure the white mat board to the wall.

2) Place the camera about 12 inches away from the white board. Make sure all that you see in a viewfinder is the white tone of the board. No part of the wall should appear in your viewfinder. If the lens's minimum distance is greater than 12 inches and the image is blurred, it does not matter. Keep your distance dial exactly the same as the previous assignment.

3) Keep your shutter speed the same as Assignment #2 and change the aperture until the camera shows a normal exposure, that is, it is creating an 18% gray image tone on the slide film. For the sake of illustration, assume this exposure is 1/60 @ f-16.

4) Compare the white mat board with the 5 standard tones of our Tone Ruler. The closest tone to the white mat board would be the 72% white tone. Now we have to convert the 18% gray image tone that was created in step 3 into a 72% white image tone.

To turn a gray tone into white, we must manually override the setting and add whiteness to the gray tone by two stops. This is done by opening-up the aperture by two stops from the normal exposure. The new exposure would be 1/60 @ f-8 (yours may be different).

5) Using these new settings, shoot the picture. As before, record the frame number, the normal exposure, and the overridden exposure on a piece of paper.

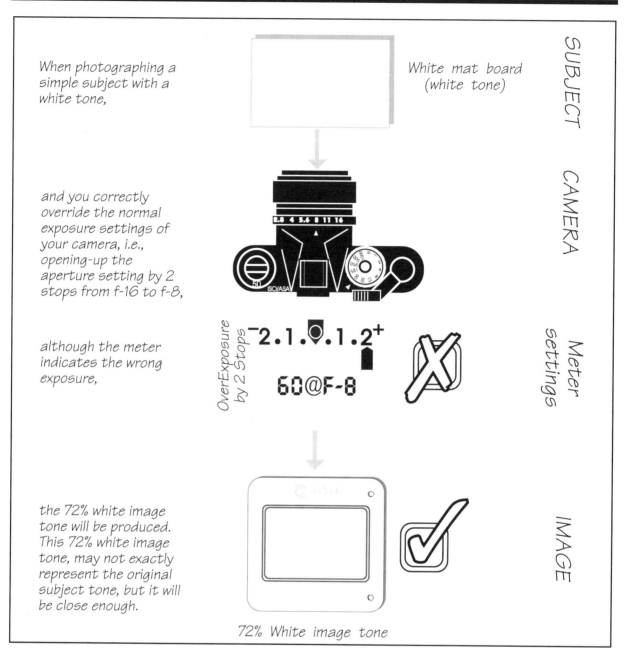

When photographing a simple subject with a white tone,

White mat board (white tone)

and you correctly override the normal exposure settings of your camera, i.e., opening-up the aperture setting by 2 stops from f-16 to f-8,

although the meter indicates the wrong exposure,

OverExposure by 2 Stops

‾2.1.0.1.2⁺

60@F-8

the 72% white image tone will be produced. This 72% white image tone, may not exactly represent the original subject tone, but it will be close enough.

72% White image tone

SUBJECT CAMERA Meter settings IMAGE

Diagram 2.16.0

Assignment #5: Photographing a white surface using a manual override technique to place it at the 72% white image tone.

Diagram showing how to override the meter in your camera to produce a properly exposed tone. The normally exposed gray image was manually overexposed by two stops to produce this 72% white image tone. For the final exposure, the meter shows a wrong exposure setting but produces the correct image tone.

If you look close enough, 1/60 @ F-8 is the standard gray card's correct exposure. (Assignment #1.)

DIGITAL FOOTNOTE:

Please remember that the Gray Scale Number ranges from black [0] to white [255]. After you have transferred your image to your computer, then:

❑ For the black subject the Gray Scale Number (using the same procedure as in section 2.2) should be *about 90 units less than the reading you obtained in section 2.2. For example if the Gray Scale Number of the gray tone on your screen was 128, then the Gray Scale Number for the corrected image would be about 38 units.*

❑ For the white subject the Gray Scale Number (using the same technique as in section 2.3) should be *about 100 units more than the reading you obtained in section 2.3. For example if the number for the gray image on your screen was 128, then the number for the corrected image would be about 228 units.*

2.17. A self test to make sure you understand the gray making property of the meter and how to compensate for it

The chances are that by now, you now have a reasonably good idea about manually overriding your normal exposure settings to expose your pictures properly. For those of you who think you understood the subject, the next few pages will be a good review and a self test (just in case)!

For those of you who are not sure, these examples are designed to help you in better understanding this technique (This is your last chance before reading this chapter again.) These examples also provide you with practical methods of converting the camera's "normal exposure" from a simple subject to one of the four standard tones that approximates the original tone of the subject. If you don't understand these, review this chapter again.

Please do not start Chapter 3, unless you **understand everything** that we talked about.

2.18. Did you ever wonder where the similarities between the FedEx operations and your camera's meter ends?

As we discussed, all FedEx packages sent from hundreds of cities passed through Memphis. From Memphis, the package was sent to hundreds of cities across the United States. This is similar to finding the "normal exposure" for hundreds of simple tones. As you know by now, all will have an 18% gray image tone.

Unlike the Federal Express that also has hundreds or thousands of destinations, our Simplified Zone System, has only five standard destinations. These are the 4.5%, 9%, 18%, 36%, and 72% image tones.

How To Photograph a Black Toned Surface

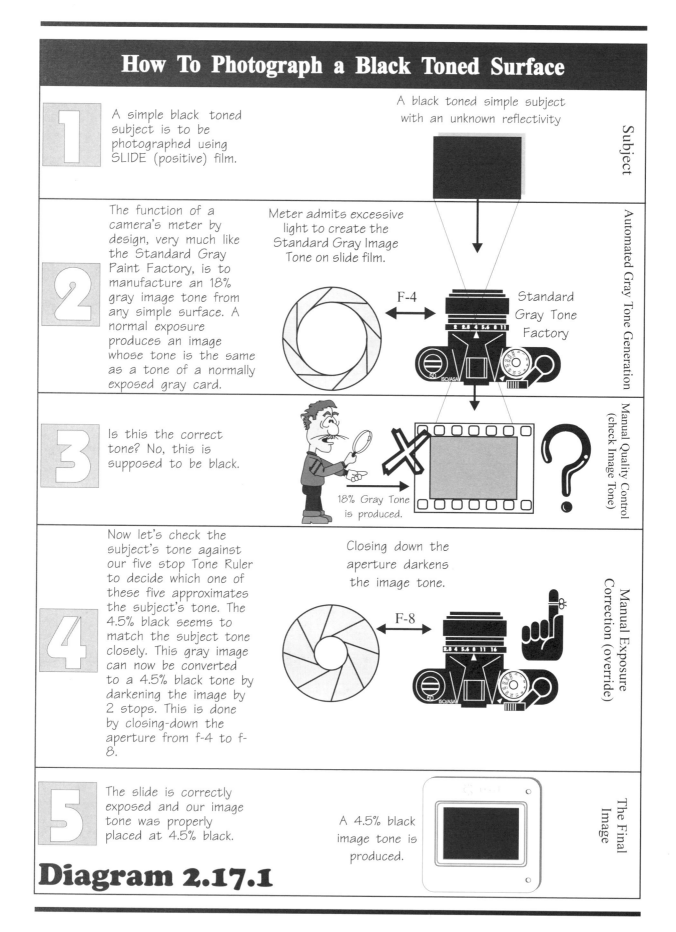

1 A simple black toned subject is to be photographed using SLIDE (positive) film.

A black toned simple subject with an unknown reflectivity

Subject

2 The function of a camera's meter by design, very much like the Standard Gray Paint Factory, is to manufacture an 18% gray image tone from any simple surface. A normal exposure produces an image whose tone is the same as a tone of a normally exposed gray card.

Meter admits excessive light to create the Standard Gray Image Tone on slide film.

F-4

Standard Gray Tone Factory

Automated Gray Tone Generation

3 Is this the correct tone? No, this is supposed to be black.

18% Gray Tone is produced.

Manual Quality Control (check Image Tone)

4 Now let's check the subject's tone against our five stop Tone Ruler to decide which one of these five approximates the subject's tone. The 4.5% black seems to match the subject tone closely. This gray image can now be converted to a 4.5% black tone by darkening the image by 2 stops. This is done by closing-down the aperture from f-4 to f-8.

Closing down the aperture darkens the image tone.

F-8

Manual Exposure Correction (override)

5 The slide is correctly exposed and our image tone was properly placed at 4.5% black.

A 4.5% black image tone is produced.

The Final Image

Diagram 2.17.1

How To Photograph a Dark Gray Toned Surface

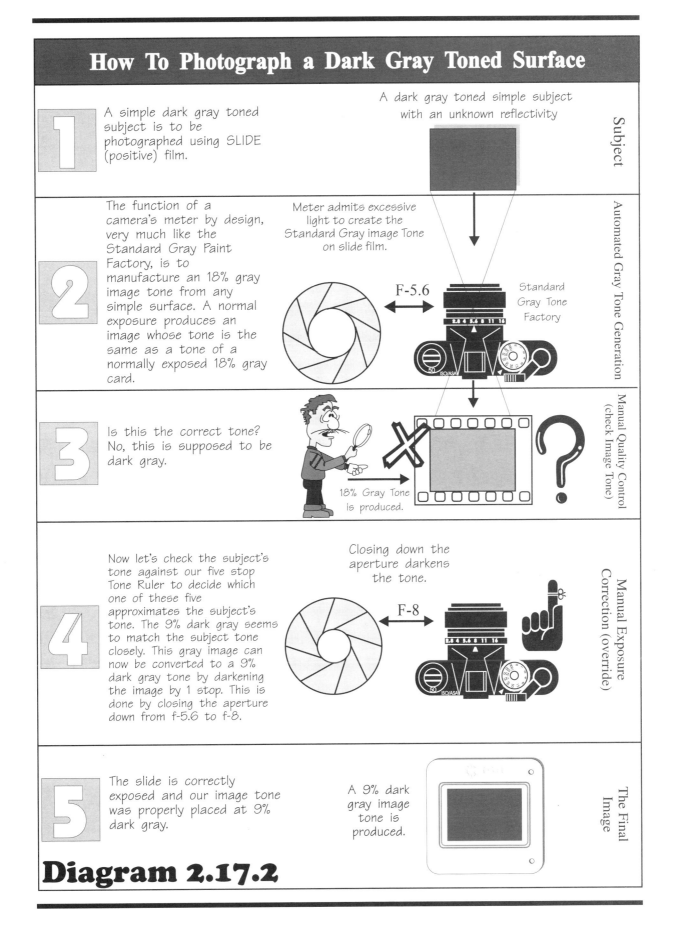

1 A simple dark gray toned subject is to be photographed using SLIDE (positive) film.

A dark gray toned simple subject with an unknown reflectivity

Subject

2 The function of a camera's meter by design, very much like the Standard Gray Paint Factory, is to manufacture an 18% gray image tone from any simple surface. A normal exposure produces an image whose tone is the same as a tone of a normally exposed 18% gray card.

Meter admits excessive light to create the Standard Gray image Tone on slide film.

F-5.6

Standard Gray Tone Factory

Automated Gray Tone Generation

3 Is this the correct tone? No, this is supposed to be dark gray.

18% Gray Tone is produced.

Manual Quality Control (check Image Tone)

4 Now let's check the subject's tone against our five stop Tone Ruler to decide which one of these five approximates the subject's tone. The 9% dark gray seems to match the subject tone closely. This gray image can now be converted to a 9% dark gray tone by darkening the image by 1 stop. This is done by closing the aperture down from f-5.6 to f-8.

Closing down the aperture darkens the tone.

F-8

Manual Exposure Correction (override)

5 The slide is correctly exposed and our image tone was properly placed at 9% dark gray.

A 9% dark gray image tone is produced.

The Final Image

Diagram 2.17.2

How To Photograph a Medium Gray Toned Surface

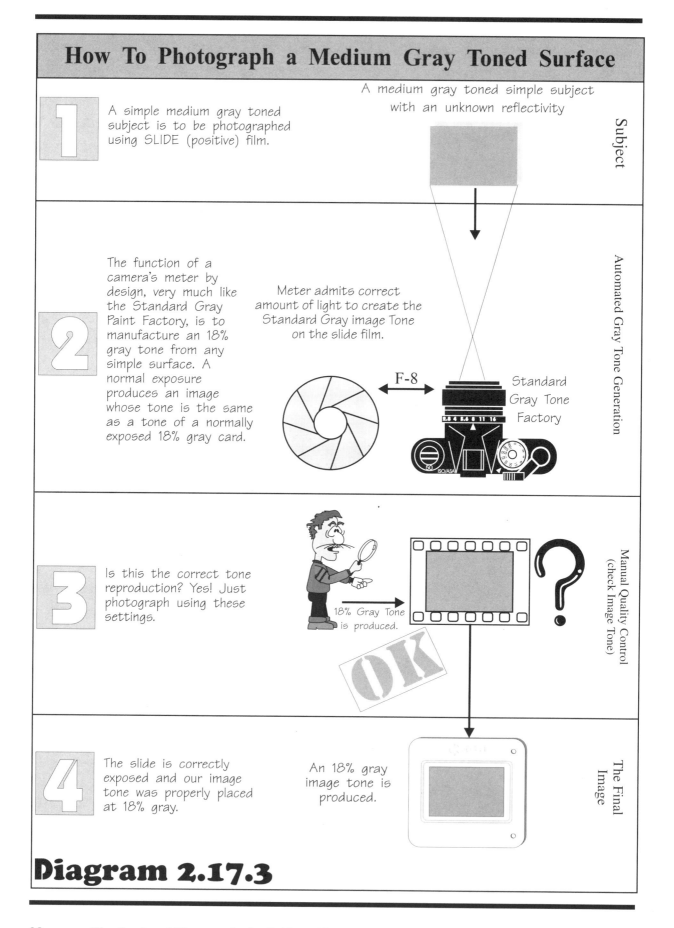

1 A simple medium gray toned subject is to be photographed using SLIDE (positive) film.

A medium gray toned simple subject with an unknown reflectivity

Subject

2 The function of a camera's meter by design, very much like the Standard Gray Paint Factory, is to manufacture an 18% gray tone from any simple surface. A normal exposure produces an image whose tone is the same as a tone of a normally exposed 18% gray card.

Meter admits correct amount of light to create the Standard Gray image Tone on the slide film.

F-8

Standard Gray Tone Factory

2.8 4 5.6 8 11 16

50 ISO/ASA

Automated Gray Tone Generation

3 Is this the correct tone reproduction? Yes! Just photograph using these settings.

18% Gray Tone is produced.

OK

?

Manual Quality Control (check Image Tone)

4 The slide is correctly exposed and our image tone was properly placed at 18% gray.

An 18% gray image tone is produced.

The Final Image

Diagram 2.17.3

How To Photograph a Light Gray Toned Surface

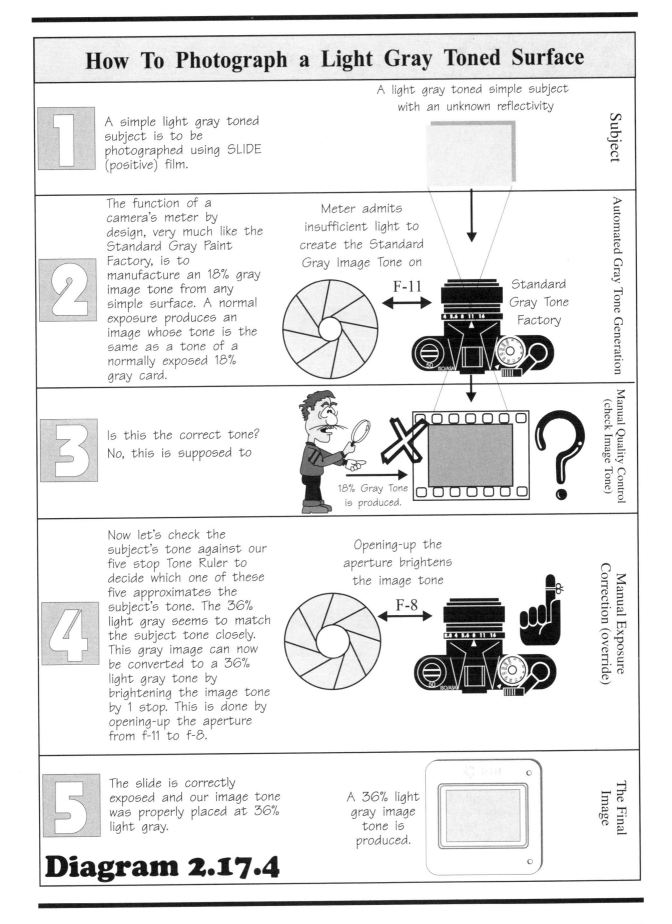

1 — A simple light gray toned subject is to be photographed using SLIDE (positive) film.

A light gray toned simple subject with an unknown reflectivity

Subject

2 — The function of a camera's meter by design, very much like the Standard Gray Paint Factory, is to manufacture an 18% gray image tone from any simple surface. A normal exposure produces an image whose tone is the same as a tone of a normally exposed 18% gray card.

Meter admits insufficient light to create the Standard Gray Image Tone on

F-11

Standard Gray Tone Factory

Automated Gray Tone Generation

3 — Is this the correct tone? No, this is supposed to

18% Gray Tone is produced.

Manual Quality Control (check Image Tone)

4 — Now let's check the subject's tone against our five stop Tone Ruler to decide which one of these five approximates the subject's tone. The 36% light gray seems to match the subject tone closely. This gray image can now be converted to a 36% light gray tone by brightening the image tone by 1 stop. This is done by opening-up the aperture from f-11 to f-8.

Opening-up the aperture brightens the image tone

F-8

Manual Exposure Correction (override)

5 — The slide is correctly exposed and our image tone was properly placed at 36% light gray.

A 36% light gray image tone is produced.

The Final Image

Diagram 2.17.4

How To Photograph a White Toned Surface

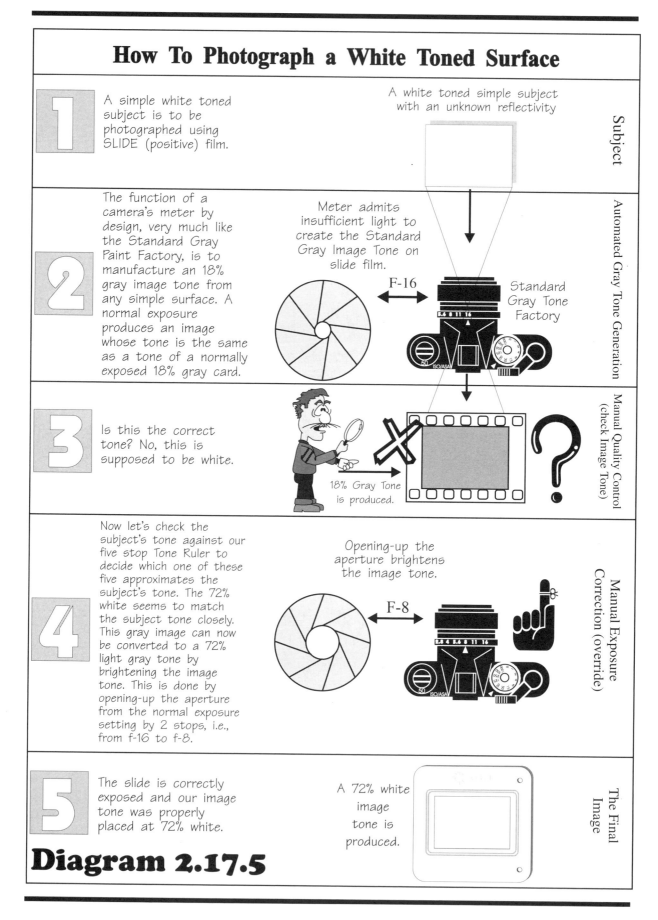

1 A simple white toned subject is to be photographed using SLIDE (positive) film.

A white toned simple subject with an unknown reflectivity

Subject

2 The function of a camera's meter by design, very much like the Standard Gray Paint Factory, is to manufacture an 18% gray image tone from any simple surface. A normal exposure produces an image whose tone is the same as a tone of a normally exposed 18% gray card.

Meter admits insufficient light to create the Standard Gray Image Tone on slide film.

F-16

Standard Gray Tone Factory

Automated Gray Tone Generation

3 Is this the correct tone? No, this is supposed to be white.

18% Gray Tone is produced.

Manual Quality Control (check Image Tone)

4 Now let's check the subject's tone against our five stop Tone Ruler to decide which one of these five approximates the subject's tone. The 72% white seems to match the subject tone closely. This gray image can now be converted to a 72% light gray tone by brightening the image tone. This is done by opening-up the aperture from the normal exposure setting by 2 stops, i.e., from f-16 to f-8.

Opening-up the aperture brightens the image tone.

F-8

Manual Exposure Correction (override)

5 The slide is correctly exposed and our image tone was properly placed at 72% white.

A 72% white image tone is produced.

The Final Image

Diagram 2.17.5

2.19. An important review in exposing a simple subject (tone)

To properly expose a simple subject is very much like picking up a cup and moving it to a desired location (Section 1.11, Diagram 1.11.0). The procedure is as follows:

To move the cup:

a) We first looked at it and located its handle. ***In this case, the cup had only one handle, i.e., we have only one logical choice.***

b) By using our fingers, we grasped the handle

c) We moved the cup to the desired location.

To photograph a subject:

a) We have to observe it in order to locate its visual handle (Reference Tone). In the case of a simple subject, it is easy since there is only one handle, this means we have only one choice.

b) Now by using your camera, ***find the "normal exposure" of this Reference Tone***. With this action, you have "***visually grabbed***" the subject.

c) Once the tone is visually grabbed, decide which one of the following tones ***you would like your final image tone to become:***

> 1) 4.5% Black
>
> 2) 9% Dark gray
>
> 3) 18% Gray
>
> 4) 36% Light gray
>
> 5) 72% White

This step of the light measurement process requires your judgment more than any other step. If you are not sure, just pick one anyway. ***Right or wrong, you must commit yourself to one of these five tones***. The following procedures show how you can ***move (change)*** your image tone from the 18% gray base to ***one of the five standard image tones***.

If you chose 4.5% black:

Darken the image tone by two stops, i.e., close-down the aperture by 2 stops (say from f-4 to f-8) ***or*** decrease the exposure time by 2 stops (say from 1/15 to 1/60). This places the image tone at 4.5% black.

If you chose 9% dark gray:

Darken the image tone by 1 stop, i.e., close-down the aperture by 1 stop (say from f-5.6 to f-8) ***or*** decrease the exposure time by 1 stop (say from 1/30 sec to 1/60). This places the image tone of the surface at 9% black.

If you chose 18% medium gray:

This does not require a manual override. In this case, the normal exposure is also the correct exposure. Shoot the picture with "normal exposure" settings. This creates an 18% gray image tone. *Please remember: this is the only time that your "normal exposure" is also the "correct exposure."*

If you chose 36% light gray:

Brighten the image tone by 1 stop, i.e., open-up the aperture by 1 stop (say from f-5.6 to f-4) *or* increase the exposure time by 1 stop (say from 1/60 sec to 1/30). This places the image tone at 36% light gray. This is what we do when photographing a Caucasian skin tone.

If you chose 72% white:

Brighten the image tone by two stops, i.e., open-up the aperture by 2 stops (say from f-5.6 to f-2.8) *or* increase the exposure time by 2 stops (say from 1/60 to 1/15). This places the image tone at 72% white (extra light gray).

Summary of most important steps in simple tone exposure determination

1) Observe your subject. This simple and very important step is usually skipped by many photographers.

2) Visually grab the simple tone (in this case we only have one tone) by finding its normal exposure. This will always create a standard 18% gray image tone on your slide film.

3) Now you *must* choose *one* of the five tones that you think your subject resembles, i.e., black, dark gray, medium gray, light gray or white.

4) If you chose *18% medium gray*, don't touch the dials. Shoot the picture.

5) If you chose any other tone, manually override the aperture or shutter speed settings to create *one* of the standard tones that you selected in step #3. This means:

❏ If you chose white, open-up the aperture by two stops to get a 72% white image tone.

❏ If you chose light gray, open-up the aperture by one stop to get a 36% light gray image tone.

❏ If you chose dark gray, close-down the aperture by one stop to get a 9% dark gray image tone.

❏ If you chose black, close-down the aperture by two stops to get a 4.5% black image tone.

6) Shoot the picture.

GALLERY

2.20. Let's prepare ourselves for exposing a complex subject: The Tone-Train approach

By now, chances are that you are able to photograph any simple subject with very little difficulty. In order to photograph a complex subject, you will need to use the same techniques that you have been using so far. *In fact now that you know how to expose a simple subject, you possess almost all the skill necessary to expose a complex subject.* Since a complex subject deals with more than one subject tone, we will break it down to simple subjects then choose *one* of these tones as a Reference Tone. Once we chose the Reference Tone, we can apply *exactly the same exposure logic for a simple subject to this tone and find its correct exposure*. Once the correct exposure is found, using the Tone-Train approach, we can determine where the other tones will fall.

In the Tone-Train technique, a *subject is represented by one loaded tank car that is filled with paint* and the *film (image tone) is represented by an empty, stationary train with five cars*. As you can see in the illustration 2.2.0, each tank car of this train has the same tones as our Standard Tone-Ruler. The objective of this technique is to use your camera to move the loaded tank car alongside the empty train until the tone of the loaded car approximates the tone of the empty car. Once these two cars are aligned, the contents of the loaded tank car is unloaded into the empty tank car. This is the same as pressing the shutter release button on your camera and capturing the image.

You can move the tank car (subject's tone) and align it with the medium gray tank car by finding the subject's normal exposure. As you can see in the illustration, the movement of the loaded tank car alongside the empty train can be achieved by opening and closing the aperture. When the aperture is opened-up by *one stop*, the tank moves to the right toward the lighter toned cars by *one car length*. When the aperture is closed-down by *one stop*, the tank moves to the left toward the darker toned cars by *one car length.* Diagrams 2.20.1 through 2.20.5 illustrate this technique for our five tones, namely black, dark gray, gray, light gray and white. The illustrations are identical to Diagrams 2.17.1 through 2.17.5.

Please take your time in studying the Diagrams since this kind of reasoning will play an important part in exposure determination of a complex subject.

DIGITAL FOOTNOTE:

Image tones represented in the Tone Train illustration can be related to the degree of blackness or whiteness **Gray Scale Density (GSD)** *of your computer monitor. As you remember "000" was the darkest and "255" was the brightest with "128" having been assigned to the medium (middle) gray image tone. In our case, 4.5% black image tone has an approximate GSD of* **038**, 9% dark gray has an approximate GSD of **078**, 18% medium gray has an approximate GSD of **128**, 36% light gray has an approximate GSD of **178**, and 72% white has an approximate GSD of **228** with about 1/2 stop left over on each side of our 5-Stop Tone Ruler.

The loaded tank car representing the tone of a simple subject. Movement of the tank car to left or right is controlled by opening-up or closing-down the aperture.

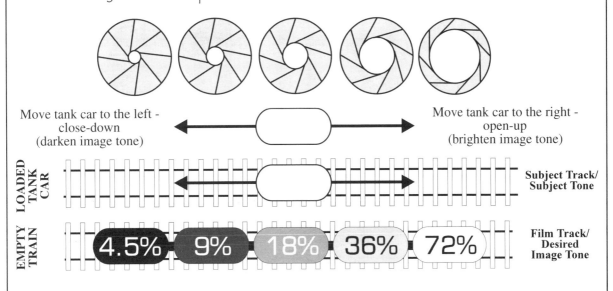

Move tank car to the left -
close-down
(darken image tone)

Move tank car to the right -
open-up
(brighten image tone)

LOADED TANK CAR

Subject Track/
Subject Tone

EMPTY TRAIN

4.5% 9% 18% 36% 72%

Film Track/
Desired
Image Tone

An empty five-car train representing the Standard Tones that can be captured by slide film. Each tank represents the image tones of our Standard Tone Ruler.

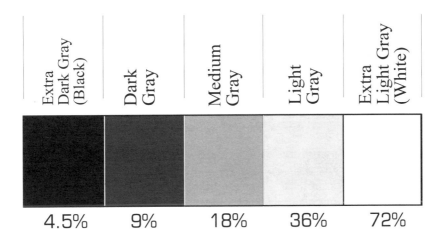

Extra Dark Gray (Black) — Dark Gray — Medium Gray — Light Gray — Extra Light Gray (White)

4.5% 9% 18% 36% 72%

The Five-Stop Tone Ruler

Diagram 2.20.0

Graphic illustrations for a loaded tank car representing a simple subject and an empty five-car train representing the film image tones. For this example, the loaded car (subject) has a white tone.

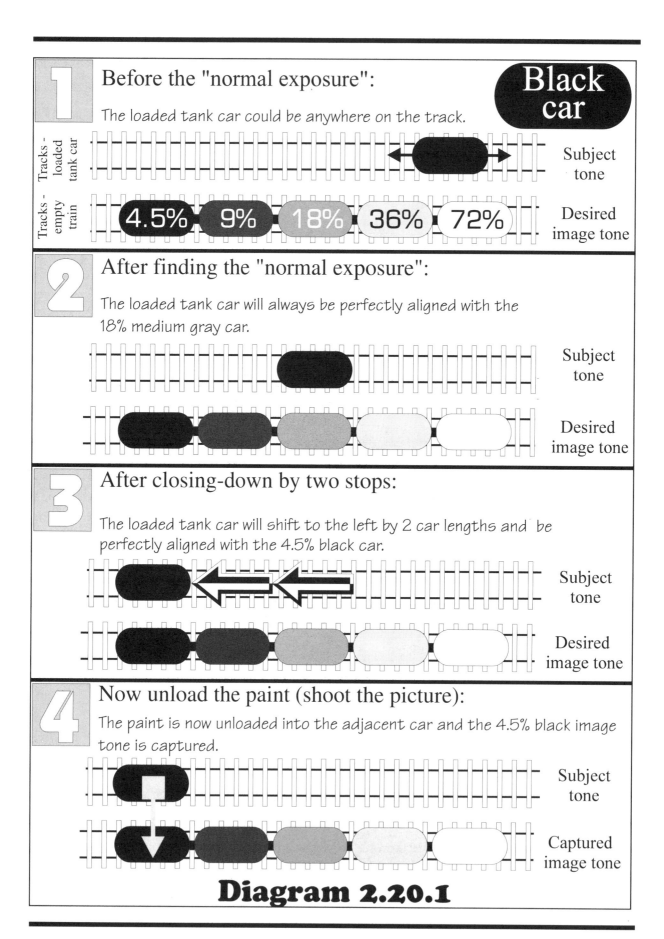

1 Before the "normal exposure":

The loaded tank car could be anywhere on the track.

Black car

Tracks - loaded tank car

Tracks - empty train

4.5% 9% 18% 36% 72%

Subject tone

Desired image tone

2 After finding the "normal exposure":

The loaded tank car will always be perfectly aligned with the 18% medium gray car.

Subject tone

Desired image tone

3 After closing-down by two stops:

The loaded tank car will shift to the left by 2 car lengths and be perfectly aligned with the 4.5% black car.

Subject tone

Desired image tone

4 Now unload the paint (shoot the picture):

The paint is now unloaded into the adjacent car and the 4.5% black image tone is captured.

Subject tone

Captured image tone

Diagram 2.20.1

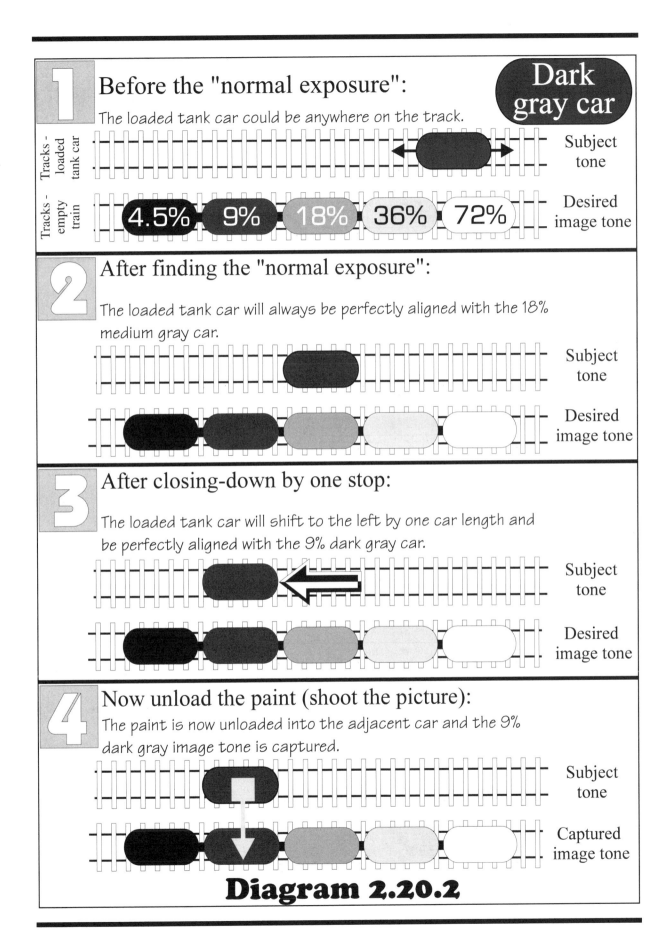

1 Before the "normal exposure":

Dark gray car

The loaded tank car could be anywhere on the track.

Tracks - loaded tank car

Subject tone

Tracks - empty train

4.5% 9% 18% 36% 72%

Desired image tone

2 After finding the "normal exposure":

The loaded tank car will always be perfectly aligned with the 18% medium gray car.

Subject tone

Desired image tone

3 After closing-down by one stop:

The loaded tank car will shift to the left by one car length and be perfectly aligned with the 9% dark gray car.

Subject tone

Desired image tone

4 Now unload the paint (shoot the picture):

The paint is now unloaded into the adjacent car and the 9% dark gray image tone is captured.

Subject tone

Captured image tone

Diagram 2.20.2

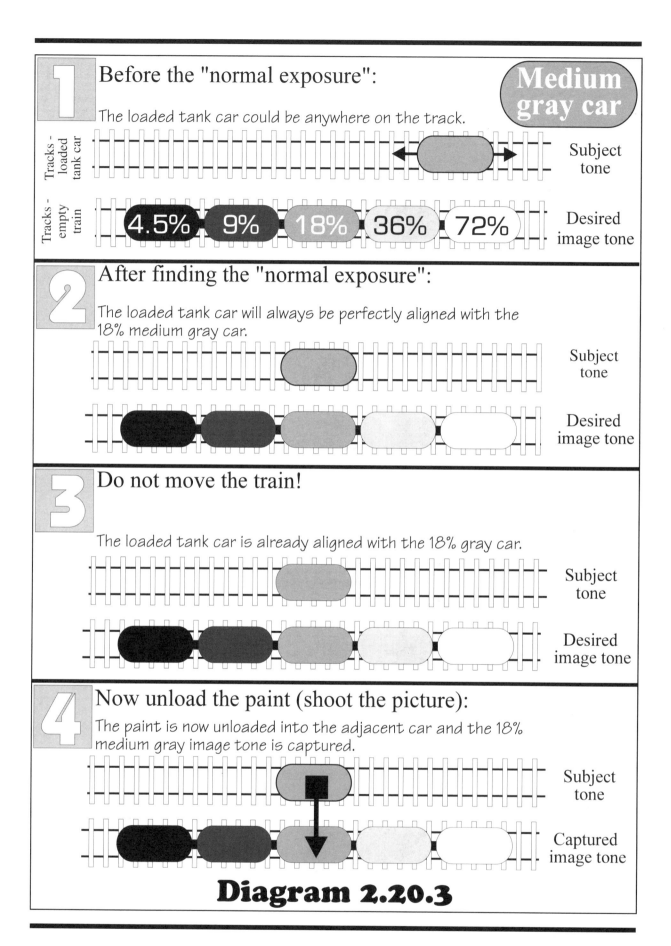

1 Before the "normal exposure":

Medium gray car

The loaded tank car could be anywhere on the track.

Tracks - loaded tank car — Subject tone

Tracks - empty train — 4.5% 9% 18% 36% 72% — Desired image tone

2 After finding the "normal exposure":

The loaded tank car will always be perfectly aligned with the 18% medium gray car.

Subject tone

Desired image tone

3 Do not move the train!

The loaded tank car is already aligned with the 18% gray car.

Subject tone

Desired image tone

4 Now unload the paint (shoot the picture):

The paint is now unloaded into the adjacent car and the 18% medium gray image tone is captured.

Subject tone

Captured image tone

Diagram 2.20.3

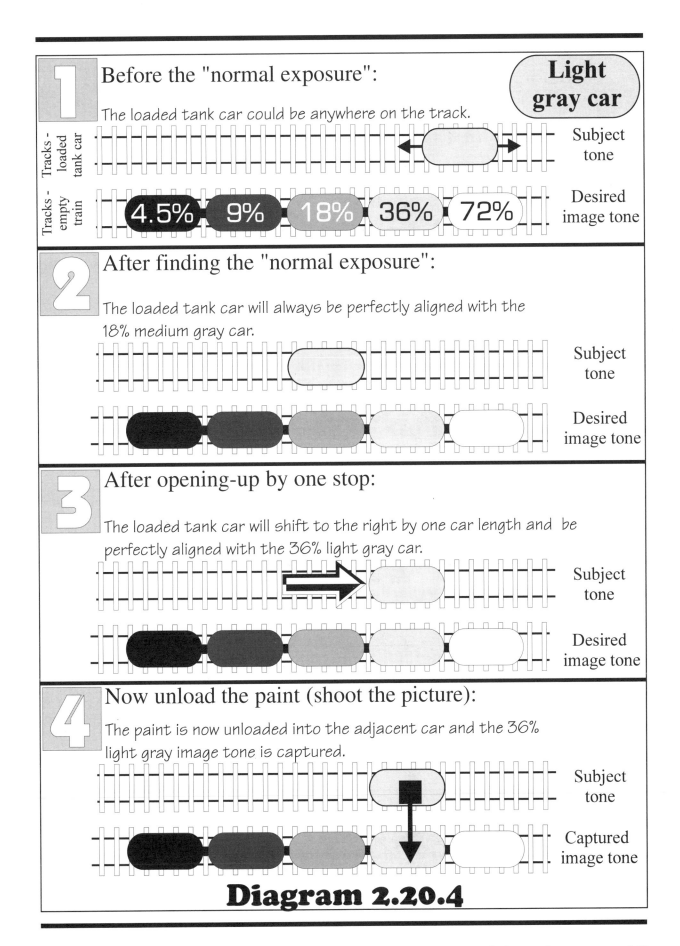

1 Before the "normal exposure": **Light gray car**

The loaded tank car could be anywhere on the track.

Tracks - loaded tank car → Subject tone

Tracks - empty train | 4.5% | 9% | 18% | 36% | 72% | → Desired image tone

2 After finding the "normal exposure":

The loaded tank car will always be perfectly aligned with the 18% medium gray car.

Subject tone

Desired image tone

3 After opening-up by one stop:

The loaded tank car will shift to the right by one car length and be perfectly aligned with the 36% light gray car.

Subject tone

Desired image tone

4 Now unload the paint (shoot the picture):

The paint is now unloaded into the adjacent car and the 36% light gray image tone is captured.

Subject tone

Captured image tone

Diagram 2.20.4

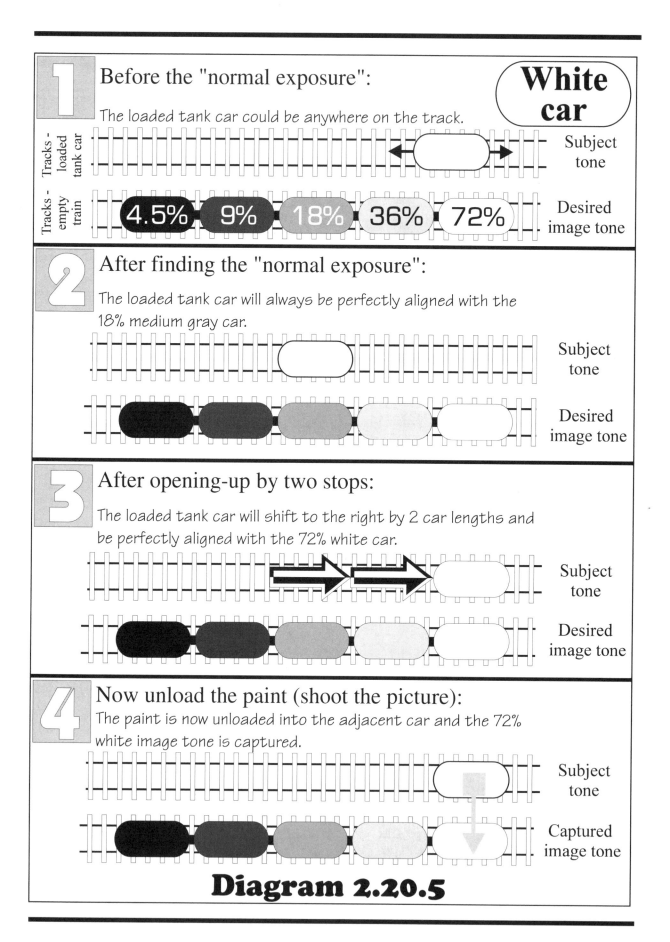

1 Before the "normal exposure":

The loaded tank car could be anywhere on the track.

White car

Tracks - loaded tank car

Subject tone

Tracks - empty train

4.5% 9% 18% 36% 72%

Desired image tone

2 After finding the "normal exposure":

The loaded tank car will always be perfectly aligned with the 18% medium gray car.

Subject tone

Desired image tone

3 After opening-up by two stops:

The loaded tank car will shift to the right by 2 car lengths and be perfectly aligned with the 72% white car.

Subject tone

Desired image tone

4 Now unload the paint (shoot the picture):

The paint is now unloaded into the adjacent car and the 72% white image tone is captured.

Subject tone

Captured image tone

Diagram 2.20.5

The Single Tone Metering Technique To Photograph a Complex Subject

What will you learn in this chapter?

In this chapter we learn the technique of breaking a subject down to its simple components. Once this is done, we can then determine the correct exposure for one of these tones and use this exposure to photograph the entire subject. The wisdom behind this simplified technique is that "if one part of a complex subject is properly exposed, then all other parts will fall into place and will be properly exposed."

Please Note: This chapter is ideal for those photographers who are interested in a quick and easy-to-understand method of photographing a complex subject by using their camera. For most of you, this chapter is all you need to know to take correctly exposed pictures.

3.1. What is the Single Tone Metering Technique to photograph a complex subject?

Briefly, this technique is similar to what you learned to expose a simple subject in the previous chapter. You simply look at a complex subject and break it down into two or more simple tones (simple subjects). Then you select only *one* of these tones and determine its *normal exposure.* Using the technique we learned in the previous chapter for exposing a simple subject, we then determine the *correct exposure* for *this* tone. Once this exposure is determined, *we can use this correct exposure to expose the entire complex subject.*

This method is simple, fast and ideal for the beginning photographer. The single tone that we selected and for which we determined the proper exposure is called a "**Reference Tone.**"

With this technique, **the Reference Tone of a complex subject that you choose, works as a handle that can be "visually grabbed" in order to "move" the entire subject to the back of the camera and record it onto the film's surface.**

3.2. Let's review simple and complex subjects.

Since the idea of simple and complex subjects plays an important part in understanding this section, let's review their definition as well as their relationship. As was explained before, a simple subject is a subject that consists of only one tone. By combining two or more simple subjects we get a complex subject. By definition, **a complex subject is a subject that has more than one distinct tone**. It could have two, or it could have many tones. Also by definition, simple subjects are the building blocks of any complex subject.

The following is the most important relationship between a simple and a complex subject: Since it takes two or more simple subjects to make a complex subject, then any complex subject can be visually divided into two or more simple subjects. As we will learn shortly, this relationship is the basis for determining the exposure of a complex subject. Simple and complex subjects are graphically illustrated in Diagram 3.2.0.

A Practical Tip!

The most practical way to determine whether a subject is simple or complex is to look through your camera and move the spotmetering circle (frame) within the boundaries of the tone that you think represents a simple subject. If the reading of your meter remains the same (i.e., the needle stays in the middle / Exposure Index indicates the same exposure reading) the subject is simple, if it does not (i.e., it changes as you move the camera), the subject is complex.

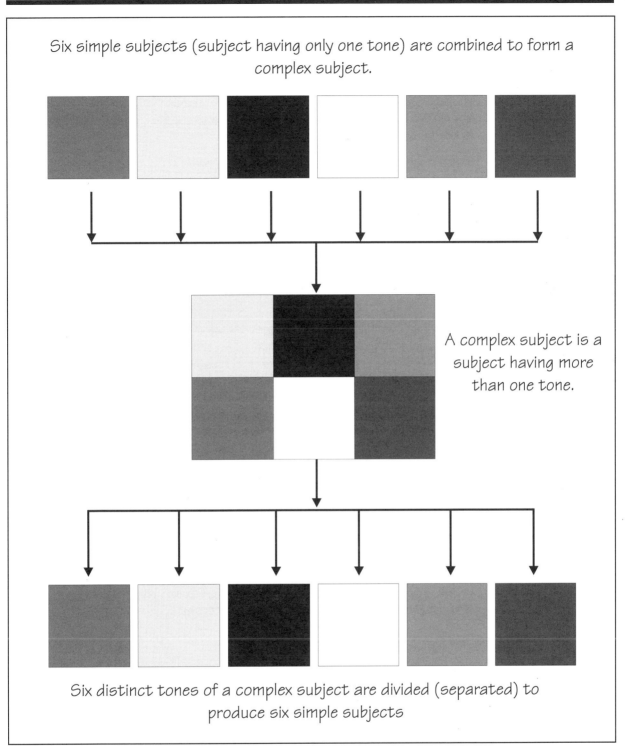

Six simple subjects (subject having only one tone) are combined to form a complex subject.

A complex subject is a subject having more than one tone.

Six distinct tones of a complex subject are divided (separated) to produce six simple subjects

Diagram 3.2.0

Relationship between simple and complex subjects

3.3. How do we select a "Reference Tone" in a complex subject?

The logic of selecting a **Reference Tone** in a complex subject, is no different from looking for a handle in a chair, so that we can move the chair with it. The following will illustrate this:

A quick experiment: Place a small chair in the middle of a room. Now approach the chair, *grab it with one hand*, and move it to the next room. Now sit and write down all the steps that you followed to move this chair from one room to another.

Analysis of the experiment: To pick up the chair, the first thing that one does is to observe it. While observing, you look for a *handle* to *grasp*. After grasping the handle, it can be *picked up and transferred to the next room and placed in a predesignated location.* The parts of the chair that can be used as handle are **the back, the arms, the seat or the legs.** The part of the chair that you chose to grasp can be safely called a "**Chair Handle.**"

We can apply identical logic to a complex subject. As was discussed before, any complex subject has two or more tones. Using the chair example, any of these tones can be used as a "**visual handle**" that the photographer can use in to move the entire subject onto the back of the camera. In photography, we use the Reference Tone as the visual handle. Therefore the graphic illustration for a Reference Tone is a hand pulling a handle. *__When photographing a complex subject, you must remember that if the Reference Tone is underexposed, then the entire subject will be underexposed. If the Reference Tone is overexposed, then the entire subject will be overexposed.__*

The next question you would ask is, "Which tone of a complex subject lends itself best to be used as a Reference Tone?" As we discussed before, when you moved a chair, you had many handles to choose from. These include the legs, the seat, the arms and the back. In your experiment, chances are that you did not move it by holding a leg. (You could have, but it is unlikely.) The same reasoning applies to choosing a Reference Tone in a complex subject. Although we can use any of the tones to be used as the Reference Tone, certain are more logical and lend themselves to this better than the others.

When using color slide film:

Use the *brighter* or *medium* tones over the darker ones. Brighter tones are easier to see, measure and can be assigned to the Tone-Ruler more accurately than the darker ones. These lighter tones also play an important part in the picture since the viewer's eye is always drawn toward them.

When using a color or a black and white negative film:

The Reference Tone is generally chosen from a *medium* or an important *darker* tone that is of interest to you. The philosophy behind this is that with underexposed lowlights one has nothing. Where one can always burn-in the overexposed highlights in the darkroom to get some detail out of the negative. If you are confused, please refer to Chapter 6.

3.4. Single tone exposure determination for a complex subject, a simple example

Assume you are taking an outdoor portrait of a white person, preferably in the shade or faced away from the sun under uniform light conditions. As portrait photography signifies, the most important tone is the skin tone of the model. In this outside setting, you have many other tones besides the model's face. These include tones that could be in the model's clothing, hair, eyes, teeth or in the background. **With this simplified technique, since the skin tone is an important tone and needs to be properly exposed, we will use it as our Reference Tone. All other tones will be ignored.**

The procedure is as follows:

❏ Manually adjust the camera-to-subject distance on your lens (i.e., focus). If you are using an auto-focus camera without spotmetering feature, let the camera determine the distance then turn the autofocus off. Once the distance is set do not touch it for the rest of this process.

❏ Determine the "normal exposure" for the skin tone:
> ➤ If your camera has spotmetering (or you have an off-camera spotmeter), determine the "normal exposure" from the forehead (or the cheek) without walking towards your subject.
> ➤ If you do NOT have spotmetering capability (older cameras), get as close as you can, so that the tone you are exposing for (in this case the forehead or the cheek) completely fills your viewfinder.
> *You must do this without casting a shadow on the surface that you are measuring*. At this point the subject will look blurred. DO NOT TOUCH THE FOCUSING DIAL!
> Now you can walk back to your original position.

❏ The "normal exposure" of the previous step must now be converted to the "correct exposure." As you remember, the Caucasian flesh tone can be placed in the light gray region of our Tone-Ruler. This can be achieved by opening-up the aperture by one stop. Now you can take your picture.

The idea behind this simplified technique is that *if one tone of the complex subject is correctly exposed (here the skin tone is correctly exposed), then the other tones will also be correctly exposed*. The rest of the tones in this case are clothing, subject's teeth, background, etc. This is similar to the chair example where "when one part of the chair is moved to the other room, we can assume that the entire chair is moved to the other room."

Please Note: For many of you whose only meter is a broad angle meter in the camera (that is, you do not have an off-camera or an on-camera spotmeter), this technique should be all that you need to learn to expose a complex subject. You can practice what you learn in this section until you can apply it with ease.
If you have a spotmeter, then you can practice the more advanced techniques of tone manipulation that you will be learning later on.

In this image, the forehead was used as a simple tone (and the most important tone) to produce a normal exposure of 1/60 @ f-5.6. For the light source, I used a cloudy day. My equipment consisted of Nikon CoolPix 990 set at ISO 100. As you recall, this exposure will produce an 18% medium gray image tone for the skin. Therefore I increased the exposure by 1 stop to 1/60 @ f-4 to generate a 36% gray image tone for the forehead. To create a more pleasant image, I had an assistant to hold a gold reflector to reflect some light onto the model's face.

Image for section 3.4.0

3.5. A detailed procedure for the exposure determination of a complex subject

1) Choosing a Reference Tone to visually pick up the subject with!

a) Break the complex subject down to its simple tone components. This means that you have to assign up to five different labels to different tones of the subject. These labels are black, dark gray, medium gray, light gray and white. A subject that you photograph may have one or more of these tones.

b) Now choose a Reference Tone. If you are not sure which tone to choose, when using a slide film, pick a medium or a brighter tone.

The Reference Tone could be an important tone (flesh tone), or it could be a tone that you are comfortable with, such as a white or light gray surface or a medium gray surface.

2) Determine the normal exposure of the Reference Tone.

With your camera focused for the final shot (with auto-focus disabled) take a selective reading from the Reference Tone and find its "normal exposure." *When determining the "normal exposure," it is essential that all you see in the viewfinder of your older camera or the spotmetering frame of your newer camera is the desired simple tone and nothing else*. When photographing a snow covered scene, the Reference Tone is snow. When taking portraits in the snow, it is the skin tone. However, if the snow in the picture becomes more important than the person's face, then the Reference Tone would shift back to the snow again. A photographer, depending on the importance of the tone in the final image, can choose different Reference Tones. If you do not have spotmetering feature on your camera, when determining the normal exposure the Reference tone *can* be blurred. Also make sure you do not shadow your subject. Simply change your aperture or shutter speed to get the normal exposure. In cases like this, the use of an off-camera spotmeter or an on-camera spotmeter would be ideal.

3) Convert the "normal exposure" to the "correct exposure."

This is done by placing (matching) the subject's Reference Tone with one of the tones on the Tone-Ruler. Once you have decided what you think the standard tone is, you can change the "normal exposure" to the "correct exposure." This simplified technique is based on the principle that "once an important tone of complex subject is properly exposed, all other tones of this subject will fall into place and are properly exposed." This is similar to the chair experiment where "when one part of the chair was moved to the other room, then we can safely assume that all other parts of the chair followed and were moved to the other room."

Please remember: *After you override your meter (determined the tone's CORRECT exposure), while photographing the subject, the meter in your camera may show overexposure, underexposure or normal exposure. At this point, these readings MUST be ignored.*

1

Break the complex subject down into its simple components and choose a Reference Tone to be used as a handle.

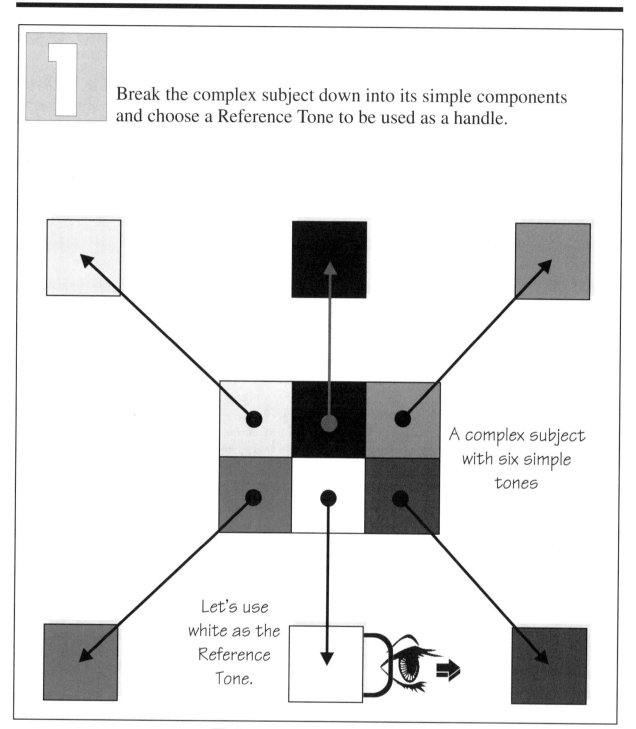

A complex subject with six simple tones

Let's use white as the Reference Tone.

Diagram 3.5.1

Breaking down a complex subject into its simple subject tones. In this case, a complex subject is divided into six simple subjects (tones). White is our Reference Tone.

2 Find the normal exposure for this Reference Tone

In the previous step, we chose white as our Reference Tone.

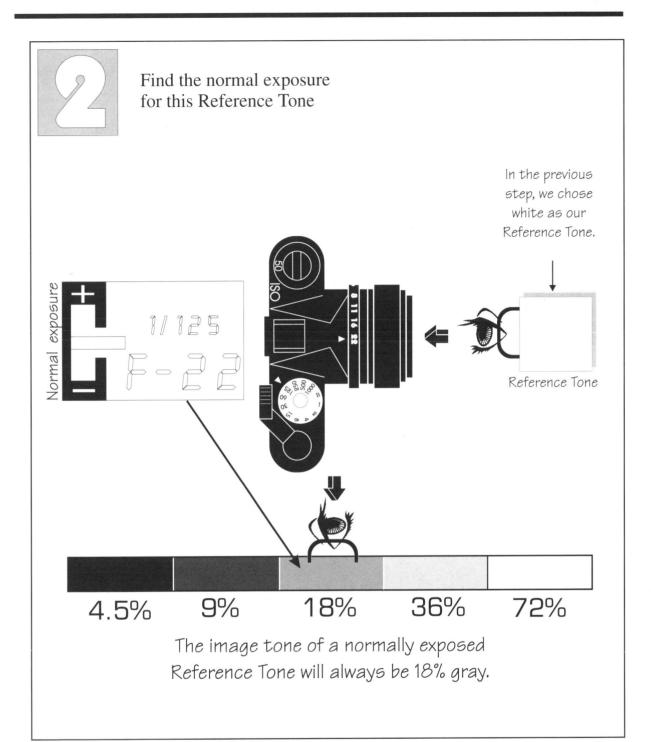

Reference Tone

4.5% 9% 18% 36% 72%

The image tone of a normally exposed Reference Tone will always be 18% gray.

Diagram 3.5.2

When normally exposing the Reference Tone, the resulting image will ALWAYS have an 18% gray tone.

3 Since our original tone was white, we simply brighten the image of the Reference Tone to 72% white by opening-up the aperture by 2 stops from the "normal exposure" setting.

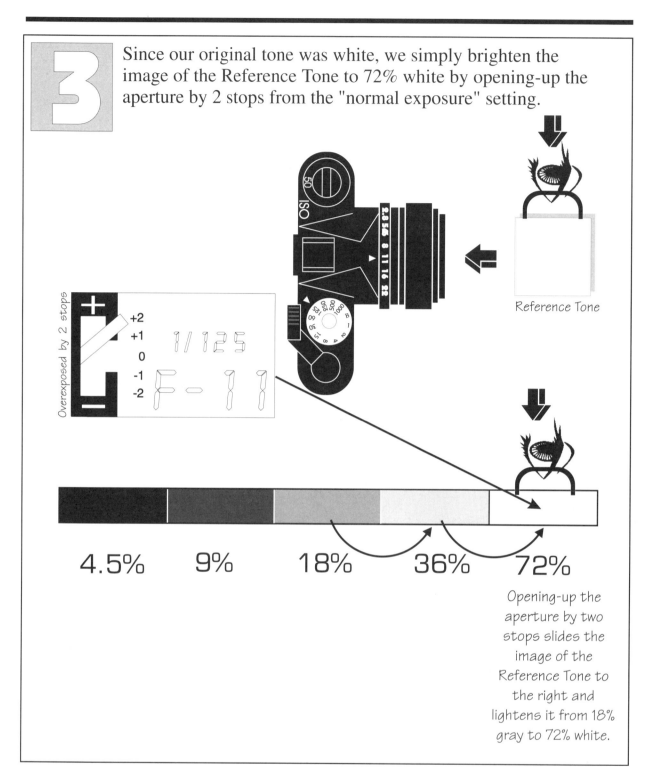

Reference Tone

Overexposed by 2 stops

+2
+1
0
-1
-2

1/125

F - 11

4.5% 9% 18% 36% 72%

Opening-up the aperture by two stops slides the image of the Reference Tone to the right and lightens it from 18% gray to 72% white.

Diagram 3.5.3

By overriding the normal exposure from 1/125 @ f-22 to 1/125 @ f-11, we lighten the 18% gray image tone by two stops to create a 72% white image tone.

4 Since the correct exposure for the Reference Tone of the subject was determined, we can use the same exposure to photograph the entire complex subject.

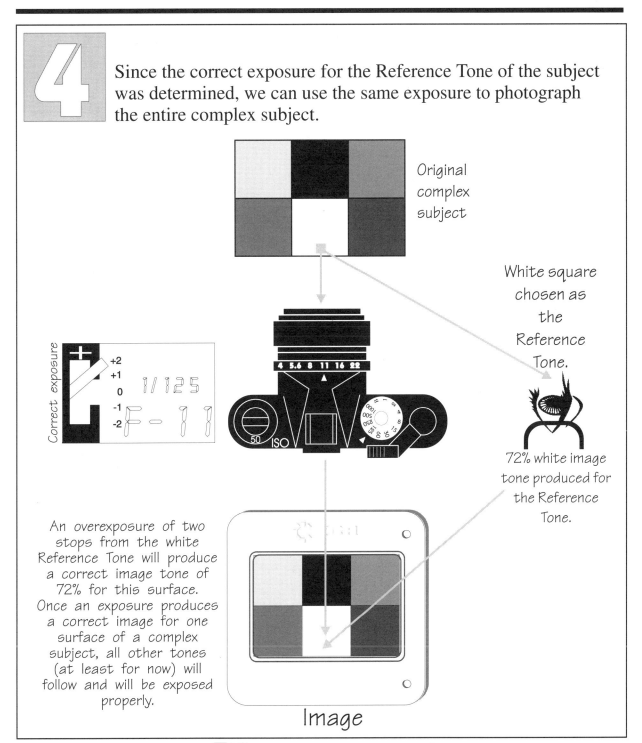

Original complex subject

White square chosen as the Reference Tone.

72% white image tone produced for the Reference Tone.

Correct exposure

An overexposure of two stops from the white Reference Tone will produce a correct image tone of 72% for this surface. Once an exposure produces a correct image for one surface of a complex subject, all other tones (at least for now) will follow and will be exposed properly.

Image

Diagram 3.5.4

In this one-tone simplified technique, we must determine the correct exposure for one of the tones. Here we determined the proper exposure for the white square (Reference Tone) to be 1/125 @ f-11. Now we can use this exposure (1/125 @ f-11) to photograph the entire complex subject. The idea behind this simplified concept is that "If one part of the complex subject is correctly exposed, then the rest of the tones will be correctly exposed."

3.6. Let's photograph our first complex subject

The snow covered cottage on the next page will be our first complex subject to analyze and photograph.

In this specific subject, we have three distinct tones, *the snow*, the *walls* and the *door*. For illustration purposes, every one of these three subjects (surfaces) can be considered a simple subject.

In each of these three examples, we choose *one* of these tones as the Reference Tone. Then by determining the correct exposure for this tone, we have determined the correct exposure for the entire subject.

To do this you need to match the Reference Tone with one of the five tones of the Tone-Ruler. It is up to you to select the "**wall**," the "**door**," or the "**snow**" as your Reference Tone. *Once you have matched the Reference Tone with a tone on the Tone-Ruler, the rest is easy.*

For some people (myself included), the hardest part of this process is to match the Reference Tone with one of the tones on the Tone-Ruler. If you are like I am and having a hard time with this technique, try the negative logic that I use.

To illustrate, let's use the **wall** as our Reference Tone.

When using this technique, we always start with 5 tones. The reasoning goes something like this:

Since the wall is not black, we are left with 4 other choices.

Since the wall is not white, we are left with 3 other choices.

Since the wall is not dark gray, we are left with 2 other choices.

Since the wall is not medium gray, we are left with 1 other choice.

By default, our only remaining choice is the light gray tone. Therefore, we will assign the 36% light gray reflectivity to the wall.

To expose the complex subject properly, we simply measure the normal exposure for the wall and open-up one stop (brighten-up the 18% medium gray image tone to 36% light gray image tone). You can use this "reverse" logic to any simple tone that you see around you to determine its approximate exposure.

Please remember that you will make mistakes in the beginning. It will always help to keep notes! As you practice, you will become increasingly skilled at placing tones into their appropriate reflectivity on the Tone-Ruler.

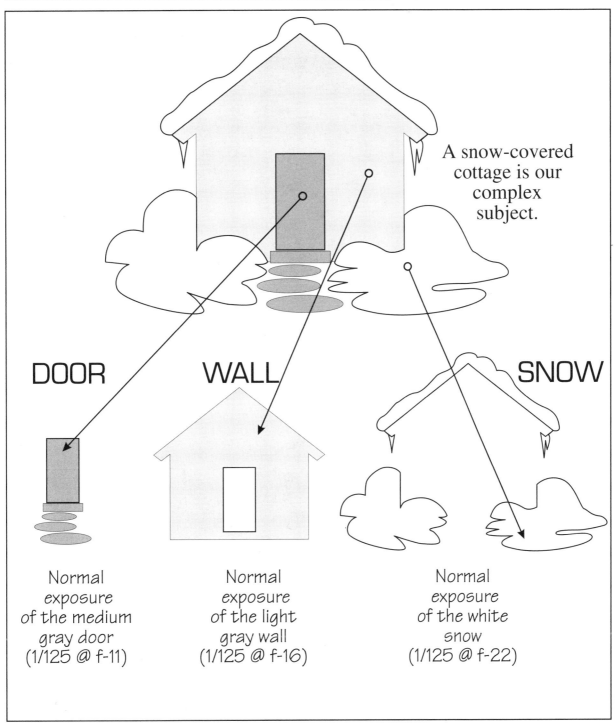

A snow-covered cottage is our complex subject.

DOOR

WALL

SNOW

Normal exposure of the medium gray door (1/125 @ f-11)

Normal exposure of the light gray wall (1/125 @ f-16)

Normal exposure of the white snow (1/125 @ f-22)

Diagram 3.6.0

The tones of a complex subject can always be broken down to its simple tones. In this case, our simple subject tones are:

1) The SNOW, 2) The WALL and 3) The DOOR.

Using the SNOW as the Reference Tone

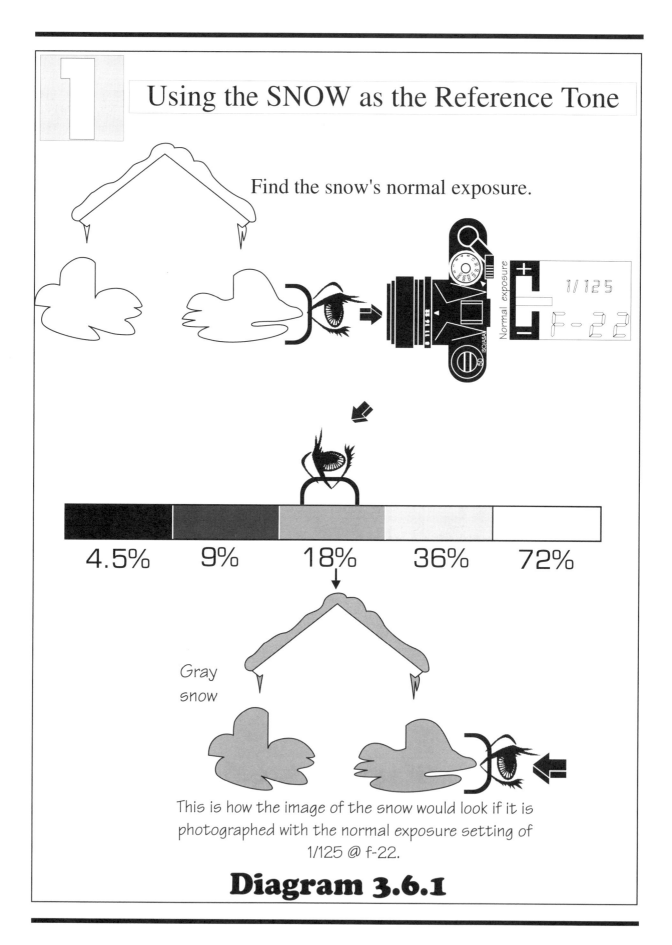

Find the snow's normal exposure.

1/125
F-22

Normal exposure

4.5% 9% 18% 36% 72%

Gray
snow

This is how the image of the snow would look if it is photographed with the normal exposure setting of 1/125 @ f-22.

Diagram 3.6.1

Using the SNOW as the Reference Tone

To change the image tone of the SNOW from 18% gray to 72% white, we need to open-up the aperture by two stops from this

| f-45 | f-32 | f-22 | f-16 | f-11 |

| 4.5% | 9% | 18% | 36% | 72% |

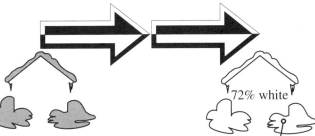

A final exposure of 1/125 @ f-11
produces this image

Once the image of the snow has a 72% white tone, the image of the DOOR will have an 18% gray tone, and the image of the WALL will have a 36% gray tone. Remember, the DOOR and the WALL fall into 18% and 36% image tones because of our original assumptions about this subject. If these two tones had different reflectivities, they would have still fallen into their appropriate places and would be correctly exposed.

72% white

Diagram 3.6.2

Using the WALL as the Reference Tone

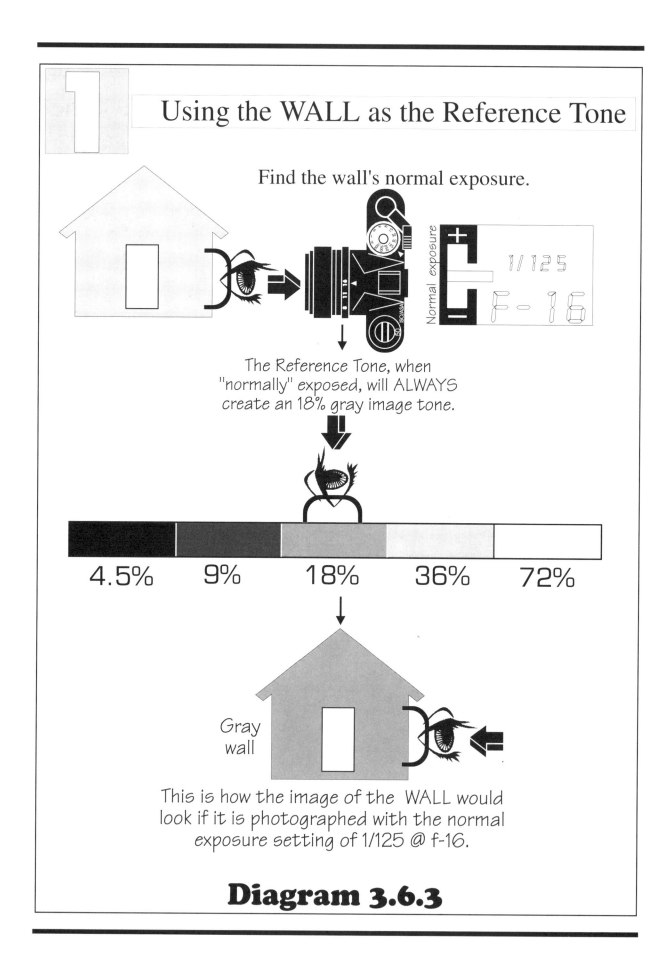

Find the wall's normal exposure.

Normal exposure

1/125
F-16

The Reference Tone, when "normally" exposed, will ALWAYS create an 18% gray image tone.

4.5% 9% 18% 36% 72%

Gray wall

This is how the image of the WALL would look if it is photographed with the normal exposure setting of 1/125 @ f-16.

Diagram 3.6.3

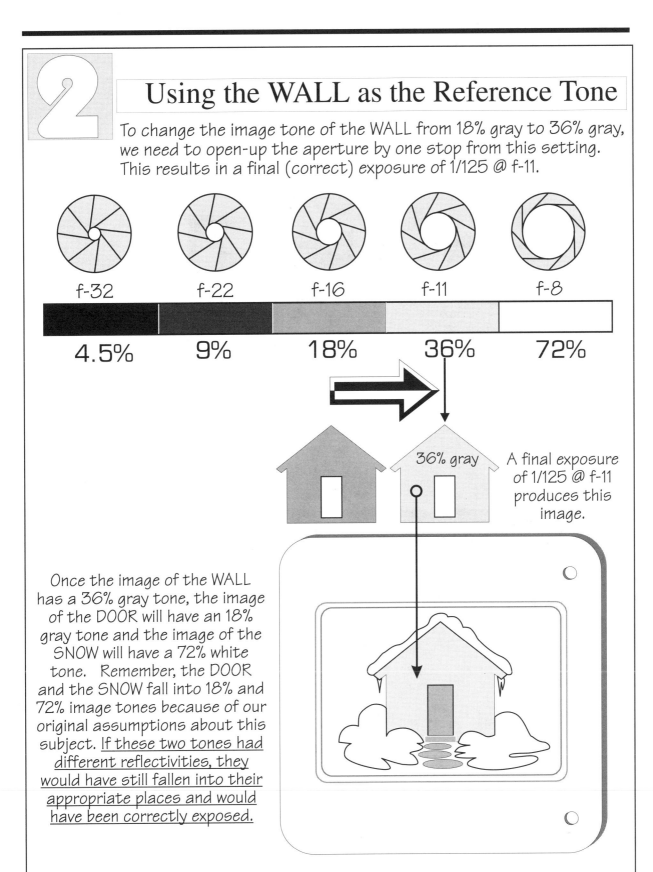

Using the WALL as the Reference Tone

To change the image tone of the WALL from 18% gray to 36% gray, we need to open-up the aperture by one stop from this setting. This results in a final (correct) exposure of 1/125 @ f-11.

| f-32 | f-22 | f-16 | f-11 | f-8 |

| 4.5% | 9% | 18% | 36% | 72% |

36% gray

A final exposure of 1/125 @ f-11 produces this image.

Once the image of the WALL has a 36% gray tone, the image of the DOOR will have an 18% gray tone and the image of the SNOW will have a 72% white tone. Remember, the DOOR and the SNOW fall into 18% and 72% image tones because of our original assumptions about this subject. If these two tones had different reflectivities, they would have still fallen into their appropriate places and would have been correctly exposed.

Diagram 3.6.4

Using the DOOR as the Reference Tone

Find the door's normal exposure.

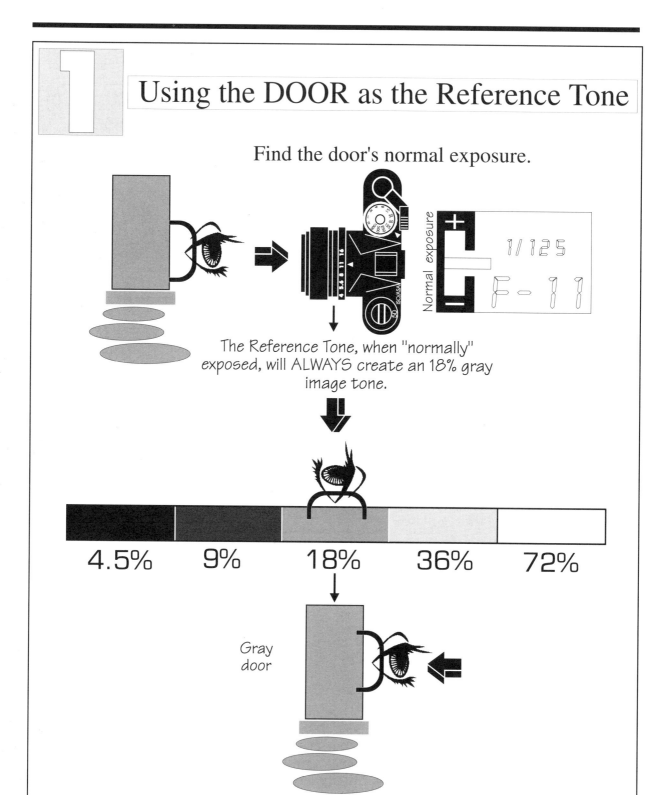

The Reference Tone, when "normally" exposed, will ALWAYS create an 18% gray image tone.

| 4.5% | 9% | 18% | 36% | 72% |

Gray door

This is how the image of the DOOR would look if it is photographed with the normal exposure setting of 1/125 @ f-11.

Diagram 3.6.5

Using the DOOR as the Reference Tone

Since the door's tone approximates a medium gray, by keeping the exposure at 1/125 @ f-11, its image will have an 18% gray tone.

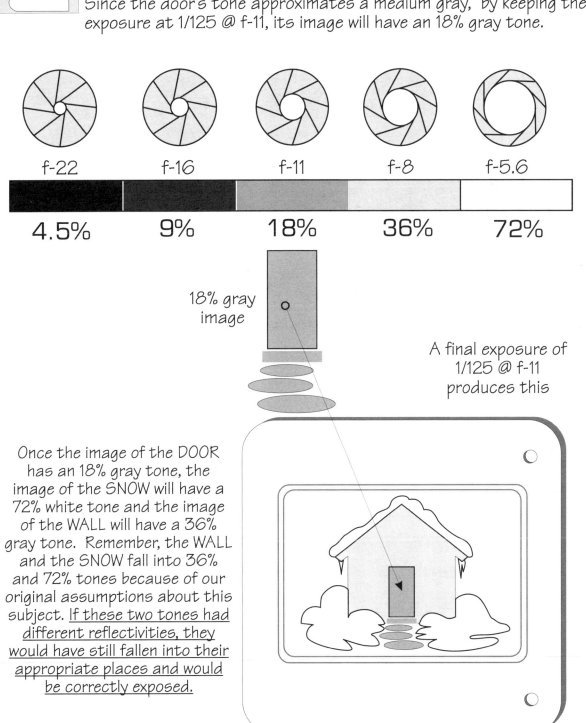

f-22	f-16	f-11	f-8	f-5.6
4.5%	9%	18%	36%	72%

18% gray image

A final exposure of 1/125 @ f-11 produces this

Once the image of the DOOR has an 18% gray tone, the image of the SNOW will have a 72% white tone and the image of the WALL will have a 36% gray tone. Remember, the WALL and the SNOW fall into 36% and 72% tones because of our original assumptions about this subject. If these two tones had different reflectivities, they would have still fallen into their appropriate places and would be correctly exposed.

Diagram 3.6.6

3.7. Let's use the Tone Train Technique to illustrate photographing the snow-covered cottage

The following three pages illustrate the Tone Train technique to determine the exposure for each of the three tones of the snow-covered cottage. Please take a few minutes to familiarize yourself with its application.

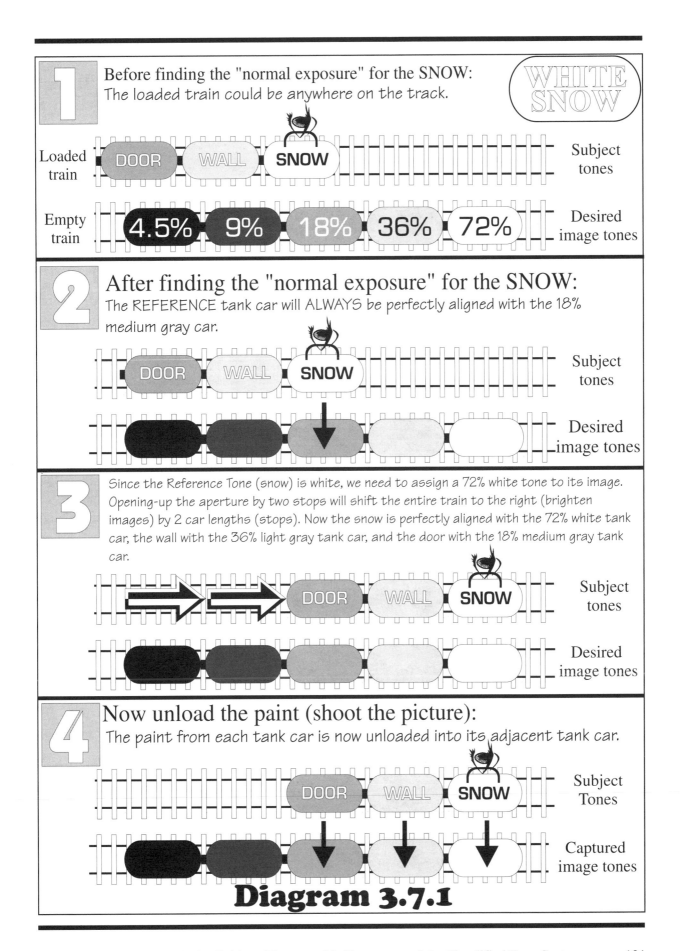

1 Before finding the "normal exposure" for the SNOW:
The loaded train could be anywhere on the track.

WHITE SNOW

Loaded train — DOOR · WALL · SNOW — Subject tones

Empty train — 4.5% · 9% · 18% · 36% · 72% — Desired image tones

2 After finding the "normal exposure" for the SNOW:
The REFERENCE tank car will ALWAYS be perfectly aligned with the 18% medium gray car.

DOOR · WALL · SNOW — Subject tones

Desired image tones

3 Since the Reference Tone (snow) is white, we need to assign a 72% white tone to its image. Opening-up the aperture by two stops will shift the entire train to the right (brighten images) by 2 car lengths (stops). Now the snow is perfectly aligned with the 72% white tank car, the wall with the 36% light gray tank car, and the door with the 18% medium gray tank car.

DOOR · WALL · SNOW — Subject tones

Desired image tones

4 Now unload the paint (shoot the picture):
The paint from each tank car is now unloaded into its adjacent tank car.

DOOR · WALL · SNOW — Subject Tones

Captured image tones

Diagram 3.7.1

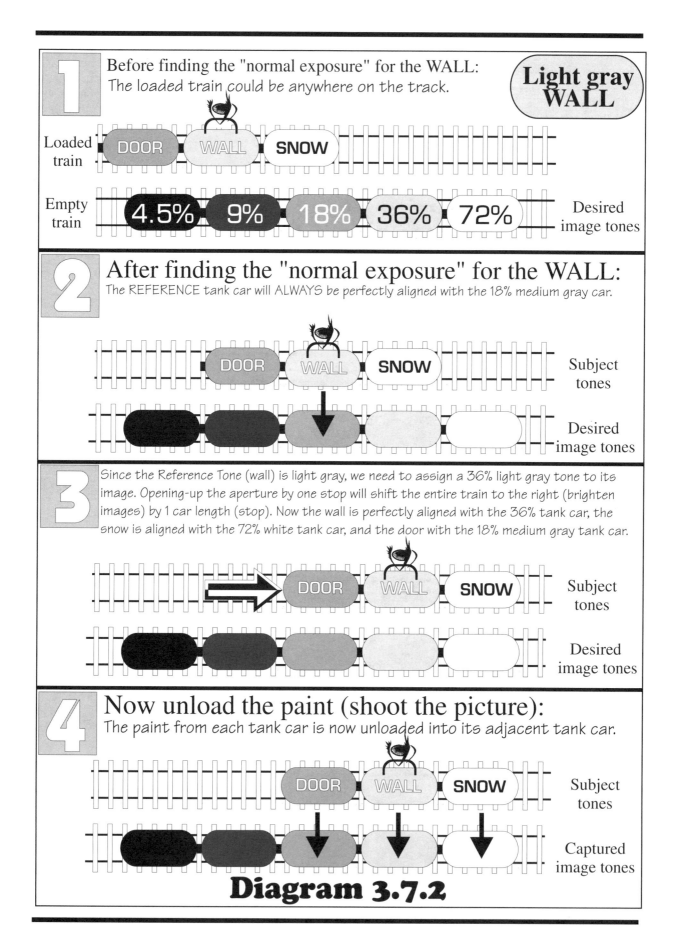

1 Before finding the "normal exposure" for the WALL:
The loaded train could be anywhere on the track.

Light gray WALL

Loaded train: DOOR WALL SNOW

Empty train: 4.5% 9% 18% 36% 72%

Desired image tones

2 After finding the "normal exposure" for the WALL:
The REFERENCE tank car will ALWAYS be perfectly aligned with the 18% medium gray car.

DOOR WALL SNOW — Subject tones

Desired image tones

3 Since the Reference Tone (wall) is light gray, we need to assign a 36% light gray tone to its image. Opening-up the aperture by one stop will shift the entire train to the right (brighten images) by 1 car length (stop). Now the wall is perfectly aligned with the 36% tank car, the snow is aligned with the 72% white tank car, and the door with the 18% medium gray tank car.

DOOR WALL SNOW — Subject tones

Desired image tones

4 Now unload the paint (shoot the picture):
The paint from each tank car is now unloaded into its adjacent tank car.

DOOR WALL SNOW — Subject tones

Captured image tones

Diagram 3.7.2

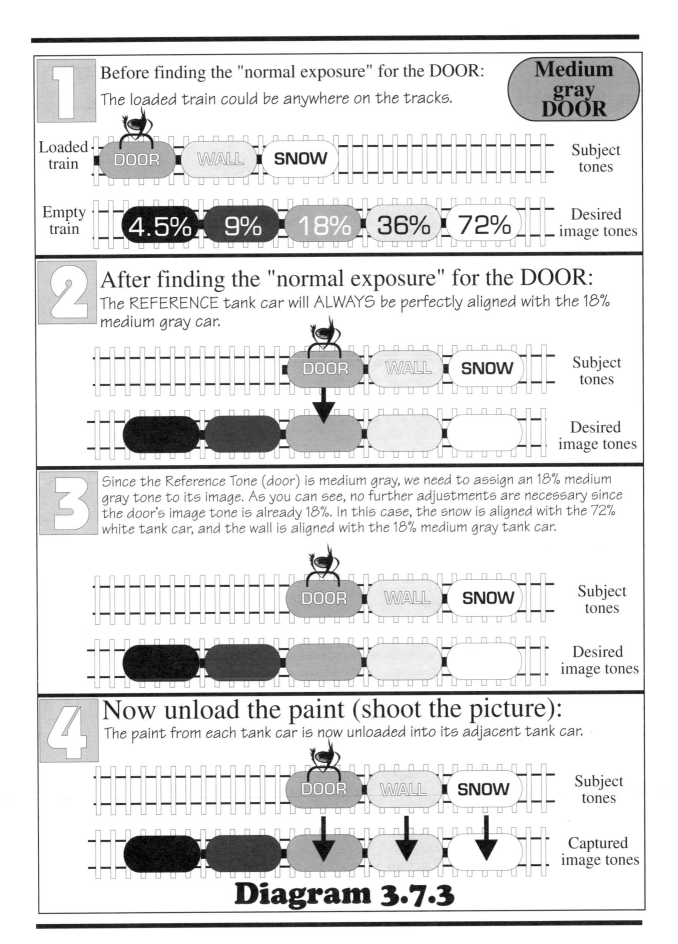

1 Before finding the "normal exposure" for the DOOR:
The loaded train could be anywhere on the tracks.

Medium gray DOOR

Loaded train — DOOR WALL SNOW — Subject tones

Empty train — 4.5% 9% 18% 36% 72% — Desired image tones

2 After finding the "normal exposure" for the DOOR:
The REFERENCE tank car will ALWAYS be perfectly aligned with the 18% medium gray car.

DOOR WALL SNOW — Subject tones

Desired image tones

3 *Since the Reference Tone (door) is medium gray, we need to assign an 18% medium gray tone to its image. As you can see, no further adjustments are necessary since the door's image tone is already 18%. In this case, the snow is aligned with the 72% white tank car, and the wall is aligned with the 18% medium gray tank car.*

DOOR WALL SNOW — Subject tones

Desired image tones

4 Now unload the paint (shoot the picture):
The paint from each tank car is now unloaded into its adjacent tank car.

DOOR WALL SNOW — Subject tones

Captured image tones

Diagram 3.7.3

3.8. Summary of the most important steps in the single tone metering of a complex subject

If you remember from our simple and complex subject discussions, we chose a chair to illustrate the concept of a subject with many handles. In this case, our goal was to move the chair from one room to a predesignated area in another room. In section 2.19 you had only one tone, in this section you have more than one tone. *Once you selected "one" of these tones as the "Reference Tone," the process of assigning it to the ruler is identical.*

If you think you have mastered the technique, you can skip the following review. If you have any doubt in your mind, please read on.

As you recall, moving the chair from one room to another location involves:

a) Choosing a handle: Observing the chair and visually choosing a handle that we can conveniently grab hold of. *Unlike a simple object, the chair has more than one handle.*

b) Grabbing the handle: Physically grasping the chosen handle.

c) Moving the chair: Physically picking up the chair and moving it to a predesignated location in another area.

Capturing the image of a complex subject on slide film involves:

a) Observing the subject

b) Converting the complex subject into its simple subject components:

Visually breaking down the complex subject into two or more simple tones (subjects).

c) Choosing a Reference Tone (handle): Now we can choose one of these tones to be used as the subject's Reference Tone. When using slide film, choosing the medium or brighter tones are recommended.

d) Visual grabbing of the handle: In photography, the "visual grabbing" of the Reference Tone is performed by finding its *normal exposure.* This can be done by your camera's meter or any other reflective meter such as a spotmeter.

e) Moving the Reference Tone's image to the back of the camera: To perform this you must assign the Reference Tone into *one* of the following five tones: 1) Black, 2) Dark gray, 3) Medium gray, 4) Light gray or 5) White. This is perhaps the most important decision that you will make about your image. Please also bear in mind that your Reference "grabbed" Tone always has the initial image tone of 18% medium gray.

The following steps, show you how to make the 18% medium gray image of your Reference Tone into one of the *following image tones*.

 1) 4.5% Black

 2) 9% Dark gray

 3) 18% Medium Gray

 4) 36% Light gray

 5) 72% White

This step of the light measurement process requires your judgment more than any other step. If you are not sure, just pick one anyway. *Right or wrong, you must commit yourself to one of these five tones.* The following procedures show how you can *move (change)* your image tone from the 18% medium gray image tone (that is where you are right now) to *one of the five standard image tones*.

❑ If you chose 4.5% black:

Darken the image tone by two stops, i.e., close-down the aperture by 2 stops (say from f-4 to f-8) *or* decrease the exposure time by 2 stops (say from 1/15 to 1/60). This places the image of the tone at 4.5% black.

❑ If you chose 9% dark gray:

Darken the image tone by 1 stop, i.e., close-down the aperture by 1 stop (say from f-5.6 to f-8) *or* decrease the exposure time by 1 stop (say from 1/30 sec to 1/60). This places the image of the tone at 9% dark gray.

❑ If you chose 18% medium gray:

This does not require a manual override. The normal exposure is also the correct exposure. Shoot the picture with "normal exposure" settings. This creates an 18% medium gray image tone. *Please remember, this is the only time where the "normal exposure" is the same as the "correct exposure."*

❑ If you chose 36% light gray:

Brighten the image tone by 1 stop, i.e., open-up the aperture by 1 stop (say from f-5.6 to f-4) *or* increase the exposure time by 1 stop (say from 1/60 sec to 1/30). This places the image of the tone at 36% light gray. This is what we do when photographing a Caucasian skin tone.

❑ If you chose 72% white:

Brighten the image tone by two stops, i.e., open-up the aperture by 2 stops (say from f-5.6 to f-2.8) *or* increase the exposure time by 2 stops (say from 1/60 to 1/15). This places the image of the tone at 72% white (extra light gray).

GALLERY

The Multiple Tone Metering Technique To Photograph a Complex Subject

What will you learn in this chapter?

In this chapter we will learn how to use an off-camera spotmeter or a camera to determine the Subject Brightness Range (SBR) and will explore different ways that the film accommodates a complex subject. You will also learn about image detail and how to previsualize the final image tones.

Please note: This chapter is for those photographers who want to learn more advanced features of the Zone System of light measurement using an on-camera as well as an off-camera spotmeter.

4.1. What is the Multiple Tone Metering System all about?

So far, all of our techniques have involved light measurement and exposure determination of a simple tone. This tone was either the only tone of a simple subject or the Reference Tone of a complex subject.

The simplified idea behind choosing a Reference Tone for a complex subject is that if one tone of a complex subject is properly exposed, then the rest of the tones in the subject also will be properly exposed. *We used this technique without any consideration for the type of film that we used, the brightness range of a subject, or the amount of detail in the different tones of the image.* To explain and illustrate this new technique, we will be using the Tone Train concept again. If you look back at the Tone Train illustrations of the previous chapter, every one of our subject tones (loaded tank cars) was eventually aligned with an image tone that was represented by an empty tank car. In this chapter, for subjects with a *long tonal range, the loaded train (the subject) can have more than five tank cars.* Here, since the subject train is longer than the film train, some end cars of the loaded train will not correspond to a tank car on the empty train. Here the cargo cannot be unloaded. In photographic terms, these tones will simply not be recorded on the film. Their image will be either washed out (too white) or will be totally black. The Multi Tone Metering System is a method that allows you to control your image tones in order to produce the best result. Before we start with a detailed explanation of this technique, here are a few terms that you need to understand. These are:

1) The angle of view and the angle of measure (acceptance)

2) Equivalent exposures

3) A spotmeter

4) The Subject Brightness Range (SBR)

5) The film and its Contrast Range (FCR)

6) The image detail

4.2. The angle of view and the angle of measure (acceptance)

The angle of view is the angle with which an instrument such as a camera views the subject. Generally, if you are looking at a subject and the subject looks larger than what you see with your eyes, then the lens on the camera is considered to be a telephoto (telescopic) lens. Similarly, if the subject looks smaller than what your eye sees then, the lens is considered a wide angle lens. If the subject looks the same size as with the naked eye, the lens is considered "normal."

The diagonal viewing angle for a normal lens is about forty-six degrees (46) and its focal length is about 50mm. To test this with the 50mm lens of your camera, simply look through the viewfinder with one eye and **keep the other eye open**. The images from both eyes will coincide. Telephoto lenses have a smaller angle

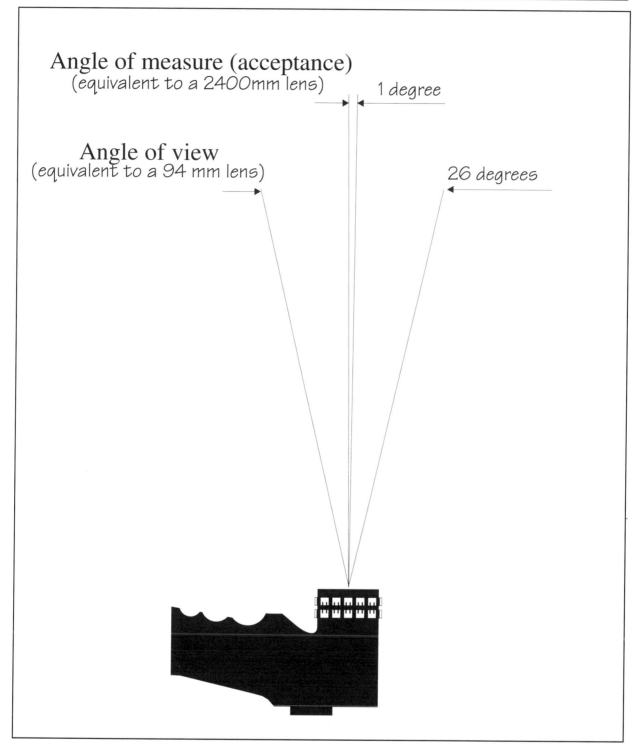

Angle of measure (acceptance)
(equivalent to a 2400mm lens)

1 degree

Angle of view
(equivalent to a 94 mm lens)

26 degrees

Diagram 4.2.1

Diagram showing the angle of view and the angle of measure (acceptance) for a 1 degree Pentax digital spotmeter.

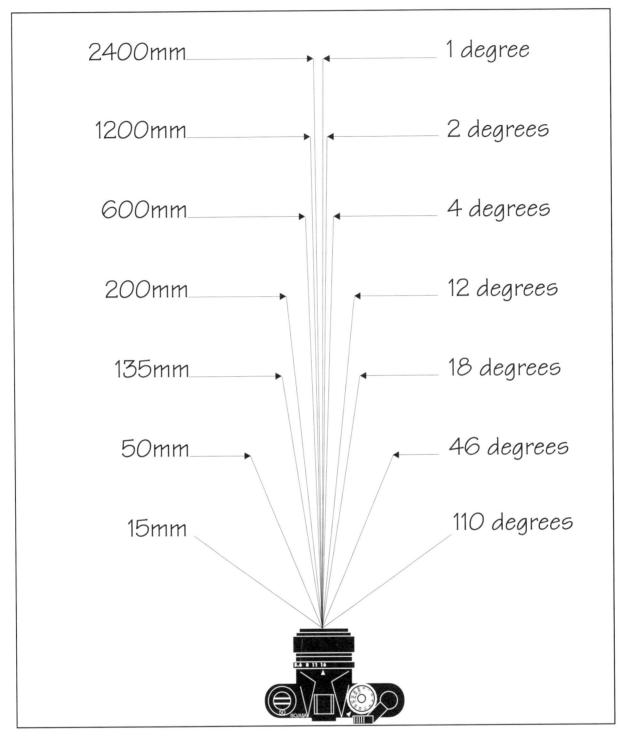

2400mm — 1 degree

1200mm — 2 degrees

600mm — 4 degrees

200mm — 12 degrees

135mm — 18 degrees

50mm — 46 degrees

15mm — 110 degrees

Diagram 4.2.2

Diagram showing the approximate angle of measure (acceptance) for a 35mm camera with different lens attachments. With a 2400mm lens, a standard camera has approximately the same angle of measure (acceptance) as a 1 degree spotmeter.

of view and wide angle lenses have a larger angle of view. Please see Diagram 4.2.2.

Why should we be interested in the angle of view? Well, this is the way the meter in your camera sees the subject and finds its normal exposure. In standard cameras without the spotmetering feature, the angle of view and the angle of measure are generally the same. In a spotmeter the angle of view could be about 26 degrees where the angle of measure (acceptance) can be as narrow as 1 degree (1°). In Diagram 4.2.2, you can see the approximate angles of view for different lenses for your 35mm camera.

4.3. Equivalent exposures and the Law of Reciprocity in slide films

When you find the exposure for a scene or a gray card, and your camera's meter shows a correct exposure of 1/1000 @ f-2.8, you must realize that this is *not* the only correct exposure. The following table shows other exposures that will produce the same correct exposure.

Shutter speed/aperture pairs producing identical exposures							
The following row illustrates eight consecutive exposure times in increasing order							
1/1000	1/500	1/250	1/125	1/60	1/30	1/15	1/8
f-2.8	f-4	f-5.6	f-8	f-11	f-16	f-22	f-32
The above row illustrates eight consecutive aperture openings in decreasing order							

Equivalent exposures are possible since every full click on the aperture is equivalent to a full click of the shutter speed dial, and a full click on each dial is also equivalent to one stop. If a photographer is interested in freezing the action, perhaps he uses 1/1000 @ f-2.8, and if he requires the maximum depth of field, then he uses 1/30 @ f-16. The law that governs equivalent exposures is known as the law of reciprocity. Like anything else in life, there are limits to the practical applications of this law. For example, the following exposures 1/15 @ f-2, and 8 sec. @ f-22 theoretically produce equivalent exposures. In practice, this law does not hold if you are using Kodachrome 64, Ektachrome 64, or Agfachrome 50 RS slide films and the exposure is longer than 1/10 sec. or if you are using a Fujichrome 50 film and the exposure is longer than 1 second.

For these films, the longer the exposure, the less sensitive they become. For example, if an exposure of 1/15 sec. @ f-2 produces a correct image, then the equivalent exposure of 8 sec. @ f-22, using Kodachrome 64 film would result an underexposure of almost 2 stops. Another side effect of reciprocity failure in color films is the unwanted color shift. A serious photographer who is using long exposures with slide film must be aware of these drawbacks and should compensate for them. If you do not know what the reciprocity failure characteristics of a film are, you can contact the manufacturer or simply take a test roll and see how it behaves. At times, you may have to ignore the

manufacturer's recommendations. For example, although Kodachrome 64 film is not recommended by Kodak for exposures of more than 1 sec., some successful photographers have used it for exposures of four to eight hours. These exposures are used to trace stars in a moonless night or for photographing a moonlit scene. For extremely long exposures like these, Kodachrome 64 acts like a film with an approximate ISO of 8.

4.4. What is a spotmeter?

A spotmeter, as the name implies, is a long distance, narrow-angle, and traditionally an off-camera light metering device. This characteristic makes it the ideal meter for finding the normal exposure of a simple subject and to determine the brightness range of a distant complex subject (we will be talking about this shortly).

The evolution of CDS (**Cad**mium **S**ulfide cell) technology gave birth to development of the spotmeter in the late 1950s and the early 1960s. <u>The first Pentax analog (spring supported needle) was introduced at 1960 Photokina and it was mass produced for public consumption in 1961. Spotmeter's invention revolutionized the concept of exposure and for the first time enabled the photographer to apply the theory of the Zone System of exposure to produce correctly exposed images of distant and scenic subjects.</u> Minolta's version, Auto spot 1 was introduced into the market in 1968. Another spotmeter that has been around for many years is made by Soligor.

My Pentax digital spotmeter's viewing angle is about 26 degrees (26°). Located in the center of this viewfinder is the 1° spotmetering circle (frame).

When using a spotmeter, please note that the 1 degree circle in the viewfinder of the spotmeter must fall within the boundaries of the simple subject that you are measuring; otherwise, your normal exposure reading will not be accurate and can not be interpreted correctly.

As I mentioned before, to illustrate the spotmeter functions, I have used my Pentax digital spotmeter. If you have a different brand of spotmeter, read your meter's manual to see how you can obtain a normal exposure reading from a simple subject. Techniques that you learn in this chapter are independent of the brand of your spotmeter. They will enable you to operate your meter skillfully to find the proper exposure for any complex subject.

The gray-making property of your spotmeter is very much like your camera. Therefore, when you obtain a normal exposure from a simple subject, this exposure will create an 18% gray image tone on the film. With the spotmeter, the normal exposure is determined by pointing it at a simple tone. The spotmeter then provides the photographer with a number that ranges from 1 to 20 (your meter's range may be different). Using the dials on your meter, this number can then be converted to a series of shutter speeds and aperture settings (Equivalent Exposures) for a given film. The unit for this readout is EV, which stands for "Exposure Value." The brighter the light, the higher is this number. We will learn more about the EV scale in the next section.

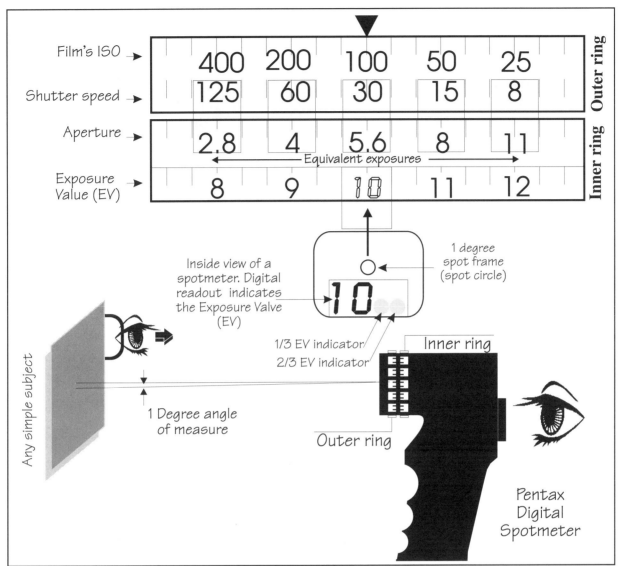

					Outer ring
Film's ISO →	400	200	100	50	25
Shutter speed →	125	60	30	15	8
Aperture →	2.8	4	5.6	8	11
Exposure Value (EV) →	8	9	10	11	12

← Equivalent exposures →

Inner ring

Inside view of a spotmeter. Digital readout indicates the Exposure Valve (EV)

1 degree spot frame (spot circle)

1/3 EV indicator
2/3 EV indicator

Inner ring

Outer ring

Any simple subject

1 Degree angle of measure

Pentax Digital Spotmeter

Diagram 4.4.1

Normal exposure determination using an off-camera spotmeter

1) Set the ISO to appropriate setting on the outer ring (in this case ISO 100).
2) Turn on the meter.
3) Point the meter at the subject so that the measuring spot circle (frame) falls within the boundaries of the simple subject. Now you can read the indicated Exposure Value (in this case *10* EVs)
4) Turn the lower (inner) ring to this value, as shown by the arrow. Remember, the top ring is fixed and points at ISO 100.
5) Read the normal exposure settings (aperture opening/shutter speed pairs) as indicated on the diagram. Equivalent exposures that produce the same "normal exposure" include: 1/125 @ f-2.8, 1/60 @ f-4 and 1/30 @ f-5.6, 1/15 @ f-8, etc.

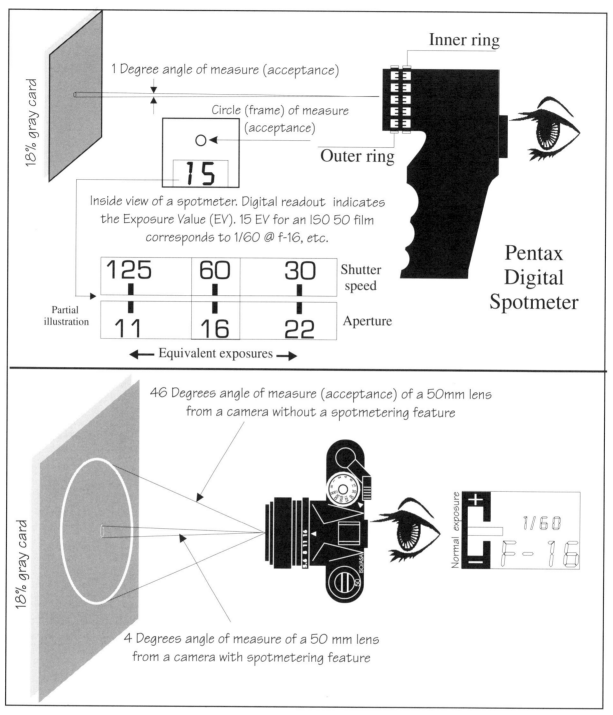

1 Degree angle of measure (acceptance)

Inner ring

18% gray card

Circle (frame) of measure (acceptance)

Outer ring

Pentax Digital Spotmeter

Inside view of a spotmeter. Digital readout indicates the Exposure Value (EV). 15 EV for an ISO 50 film corresponds to 1/60 @ f-16, etc.

125	60	30	Shutter speed
11	16	22	Aperture

Partial illustration

← Equivalent exposures →

46 Degrees angle of measure (acceptance) of a 50mm lens from a camera without a spotmetering feature

18% gray card

Normal exposure

1/60
F-16

4 Degrees angle of measure of a 50 mm lens from a camera with spotmetering feature

Diagram 4.4.2

Your camera (irrespective of its metering system), and a spotmeter will produce approximately the same normal exposure from the same SIMPLE subject. In this case, both meters produce the same exposure of 1/60 @ f-16. This is because both meters are calibrated to render an 18% gray image tone.

Like any off-camera light measuring device, when using a spotmeter in conjunction with a camera that has filters, extension tubes, or teleconverters, you must remember to compensate for the loss of light through such devices. To simplify things, in most of our examples, we will not be using these attachments. Currently there are two types of spotmeters on the market.

1) The standard (analog) spotmeters use a moving needle to show the EV number.

2) The digital spotmeters use digital readouts to show the EV number. The question is, which one of these would serve you best?

Here are the advantages of a digital spotmeter over the analog:

❏ A digital spotmeter has no moving components, it is smaller and is more resistant to impacts.

❏ A digital spotmeter can be used even in lowlight situations to find the normal exposure of a very dark subject. The digital readout from my Pentax spotmeter simply shines in the viewfinder. Under these circumstances, if you use a standard spotmeter, chances are that you will not be able to see the needle indicating the EV reading.

Here is the only advantage of the standard (analog) spotmeter:

❏ The only advantage of this meter is its price. It is usually 30 to 40% cheaper than the digital spotmeter that is produced by the same manufacturer. Spotmeters currently on the market include: Soligor, Sekonic, Gossen, Pentax, and Minolta.

4.5. What is the EV numbering system used in spotmeters?

All spotmeters use some type of EV numbering system. EV is the abbreviation for Exposure Value. The brighter the light, the higher the EV is. To understand EVs, simply relate it to the amount of money that a person has. If a person's wealth is only a few dollars, the person is considered to be poor (low-light, low EV) and if a person's wealth is measured in millions of dollars, then he or she is considered to be rich (bright surfaces, high EV).

Exposure Value (EV) as it relates to the amount of light has an exact scientific definition. We leave this definition for the scientists who created it and do not worry about it! As far as we are concerned, if we place a white piece of paper about 3 feet away from a household candle, its brightness would be about 1 EV.

Another example? Set the ISO of your camera to 800, your shutter speed to 1 sec. and the aperture to f-4 and *do not touch these settings for the next experiment*! Now get a piece of white paper and place it beside a candle or a household night lamp. Move the white paper away from the light source until your camera shows a normal exposure, i.e., the needle is in the middle with the exposure setting of 1 sec. at f-4 with the ISO of your camera set to 800. The intensity of the piece of mat board is approximately 1 EV.

If we place the same white piece of paper in the bright sunlight, its brightness reading would be about 17 EVs (equivalent to a normal exposure of 1/500 sec. @ f-16 for ISO 100 film). If you measure the EV of an 18% gray card, in the noon sun, it would be about 15 EVs (equivalent to a normal exposure of 1/125 sec. @ f-16 for ISO 100 film). As you may notice, this exposure is the same as Sunny-16 exposure for ISO 100 film.

For example, an EV of 15, for ISO 100 film will produce a series of equivalent exposures (please refer to sections 1.15 and 4.3). These include 1/250 @ f-11, 1/125 @ f-16, 1/60 @ f-22 or 1/30 @ f-32 and so on. As you notice, every one of the above settings exposes the film with the same amount of light. These equivalent exposures are considered to have the same Exposure Value. *Increasing or decreasing the light by 1 EV is identical with increasing or decreasing the light entering your camera by 1 STOP.*

For example, a surface with a brightness of 3 EVs is twice as bright as a surface with brightness of 2 EVs. The same surface is 1/2 as bright as a surface with brightness of 4 EVs (please see Diagram 4.5.0 with electric lamps). By using the sliding scale on the spotmeter, any EV reading can be converted to a series of equivalent exposures that can be set on your camera.

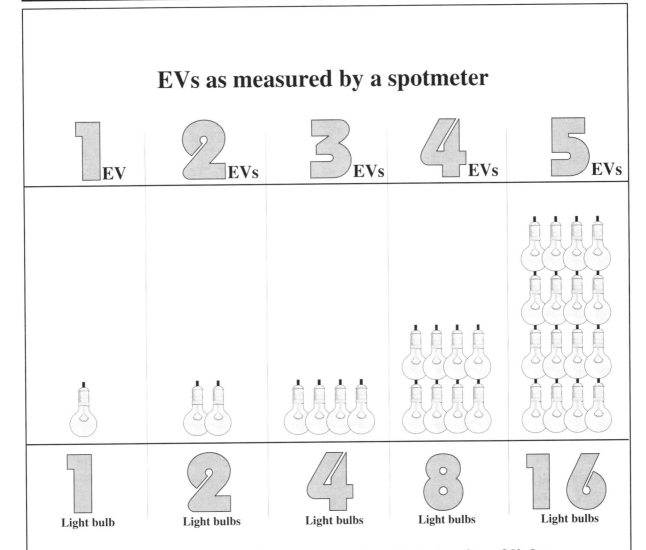

EVs as measured by a spotmeter

1 EV	2 EVs	3 EVs	4 EVs	5 EVs
1 Light bulb	2 Light bulbs	4 Light bulbs	8 Light bulbs	16 Light bulbs

Number of small light bulbs representing the intensity of light source

Diagram 4.5.0

Exposure Value (EV) Illustration

Assume a surface brightened by the first lamp results in a spotmeter reading of 1 EV. In the second column, the two bulbs brighten the surface by 2 EVs, and so on. From left to right, each column generates twice as much light as the previous one. For example, the "3 EV" column produces twice as much light as the "2 EV" column and 1/2 as much light as the "4 EV" column. As you know, the same is true for the shutter speed, aperture, and ISO scales.

As far as you are concerned, the change of 1 EV corresponds to the change of 1 STOP on the shutter speed *or* the aperture setting of your camera.

4.6. Subject Brightness Range (SBR)

Another term that needs to be understood to analyze a complex subject is the Subject Brightness Range (SBR). This subject analysis will eventually help us to find our subject's desired exposure.

Brightness range is simply the measure of the number of EVs or STOPs in a scene, including its *darkest* and *brightest* tones. If you are confused, let's try again. Measuring SBR is very much like measuring the height of a subject from the *lowest* to its *highest* point. The subject can be a ladder or a file cabinet. To measure the height of a ladder or a file cabinet in feet, we could count the number of 1 foot regions from the lowest to the highest point (please see Diagram 4.6.1). To measure the Subject Brightness Range in stops, we can use a spotmeter that has markings in EVs. As I mentioned before, *each EV can be treated as 1 stop on a camera*. Now, let's examine the snow-covered cottage that we used in the previous chapter. To refresh your memory, the darkest tone of the subject (the door) had a normal exposure of 1/125 @ f-11. The brightest tone of the subject (the snow), had a normal exposure of 1/125 @ f-22.

To measure the Subject Brightness Range (SBR) of our snow-covered cottage in the previous chapter, simply count the number of EVs from darkest to the brightest. In this case, it is 3 stops (➡f-11, ➡f-16, ➡f-22). This is the number of stops that must be recorded on film.

PLEASE NOTE: As is illustrated in the height of the ladder (Diagram 4.6.1), the spotmeter or your camera measures the regions or divisions and not the markings (remember, the number of markings is always *one* more than the number of regions.) This means each EV indicated on your spotmeter is equivalent to a "yardstick" or in this case an "EV stick" and not like the notches (markings) on your rulers or measuring tapes (Diagrams 4.6.4 and 4.6.5.) Please look at these diagrams and make sure that you understand this concept.

The range of the cottage's brightness, as was explained, is 3 stops (➡f-11, ➡f-16, ➡f-22). **Now let's use a spotmeter to find the Subject Brightness Range of the same snow-covered cottage. By pointing the spotmeter at the snow, we get an EV of 17. By pointing the spotmeter at the door, we get an EV reading of 15. Counting the EVs, provide us with an SBR of 3 (➡15, ➡16, ➡17) stops.**

The sequential EV numbering of a spotmeter makes it a very convenient tool to measure the Brightness Range of a subject. For example, if a subject has a lowlight reading of 10 EVs and a highlight reading of 16 EVs, the SBR for this subject is 7 stops (➡10, ➡11, ➡12, ➡13, ➡14, ➡15, ➡16).

In our Tone Train example, each EV (stop) is represented by one tank car. The Subject Brightness Range (SBR) will be represented by the number of tank cars of a loaded train. For example, if the SBR of a subject is 6 stops, it will have 6 loaded tank cars; if it is 3, then it will have only 3 cars. As before, the outer tone of the car will represent the tone of the subject. The Tone Train illustration will be extensively used to illustrate the relationship between a subject and its corresponding image.

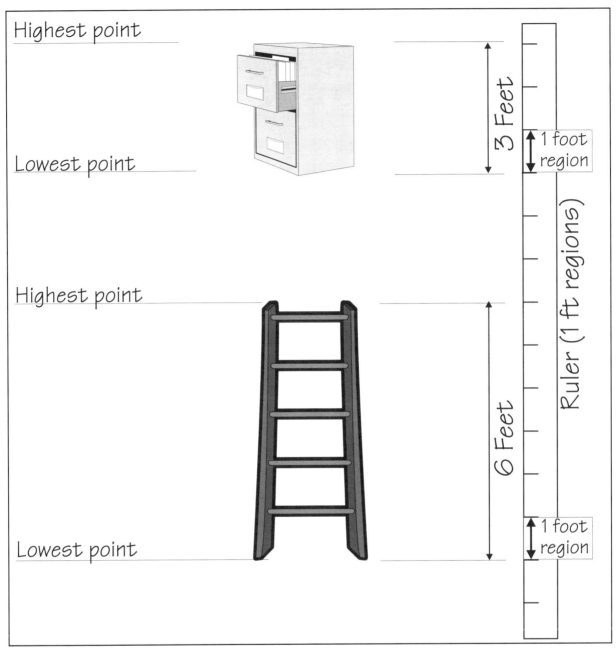

Diagram 4.6.1

Subject's height measurement illustration

Height measurement is made from the lowest point to the highest. In this illustration, the file cabinet is 3 feet high and the ladder is 6 feet high. Please remember that to find the height, you count the number of 1-foot regions between the markings.

Another important feature of this method of measurement is that the number of notches on the ruler are always one more than the height of the subject. In the case of the file cabinet, it is four (one more than three) and in the case of the ladder it is seven (one more than six).

The Five-Stop Tone-Ruler

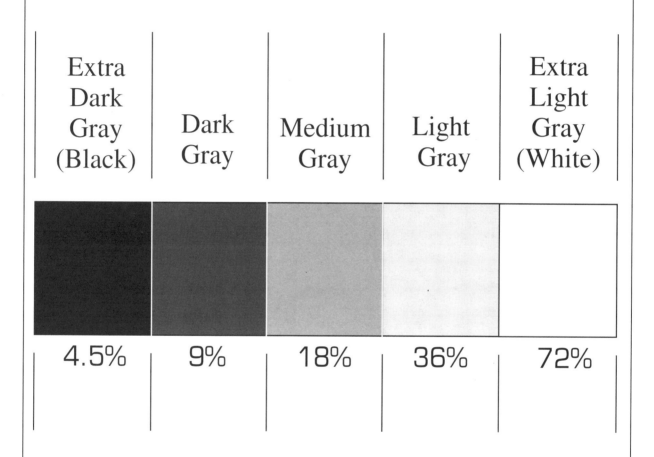

Extra Dark Gray (Black)	Dark Gray	Medium Gray	Light Gray	Extra Light Gray (White)
4.5%	9%	18%	36%	72%

Diagram 4.6.2

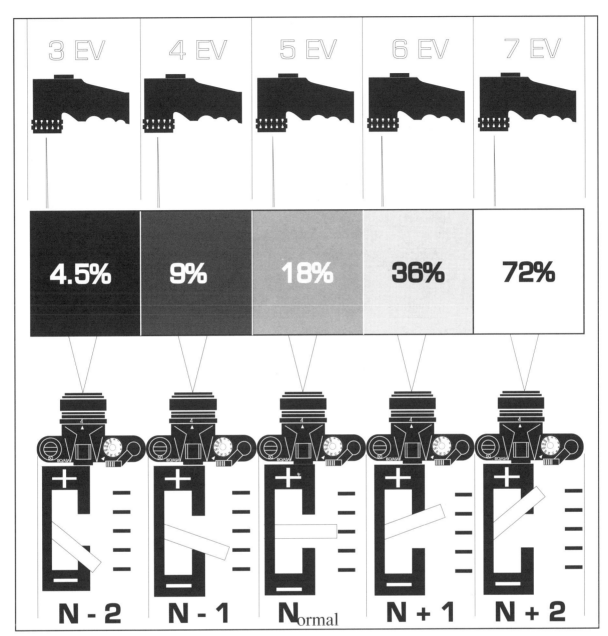

3 EV **4 EV** **5 EV** **6 EV** **7 EV**

4.5% **9%** **18%** **36%** **72%**

N - 2 **N - 1** **N**ormal **N + 1** **N + 2**

Diagram 4.6.3

Exploring the unique property of the Tone-Ruler

Find the normal exposure from the 18% gray tone using a camera or a spotmeter. Now keep these camera settings and point the lens towards the other four tones. Your camera will show an underexposure of two stops from 4.5% black and as the tones become brighter, it will show an overexposure of two stops from the 72% white. In this case, you are using your camera as a crude spotmeter. If you do not know how a spotmeter works, simply ignore the upper part of this illustration.

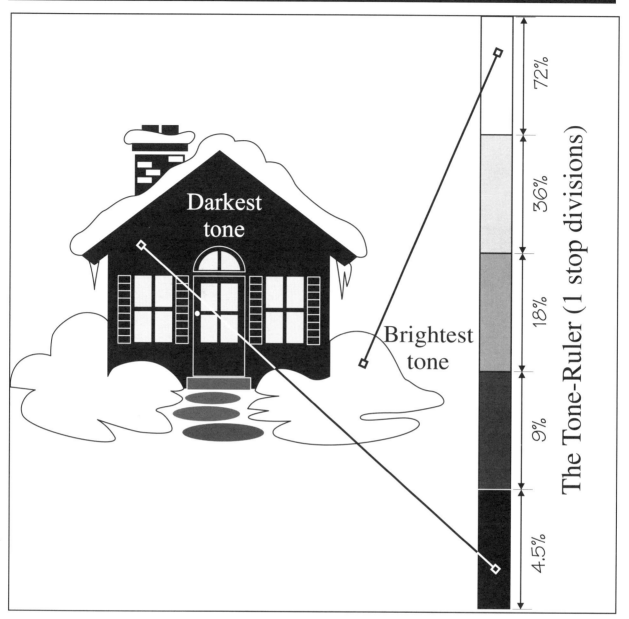

The Tone-Ruler (1 stop divisions)

72%
36%
18%
9%
4.5%

Darkest tone

Brightest tone

Diagram 4.6.4

Subject Brightness Range illustration

In Diagram 4.6.1, we used a ruler to measure the height by counting the number of 1-ft regions along the length of the subject. In this example, we simply measure the number of EVs from the darkest to brightest region.

In the same illustration, the unit of height was FEET. In this example the unit of range is EV or STOP. The SBR for this subject is 5.

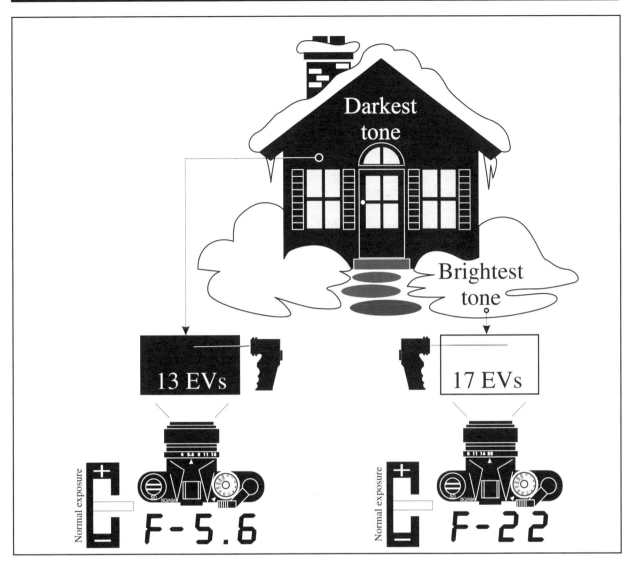

Diagram 4.6.5

Subject Brightness Range illustration

The meter indicates f-5.6 from the darkest and f-22 from the brightest part of the subject (the shutter speed is kept constant). Since the aperture sequence is 22, 16, 11, 8, and 5.6, then the SBR of this subject is 5 stops.

The same number can be obtained by counting the number of EVs on the spotmeter. EVs of 13 through 17 indicate a SBR of 5 stops (➡13, ➡14, ➡15, ➡16, ➡17). Please remember, with numbering method that is used in this book, counting all readings (including the extremes) indicated by the spotmeter will produce the SBR. If you are confused, simply think of each EV reading as a yardstick and not as a notch of a ruler. When using a yardstick, one counts the number of times that stick is placed along the subject. If this count is 5, then the length is 5 yards and if it is 1, then the length is 1 yard. The same applies to the spotmeter readings.

A summary of the spotmeter's functions:

❑ Has a narrow angle of measure with tunnel vision (well, almost) of 10 degrees or less. Most accurate off-camera spotmeters currently have a measuring angle of 1° degree.

❑ Measures the amount of reflected light from a simple subject in EVs (short for Exposure Values). An Exposure Value (EV) can always be converted to a series of f-stop and shutter speed settings that are called "equivalent exposures" on your camera. This series of settings produces the same "normal exposure" from a simple subject.

❑ An ideal instrument for the Zone System of light measurement. By measuring the EVs for the brightest and darkest part of a subject, the Subject Brightness Range can be easily determined. Subject Brightness Range or SBR is another key element in the understanding and application of the Zone System of light measurement.

4.7. What is a Film Contrast Range (FCR)?

The most important property of film that is being used in our Simplified Zone System of light measurement is the Film Contrast Range (FCR).

The FCR of a film is simply the capacity of the film to accommodate the Subject Brightness Range (SBR) of a subject. The FCR (capacity) of a film is very much like the capacity of a vehicle to accommodate passengers. For example, a bicycle can accommodate only 1 person, a sports car accommodates 2, a sedan accommodates 4, a van can accommodate 8 and so on. In Diagram 4.8.0, you can see that the normal eye has an approximate contrast range of 10 stops, black and white film has a practical range of 7 stops, and slide film and digital cameras have a range of about 5 stops. Fortunately for us, most subjects that one deals with have an SBR of 7 STOPs or less. *In this book, since our medium is slide film and slide film has an approximate contrast range of 5 stops, the SBR of a subject that can be recorded will be limited to 5 stops*. However, once you understood the logic, you will not be limited to the slide film. You can apply this technique to a variety of subjects and films with different FCRs. As in the previous illustrations, the FCR of the film will be graphically illustrated by 5 empty tank cars of a train. We will use this important notation extensively to illustrate the principle of the multi-tone metering system.

4.8. Using the Multiple Tone Metering Technique to photograph a complex subject

Now that we have learned all the basics of exposing a complex subject, let's see how we can put them to practice. The following process is based on a logical and systematic approach to this technique.

❑ When using this technique, the first thing a photographer needs to know is the Film Contrast Range (FCR). **Since we will be using slide film and the FCR for**

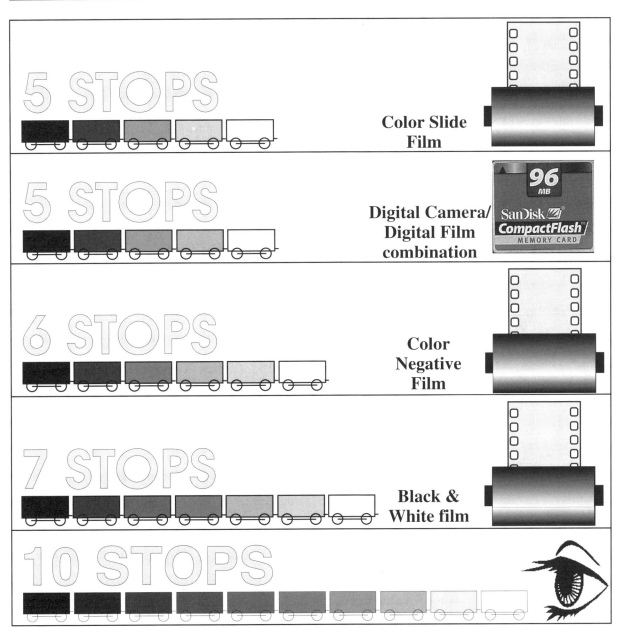

5 STOPS — Color Slide Film

5 STOPS — Digital Camera/ Digital Film combination

6 STOPS — Color Negative Film

7 STOPS — Black & White film

10 STOPS

Diagram 4.8.0

Practical Contrast Range for some popular films
(Approximate -- for illustration purposes only)

A simplified diagram showing the average contrast range for some popular films. As can be seen in this illustration, the contrast range of the eye is much greater than the contrast range of any film. In this chapter, you will learn how to best accommodate a subject's image into the appropriate film.

Please also note that with standard film, the film *senses* and *records* the image whereas with digital photography the camera *senses* the light and then *records* the digitized information on film.

this film is 5 stops, the FCR of 5 will become our base for exposure calculations.

❏ Another term that we discussed before was the **S**ubject **B**rightness **R**ange (SBR). SBR is a measure of the brightness range of a complex subject. This is very much like knowing how high your truck is before going under a low bridge. The SBR can be determined by using a spotmeter and counting the number of EVs that is indicated when pointing it toward the darkest and the brightest tones of a complex subject.

❏ **The process of fitting the SBR of a subject into the FCR of a film**. How you photograph the subject will depend very much on how you use the combination of FCR, SBR, and your judgment to produce the final image. Let's explain!

Assume we have a bus with 32 seats: If there are 32 passengers, all passengers would fit nicely into the bus. If the number of passengers exceeds 32, you (the driver) must make a decision about which passengers will be left behind. This is where your judgment comes into play.

If there are fewer than 32 passengers and these passengers must sit beside one other, you will have three seating choices. You could seat them in front, in the middle, or in the back. In the above example, the passengers represent the SBR of a subject and the bus represents the FCR of a film.

As you remember, the Tone Train approach consists of a loaded "subject" train and an empty "film" or "image" train. The number of subject tank cars in these examples represents SBR and the number of film tank cars represent the FCR of the film.

The ultimate objective is to transfer cargo from the subject train into the film train or to fit the Subject Brightness Range onto the Film Contrast Range (FCR).

We will use the Tone Train to illustrate the following three possibilities:

a) When the SBR is greater than the FCR. This is common with subjects with a long tonal range, for example, sunlit snow and dark lowlights (shadows). Different ways of capturing this subject's image will be discussed. Since this case requires new reasoning, I will explain it in detail.

b) When the SBR is the same as the FCR and both are equal to 5 stops. In this case you have one logical method of fitting the subject into the film. If you understood the reasoning behind the last chapter's example of snow-covered house with an SBR of three, you should be able to work this one out easily. You can get to the same result if you choose the darkest or the brightest tones as Reference Tone. If you choose the darkest tone, find its normal exposure and decrease this exposure (close-down) by two stops. For example if the "normal exposure" from the darkest tone is 1/60 @ f-2.8, then the correct exposure would be 1/60 @ f-5.6. If you choose the brightest tone, find its normal exposure and increase the exposure (open-up) from this setting by two stops, giving it a 72% white image tone. For example if the brightest tone has a "normal exposure" of 1/60 @ f-11, then the correct exposure would be 1/60 @ f-5.6. Please note that the final correct exposures for both cases are identical.

c) When the subject's SBR is less than the film's FCR. Here we have more than one choice of accommodating the subject tones. Since this case is also an easy one, I have deliberately omitted it from the book. If you as a reader cannot reason

it out for yourself, you need to go back through the previous chapter and review the technique that we used in the with the snow-covered house.

Please note that technically you can fit the subject in [➡4.5%➡9%➡18% zones], [➡9%➡18%➡36% zones], or [➡18%➡36%➡72% zones]. Although each one of these three exposures will produce a technically correct exposure, chances are that one will look more real than the other two.

4.9. When Subject Brightness Range (SBR) exceeds the Film Contrast Range (FCR)

Here the subject does not fit onto our slide film. Therefore an educated compromise is the best solution. For cases like this, you need to use your best judgment (logical and/or artistic) to fit the image onto the film. This is typical of sunny days when you have bright subjects such as snow or a brightly painted building (highlights), as well as deep shadows (lowlights). **This is similar to a situation where there are 7 people and only 5 bicycles. Two of the people will be left out.**

Assume that the spotmeter reading shows an EV of 18 from the brightest area and an EV of 12 from the darkest area (➡18, ➡17, ➡16, ➡15, ➡14, ➡13, ➡12), an **SBR of 7 stops. Keeping the shutter speed constant at 1/125 sec., your camera could show a normal exposure of f-32 from the whitest and an aperture of f-4 from the darkest (➡f-32, ➡f-22, ➡f-16, ➡f-11, ➡f-8, ➡f-5.6, ➡f-4) areas of the scene. Outcomes can be different if different Reference Tones are used.**

If one chooses the *highlights as the Reference Tone*, darker areas of the subject will be blacked-out. *If one chooses the lowlights as the Reference Tone*, the highlights will be overexposed and will be washed-out. *If the medium tones are favored and are chosen as the Reference Tone*, the highlights as well as lowlights will be compromised. For a better understanding of this method, please carefully follow the Tone Train illustrations.

With the Tone Train example, the loaded train has 7 cars. As you can see, there are many ways that the subject train can park alongside the empty film (image) train for a partial cargo transfer. We will examine three of these.

PLEASE NOTE: When reading this section and studying its illustrations, you will see reflectivities that are referred to as 1.12%, 2.25%, 144% or 288%. These reflectivities simply are extensions of our 5-stop Zone System and are obtained by multiplying 72% by 2 and dividing 4.5 by 2 and so on.

1.12%	2.25%	4.5%	9%	18%	36%	72%	144%	288%

If reflectivities of 144% and 288% do not make sense to you, remember that 144% reflects twice as much light as a 72% (or eight times as much as the 18% gray tone) surface and so on. *For our purposes, any reflectivity that is greater than 100 is simply an index and it does not represent the actual reflectivity of a subject*. For further explanation of this please see section 4.10.

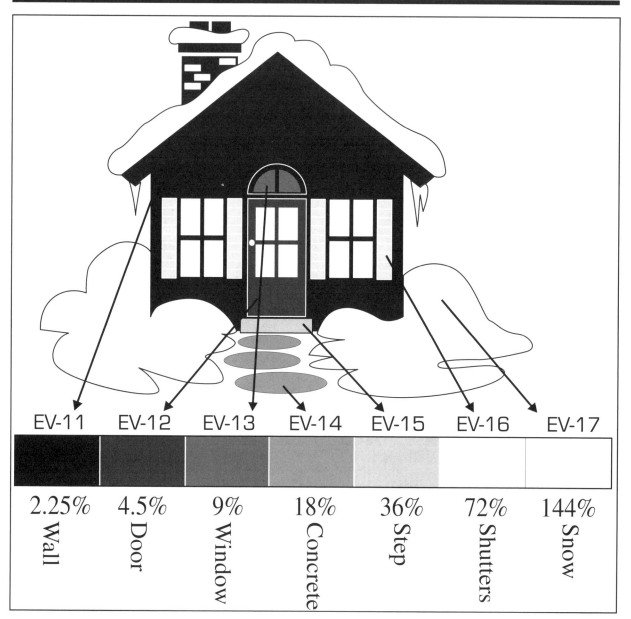

EV-11	EV-12	EV-13	EV-14	EV-15	EV-16	EV-17
2.25%	4.5%	9%	18%	36%	72%	144%
Wall	Door	Window	Concrete	Step	Shutters	Snow

Diagram 4.9.0

When Subject Brightness Range (SBR) is greater than the Film Contrast Range (FCR). In this case the SBR is 7 and the FCR (as always in this book) is 5.

AN EXTREMELY IMPORTANT NOTE: Reflectivity of 144% means that the surface is 8 times (3 STOPs/EVs) more reflective than the 18% gray. For example, if the EV of the snow is 17, then the EV of what we chose to be gray is 14. In this book, any surface whose reflectivity is indicated to be more than 100%, is simply more than 2.5 stops (EVs) brighter than the middle gray tone of that subject. In all of these cases, the reflectivity becomes a reference number (index) and is relative to the amount of light reflected from the surface of an 18% gray card and not the actual reflectivity of the subject. *If the SBR of more than 7 confuses you, please ignore this example. Chances of you coming across a situation like this is rare.*

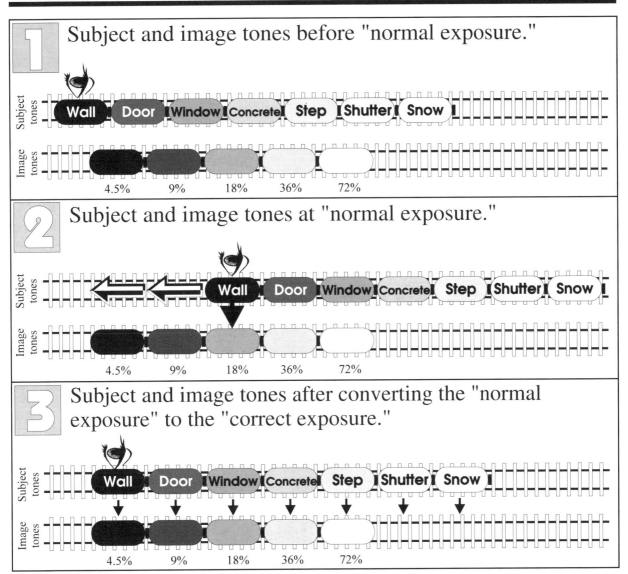

1 Subject and image tones before "normal exposure."

Subject tones: Wall | Door | Window | Concrete | Step | Shutter | Snow

Image tones: 4.5% | 9% | 18% | 36% | 72%

2 Subject and image tones at "normal exposure."

Subject tones: Wall | Door | Window | Concrete | Step | Shutter | Snow

Image tones: 4.5% | 9% | 18% | 36% | 72%

3 Subject and image tones after converting the "normal exposure" to the "correct exposure."

Subject tones: Wall | Door | Window | Concrete | Step | Shutter | Snow

Image tones: 4.5% | 9% | 18% | 36% | 72%

Diagram 4.9.1

Option 1: Choosing the black wall as the Reference Tone when the SBR = 7 and the FCR = 5.

When lowlights (dark or shaded areas) are important, simply measure the normal exposure from the darkest tone. This aligns the black wall with the 18% gray image tone. Now close-down (move train to the left) by 2 stops to place the wall at the 4.5% image tone. In this case, the two brightest tones (the shutters and the snow) will be placed outside our scale at the 144% and 288% image tones and will be overexposed.

Detailed example: Assume that the normal exposure reading indicates f-4 @ 1/125 sec. from the darkest part of the subject (wall). This exposure will generate an 18% image tone from the wall. To make this image tone 4.5% black, we need to close-down from our "normal exposure" by 2 stops, i.e., change the aperture from f-4 to f-8. The correct exposure would be f-8 @ 1/125 sec.

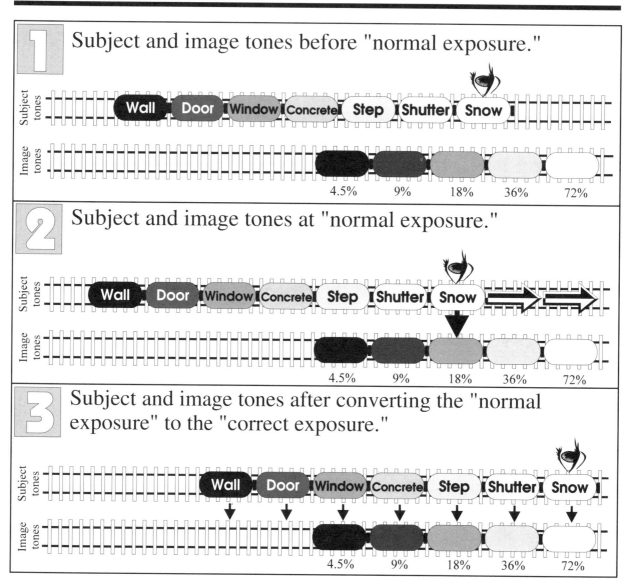

Diagram 4.9.2

Option 2: Choosing snow as the Reference Tone when the SBR = 7 and the FCR = 5.

When highlights (bright areas) are important, simply measure the normal exposure from the brightest area. This aligns the bright and sunlit snow with the 18% gray image tone. Now open-up 2 stops to place the snow at the 72% image tone. In this case, the two darkest tones (the door and the wall) will be placed outside our scale, at the 2.25% and 1.1% image tones and will be black with no detail.

Detailed example: Assume that the normal exposure reading indicates f-32 @ 1/125 sec. from the brightest part of the subject (snow). This exposure will generate an 18% image tone from snow. To make this image tone 72% white, we need to open-up from our "normal exposure" by 2 stops, i.e., open-up from f-32 to f-16. The correct exposure would be f-16 @ 1/125 sec.

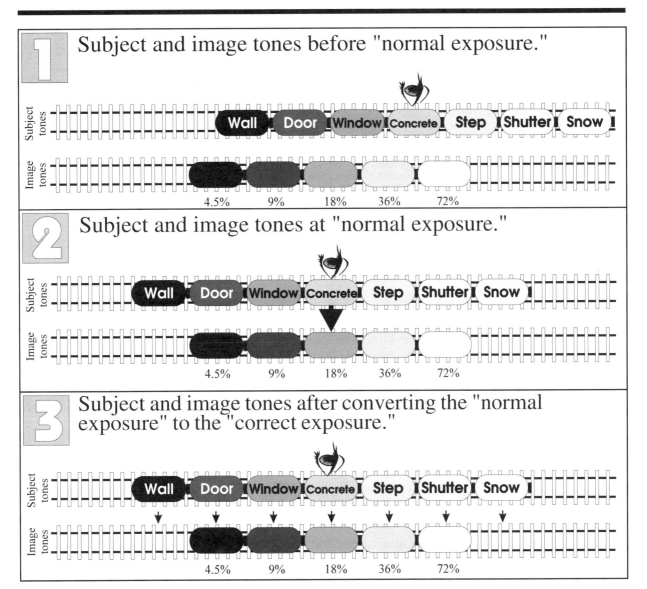

1 Subject and image tones before "normal exposure."

Subject tones: Wall · Door · Window · Concrete · Step · Shutter · Snow

Image tones: 4.5% 9% 18% 36% 72%

2 Subject and image tones at "normal exposure."

Subject tones: Wall · Door · Window · Concrete · Step · Shutter · Snow

Image tones: 4.5% 9% 18% 36% 72%

3 Subject and image tones after converting the "normal exposure" to the "correct exposure."

Subject tones: Wall · Door · Window · Concrete · Step · Shutter · Snow

Image tones: 4.5% 9% 18% 36% 72%

Diagram 4.9.3

Option 3: Choosing concrete as the Reference Tone when the SBR = 7 and the FCR = 5.

When medium tones are important, simply measure the normal exposure from the average or medium toned subject (concrete). This aligns the medium-toned surface (concrete) with the 18% gray image tone. Since in this case, normal exposure and the correct exposures are identical, leave the dials as they are and shoot the subject.

Detailed example: Assume that the normal exposure reading indicates f-11 @ 1/125 sec. from the medium gray part of the subject (concrete). This exposure will generate an 18% image tone from this surface. Since in this case the "normal exposure" and "correct exposure" are identical, we leave the dials as they are, i.e., at f-11 @ 1/125 sec. and shoot. In this case, the wall will have a black image tone with no detail and snow will have a white and washed-out image tone.

4.10. Let's expand our number of Standard Tones (Zones) to seven

So far in this book (except in section 4.9.0), we have covered 5 zones. If you refer to Chapter 2, you will remember that 4 of these zones (4.5%, 9%, 36% and 72%) were obtained by dividing and multiplying 18 by 2. **As it was mentioned before, theoretically we can divide and multiply forever and get as many zones as we wish. Of course due to the limited number of zones that can be recorded on any film, we can only make use of a few of them.** Although we will still be using these 5 image tones for the rest of the book, to illustrate the subject detail, we need to add a zone to each side of our 5-stop Tone-Ruler. These two new tones are obtained by dividing 4.5% by 2 (2.25%) and multiplying 72% by 2 (144%). Our expanded zones are illustrated in the following table. Please note that the 18% gray tone is still in the middle of this table.

2.25%	4.5%	9%	18%	36%	72%	144%

The 2.25% in the lower end of scale represents a surface that is half as reflective as the 4.5% zone (black velvet is approximately 1% reflective.) As you can see, the next standard tone after 72% white is 144% white. To the logical person, this reflectivity may not make much sense since it reflects more light than it takes in. In our application, all this number means is that surface reflects twice as much light as the 72% white tone, four times as much light as the 36% tone and eight times as much as the 18% gray card that is placed in a scene with a long tonal range. *As far as we are concerned, any reflectivity greater than 100% becomes a reference number or an index.*

If you are still shaking your head and you don't believe me, try the following experiment:

Use two sheets of white paper. Place the first sheet in a well-lit place (under a lamp) and the other a few feet away in a darker spot.

Assume that the *normal exposure* of the brighter sheet of paper is 1/60 @ f-5.6, and the darker sheet is 1/60 @ f-4 (a difference of one stop). What these readings indicate is that the first surface is simply twice as bright as the second. *Since both papers are white, and we would like them to be in the same photograph, if we assign a 72% white tone to the darker paper (i.e., open-up two stops from the "normal," 18% gray reading of 1/60 @ f-4), the image tone of the brighter paper will simply be placed at 144% zone. This is because this surface is twice as bright as the other.*

4.11. Image detail

If you have read books on the subject of photography, perhaps you have heard of terms such as "detail in the highlights" or "shadow detail." Detail is an important element of any photograph and helps to make the image look more real and three dimensional. Subjects without detail look washed out (very white) or blacked out (very dark). Therefore, a photographer not only needs to expose a subject properly, he or she also needs to know how to control the amount of detail for very bright or very dark (extreme) tones. The following is an explanation of how detail comes into play in our Simplified Zone System.

The image of a 2.25% black surface retains a minimal or no detail and will be blacked out.

The image of a 4.5% black surface retains marginal detail.

The image of a 9% dark gray surface retains good to moderate detail.

The image of an 18% medium gray surface retains the ideal detail.

The image of a 36% light gray surface retains good to moderate detail.

The image of a 72% white surface retains marginal to poor detail.

The image of a 144% ultra white surface retains a poor detail and will be washed out.

As can be seen from the above table and illustrations that follow, *Tone* and *Detail* generally oppose one another. For this reason, as we will shortly see, a photographer must compromise between a subject's tone and its desired detail.

DIGITAL FOOTNOTE:

Digital cameras (films) closely follow the Tone/Detail characteristics of slide films.

4.12. The black floor mat — tone versus detail.

To illustrate tone versus detail, I went to a department store and bought one black and one white floor mat.

I then photographed the black mat at different exposures.

I used a copy stand, two tungsten lights and a Kodak, ISO 64 Ektachrome Tungsten film. **The first thing I did was to find the normal exposure for this subject. As you remember, at this exposure, the image tone of the black floor mat would look approximately 18% gray.**

Now by closing down the aperture from this exposure by three stops, the floor mat will be placed at 2.25% image tone. This number (2.25%) was obtained by dividing 18 by 2 three times (➡9%, ➡4.5%, ➡ 2.25%). For the next series of exposures, this will be our starting point. To analyze image tone versus detail, we will be **brightening** the image from this setting by 1 stop each time and observe the results.

❏ *If we place the image tone at 2.25% super black, we will have almost no detail in the image*. This means that no texture will appear on the slide. For all practical purposes the image will be black.

❏ *If the aperture is opened-up by one stop from the previous setting, the image tone will be placed at 4.5% black.* Here we will see a marginal detail on the final slide film. Due to reproduction limitations in this book, chances are that you could not differentiate between 2.25% and 4.5% images.

❏ *By opening-up the aperture from the previous setting by one stop, we get the image tone of the floor mat at 9% dark gray.* Here we will have a good to moderate detail in the image.

❏ *If the aperture is opened-up by another stop, the floor mat's image tone will be placed at 18% medium gray.* At this point, your image will have the ideal detail. As you remember, this exposure was our normal exposure and our original starting point.

❏ *By opening the aperture up by 1 more stop, the image tone will be at 36% light gray.* At this stage we have a good to moderate image detail.

❏ *When the aperture is opened-up by one stop from this point, the image will be placed at 72% white.* At this tone, we will have a marginal to poor detail.

❏ *If the aperture is opened-up by another stop, placing the image tone at 144% super white,* At this image tone we will have a clear and washed-out image.

If you follow the logic, chances are that we had the best detail when the image was somewhere around the 18% gray. The problem is that the floor mat looks gray and the black tone is missing. At 4.5% we got the correct tone, but the details are missing or are not strong. As an old Persian proverb says **"You can't have it all!"** What are we supposed to do? Well, perhaps compromise is one of the alternatives. If you are not sure, try the surface of your interest and photograph it with different exposures. Once you find the exposure that produces

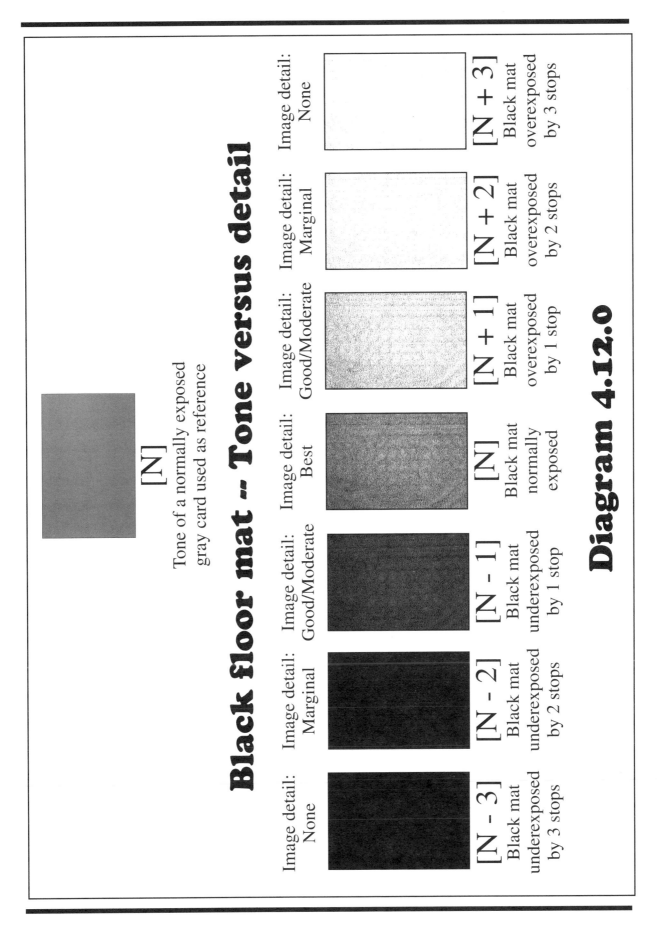

[N]
Tone of a normally exposed
gray card used as reference

Black floor mat -- Tone versus detail

Image detail: None	Image detail: Marginal	Image detail: Good/Moderate	Image detail: Best	Image detail: Good/Moderate	Image detail: Marginal	Image detail: None
[N + 3] Black mat overexposed by 3 stops	[N + 2] Black mat overexposed by 2 stops	[N + 1] Black mat overexposed by 1 stop	[N] Black mat normally exposed	[N - 1] Black mat underexposed by 1 stop	[N - 2] Black mat underexposed by 2 stops	[N - 3] Black mat underexposed by 3 stops

Diagram 4.12.0

4.13. The white floor mat — tone versus detail

In this example, I'll be photographing the white floor mat at different exposures. I used a copy stand, two tungsten lights and Kodak, ISO 64 Ektachrome Tungsten film. **The first thing I did, was to find the normal exposure for the white mat. As you remember, at this exposure, the image tone of the white floor mat will look approximately 18% gray.**

Now by opening-up the aperture from this exposure by three stops, the image of the floor mat will be placed at the 144% image tone. 144% was obtained by multiplying 18 by 2 three times (➡36%, ➡72%, ➡144%). For the next series of exposures, this will be our starting point. To analyze image tone versus detail, we will be **darkening** the image from this setting by 1 stop each time and observe the results.

❑ *At 144% super white image tone, the image detail will be non-existent or at best minimal.* At this image tone we will have a clear and washed-out image.

❑ *If we close down by 1 stop from the 144% setting, the white floor mat will be placed at the 72% white tone.* With this image tone, we will have a marginal to poor image detail.

❑ *By closing down the aperture by 1 more stop from the previous setting, we will be at the 36% light gray image tone.* Here, our image tone will be a little gray with a good to moderate detail. This is the point where we start to lose detail to whiteness.

❑ *If we close down the aperture one more stop from the previous setting, we will be at the 18% medium gray image tone.* Here, the image has the ideal detail. If one places the snow in this zone, although one gets a great detail, the snow would look dull and medium gray.

❑ *Closing down by 1 more stop from the previous setting, our image will be placed at the 9% dark gray tone.* At this tone, we will have a good to moderate detail since we start losing detail to darkness.

❑ *If we close down the aperture from the previous setting by 1 more stop, the image tone is at 4.5% black* and for all practical purposes will be black with a marginal detail.

❑ *Closing down another stop, we are at the 2.25% super black image tone.* Here, we will lose all detail and the subject will be totally black. In this book, due to mechanical reproduction limitations, the 2.25% and 4.5% image tones may look totally black and indistinguishable from one another.

As in the black floor mat, compromise is the best solution. If you are not sure where you would like to place your white tones, simply experiment with different exposures and take notes until you get the image that pleases you the most. Once you find the exposure that produces your favorite tone/detail combination, write it down and use it for future assignments.

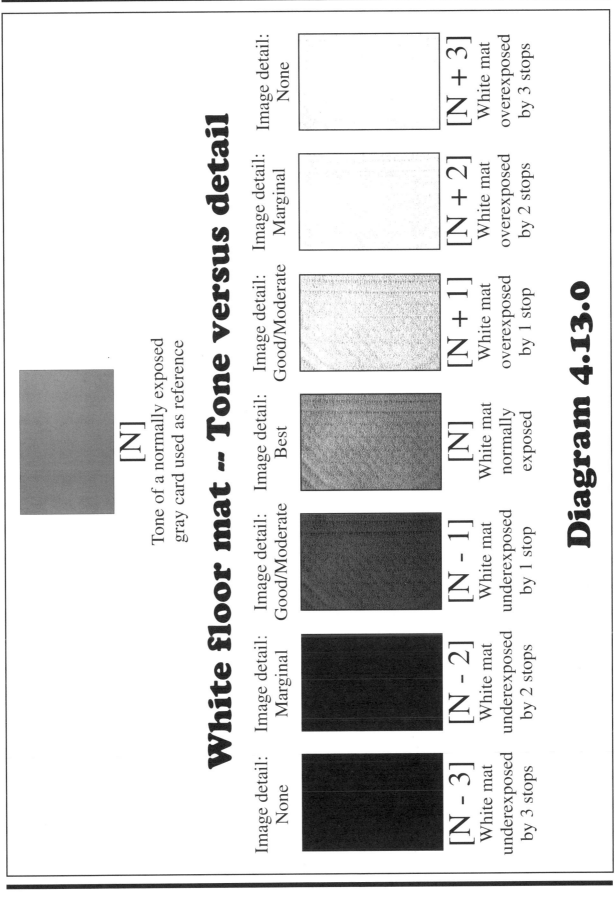

White floor mat -- Tone versus detail

[N]
Tone of a normally exposed
gray card used as reference

Image detail: None	Image detail: Marginal	Image detail: Good/Moderate	Image detail: Best	Image detail: Good/Moderate	Image detail: Marginal	Image detail: None
[N - 3] White mat underexposed by 3 stops	[N - 2] White mat underexposed by 2 stops	[N - 1] White mat underexposed by 1 stop	[N] White mat normally exposed	[N + 1] White mat overexposed by 1 stop	[N + 2] White mat overexposed by 2 stops	[N + 3] White mat overexposed by 3 stops

Diagram 4.13.0

GALLERY

Alternative Light Measurement Techniques and Related Examples

What will you learn in this chapter?
 This chapter covers various related topics that include incident light measurement techniques, exposure without an exposure meter and many examples of standard and non-standard exposure situations such as portraits, fireworks and moonlit scenes.

Please Note: This chapter covers other types of exposure with or without a meter.
Reading of this chapter is highly recommended to the interested photographer.

5.1. Other light measurement techniques with or without a meter

In this chapter, we will learn other methods of exposure determination. These include:

1) Incident light measurement techniques

2) Exposure determination by substitution

3) Exposing without a meter

4) Exploring the exposure for some hard-to-expose subjects

5.2. What is incident metering?

Before we get into the details of incident light measurement, let's review what we mean by the term "incident light." Please refer to section 1.4 (chapter 1) and Illustration 1.4.0.

To measure the incident light, the incident light meter must be placed in the path of light *before* the light *strikes the subject*. Unlike the reflective light measurement where your meter faces the subject, with incident light measurement, your meter's light measuring diffuser (generally a round white plastic semi-sphere) faces the source of light. In the reflective light metering technique, the reading of the meter was directly proportional to the reflectivity of a surface, that is, the brighter the tone, the higher the exposure value reading. In the incident light measurement. *Since the diffuser never faces the subject, the reading of the meter will always be independent of the tone of the subject* (please see Illustration 5.2.0). As you can see, when you take a picture of a white, gray, or black mat board under the same lighting conditions, the exposure indicated by the incident meter will be the same for all three cases.

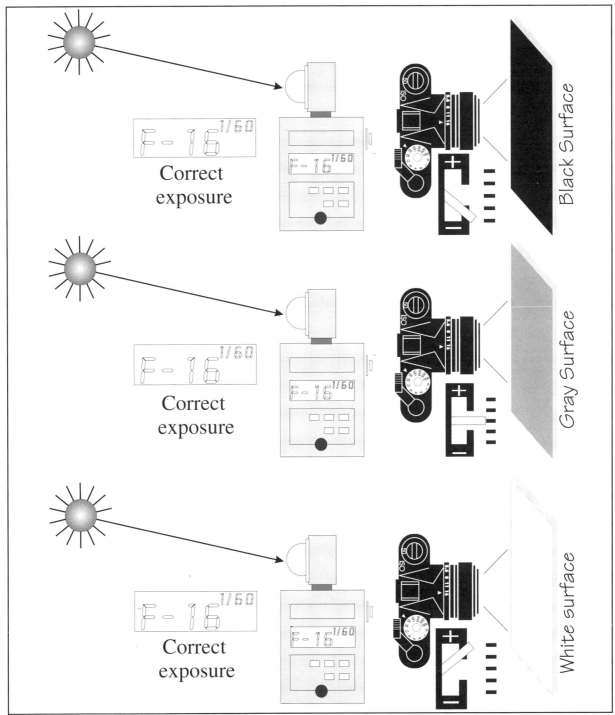

Correct
exposure

Black Surface

Correct
exposure

Gray Surface

Correct
exposure

White surface

Diagram 5.2.0

Illustrating the application of an incident meter. As you see, the white bubble faces the sun (in the opposite direction of the camera) and the back of the meter is towards the subject. As you can also observe, the meter's readings are identical since the intensity of the incident light is the same and is not influenced by the reflectivity of the subject.

5.3. What is an incident lightmeter?

The incident light meter is an off-camera exposure meter, capable of measuring incident light. The meter illustrated in Diagram 5.3.0 is modeled after a Minolta exposure meter. If you have a different meter, don't worry; the meters' functions are similar. Just make sure you read your meter's manual thoroughly and learn how to operate it. Incident meters, have many kinds of attachments (exposure heads). We will only discuss two that are most commonly used.

1) The **reflective metering attachment** is a round plastic with a circular opening. By using this type of head, the exposure meter works very much like your camera. All readings from this combination are subject to interpretation, very much like the camera and a spotmeter. This type of head usually has an angle of view of 40-50 degrees, very much like the 50mm normal lens on your camera.

2) The most popular type of **incident light metering attachment** is what is called a **"spherical diffuser."** If you own one of these attachments, chances are that you keep it on the meter all the time! (that is what I do!) This spherical diffuser collects the incident light from all directions (180 degrees) and will give you the correct exposure settings for the subject. With this kind of meter, the photographer does very little thinking and the meter gives you the most accurate reading that one can wish for.

An exposure meter is generally made-up of the following components:

1) The meter itself

2) The meter head attachment

3) The measuring button

4) The ISO/ASA film speed setting

5) The exposure time (shutter speed) and aperture (F-stop) window.

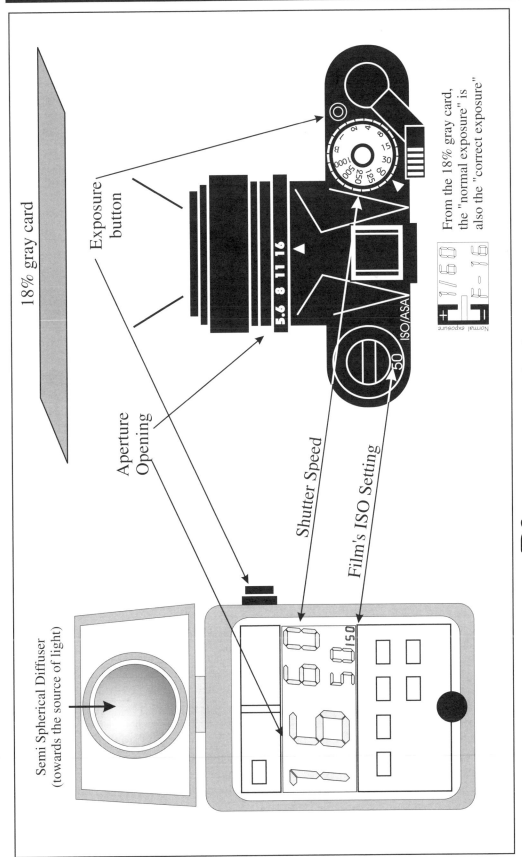

18% gray card

Exposure button

Aperture Opening

Shutter Speed

Film's ISO Setting

ISO/ASA

5.6 8 11 16

Semi Spherical Diffuser
(towards the source of light)

From the 18% gray card, the "normal exposure" is also the "correct exposure"

Normal exposure

Diagram 5.3.0

Illustrating a typical incident meter with the semi spherical diffuser attachment. Very much like your camera, it has dials for shutter speed, aperture openings and the film speed (ISO). Under the same lighting conditions, an incident meter's exposure readings always approximate your camera's readings from a normally exposed 18% gray card (correct exposure). The only difference is that the incident meter will always face the source of light rather than the subject.

5.4. How to operate an incident lightmeter

The first thing you need to do is to set the ISO/ASA of the meter to the film's speed. Once this is set, you must choose a starting shutter speed. If you have no idea where to start, for outdoor shots set your shutter speed to a number that is close to your ISO/ASA of the film. For example, if you are using an ISO 64 film use the shutter speed of 1/60 second. If you are using ISO 400 film and your camera is old, then use the standard shutter speed of 1/500 second. With some newer cameras you can use a shutter speed of 1/360th of a second). Once you've done this, place the meter in the path of light as shown in the diagram, with the white bubble facing the source of light, with its back toward the subject and then press the button.

This type of meter, very much like a spotmeter, works with Exposure Values (EVs) and provides the photographer with a range of equivalent exposures to choose from. For example, for a sunny subject the exposure could be 1/60 @ f-16, 1/125 @ f-11, 1/250 @ f-8, 1/500 @ f-5.6, 1/1000 @ f-4, and so on. As you know, each of these combinations produces the same exposure on the film.

If you wonder which one of these exposures is made for you, the following is a quick review.

The rule is that if your subject is moving fast, or if you are interested in shallow depth-of-field, you use the combinations that use shutter speeds like 1/250, 1/500, or 1/1000 second. If you are interested in maximizing the depth-of-field and you are photographing a subject that does not move, then you need to use the combination that uses the smaller apertures such as f-16 or f-22.

Choosing the right aperture and shutter speed combination is very much like going to a food store and choosing a TV dinner. Assuming that all of them cost the same, you will choose the one that has a combination that you like best.

A special note: The aperture opening (f-stop) reading that is displayed by the incident meter is not always a whole f-number, i.e., f-16, f-11, f-8 or f-5.6. The decimal point to the right hand side of the f-stop indicates the aperture in 1/10 stop divisions. For example an aperture setting of f-8.**5** is 1/2 stop between 8 and 11 and an aperture setting of 5.6.**8** is **8/10** (or **.8**) of a stop smaller than f-5.6 or 2/10 (or .2) of a stop larger than f-8. In this book, to simplify things, we will ignore the decimal point. For practical purposes, to transfer this reading to the lens, the photographer must round it up or down to the nearest 1/2 stop or in the case of more expensive/advanced/professional or digital cameras to its nearest 1/3 stop.

For example the aperture setting of f-8.8 on most cameras can be rounded up to f-11, the aperture setting of f-8.6 can be rounded down to f-8.5 (1/2 click away from f-8) and the aperture setting of f-8.2 can be rounded down to f-8. If you ask why the manufacturer comes up with 1/10 stop divisions when the best you can do is 1/2 stop or 1/3 stop adjustments on your camera, you must realize that transferring these settings to the camera is not the only function of this reading. These meters can be used in the darkroom under the enlarger to reproduce an exact density on paper or for comparative analysis. Finally, when copying large art work, you can obtain readings from each corner and the center of the art work to ensure the uniformity of light falling on the subject.

An incident meter was used to determine the correct exposure for this image. A gray card or an incident meter is also a great tool for photographing these kinds of subjects. I used a Pentax *ist-D Digital camera with a Tiffen Pro-Mist #1/2 to capture this image .
It was shot at 1/30@ f-5.6@ISO200. In this picture a Minolta Exposure Meter was used with its diffuser (white bubble) facing towards the diffused window light to determine the correct exposure for the subject.

Image for section 5.4.0

Minolta exposure meter with its reflected light metering attachment (a plastic attachment with a small round opening)

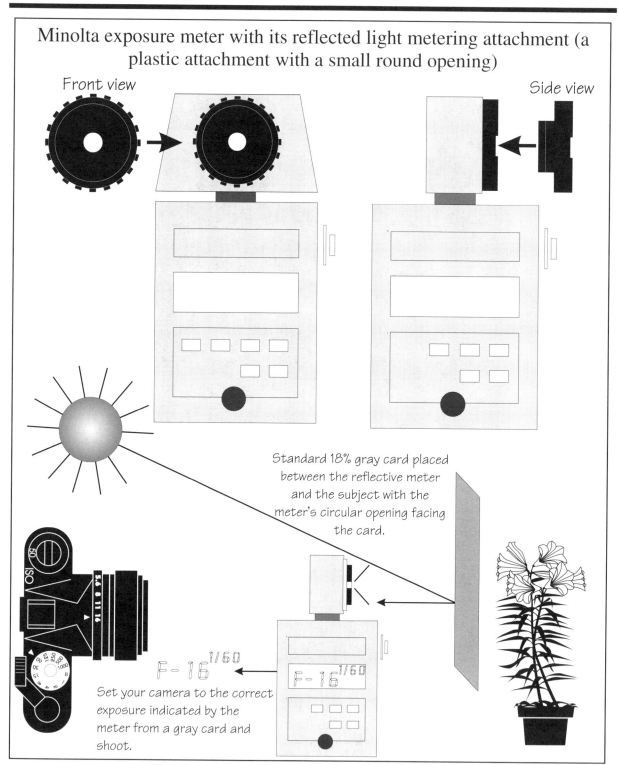

Front view

Side view

Standard 18% gray card placed between the reflective meter and the subject with the meter's circular opening facing the card.

F - 16 1/60

F - 16 1/60

Set your camera to the correct exposure indicated by the meter from a gray card and shoot.

Diagram 5.4.1

An exposure meter with a reflective attachment (black round plastic with a circular opening).

Minolta exposure meter with its Incident light metering attachment
(semi spherical diffuser)

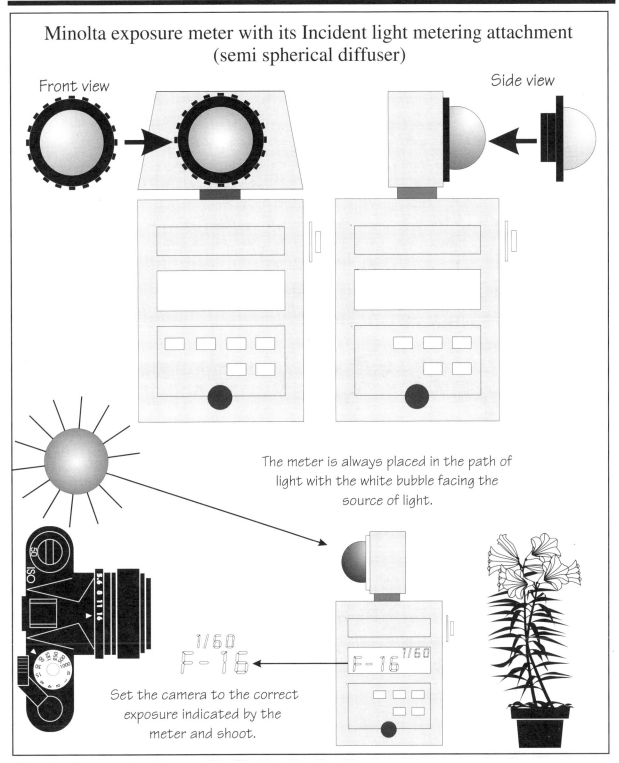

Front view

Side view

The meter is always placed in the path of light with the white bubble facing the source of light.

Set the camera to the correct exposure indicated by the meter and shoot.

1/60
F - 16

F - 16 1/60

Diagram 5.4.2

Diagram illustrating an off-camera exposure meter with an incident meter attachment (a white semi sphere). This "white bubble" must always face the source of light.

5.5. What are the advantages of incident metering over reflective metering?

Incident metering has a few distinct advantages over reflective metering. These are:

❏ Convenience is perhaps the greatest feature of this type of metering

❏ **Incident metering consistently suggests the correct (proper) exposure for a majority of subjects. Consistency means that readings provided by this metering system are reliable and can be trusted.**

❏ **It is simple to use. Therefore is a great tool for the novice or the unskilled photographer who knows very little about light measurement.**

❏ **The incident meter's readings do not need to be interpreted.**

❏ **It is a great tool for general photography and outdoor scenes. It works well with subjects having a range of 4.5% black to 72% white. It is also ideal for normal copy work.**

5.6. What are the disadvantages of incident metering?

❏ The major drawback of an incident meter is that you (and the meter) must be under the same lighting conditions as your subject. For example, you cannot sit in your room and find the exposure of a blossom covered tree that you see out of your window, nor can you photograph a colorful sunset.

❏ It costs extra money to buy one.

❏ It cannot be effectively used to control and manipulate image detail.

❏ It is not useful for photographing extremely high-key (bright) and low-key (dark) subjects and scenes.

❏ It takes time to transfer the readings to your camera. Sometimes, even one second is a precious commodity that one can not afford.

❏ It does *not* easily lend itself to close-up (macro) photography.

❏ Another item to carry and keep track of.

GALLERY

5.7. What do incident and reflective meters have in common?

The common ground between these two meters is the 18% medium gray card.

Assume that you measure a gray card using a *camera*. You could also measure the exposure of the same gray card using a *spotmeter*. Finally, you could use an *incident meter* to determine the gray card's exposure.

If your metering is correct, all three will show *approximately* the same exposure. Unfortunately, due to the lack of strict standardization, and the way the spherical diffuser collects light, sometimes discrepancies of up to 1/2 stop can exist between these two methods of light measurement.

Generally, different incident meters show a slight overexposure. For example, if a reflective meter shows an exposure of 1/60 @ f-11 **from a gray card**, an incident meter **could** show an exposure of 1/60 @ f-8.5 (equivalent of 60@9.7 on your camera), where .5 indicates 1/2 stop between f-8 and f-11. As far as you are concerned, you can ignore this small discrepancy. For the sake of simplicity, in this book, I have assumed that both meters under these circumstances will indicate approximately the same exposure settings.

5.8. Filters and off-camera meters

Filters are transparent disks that, when attached to the front of the lens, alter the characteristics of light. Since this is a light measurement book, I will review only a few of them. There are many good books on the subject of filters and filtration.

FILTER FACTOR: This number signifies the amount of light in *stops* that is lost when the light passes through a filter. On some filters you might see this number printed on the side of the metal ring. Generally the darker the filter, the higher the filter factor. This factor is also zero or negligible for filters such as SKY 1A, Haze, and Ultra Violet. When you are using the meter in your SLR camera to determine the subject's exposure, you do not have to worry about this factor. In most cases, the built-in meter will take care of it automatically. *Filter factors are necessary when you are using an off-camera meter to determine the subject's exposure. In this case you **must** increase the exposure by opening-up the aperture (or using slower shutter speeds/longer exposure times) to correctly expose your pictures.* Some filters have filter factors that have a fraction of a stop, such as 1/3, 2/3 or 1-1/3. If there are no 1/3 stop divisions on your camera's shutter speeds (exposure times), you may have to guess the 1/3 stop on your lens. To simplify things, the filter factor for each of the following examples was chosen to be 2.

Example 1: We have daylight film in the camera and we want to take a picture of a subject that is illuminated by 3200K tungsten lights. The filter to use is 80A and its filter factor is 2. Assume the camera's meter (with the filter attached) indicates an exposure of 1/30 sec. @ f-4 from a gray card. In this case, the camera's meter automatically takes care of the filter factor and the photographer does not need to worry about it. When using an off-camera incident meter, its reading could be 1/30 @ f-8. In this case we must increase the exposure by 2 stops and transfer them to the camera before we can take the picture. Increasing exposure by 2 stops

means changing the camera setting from 1/30 @ f-8 to 1/30 @ f-4, or an equivalent exposure.

Example 2: In order to get saturated colors and reduce glare, you are using a Polarizer filter with a filter Factor of 2. Assume your off-camera meter indicates a correct (gray card) exposure of 1/60 sec. @ f-16 for ISO 64 film. Before transferring these settings to your camera, you need to increase exposure by two stops to compensate for the light loss through this filter. In this case, the final exposure could be 1/60 @ f-8, 1/15 @ f-16, or 1/30 @ f-11. All of these exposures let in two stops more light than was indicated by the off-camera meter.

I deliberately choose the Polarizer filter since many camera's metering systems could fail when used with the standard linear (cheap, $20) polarizing filters. If you do not have an off camera exposure meter, when using this filter, use your camera to determine the exposure *without* a filter. Then attach the filter and increase the exposure by the filter factor, in our case 2 stops.

Filter Tip: When using a filter for an extended period of time, you can adjust the ISO for your *off-camera* meter so that it would give you direct readings that includes the filter factor. In the above example, decrease the ISO on your incident meter/spotmeter by 2 stops. For ISO 64 film, *we divide 64 by 2 two times*, i.e., 64 ÷ 2 = 32 and 32 ÷ 2 = 16. Therefore you need to set the ISO on your off-camera meter to 16. In this case, readings from the meter are directly transferred to your camera and you can shoot your picture.

If you used a filter and the filter factor was "1" stop, you would *simply divide 64 by 2 only once*, i.e., 64 ÷ 2 = 32. In this case, the ISO setting of your off-camera incident meter/spotmeter would be 32. *The only drawback of this system is that you may forget to change the ISO of the meter back to its correct value after you have removed the filter*. The results will be disappointing since all your images will be exposed by up to two stops!

Popular outdoor filters made by Tiffen Corporation include: Polarizer (to provide you with darkened sky and saturated colors). Haze 1, Haze 2A, UV15, UV16, UV17 (to reduce Ultra Violet light and add warmth to the image) and Neutral Density (ND) to reduce the overall brightness of the subject. Neutral Density filters can also be thought of as sunglasses for your lens. We will be discussing some of these filters and their application later on in this chapter.

5.9. Exposure determination by substitution — using the gray card as a substitute

One of the most popular methods of exposure determination is to use a Standard Gray Card with your camera or any other reflective meter. You simply substitute the subject with a gray card (put a gray card in front of your camera in the place of the subject). Make sure there is no glare on the card, and measure the exposure (I prefer using *plastic* gray cards because they minimize glare and last for a very long time.) Once you determine the exposure, simply remove the card and shoot the picture. *When shooting the picture, your meter could show*

underexposure, normal exposure or overexposure. In each case ignore the reading!

Using a gray card is very much like using an incident meter. We simply measure the exposure, without any reference to the actual reflectivity of the surface that we are photographing. This technique is called exposure determination by substitution. The basis for this technique is using a surface with known reflectivity to determine the correct exposure of an average (not too bright and not too dark) subject. The technique will work with all of the tones on our Tone-Ruler but it is not recommended for extreme reflectivities such as 2.25% and 144%. If you correctly expose for the middle tone, then the other tones will be correctly exposed.

5.10. Exposing without a meter — The Sunny-16 exposure technique

The 'Sunny-16' rule is a method of determining exposure when you are photographing a **sunny subject**. With this technique, you always set your aperture to f-16 and set your shutter speed to the closest ISO of the film and shoot. The concept is based on the fact that the sun's intensity is approximately the same in most parts of the world. Although there are some seasonal and geographical adjustments to this intensity, this is an extremely useful exposure tool that is available to a serious nature photographer.

Now let's go through a few examples.

Assume that you are using ISO 64 film. For sunny subjects, set your aperture to f-16 and shutter speed dial to 1/60. (ISO 64 is close to 60 on your shutter speed dial), and take the picture.

Now if you use ISO 400 film, set your aperture to f-16. In this case, your shutter speed becomes 400. Since on older cameras this is not a standard shutter speed, you find the closest shutter speed on your camera. Since 400 lies between 500 and 250 on your shutter speed dial and 400 is closer to 500 than 250, we choose 1/500 as our shutter speed.

> To show how the Sunny-16 rule works, I used a spotmeter and a gray card and measured the light intensity at 11:00 a.m. in Birmingham, Alabama. My ISO setting was 100 and my Pentax digital spotmeter showed an EV reading of 15. The following table shows the "Equivalent Exposures" that were indicated on the spotmeter. The Sunny-16 exposure is indicated by ☀ in 1/125 @ f-16 column. We will talk about the other exposure (1/1000 @ f-5.6) later on.

Shutter speed	1/60	1/125	1/250	1/500	1/1000
Aperture Opening	22	16 ☀	11	8	5.6 ☀

Sunny-16: This picture was taken using Fuji Velvia-50 slide film and a 28 mm lens. Exposure was 1/60 @ f-16. In this picture, white trees are slightly overexposed.

Sunny-22: This picture was taken using Fuji Velvia-50 slide film and a 28 mm lens. Exposure was 1/60 @ f-22. Since the scene consists of white trees, to get more detail in the trees and increase its graphic impact, it was underexposed by 1 stop from the Sunny-16 settings. The same logic would also apply if you want to use the technique to photograph a sunlit snow scene.

Images for section 5.10.0

❏ From **Sunny-16** come **Hazy-11**, **Cloudy-8** and **Overcast-5.6**. In all of these situations, yo**ur shutter speed will be the same as Sunny-16** and the f-stop will be 11, 8, and 5.6 respectively.

❏ **Hazy-11** is used when you are shooting under hazy conditions. To differentiate between "hazy" and "cloudy" days, under the hazy sky conditions, you would only be able to see your body's soft shadow on the ground.

❏ **Cloudy-8**, is used when it is cloudy, bright and you can't see your shadow.

❏ **Overcast-5.6**, is used when you are shooting and the weather is cloudy and dark or if you are shooting in the open shade.

These terms may sound boring until your meter stops functioning when you are in a foreign country or on a camping trip.

A FEW WORDS OF CAUTION:

1) Sunny-16 in most parts of the world yields excellent pictures for all subjects except bright white snow. The reflectivity of bright sunny snow, because of the glare of the sun, can exceed 100%. This can happen when the particles of snow act like a mirror in reflecting the sun's image. Under these circumstances, to get detail in the snow, the Sunny-16 becomes Sunny-22. For example, using ISO 64 film, the exposure becomes 1/60 @ f-22.

2) A serious photographer must measure the exposure for the sunlit gray card (9:00 AM to 3:00 PM) by setting the shutter speed closest to the ISO and remember this setting. If you live in extreme geographical areas, your Sunny-16 could be a Sunny-22 or Sunny-11. While your meter works, do this experiment and remember your 'Sunny-?', since there are occasions when you will be glad you did.

5.11. Exposing without a meter — Using Sunny-16 to photograph the full moon

Since the full moon is a sunlit subject, the same Sunny-16 technique can be used to photograph it. Using ISO 64 film, set your shutter speed to 1/60 and the aperture to f-16, and shoot. The reason that you see the full moon as bright because your eyes, due to the moon's black background, simply "overexpose" it! Therefore, if your Sunny-16 pictures with ISO 64 film of the moon are too dark for your taste, try to expose them at 1/60 @ f-11 or at 1/60 @ f-8. If you really want to know how bright the sunlit moon is, look at it during the day since it has the same intensity as it has at night.

Advanced note: If you are using a 2X Teleconverter to increase the power of your zoom or telephoto lens (i.e., a 2X Teleconverter makes an 800mm lens out of your 400mm lens), the f-16 of the Sunny-16 becomes f-8 (i.e., 1/60 @ f-8 for ISO 64 film). If you are using a 1.4X teleconverter with your telephoto lens, then you have to increase the exposure by one stop, i.e., Sunny-16 exposure for ISO 64 film becomes 1/60 @ f-11. If you do not know what I am talking about, simply ignore this note!

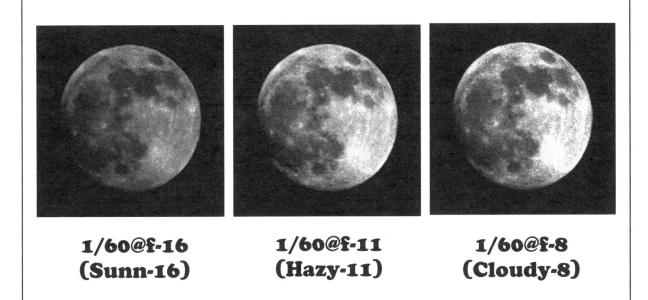

**1/60@f-16
(Sunn-16)** **1/60@f-11
(Hazy-11)** **1/60@f-8
(Cloudy-8)**

Using Sunny-16 to photograph the moon:

Since the moon is a sunlit subject, you can use Sunny-16 to photograph it. Unfortunately Sunny-16 exposure (1/60 @ f-16 for an ISO 50/64 film) can create an image that is a little too dark for one's taste (at night, due to the dark sky, your eyes actually overexpose the moon! This means that it appears much brighter than what it actually is. If you want to know how bright the moon is, simply look at it during the day).

Three images above were captured by increasing the exposure from Sunny-16 by one and two stops. These exposures were 1/60 @ f-16, 1/30 @ f-16 and 1/15 @ f-16 using a 600-1200mm zoom lens. As far as you are concerned, try these exposures with your own equipment and choose the one that you like and then stick with it.

Images for section 5.11.0

5.12. Exposing without a meter - Freezing-5.6 to freeze the action

Freezing-5.6 is a derivation of the Sunny-16 rule when you are using a *low-to-medium speed film such as ISO 25, 50, 64 or 100*. If you look at the table in the section 5.10, one of the equivalent exposures uses the aperture of 5.6. This setting can be used to *freeze* the action with higher shutter speeds than Sunny-16.

Although Sunny-16 can be used successfully to photograph sunlit subjects, when using 25 to 100 ISO films, you may need a faster shutter speed to freeze the action. The action could be an outdoor soccer, tennis, or baseball game.

Freezing-5.6

For fast moving *SUNNY* subjects, when using a low-to-medium speed film, always set your aperture to 5.6 and your shutter speed to ten times the ISO of your film (10 × ISO).

For ISO 25 film it is 1/250 @ f-5.6, for ISO 50 it is 1/500 @ f-5.6, for ISO 100 film it is 1/1000 @ f-5.6 and so on.

Assume that you are using ISO 64 film. With Sunny-16, your speed would be 1/60 @ f-16. To freeze action, you need to use shutter speeds of 1/250 to 1/1000 sec.

With Freezing-5.6, **your aperture will ALWAYS stay at 5.6 and the shutter speed WILL ALWAYS be 10 times the film's ISO.** For example, using ISO 64 film, set your aperture at 5.6 and your shutter speed to 10 × 64 = 640. Since 640 is not the standard shutter speed, set your shutter speed to its closest number, i.e., 500. Let's try another example. Using ISO 100 film, to freeze the action, simply set the aperture to 5.6 and the shutter speed to 100 × 10 = 1000 (1/1000 sec.). For ISO 25 film, set the aperture at 5.6 and the speed to 10 × 25 = 250 (or 1/250 sec.)

5.13. Moonlight-64 for moonlit landscapes and tracing the stars

Since the moonlight cannot be measured by most meters that are in common use, I came up with the idea of Moonlight-64 (originally I called it Moony-64). This exposure is for moonlit scenes without the moon included in the image. Since I never carry my notes with me, with this technique, I can remember how to expose my average (not too dark and not too bright) moonlit landscapes. The foundation of this technique is ISO 64 film. All you have to remember is that **64 = 60 + 4**, where: **64** is the ISO of the film, **60** is the exposure time in *minutes* and **4 (f-4)** is the aperture opening of your lens.

Exposing a moonlit scene for different phases of the moon

FULL	3/4	HALF	1/4
0	**1**	**2**	**3**

Moonlight 64 Exposure +0 stop	Moonlight 64 Exposure +1 stop	Moonlight 64 Exposure +2 stops	Moonlight 64 Exposure +3 stops
For ISO 64 film: 60min@f-4 OR 30min@f-2.8 OR 15min@f-2, etc.	For ISO 64 film: 60min@f-2.8 OR 30min@f-2 OR 15min@f-1.4, etc.	For ISO 64 film: 60min@f-2 OR 120min@f-2.8 OR 240min@f-4, etc.	For ISO 64 film: 120min@f-2 OR 240min@f-2.8, etc.
For ISO 100 film: 60min@f-5.6 OR 30min@f-4 OR 15min@f-2.8 etc.	For ISO 100 film: 60min@f-4 OR 30min@f-2.8 OR 15min@f-2, etc.	For ISO 100 film: 60min@f-2.8 OR 120min@f-4 OR 240min@f-5.6, etc.	For ISO 100 film: 120min@f-2.8 OR 240min@f-4, etc.
For ISO 200 film: 60min@f-8 OR 30min@f-5.6 OR 15min@f-4, etc.	For ISO 200 film: 60min@f-5.6 OR 30min@f-4 OR 15min@f-2.8, etc.	For ISO 200 film: 60min@f-4 OR 120min@f-5.6 OR 240min@f-8, etc.	For ISO 200 film: 120min@f-4 OR 240min@f-5.6, etc.
For ISO 400 film: 60min@f-11 OR 30min@f-8 OR 15min@f-5.6, etc.	For ISO 400 film: 60min@f-8 OR 30min@f-5.6 OR 15min@f-4, etc.	For ISO 400 film: 60min@f-5.6 OR 120min@f-8 OR 240min@f-11, etc.	For ISO 400 film: 120min@f-5.6 OR 240min@f-8, etc.

Please Note: These exposures are starting points and they may cause overexposure. While shooting, you may reduce these exposures by as much as one stop (close down) and take alternative exposures.

Diagram 5.13.0

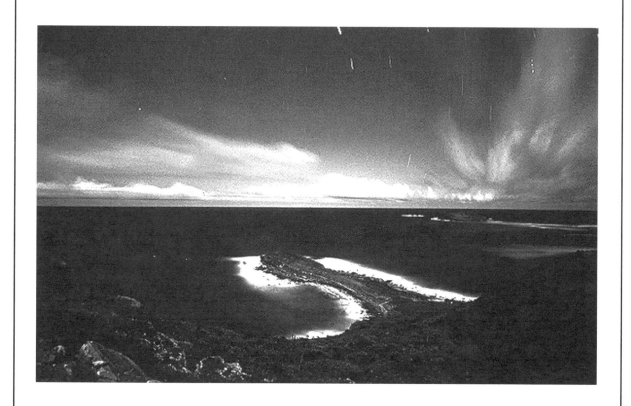

Moonlit scene, St. Barth, French West Indies:

I exposed Ektachrome-100 film for approximately 15 minutes @ f-2.8. This is equivalent to exposing ISO 64 film at f-4 for 60 minutes (Moonlight-64). You can see the Pole (North in the US) Star on the top left side of the picture. This star, which looks stationary to the camera, also works as the center for the star trace. I used a 16mm lens with the camera mounted on a tripod with a cable release locking the exposure time on "B"ulb for 15 minutes.

Image for section 5.13.0

For long exposures like this, you will need to use a tripod and a cable release that can be locked with the shutter speed of your camera set to "B" and the distance set to infinity (∞).

Approximate equivalent exposures for Moonlight-64 would be 30 min. @ f-2.8, 15 min. @ f-2 or 7.5 min. @ f-1.4 (**please note: these times are minutes and not seconds**)!

For this assignment, choose a clear night. Before you choose the scene, examine the movement of the moon to make sure that it would not sneak into the frame of your picture. The moon moves the length of its diameter every 2 minutes or so. Other considerations that will help your pictures are a wide angle lens (16, 24 or 28mm) and the position of the North (Pole) star. All the stars in the sky draw a circle around the Pole Star. This star is an important element in your picture's composition. *Remember, the Moonlight-64 is only a starting point and a method of remembering the starting exposure. Since the Reciprocity Failure Characteristics of films differ, it is highly recommended that you take alternative exposures. Moonlight-64 usually gives you a slightly overexposed image. Your alternative exposures could be 1/2 or 1 stop less than this exposure. Exposures such as 45 minutes @ f-4, or 30 min. @ f-4 for ISO 64 film should cover the majority of your moonlit subjects.*

Although ISO 50/64 films seem to work out best for long exposures, you can use the following if you are not using ISO 50/64 film:

For ISO 25, 60 minutes @ f-2.8, 30 minutes @ f-2, 15 minutes @ f-1.4, and so on
For ISO 100, 60 minutes @ f-5.6, 30 minutes @ f-4, 15 minutes @ f-2.8, and so on
For ISO 200, 60 minutes @ f-8, 30 minutes @ f-5.6, 15 minutes @ f-4, and so on
For ISO 400, 60 minutes @ f-11, 30 minutes @ f-8, 15 minutes @ 5.6, and so on

PLEASE NOTE: Moonlight-64 exposure is for the full moon. If you do not have a full moon, you must increase the exposure by 1 stop for each 1/4 moon. This means 1 stop of overexposure for 3/4 moon (60 min. @ f-2.8), 2 stops for 1/2 moon (60 min. @ f-2), and 3 stops for 1/4 moon (60 min. @ f-1.4) or equivalent.

For those of you who are really interested, sunlight is *approximately* 500,000 times brighter than the full moonlight. 500,000 times translates to 19 stops (divide 524,288 by 2, 19 times and you get 1). Adding 3 stops for reciprocity failure (approx.) for an average slide film, makes our moonlight scene about 22 stops dimmer than its Sunny-16 version. Therefore, for a given film, if you open-up 22 stops from the Sunny-16 exposure, you will get to Moonlight-64!

Tracing stars during moonless nights:

During moonless, dark, clear nights and miles away from the big cities and light pollution, you can set your camera on a tripod and point the camera at the sky. Using ISO 64 film, set the aperture to f-4 (like Moonlight-64) and **leave the shutter open for minutes or hours** (please realize that the 60 minute time limit of the Moonlight-64 *does not apply here*). This will trace the stars in the sky. Of course the longer the exposure time, the longer the trace of the stars. If you know where the Pole star is (North star in North America), you can point your camera

toward it and use it as an element of your composition. As I mentioned before, this star works as the center of the sky and other stars will trace circles around it. If you are using films other than ISO 64/50, you can use the following starting apertures: For ISO 100 film, use f-5.6, for ISO 200 film, use f-8 and for ISO 400 film use f-11.

5.14. Photographing backlit translucent subjects: flags, stained glass, leaves

A) If the sun is strong, the easiest method is the Sunny-16 method.

For example, if you are using ISO 1000 film, set your shutter speed to 1/1000 @ f-16. If you are using 100 ISO film set your shutter speed to 1/125 @ f-16 and shoot.

B) For early morning or late afternoon sun or any other light source with an unknown intensity, go to the *opposite* side of the backlighted subject with your gray card facing the sun to determine the correct exposure for the sunlit side. Now set your camera to the indicated setting, return to your original position and shoot the backlighted subject.

C) You can also determine this exposure by using an incident meter. Simply measure the exposure with the white bubble facing the sun (or the source of light), obtain the "correct" exposure, turn around and shoot.

For example if the gray card or the incident meter's exposure from the opposite (sunlit) side of the subject is 1/60 @ f-11, use this setting to expose your backlighted subject.

Please Note:

If the above technique produces images that are too dark for your taste, you may open-up the aperture by 1/2 stop to 1 stop over the recommended exposure. Please remember, these techniques are designed to give you a logical and practical starting point. What you do with this exposure, depends entirely on your objective and personal taste as a photographer.

Special Notes on Stained-Glass Windows:

The most practical method of photographing stained glass windows in churches is to use your spotmeter to find the "normal exposure" of the detailed area, usually close to the center of the window. This area could look medium gray or darker. It also does not matter if you can not place the spot circle within the boundary of a simple tone. Shooting the image with this "normal exposure" (with the camera on a tripod) has captured my best quality slides for photographic reproduction and enlargements. Please note that for best results you must choose a *cloudy* day. The white cloud works as a white/neutral backdrop and produces normal-looking colors. All stained glass windows shot with the backdrop of the blue sky or trees and buildings will have a color bias of blue or will look impure and unnatural.

Photographing backlighted Subjects:

This picture was taken using Fuji Velvia-50 film with a 250mm lens using a Medium Format Mamiya RB67 Camera. I used a Pentax Digital Spotmeter to obtain a normal exposure of 1 sec. @ f-22 of the encircled area that included medium to darker tones (not a simple subject). Of many exposure techniques available to me, this one gave me the best results. For this assignment of photographing 16 stained glass windows, I chose a cloudy day with my camera mounted on a tripod pointing upwards. This was to force the white clean cloudy sky behind the subject. Pointing the camera upwards also caused the sides of the window to converge at the top. When preparing for publication, after I scanned the image and I used the perspective control in Photoshop to make the lines parallel again.

Image for section 5.14.0

5.15. Silhouette photography

The Zone System of reflective light measurement is a perfect technique for this application. Please note that incident meters cannot be used accurately for this purpose. The objective of silhouette photography is to make the face or the subject black. In our case, let's assume that we want to create a 4.5% black image tone from a person's face.

1) Use a spotmeter or another reflective meter to determine the **normal exposure** of the model's face (flesh tone). Assume it is **60 @ f-2.8.**

2) This normal exposure indicated by the reflective meter will produce an 18% medium gray tone from the side of the face.

3) To convert this 18% medium gray skin to 4.5% black image tone, simply close the aperture down by 2 stops from this normal exposure setting. The face now has a 4.5% image tone and is black. Therefore the final exposure would be 60 @ f-5.6.

Question:

In the above scenario, assume that the wall behind the subject has the same tone as the subject's flesh tone. Now with the help of a light source that only illuminates the wall (face's exposure remains the same), we want to make the wall's image tone to look 72% white. By how many stops the intensity of the background must be increased so that the exposure of 60 @ f-5.6 would create a 72% white image tone from the background? In this case, if you point a camera at the wall, what would be the bright wall's "normal exposure?"

Solution — Method 1:

For the background to be 72% white, it must be brighter than the final exposure for the face by 4 stops (the SBR of 5 stops). This means if you point the meter toward the background without touching any settings, the needle should shoot up from -2 to +2 (➡4.5% [-2], ➡9%[-1], ➡18%[0], ➡36%[+1], ➡72%[+2]). For the normal exposure of the background, we must decrease the amount of light by 2 stops (remember, the needle at the exposure of 60 @ f-5.6 from the background is indicating a +2 exposure). Closing down by two stops gives us a normal exposure of 60 @ f-11 for the background.

Are you confused? Try the next solution:

Solution — Method 2:

In this example, we know that the image tone of the face will be 4.5% black. For the background to have a 72% white image tone, our subject must have an SBR of 5 (identical to our standard Tone Ruler). Therefore the range covered by the "normal exposure" of the face and the "normal exposure" of the background must be 5 stops (➡f-2.8, ➡f-4, ➡f-5.6, ➡f-8, ➡f-11).

If the above explanations confuse you, don't feel too bad. I am sure you can go through life without knowing this. In the past, this question has confused many of my best students including myself.

Exposing for a silhouette

To make a silhouette of a face (i.e., making the image of the flesh tone 4.5% black) you need to do the following:

1) Obtain a normal (*not a correct*) exposure reading from side of the face using a reflective meter such as your camera or a spotmeter (*do not* use an incident meter).

The medium gray image tone of the face in the picture above was taken using the normal exposure of 1/125 sec. @ f-5.6 from the skin tone.

2) Reduce the normal exposure from this setting (close down) by two stops to produce a 4.5% image tone for the side of the face. The above picture was taken by closing the aperture down from the "normal exposure" setting of 1/125 sec. @ f-5.6 to 1/125 sec. @ f-11.

To get a distinct portrait, the background should be at least two or three stops brighter than the normal exposure for the skin tone, i.e., the normal exposure of the background in our example should be 1/125 @ f-11 or f-16.

For the background to have a 72% white image tone, it should be about four stops brighter than the face. For example if the normal exposure for a face is 1/125 @ f-5.6 (say, EV 10 with a spotmeter), the normal exposure for the background should be 1/125 @ f-22 (EV 14 with a spotmeter.)

Images for section 5.15.0

5.16. Photographing translucent subjects on the surface of a light box

To illustrate this, drop a processed color slide on top of a light box. The objective is to take a picture of the surface of the light box (with the slide covering a little part of it) so that you see the image slide the way your eye sees it.

Remove the slide and determine the normal exposure of the white surface of the light box. This exposure will create an 18% medium gray image tone from this surface. Since the light box emits 100% of the light, open-up 2-1/2 stops from the normal exposure setting and shoot. You open-up 2-1/2 stops from the normal exposure setting because a 100% is about 2-1/2 stops away from an 18% medium gray image tone.

If you want to use an incident meter, simply stick the white bubble (diffuser) to the surface of the light box and use the reading directly. It will be very close to your interpreted exposure

If you are interested in actual 1/2 stop numbers for situations like this, please refer to Illustration 6.9.0 in Chapter 6.

5.17. Time exposure photography

Time exposure photography is tricky, especially with color slide films. Before you decide to expose your film for minutes or hours, you need to know the reciprocity-failure characteristics of your film. You not only need to adjust your exposure, especially with color slide film, but you will also need to correct the color. You may also look into using Neutral Density filters to reduce the amount of light. When using these gray, neutral density filters one can theoretically increase an exposure from, say, 1/60 second @ f-22 to 10 minutes @ f-22.

Three filters of the same grade are sandwiched together on top of a daylight light box to form a neutral tone of gray. A manufactured Neutral Density filter is also placed on top of the light box for reference. Finding the correct exposure for this subject misleads many photographers, even the professionals.

If the picture is overexposed, these filters will be washed out. If it is underexposed, the white and detailless surface becomes gray. The trick is to measure the light from the white area of the surface (with filters removed) and find its normal exposure. Once this is determined, open-up by 2-1/2 stops to place the white surface at 100% reflectivity (since 100% of the light is coming from the surface).

My normal exposure with ISO 64 Kodachrome film was 1/15 @ f-11. Opening-up 2-1/2 stops from f-11 gave me a correct exposure of 1/15 @ f-4.5 (half stop between f-4 and f-5.6).

If you want to use your incident meter, simply stick the white bubble to this surface and you will end up with approximately the same correct exposure. You do not have to adjust this reading. In my case, the direct reading was 1/15 @ f-4.9 which was close to my corrected exposure.

Please note that the extension of your lens (i.e., when you are focusing your camera at close subjects) will decrease the amount of light going through it and will show a somewhat longer exposure (in my case about 1/2 stop).

Image for section 5.16.0

5.18. Photographing in the fog

Exposure determination in the fog will depend on your personal taste. Measuring the intensity of light with a reflective meter such as your camera or a spotmeter and **opening up by one stop** from this reading will give you a good starting point. This method places the image of the fog at 36% light gray.

Exposing for the fog:

Where to place the fog very much depends on your personal taste. Generally the 36% image tone (i.e., opening-up by 1 stop from the normal exposure) is a good starting point.

Image for section 5.18.0

5.19. Photographing sunrises and sunsets

Although there are no exact methods of exposure determination for sunrises or sunsets, the following are general guidelines:

1) Always use a heavy tripod with telephoto lenses whose focal lengths are more than 200mm.

2) If you want a high degree of magnification and you cannot afford a long lens, use a 2X teleconverter. In cases like this, they are lifesavers.

For those of you who are not familiar with teleconverters, when a "2X" teleconverter is placed between your telephoto lens and your camera, it doubles its "mm" power. For example it converts your 600mm lens to a 1200mm lens (makes it more telescopic). By the same token it doubles the zoom power of your 80-200mm lens. Your new zoom will have the effective power of a 160-400mm zoom lens.

3) *If the sun is too bright to be looked at, do not try to look at it or photograph* it. Sunrises are generally less colorful than sunsets. They are cleaner and more yellow. Sunsets are usually more red since the sun has to travel through the expanded atmosphere. The redness of the sunset is magnified if you live in areas with polluted air.

4) Clouds are extremely important reference points in a sunrise or a sunset scene. Find a patch of cloud whose tones fall somewhere in the middle (not too dark and not too bright), take the spotmeter or telephoto reading from that area, set your camera to this normal exposure and shoot.

If you use a spotmeter, do not let the sun in its view. Even though the sun is not in the spot circle (spot frame), the stray light will cause erroneous readings and your pictures will be underexposed.

5) If you cannot find a medium toned Reference Tone and you do not have time to find the proper exposure (the sun rises and sets rather quickly), use your telephoto lens and obtain a _**normal exposure**_ reading adjacent to the sun. ***Do not include the sun itself in your metering area.*** Once you have determined this _**normal exposure**_, include the sun in your image area and shoot with this setting.

6) If the sun is faint, include it in your metering area and find its normal exposure. Always take two or three shots opening-up the aperture (or increasing the exposure time) by one or two stops from the normal exposure setting. You must experiment with the metering system of your camera to find the exposure that you like. On my Pentax LX, it is about two stops over the normal exposure. My camera settings a few minutes before the sun sets range from 1/60 to 1/250 sec. @ f-16 with a 1200mm telephoto lens and ISO 100 Kodak Ektachrome slide film, i.e., one stop to each side of the Sunny-16 (this is purely coincidental)!

I used a 120-600 mm Vivitar zoom with a 2X teleconverter on a tripod to capture this image near Birmingham, AL after a rainstorm. To determine the exposure, I chose the medium gray toned cloud to the right of the setting sun as the subject's Reference Tone.

Image for section 5.19.0

5.20. Photographing fireworks

Fireworks is another hard subject to photograph, since the normal metering system of your camera cannot determine its exposure. As a starter, you can use the Moonlight-64 aperture. In this case, when using ISO 64 film, set your aperture to f-4, set your shutter speed to "B" on a tripod, and leave the lens open for two or three bursts (In this case, ignore the 60 minute time factor.) If you use ISO 100 film, set the aperture to f-5.6; for ISO 200 film at f-8, and so on.

Please realize that these are starting exposures and depending on your taste, you may *close down by one or even two stops from these aperture openings*. For example, with ISO 64 film, you can start with f-4 and take alternative exposures at f-5.6 and f-8. Once you determined the aperture opening that you liked, record it and stick with it.

An important note: Avoid street lights as they will cause light pollution and ruin your picture. Do not leave the camera open for more than a couple of bursts. Fireworks will lighten the smoke-filled air that is left from previous bursts. Hence, long exposures of more than two or three bursts can overexpose your picture!

5.21. Photographing lightning at night

Lightning is another hard subject to photograph since you have absolutely no control over its brightness or its composition. In situations like these, luck is your best friend! If you have forgotten your notes, simply remember the ISO 64 and f-4 aperture that we used in Moonlight-64. If you are not using ISO 64 film, you can estimate the correct aperture with other films accordingly. For ISO 100 it is f-5.6, for ISO 200 is f-8 and so on.

Set up your equipment in a *dark and dry place*, away from a major light source. Remember, if you are getting wet, or the hair on your body is raised before lightning strikes, you are too close and the picture can cost you your life, especially when using a metallic tripod.

Using ISO 50/64 film, set your aperture to f-4, set your shutter speed to "B" on a tripod with the distance set at infinity. Leave the lens open for one or two lightning bolts.

If these images are too bright for your taste, try f-5.6 or f-8. If you are using ISO 100 film, vary your aperture from f-5.6 to f-11, for ISO 200 film, vary your aperture from f-8 to f-16 and so on.

Capturing lightning bolts during the day is much harder than at night. To have long exposures, i.e., *exposures of a few seconds or more*, you will need a tripod. Simply find the *correct exposure* from a *medium toned* area of the scene. Point your camera to the general area of the lightning and shoot. You can also use your camera with a Neutral Density filter to achieve long exposures.

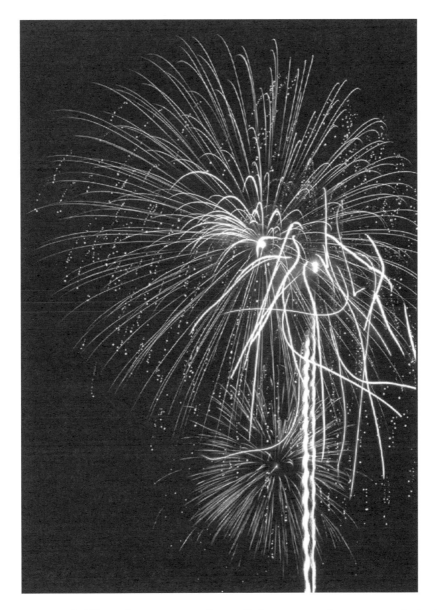

Fireworks, very much like other scenes whose light can not be measured, is difficult to control. The above picture was taken using a derivation of Moonlight-64. As you remember, for ISO 64, the aperture is set to f-4 (this is a good way to remember just in case you forgot to bring along your notes). In this case the time does not come into play, i.e., using a tripod, you set your shutter speed to "B" and leave the aperture open for two or three bursts. This aperture may produce a slightly overexposed and painterly image. If you like a more graphic and colorful image, choose f-5.6 or f-8, i.e., close 1 or 2 stops from the "f-4" base. This image was captured on Fuji Velvia (ISO 50) film using a 70-200mm zoom lens with the aperture set to f-8.

PLEASE NOTE: If you use 100 ISO film, the range is f-5.6 to f-11. For ISO 400 the range is f-11 to f-22 and so on.

Images for section 5.20.0

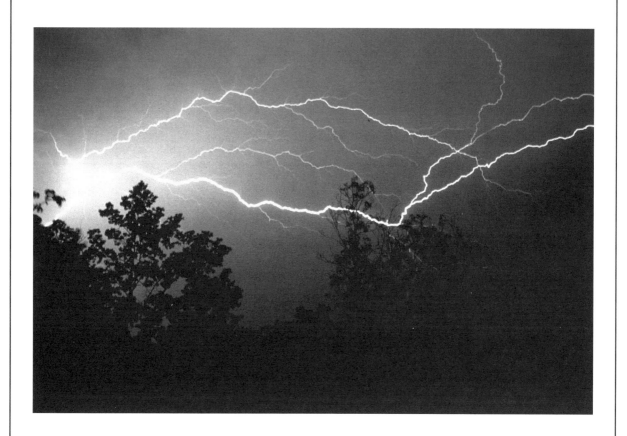

Photographing Lightning at Night

The above picture was taken using a derivation of "Moonlight-64." As you remember, for ISO 64 film, the aperture is set at 4 (it is a good way to remember the starting aperture that you shoot with.) In this case, the time does not come into play, i.e., you leave the aperture open for one or more lightning bolts.

I used a Ektachrome-64 color slide film and a 28 mm lens set at f-4 to capture this image. If this exposure is too bright for your taste, you can use the same film at f-5.6 or f-8 until you can find the aperture that works best for you.

Image for section 5.21.0

5.22. Exposure determination by substitution — using the palm of your hand as a substitute

Although the standard gray card is the most convenient tool, the substitute need not be a gray card, especially when carrying a gray card is not practical or convenient. The palm of your hand is another tone with a known reflectivity that you carry with you all the time! When using the palm of your hand as a substitute, simply determine the **"normal exposure"** for the palm of your hand. Now if you use this exposure to take the picture, your hand will have an 18% medium gray image tone and will be too dark. If you are Caucasian, chances are that you are a "thirty-six percenter" simply open-up the aperture by 1 stop to brighten the tone. In this case your palm will be placed at the 36% light gray image tone and will be properly exposed. Now let's go through an example.

Assume you are a Caucasian and that the normal exposure from the palm of your hand is 1/60 @ f-22. Simply open-up by 1 stop and shoot your picture at 1/60 @ f-16. If you are an African American, you can be an "eighteen percenter" or a "twenty-five percenter." *If you are not sure how reflective the palm of your hand is, by using the gray card and palm of your hand, obtain two readings under identical lighting conditions*. If the reading from palm of your hand is the same as your gray card, you are an "eighteen percenter" and you do not have to make any adjustments. If the exposure from your hand is say, 1/60 @ f4.5 (1/2 stop between 4 and 5.6) and from the gray card is 1/60 @ f-4, you are a "twenty-five percenter." In this case, open-up by 1/2 stop from the palm of your hand for correct exposure. If you are Hispanic, chances are that you are also a "twenty-five percenter," this means that you also need to open-up the aperture by 1/2 stop from your palm's normal exposure. *It is always best to perform the above test with a gray card and remember the result*. I found a spotmeter is great for this type of comparative analysis.

A WORD OF CAUTION: When using this technique, you must be careful not to shadow your hand with your body or the camera's lens. Another important point to remember is that if you do not have spotmetering feature on your camera, the *blurred* tone of your palm *must* be *all* that you see in the viewfinder.

One Handed Exposure Technique!

If your camera has Shutter Priority feature and you have a hard time finding the normal exposure of your palm with one hand, you can try this: Set your shutter speed to a desired value (say 1/125) and then set the camera to shutter priority mode (usually "S" or "Tv" on newer cameras), then point it towards your palm. It will automatically give you the aperture for the "normal exposure" for your palm (say f-8). Assuming you are Caucasian, your correct exposure is 125@f-5.6. Now set your camera back to the "M"anual mode, set the aperture to f-5.6 and shoot.

5.23. Close-up Photography

Close-up Photography is a world of its own. It can become very specialized and complex. For basic close-up photography, you need a 50 or a 100mm macro lens. These lenses let you get within a few inches of the subject. One advantage of 100mm Macro lens is that it does not get as close to the subject as a 50mm lens; therefore it would not cast a shadow on the subject. The great disadvantage is that they are much more expensive. If you do not want to spend three or four hundred dollars for a good macro lens, you may have to settle for your normal 50 mm lens and a few extension tubes. Vivitar corporation makes extension tubes for almost every brand of camera. These tubes, when inserted between the lens and the camera, increase the camera's magnification power. If you want to take close-up pictures, **avoid incident meters or off-camera spotmeters since their readings, depending on the degree of magnification, must be adjusted before they can be used.** Your best tool for measuring light would be the 18% gray card. To use the gray card, focus your camera on the subject and replace the subject with the card. Then find its normal exposure. Remove the card and shoot the picture with the normal exposure obtained from the gray card. If you have a camera with a built-in spotmeter, you can use this feature to accurately expose your picture. The great advantage of this built-in metering system is that it compensates for the lens extension due to extension tubes and simplifies exposure determination. Close-up photography, very much like photographing with a telephoto lens, is extremely sensitive to camera shakes. Make sure you use a tripod or a copy stand and press the shutter release gently.

5.24. Using a Copy Stand

In my life, I have done much copying on the copy stand. Whether you are copying some old photographs or small paintings, you need a minimum of two light sources, mounted on two sides of the subject at an angle of approximately 45 degrees.

The best cameras for copying are the types with removable viewfinders such as old Nikons such as a Nikon F. Another advantage of Nikons over other cameras is that what you see in the viewfinder is exactly what you get on the film.

To determine the exposure, you can place an incident meter on the base and transfer the readings to your camera. You can also use a gray card to determine the exposure. *When using newer cameras with removable viewfinders, attach the viewfinder before determining the exposure or you'll get erroneous exposure readings.*

If you use a tungsten light source, make sure you use the corresponding tungsten color slide or color negative film or you will end up with extra-yellow pictures. The most common type of tungsten light is the 3200K lamp and the type of color film corresponding to this is known as "TYPE B" color film. In my experience, copying on medium speed, tungsten balanced "TYPE B" slide film (ISO 50/64) yields the best results.

Another source of light that is available to a photographer is daylight-balanced fluorescent light. These are special fluorescent lights that can be used with the

Close-up (Macro) Photography

Close-up photography, using a macro lens and/or extension tubes, can become complicated and cumbersome, especially if you are using an off-camera meter. The easiest way to measure the light is by using an 18% gray card and the built-in meter in your camera. This abstract photograph is a close-up of an aluminum foil colored by colored gels on a windowside table. I used a 50mm macro lens and a gray card to expose this image. The exposure was 1/2 sec. @ f-22 on Kodachrome-64 slide film. The original slide had a slight Cyan (blue/green) color tint.

Image for section 5.23.0

daylight balanced film (5500K) without any additional filtration. These lights are popular because daylight films are less expensive and more readily available in different stores. The major disadvantage of daylight florescent lights are their less-than-perfect color balance and the way they react to films made by different manufacturers. As these lights get older, their color balance shifts from neutral to green and the photographer must use a Magenta Color Compensating (CC) filter to color-correct the image.

5.25. Photographing subjects with glare

The best way to photograph subjects with glare is to *exclude* the glare from your metering area. The glare can come from ice, water or metallic objects. You need to choose another area of your subject and after determining its normal exposure, place it into one of the five zones that we discussed in the book. Once the exposure is determined for this simple subject, you can use its exposure to photograph the entire subject.

5.26. Aerial Photography — a single engine plane or a helicopter

Aerial photography is exciting and creative and it can be used for documentary or artistic purposes. The plane's window must be equipped with a special opening for the lens. Although any single engine plane can be used, a high-winged single engine airplane makes the life easier. Helicopters are very expensive to rent and vibrate more than a single-engine plane, but they can also go places where planes cannot.

If your objective is to document an area, always use a clear, sunny day with good visibility. If you are after artistic effects, fly early mornings or in the late afternoons, where the shadows are long or color of the sun paints your subject.

Choose a 35mm camera with a 28-70mm zoom lens. Using a low to medium speed film (ISO 25 to 64) ensures good image detail. While taking pictures, the distance setting on your camera will **always** be fixed at infinity (∞).

For most photography, heights of 1000-2000 feet are ideal. If the subject's tone is medium, you can use the exposure setting indicated by your meter with the shutter speed set to 1/250 to 1/500 sec. Always double check this exposure against Sunny-16 or Freezing-5.6. Under sunny conditions, you should get approximately the same readings.

If the subject is too white or too dark, use your spotmeter to get a reading from a section of your subject and place it into one of the 5 tones we discussed in the book.

5.27. Aerial Photography — Commercial plane

When flying high at thirty-some-thousand feet on a commercial jetliner, photographing through the scratched and dirty windows usually does not produce the best image. If the plane is not full, move around, you may be able to find a clean window.

If you are determined to take pictures, here are some tips:

1) Travel early or late, when the sun is in an oblique position.

2) Get a window seat, **preferably _not on the wing_.** *On many domestic flights, window seats are numbered "A" or "F." If you are flying Northwards in the morning, choose "A". If you are flying Southwards in the afternoon, choose "F." If you are flying Southwards in the morning choose "A" and when you are flying Southwards in the afternoon choose "F." Talk with your travel agent and request that this should be noted in your profile.*

3) Use a rubber lens hood. To eliminate the reflections from the interiors of the plane, stick the lens hood to the window. Use a 50mm or longer telephoto lens.

4) If you are using the camera's meter and the subject is average (not too bright and not too dark), use the meter's reading and shoot.

5) If you have a spotmeter (**incident meters are ineffective** for this type of metering and **cannot be used**), pick a sunlit cloud and determine its normal exposure. From this setting open-up by two stops and shoot. If the subject that you are photographing is on the ground, find a Reference Tone and determine its normal exposure. Once this is done, place this tone into one of the 5 Zones of the Tone Ruler and shoot.

6) If you are shooting in the general direction of the sun, use Sunny-16 as the starting exposure. Although the airplane's window works as a sort of Neutral Density filter and increase the exposure by one or two stops, the brighter sun at high altitudes will compensate for some of this. If in doubt, take your first picture using Sunny-16. Take the next two by opening-up one and two stops from this setting, i.e., at f-11 and f-8.

7) At high altitudes, you will find plenty of Ultra Violet radiation that will result bluish pictures. You can reduce this bluish effects of UV radiation by using UV filters such as UV15, UV16 or UV17. *Avoid using Polarizing filters unless you plan to capture the rainbow-like stress patterns in the jetliner's window!*

5.28. Photographing a computer or TV screen

When photographing a TV screen, you need to use a daylight-balanced color slide film. Your exposure should be 1/30 sec. or longer, such as 1/15, 1/8 or 1/4 sec. If the subject is moving, 1/30 sec. works the best. Exposures shorter than 1/30 sec. (such as 1/60 or 1/125) will result in an incomplete or undesirable image.

I used my Pentax LX camera and 80-200 mm zoom lens at about 6:00 a.m. local time as the jet was ascending to its cruising altitude. I used Sunny-16 equivalent exposure technique allowing one stop for loss of light through the jet's window. The final exposure with 50 ISO Fuji Velvia was 1/125 @f-8. The slide was then scanned into my PC and was enhanced in PhotoShop.

Image for section 5.27.0

For average subjects, use the exposure reading of the built-in meter in your camera. If the subject is bright, using a spotmeter or a camera, take a reading from the brightest part of the screen and depending on the desired image tone, open-up by one or two stops from this setting.

If you have a graphic package like Adobe Photoshop, or Corel Paint on your computer (if you do not, please ignore these examples), you can create a large square and fill it with pure white (grayscale value Red:255 Green:255 Blue:255). Now turn the lights off and by using a spotmeter or a camera, with your shutter speed set to 1 second find the normal exposure for the white square. Then open-up two stops from this normal exposure to get the correct exposure. Keep this setting and shoot your screen with non-white graphic images.

For example, if the normal exposure for the white area reading is 1 sec. @ f-8 for a 100 ISO film, the correct exposure will be 1 sec. @ f-4. You can also fill the square with the medium gray tone of R:128, G:128, and B:128. In this case it would give you the normal exposure will also be the correct exposure of 1 sec. @ f-4. When measuring the medium-toned screen and when photographing the screen, darken the room and make sure there are no unwanted reflections (this includes reflections from you, your tripod and your camera). If you cannot make the room dark, use a black cloth with a hole to put in front of the screen. You can now shoot through the opening.

For critical work, you must take a test roll to fine-tune your exposures.

Please Note: Computer and TV screens produce a considerable amount of ultraviolet radiation that your eye does not see, but it gets recorded on the film as a bluish tint. To reduce this bluish tint, try your luck with commercially manufactured UV filters such as UV15, UV16 or UV17 (I have not tried these!). If you do not have access to these, use a **yellow** Color Compensating filter (CCY 05 to CCY 15) in front of your lens.

5.29. Photographing with Neutral Density Filters

Neutral density filters can be considered as sunglasses for your camera. These filters are designed to reduce the amount of light reaching the film without changing its original color. When placed on your lens, they can reduce the light entering your camera to 1/2, 1/4, 1/8, 1/16, and 1/32 of its *original brightness*. Filter identification numbers corresponding to above reductions in light are .3 (one stop), .6 (two stops), .9 (three stops), 1.2 (four stops) and 1.5 (five stops).

Plastic, throw-away glasses that you are given by your eye doctor after he or she dilates your eyes have an ND equivalent of 1.5 (approx.). Therefore, these glasses reduce the light reaching your eye by about 5 stops.

The strongest ND filter manufactured by Tiffen Corporation is rated at 4.0. This filter reduces the amount of light entering your camera to 1/10,000 of its original strength, or by 13 1/3 stops.

An example of use: Assume the exposure for a waterfall is 1/15 sec. @ F-22, using ISO 25 film. However, for a special effects want to use a slow shutter speed. To do this we require an exposure of f-22 @ 2 seconds.

In order to achieve this, we must reduce the amount of light by 5 stops. Five stops is the difference between 1/15 sec. and 2 sec. (➡1/8, ➡1/4, ➡1/2, ➡1 sec., and ➡2 sec.) This can be achieved by using a 1.5 ND filter or five 0.3 ND filters (0.3 + 0.3 + 0.3 + 0.3 + 0.3 = 1.5) or by combining a 0.9 and a 0.6 ND filter (0.9 + 0.6 = 1.5) and so on. **In cases like this, the fewer filters used, the better will be the quality of the final image.**

5.30. Photographing with Graduated Neutral Density Filters (ND Grads)

The Standard ND filters are used to reduce the brightness of the entire scene. Another type of Neutral Density filter is the Graduated Neutral Density known as ND Grads. These filters are usually used in scenic photography to reduce the brightness range of a subject. This filter is generally used during the early mornings or late afternoons when the brightness range between the shadowed foreground (usually ground and trees) and the sunlit background (usually sky and the tip of a mountain) exceeds the Film Contrast Range (FCR). These graduated Neutral Density filters consist of a partially clear glass (usually the bottom half) with a top part of gray Neutral Density filtration. There is a smooth transition between these two elements.

The numbering system is identical with the Neutral Density filters that were discussed before, except that instead of ND 0.6 the filter is labeled CLEAR/ND 0.6.

To illustrate the use of these filters let's use the following illustration: On a sunny day, find an outside scene that is partly in the sun and partly in the shade. Place a **white card in the sunny part of the scene** (this represents the highlight or the brightest part of the subject) and place a **black card in the shaded** portion (this represents the lowlight or the darkest part of the subject).

By using a spotmeter, find the Brightness Range of this subject. Assume the spotmeter reading from the white cardboard is 17 EVs, and from the black cardboard is 11 EVs. From what we've previously learned, this subject has an SBR of 7 (➡17, ➡16, ➡15, ➡14, ➡13, ➡12, ➡11). Since the Brightness Range of the subject (7) is greater than the FCR of the slide film (5 stops), instead of compromising, we can use a Graduated Neutral Density Filter. **In this situation we can use a 0.6 Clear/ND filter to reduce the brightness of the background by 2 stops, hence reducing the SBR to 5.** With a correct exposure, we can fit this subject on slide film.

GRADUATE NEUTRAL DENSITY FILTERS - A detailed and practical example: Assume the sunlit tip of a snow-covered mountain at sunrise (background) shows an EV of 16. A dark area of the shadowed foreground, in which we care to retain marginal detail, indicates an EV of 9. Using the same method as the previous example, the SBR of the subject can be calculated to be 8 stops.

An EV of 16, from the snow (highlight area) in the background, with ISO 64 film, yields a normal exposure of 1/60 sec. @ f-22.

Graduated Neutral Density Filter Example

This picture was taken using Fuji Velvia-50. Correct exposure for the sunlit middle tone (18%) was 1/60 @ f-11 (this exposure was used to take this picture). The "correct exposure" for the middle 18% tone of the Tone Ruler in the shaded area was 1/60 @ f-4. **There was a 3 stop difference between these two "correct exposures."** As you can see, the background Tone Ruler is underexposed by about three stops. This means for every stop of underexposure the 4.5% black tone shifts to the right by 1 stop/cardboard (i.e., the 36% tone becomes 4.5% black and the zones 4.5% through 36% can not be differentiated).

An ND Grad filter of .9 reduces the amount of light reaching the camera for the lower half by 3 stops (left). The middle part of the filter was aligned with the shadow line. This picture was taken using the "correct exposure" of the shaded area (1/60 @ f-4). As you can see, all five tones of both Tone Rulers are distinctly visible and correctly exposed. With this new exposure, you can see details of the wall and the window where they were literally black in the original picture.

QUESTION: Assuming that *shaded* 4.5% black cardboard is the darkest part of the scene, what is the Subject Brightness Range (SBR) in STOPs/EVs?

Images for section 5.30.0

As you should know by now, this exposure creates an 18% medium gray image tone for the sunlit snow. By opening-up the aperture by two stops from f-22 to f-11 (➡f-22, ➡f-11), we create a 72% white image tone for the snow. *__In this case, 1/60 @ f-11 is the correct exposure for the snow and its image tone will have marginal detail.__*

An EV of 9, from the lowlight area of the foreground, with ISO 64 film, yields a normal exposure of 1/60 sec. @ f-2. As you should know by now, this exposure creates an 18% gray image tone from the lowlight area of the foreground. By closing-down the aperture by two stops from f-2 to f-4 (➡f-2.8, ➡f-4), we create a 4.5% black image tone for the lowlights. *__In this case, 1/60 @ f-4 is the correct exposure for the lowlights and this dark image tone will have marginal detail.__*

We now seem to have a problem! For the *highlights*, we have a *correct exposure* of 1/60 sec. @ f-11. For the *lowlights* we have a *correct exposure* of 1/60 sec @ f-4. *We have a difference of 3 stops between these two "correct exposures." Our ultimate objective is to make these two "correct exposures" the same!*

Now by using an ND Grad of 0.9 (three stops) we can increase the highlight exposure of 1/60 @ f-11 to 1/60 @ f-4 (➡8, ➡5.6, ➡4). Now with the use of this filter, we *made* the background exposure (mountain) to be the same as that of the foreground, i.e., 1/60 sec. @ f-4. With this exposure, we simply reduced the SBR of the subject to five. Therefore the entire subject can now be successfully recorded on slide film.

5.31. Eliminating (minimizing) Glare

Glare, at times, can be an unwanted element of your image. This can occur when you are photographing a scene through a window with unwanted reflections or picking up glare when you are trying to copy an oil painting with your camera.

To reduce (and sometimes eliminate) glare and reflections, you need to use a polarizing filter. These filters look very much like two Neutral Density filters combined. Although the use of this filter does not always guarantee a successful and reflection-free image (especially with glare from metallic subjects), the easiest way to know this is to look through your camera. When using these filters, look through the viewfinder and turn the front element of the filter until you observe that reflections have disappeared. Polarizing filters reduce the amount of light entering the camera by about two stops, very much like an ND .6 filter. When using these filters, an off-camera metering is recommended since the meter in your camera may not react correctly to inexpensive ($20) linear polarizing filters.

If you do not have an off-camera meter, determine the "correct" exposure (with filters removed) and then open-up by two stops with the filter on. For example, if your correct exposure for a subject (without a filter) is 1/15 sec. @ f-22, your final exposure (with a filter) should be 1/15 sec. @ f-11.

5.32. Analysis of the blue sky

The blue sky is perhaps a good reference point and plays an important role in outdoor/nature photography. Daylight, as far as a photographer is concerned consists of three primary colors (please refer to Appendix B). These are **Blue**, **Green** and **Red**. The blue color of the sky comes from the fact that the blue light has the shortest wavelength of the three primary colors, and some of it gets stopped by our atmosphere. If you are like I am and have problems understanding this logic, the following explanation is for you. Simply think of **White** light as **mainly** consisting of **Blue**, **Green** and **Red** colors. You can also think of these colors as watercolor pigments, with **Blue** having the *shortest legs* and red having the longest.

In order for these pigments to get to earth, they have to clear the atmosphere which works as a hurdle. Since blue has the shortest leg, some of it can not clear this hurdle and gets stuck in the atmosphere creating the color of the blue sky. What gets to earth, is what is left of the blue (which is most of it) and other colors. The blue sky also works as a blue filter. For this reason, on a sunny day, when you are taking color pictures in the shade, your pictures will generally have a blue tint.

Although a blue sky is not exactly a reflective surface (it is more like a translucent medium), to simplify things, we can consider it to act as a reflective surface. By pointing your spotmeter at the blue sky that is **away from the direction of the sun,** you should expect to get readings of 13 to 15 EVs. Please remember that a sunlit gray card has an EV reading of 15 (Section 5.10), which is the basis for our Sunny-16 rule, i.e., a correct exposure of 1/125 sec. @ f-16 with ISO 100 film.

If we expose for the EV of 15 (i.e., the gray card will be captured as 18% medium gray), this blue sky (with an EV of 15) will have an image tone of about 18%. The same exposure will produce a 9% dark gray image tone from the 14 EV sky and a 4.5% black image tone from a 13 EV sky.

If you are using a Minolta exposure meter with a reflective (the attachment with a circular opening and NOT the white bubble) metering attachment, in order to obtain a true EV reading from the sky, make sure to set your ISO to 100. Otherwise, you will not get these EV readings that I obtained with my Pentax Digital Spotmeter. On the previous page you see a series of exposure placing the sky from 4.5% black to 72% white with the normal exposure tone in the middle. If you are looking for using the blue sky as your Reference Tone, you can use these as your approximate guide. If you have scattered, bright clouds in your scene, you can also use Sunny-16 or you can use a spotmeter to place the sunny part of the cloud in the 72% white zone. To your surprise, this exposure would also be very close to the Sunny-16 exposure.

5.33. Photographing subjects that are too dark to be metered

Sometimes you are in a situation in which you are using your normal 50mm lens and it is simply too dark to meter with a gray card. If this is the case, use a white

Different tones of the blue sky

BLUE SKY @ 4.5% IMAGE TONE (N - 2)

N - 2

BLUE SKY @ 9% IMAGE TONE (N - 1)

N - 1

BLUE SKY @ 18% IMAGE TONE NORMAL EXPOSURE (N)

N ORMAL

BLUE SKY @ 36% IMAGE TONE (N + 1)

N + 1

BLUE SKY @ 72% IMAGE TONE (N + 2)

N + 2

Depending on the tone of the sky,
Sunny-16 usually places the blue sky
at N or N-1 image tone

Images for section 5.32.0

Series of tones demonstrating the relationship between different exposures of the blue sky and its corresponding image tones. The *middle* image was produced when the sky was normally exposed. The normally exposed sky is signified by the letter "N". Overexposures are indicated by N + 1 and N + 2 stops and underexposures are indicated by N - 1 and N - 2 stops. You can use this as a rough guide to create the desired image tone from the sky.

sheet of paper, find its normal exposure and open-up the aperture (increase the exposure) by two stops to obtain the correct exposure. If this does not work, turn your camera around 180 degrees or toward the source of light and find its normal exposure. Now open-up (or increase the exposure) by 4 or 5 stops from this setting and shoot. The picture that you get may not be the best exposed image in the world but under those circumstances it should do! If you are really interested where these four stops came from, perform the following experiment:

1) On a sunny day, _stand in the shade_ and use your exposure meter with the reflective attachment (the attachment with a circular opening and NOT the white bubble).

2) Measure the "normal exposure" for an 18% gray card facing the sky. In my case it was 11 EVs for ISO 100 film. As you should know by now, this reading also corresponds to the "correct exposure" for the gray card or the subject behind it that is illuminated by the sky.

3) Turn the meter by 180 degrees so that now it faces the sky (do not include the sun!) and note the EV indicated by your meter. In my case it was 15 EVs.

4) By subtracting 11 from 15 we will get our 4 EVs (STOPs). This is the difference between the "correct exposure" of the subject and the "normal exposure" of the sky illuminating the surface.

Example: Assume the "normal exposure" for a source of light (i.e., pointing the camera at the general direction of light source) measured to be 1 sec. @ f-1.4. Since we can not open the aperture any more, we have to increase the exposure by increasing the exposure time. Increasing the exposure by 4 stops from this reading means doubling 1 second 4 times or multiplying it by 16 (➡2, ➡4, ➡8, ➡16), i.e., the subject needs to be exposed at 16 sec. with an aperture of f-1.4. Please remember, this exposure does not include the adjustment for the film's reciprocity failure. Increasing this exposure by 1 extra stop to compensate for this will yield a correct exposure of 32 seconds @ f-1.4. For reciprocity failure characteristics of some common slide films please refer to Appendix C.

5.34. How to photograph subjects whose Reference Tone is outside of the image area

To illustrate this example, let me show you a picture of falling snow illuminated by a parking lot light. At first glance, you would have a few ideas about how to photograph this. If you think hard enough, you will realize that it is not as easy as it looks. The point source of light (very much like the bright sun) must be eliminated from our light measurement considerations. What is left is the falling snow that by itself is not a surface that can be measured properly to provide us with a consistent reading. When I was confronted with this subject, I thought about the method that I would use if I had a wide angle lens. With a wide angle lens, I would use a spotmeter to measure the snow that was covering the ground and I would open-up by 2 stops to place the snow at the 72% white image tone. That is exactly what I did. I measured a spot on the ground that was about 10 to 15 yards away from the pole and found its normal exposure. Then opened up two stops and pointed my 70-200mm zoom lens at the light and shot the image with my lens fully opened at f-4. Since the weather was bad, I did not record the shutter speed. After I got my slides back, I determined that the shutter speed was 1/8 of a sec. How did I determine that? For those of you who are interested, these lights turn on and off 60 times every second (very much like a strobe that turns on and off 60 times per second). If you count the number of flickers on **one** snow flake, you will see that it was turned on and off 8 times. Dividing 8 into 60 will give me the approximate shutter speed of 1/8 sec.

Photographing a subject whose Reference Tone is outside of the image area

This is an example of a hard subject to photograph. Especially if you have only one frame left in your camera. With this subject, the Reference Tone is outside the image area. Therefore the trick is to assume that you have a wide angle lens and you want to take the a general picture of the entire parking lot. Point your meter or lens at the snow-covered parking lot, about 30 to 40 feet away from the lamp post and determine the normal exposure for snow. Now open-up by two stops from this exposure to place the snow (Reference Tone) at the 72% image tone. Use this exposure to photograph the lamp. The exposure for this shot was 1/8 sec @ f-4 with a 70-200 mm zoom lens using Fuji Velvia-50 slide film.

Image for section 5.34.0

5.35. Photographing indoors with available light

When photographing indoors under a mixed lighting situations (i.e., tungsten, daylight, fluorescent, etc.) one must compromise. When using slide film, color meters provide the most accurate (and also the **most expensive)** method of producing a color balanced image. This equipment (costs about $1000) will help you decide what kind of filtration you need to use to photograph a given scene. Since this is beyond the scope of this introductory book, we will not discuss it any further.

Photographing under tungsten lights

If the tungsten light (light from ordinary light bulbs) is the dominant source of light and you are using slide film, simply use a tungsten (3200K, type B) balanced slide film and you will get a correct image. Using a daylight film will result in a yellowish image. To correct this, try to an 80A (blue) filter. In this case, although using a filter will improve your image, however, the **quality of the image will not** be as good as the image if you had used a tungsten film.

Photographing under Fluorescent lights

If you want to photograph large spaces lit by the fluorescent light and you are using a color slide film, you must correct the greenish cast produced by these lights. For most fluorescent lights a 30 (.30) Magenta Color Compensating filter (CC30M) will do the job. This filter is available at your camera store or you can get it from a filter pack that converts a black and white enlarger to a color enlarger. I found the manufactured filters like FLD to be a waste of money and impractical, especially if you are using a wide angle lens to photograph an indoor subject. In cases like this, remove the lens and cut a small circular piece of CC30M filter and **carefully and securely tape it to the back** of your wide angle lens. Now mount the lens on your camera and shoot the picture.

What is the Zone System?

What will you learn in this chapter?
In this chapter we discuss the concept of zones as it applies to our everyday life. We then discuss the make-up of a time zone and its relationship with a "photographic" subject zone.

Please Note: This chapter, although interesting, is designed for the curious photographer. If you are not curious, you can skip it without a great loss!

6.1. What is the Zone System of light measurement?

So far we went through this book without fully explaining what the Zone System of light measurement really is. If you are reading this, perhaps you have been persistent enough to get here. Since you are still looking for some answers, I will try to explain and illustrate the meaning of the term "zone" as it applies to different applications. These applications include:

1) Temperature reading of a glass thermometer.

2) The North American Time Zones.

3) A playground slide.

Before you start reading the next section, I must warn you that although the generic concept of the Zone System is not hard to understand, explaining it can become detailed and you must be patient. If you do not understand it the first time through, put the book down, think about what you were reading, and try it again until you understand the idea.

6.2. The Glass Thermometer as an example of the Zone System

If someone asks you how cold (or warm) the weather is, without looking at a thermometer, chances are you can tell them it is in the fifties, sixties or the seventies and you could be right. You can do this because a temperature range of 10 degrees is broad enough so that you can make this educated guess. The same type of guessing will be expected from you later on when you will be matching the tone of your subject to a tone of a Tone Ruler.

In order to create a zone, we need to understand three terms that are the building blocks of any *Zone System*. These are: 1- **Continuous scale**, 2- **Stepped scale** and 3- **Zoned scale.**

6.2.1. Continuous scale

In our first thermometer illustration, let's analyze a special glass thermometer that has two markings. These two markings signify the beginning and the end of a "continuous" scale. We call this scale continuous since a gap of 50 degrees that exists between these two markings is too wide to be of any practical value. To make this thermometer practical, we need to divide the range into smaller divisions. Another feature of this continuous scale is that as the temperature increases, so does the height. Since there is a direct relationship between the temperature and the height of the mercury or alcohol in the glass, we would use the term "analog" to describe this continuous scale. This means there is an "analogy" between the height of the column of mercury or alcohol and the indicated temperature.

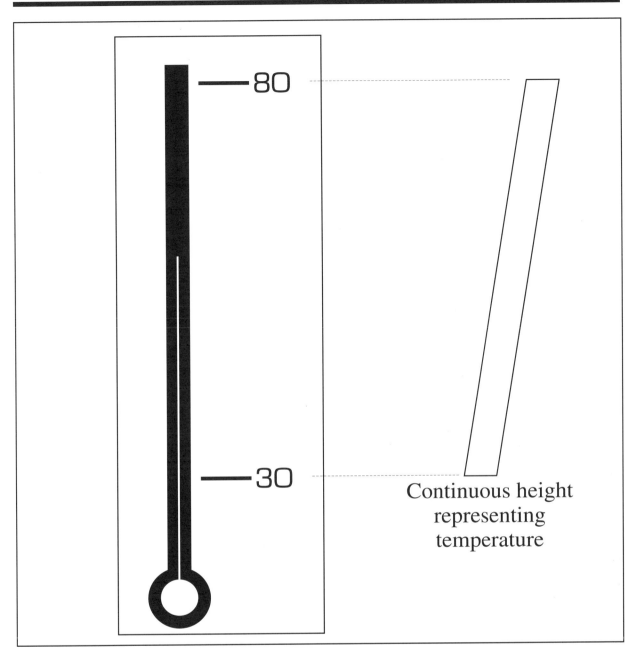

Continuous height representing temperature

Diagram 6.2.1

An example of Continuous Scaled Temperature

This thermometer covers temperatures from 30 to 80 degrees. Since there are no other markings between the two ends, then this scale is impractical for our daily use. Since this scale needs further division before we can use it, this can be considered to represent a continuous scale. The slide on the side illustrates the continuous height of the alcohol. The higher the alcohol, the warmer the temperature.

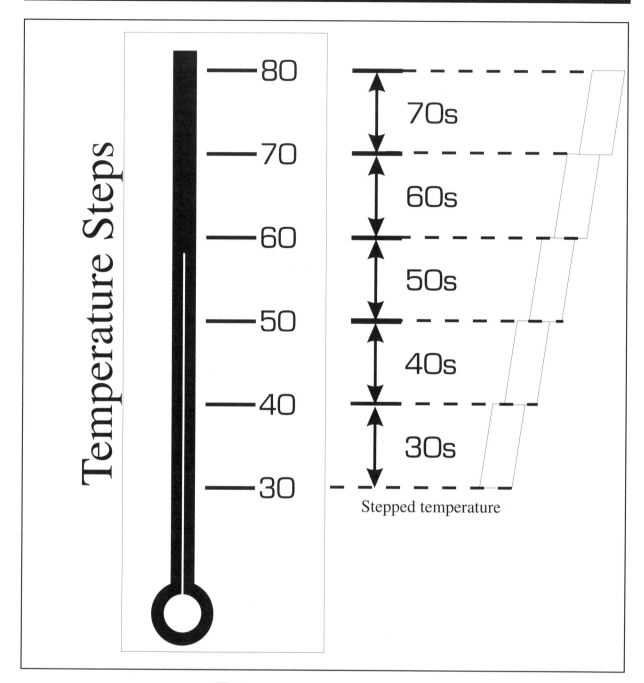

Diagram 6.2.2

An example of Stepped Temperature

This alcohol height covers a temperature range of 50 degrees where the lowest is 30 and the highest is 80 degrees. As you can see, it has six markings, producing 5 equal heights or temperature steps. These steps represent temperatures that are in 30s, 40s, 50s, 60s and 70s. One important property of a stepped scale is that by looking at the thermometer you can also guess whether the temperature is, in the upper, middle or lower 50s and so on. In this specific example, it is in the upper 50s.

6.2.2. Stepped scale

Now let's make the thermometer "more accurate" by making it "less continuous." This can be done by dividing the range between 30 and 80 degrees into five equal divisions or steps. We number these new markings as 40, 50, 60 and 70 degrees. The process of dividing the length of the glass into equal divisions is making a **"stepped"** temperature scale out of a **"continuous"** one.

As you can observe, although the stepped thermometer is not as accurate as we would like it to be, it is more accurate than the continuous scale. With this new scale, we can read temperatures with an accuracy of a few degrees. By using the stepped scale, not only we can see whether a temperature is in the 60s or the 70s, but we can also qualify it to be in the upper 40s or the lower 70s, etc. In the stepped scale illustration, the temperature indicated by the thermometer is in the upper 50s.

6.2.3. Zoned scale

Now let's take this thermometer and arrange the scale so that it covers the same five divisions.

Let's identify these as 35, 45, 55, 65 and 75 degree divisions. These numbers, as you can see, were taken from the midpoint of each division that we can now call zones. With this notation, any temperature that is in the 50s (i.e., its first digit is a "5") would be represented by a single 55 degree zone. The same logic also applies to other zones. Now assume that you have a digital sensor that covers the thermometer and has five displays. As you guessed, if the temperature is in the 30s, the 35 degree zone lights up, if it is in the 40s, the 45 degree zone lights up and so on. It is imperative that you understand that you will only get five readings from this zoned thermometer. This is very much like a digital speedometer in a car that indicates 1 to 5 miles per hour in 5 steps or five distinct readings. Any other speed in between these numbers like 3.6 mph will not be indicated since we only have one column to (one digit) to display the speed. For 3.6 mph, the digital meter could show "3" or "4" instead. Now let's see how accurate this zoned thermometer is. You could safely assume that readings of this thermometer are not very accurate and you would be correct; however, these readings will be simple and consistent. The best case scenario would be if the temperature reading was, say, 75 or a temperature close to it. The worst case scenario would be if the temperature was, say, 70 or 79.9.

In the zoned system, although temperatures of 70 or 79.9 are at the opposite edges of the zone, both will be represented by the 75 degree zone. In this case, our digital readout is off by about 1/2 division or five degrees from each of these temperatures. Please understand that if you want to use the Zone System of approximations, you have to live with these inaccuracies.

Are you confused? To illustrate, let's consider another example where the temperature indicated by this thermometer is 35 degrees. Working backwards, we can conclude that the actual temperature must range from 30 to 39.9 degrees. The best case scenario would be if actual temperatures were 33, 34, 35, 36 or 37 degrees. With these temperatures (except 35) we are off by one or two degrees. The worst case scenario, like the previous example, would have been if the temperatures were 30 or 39.9 degrees.

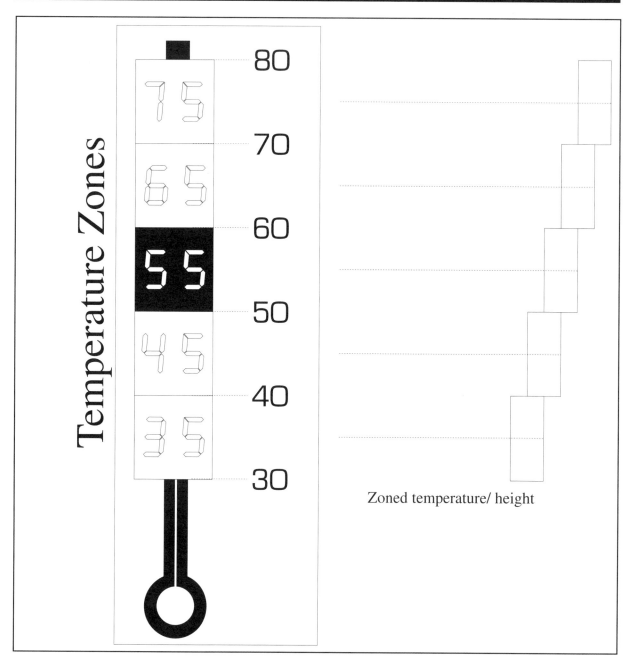

Temperature Zones

80
75
70
65
60
55
50
45
40
35
30

Zoned temperature/ height

Diagram 6.2.3

An example of the Zoned Temperatures

In this illustration, we chose the temperature of the midpoints to name each temperature zone. Like the stepped example, these five zones still represent 50 degrees of temperature difference. Please note that for any temperature that ranges from 30 to 80, this thermometer has ONLY FIVE READOUTS. This thermometer will show 55 if the temperature is in the 50s, 65 if it is in the 60s and so on. Unlike the stepped example, you will NOT be able to know whether a temperature is in the lower 50s or upper 60s, etc. The old temperatures are only shown for reference.

The great feature of using the Zone System to indicate our temperatures, is its simplicity, i.e., it has only five readouts. Its disadvantage is that at times it can be inaccurate, i.e., once in a while it can be off by as much as 1/2 division or five degrees. With the Zone System of temperature representation, we knowingly give up some accuracy to achieve simplicity and consistency.

When one utilizes the Zone System, one knowingly trades off a little bit of accuracy to achieve simplicity and consistency.

6.3. The North American Time Zones as an example of the Zone System

A time zone, by definition, is a geographical region within which the same standard time is used. In the North American Time Zones, like any other time zone, each zone is exactly one hour. Although in our everyday life, we have accepted the time zone concept, one has to remember that the standardized time is technically correct only in those regions that are located exactly in the middle of the zone. The actual time for any other location within that zone, could theoretically be off as little as one second or as much as 1/2 hour. This is very similar to the 55 degree zone that we chose to represent any temperature that starts with a digit "5". As you also notice, using one standard time may not be fair to those people who are living at the extremes of the zone since theoretically their actual times could be off as much as 1/2 hour. The great advantage of this method is that it is convenient and it simplifies time keeping. The alternative would have been keeping up with hundreds of different times in a specific geographic area. This method would have been inconvenient, impractical and confusing.

In the next illustration of North American Time Zones, you will see the same illustration as before. At the bottom, the times shown are actual times that are at the edges of these time zones. These extremes (edges) are important because without them we cannot analyze the make up of a zone.

This case that is identical with our thermometer example. We have 6 markings (vertical lines) creating a five-hour time zone.

Actual time at the CENTER of each Time Zone

PACIFIC MOUNTAIN CENTRAL EASTERN ATLANTIC

4:00 AM 5:00 AM 6:00 AM 7:00 AM 8:00 AM

3:30 AM 4:30 AM 5:30 AM 6:30 AM 7:30 AM 8:30 AM

Actual time at the EDGE of each Time Zone

Diagram 6.3.1

Diagram illustrating actual times for the "center" as well as the "edge" of each North American Time Zone. By subtracting 3:30 from 8:30, we get a difference of 5 hours. For this reason this illustration represents a five-hour Time Zone.

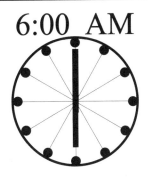

6:00 AM

18% Tone of the Zone Ruler

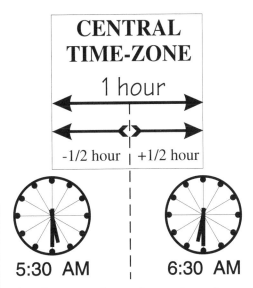

CENTRAL TIME-ZONE

1 hour

-1/2 hour | +1/2 hour

5:30 AM | 6:30 AM

A time assigned to the time zone represents times for many locations, the extremes of which include 1/2 hour on each side of the zone.

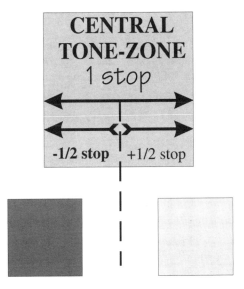

CENTRAL TONE-ZONE

1 stop

-1/2 stop | +1/2 stop

The extreme reflectivities represented by the 18% zone (or any standard zone) are a 1/2 stop less reflective and 1/2 stop more reflective than the number assigned to the center of that zone.

Diagram 6.3.2

Detailed make up of a zone

As a Time-Zone represents all regions including those that are 1/2 hour ahead and 1/2 hour behind, a Tone-Zone represents reflectivities that are 1/2 stop darker and 1/2 stop lighter than the reflectivity of the center of the zone. If you wonder what the exact reflectivity of these midpoints are, I will spare you the mathematical detail. Please refer to the 1/2 zone illustration for Subject Brightness Ratio in Diagram 6.9.0.

6.4. A playground slide as an illustration of the Zone System

The most common equipment that lends itself to the Zone System is a children's slide in a playground. This equipment is made up of two parts: 1- The slide (continuous) section and 2- The stepped (zoned or non-continuous) section. In most playground slides, both of these components reach approximately the same height. Perhaps by now you are curious about the relationship between a playground slide and a photographic zone. As you remember, in the thermometer example, we measured the height of the mercury or alcohol using a ten-degree unit. In the North American Time Zones, we measured time in "one-hour" intervals and in this case what we measured is height and the unit that we measured it with is "steps." Also to simplify things, assume that the height of each step is one foot.

To illustrate how the playground slide relates to our Zone System, let's pick a point on the slippery portion of the slide. Now you are asked to estimate how high this point is from the ground. The question is hard to answer if you cannot look at the steps. Once you look at the steps, then you can draw a horizontal line across and you can safely guess the height of the spot above the ground. Using the steps gives you a visual guide to make an educated guess about the height of the point. This is similar to what you did with the thermometer. Although this example is for illustration purposes only, the slide that would be technically correct will have two short (1/2 step) steps at its extremes. This is very much like the thermometer example that has two five-degree (division) steps at two extremes of the scale. The process of making zones (steps) out of the continuous (slippery) part of the slide is illustrated in the diagram. Please study it carefully and try to understand the logic that goes behind it.

Brighter tones (highlights)

Darker tones (lowlights)

A continuous Gray Scale

High points

Low points

A continuous (slippery) section
of a playground slide

Diagram 6.4.1
Continuous Scale Illustration

In both cases, transition from low to high (black to white) is gradual.

Zone representing the brightest tone

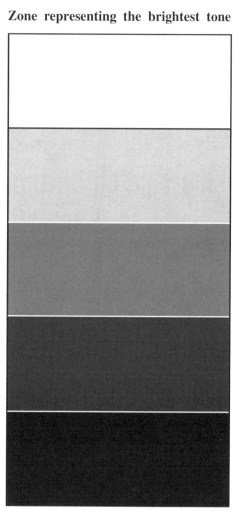

Zone representing the darkest tone

A zoned gray scale

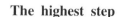

The highest step

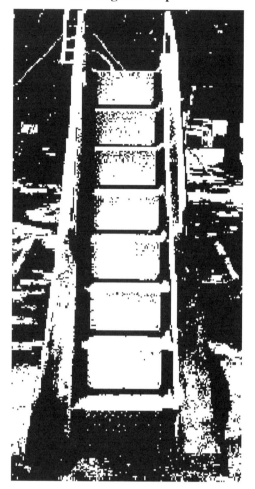

The lowest step

A zoned height

Diagram 6.4.2

Zoned Scale Illustration

In both cases, transition from low to high (dark to light) is no longer smooth and gradual. For a more exact illustration of Zoned and Stepped heights please see illustration 6.4.3

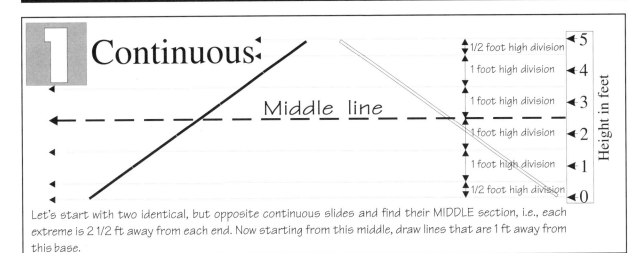

1 Continuous.

Middle line

1/2 foot high division ◄5
1 foot high division ◄4
1 foot high division ◄3
1 foot high division ◄2
1 foot high division ◄1
1/2 foot high division ◄0

Height in feet

Let's start with two identical, but opposite continuous slides and find their MIDDLE section, i.e., each extreme is 2 1/2 ft away from each end. Now starting from this middle, draw lines that are 1 ft away from this base.

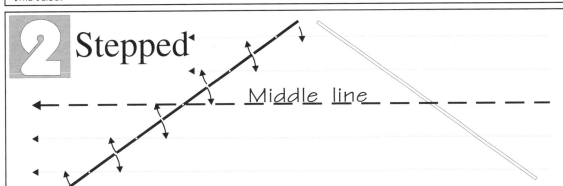

2 Stepped.

Middle line

Now cut the slippery slide on the left 1/2 ft above and 1/2 ft below these lines. With this we have converted a continuous height to a stepped height. Now rotate these sections clockwise around their middle to form five steps

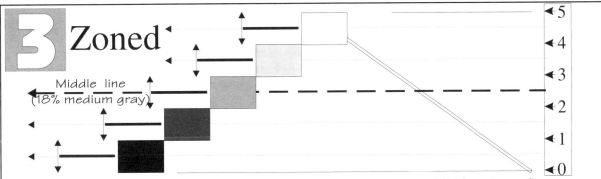

3 Zoned.

Middle line
(18% medium gray)

◄5
◄4
◄3
◄2
◄1
◄0

As you can see, we have five steps and each step's reach is 1/2 ft above and 1/2 ft under it. The total reach of these five steps is our original height of five feet. This is the zoned representation of the original playground slide.

Diagram 6.4.3

These three important drawings illustrate how to convert a continuous height into stepped and then zoned divisions. You can apply exactly the same reasoning to the tones that we created in our Zone/Tone Ruler. As was mentioned before, although the difference between the five tones was 4 stops, their reach is five stops. In this example, although the difference in height between the lowest step and the highest is 4 feet, however their reach (range) is five feet.

In the zoned illustration, please note that the ruler has 6 notches enclosing five 1-ft zones.

6.5. What makes a photographic Subject Zone?

To understand the make up of a Subject Zone, let's analyze our Tone Ruler, which by now can be safely called a Zone Ruler. Let's apply the same logic that we applied to our thermometer, time zones and playground slide to our tones. As you remember, each zone of our standard Tone Ruler had only one tone. The important point to remember is that each of these five standard tones (zones) represent the tones that are up to 1/2 stop brighter and 1/2 stop darker than their assigned midpoint reflectivities (i.e., 9%, 18%, and so on). As the thermometer had 35, 45, 55, 65 and 75 degrees named after the middle of their temperature zones, tones of 4.5%, 9%, 18%, 36% and 72% are the middle of our standard tone zones. If you wonder why these numbers do not follow the same pattern as the time zones or temperatures, I have to admit they use a slightly different principle since they follow a geometric progression rather than an arithmetic one. If you do not want to concern yourself with its mathematical details, please take my word for it since the reasoning is identical. The process that you use to look at a surface with an unknown reflectivity and assign its tone to the Zone or Tone Ruler is identical with assigning the temperature of 68 or 61 degrees to the 65 degree temperature zone. For each representation, the actual figure could be exact or it could be off by as much as 1/2 unit. This unit is 1/2 division (5 degrees) in the thermometer's case, 1/2 hour in time zone's case, 1/2 step (feet) in the playground slide's case and 1/2 stop when placing a tone. Ideally, we would like our system to be more accurate, but like anything else in life, one has to compromise. In the Zone System, the drawback in accuracy is nicely compensated for by many other advantages such as its convenience, simplicity and practicality. Estimating tones and assigning them to one of the tones on the Tone Ruler needs your judgment as well as your skill. You must practice and improve your judgment skill so that you can place the tones properly. As a starter, you can decide to place anything that crosses your path for a week or two. When placing a tone, the untrained and unskilled may be off as much as one stop from the actual value, but this is expected and one improves with time. Fortunately, in photography, when you get your slides back, you will always know how good your judgment works and how accurately you are placing your subject tones. When you made a wrong decision, learn from your mistakes and correct the exposure until you get what you expect from your image.

Summary

The idea behind the Zone System is to divide something that is smooth or constantly changing like "temperature," "time," "height" or "tone" and break it down into units of "ten-degrees," "hours," "steps" or "stops" respectively. Dividing these "slippery" elements into "equal steps" or "equal zones" is similar to starting with a smooth edged piece of sheet metal and cutting it so that it eventually looks like the cutting edge of a saw.

6.6. What happens when the subject tone does not closely match the tones on the Tone Ruler?

While reading this book, this question may have crossed your mind more than once. The question is "what happens if an important subject tone does not match any tones on the Tone Ruler?" This is when you are not sure where to place a tone. This is typical of the tones that in your opinion are about 1/2 stop away from the middle of any two standard tones. This is similar to buying an item that costs $1.50. If all you have is $1 bills and the cashier has no change, chances are you will compromise and pay the extra 50 cents to buy what you want. It is also possible (but not likely) that the store manager will compromise and sell the item to you for $1.

In photography, you can do one of the following: 1) Assign the subject tone to either of its neighboring standard tones. It all depends on your personal taste. With multiple tone metering of a complex subject, you must also figure out where on your Tone Ruler the rest of the tones would fall, i.e., toward overexposure or underexposure.

2) Follow the non-standard assignment and assign the subject tone to one of the tones that fall at a half stop between the standard tones. In our 5-stop tone system, we have 4 of these midpoint markings. We can place a tone into any of these 4 tones by opening-up or closing-down the aperture by 1/2 stop or 1-1/2 stops from the normal (18% standard gray image tone) exposure.

For example, to place image of a simple subject at 12.7% (half the way between 9% and 18% tones), close the aperture from the "normal exposure" by 1/2 stop. Another example is to place the same surface in the 50.8% zone (1/2 stop brighter than 36% zone). This can be achieved by opening the aperture from the normal exposure setting by 1-1/2 stops. An increase or decrease of 1/2 stop is normally achieved by turning the aperture of many lenses by 1/2 stop (click). Please note that with most older cameras, you cannot achieve this accurately by changing the shutter speed since the shutter speed dials are usually fixed and do not have any 1/2 stop divisions. Diagram 6.9.0 illustrates the reflectivities at the edges of our Standard Tone Ruler (1/2 stop divisions).

6.7. How does the zone representation affect the range of a system?

What confuses many people about the zoned notation is the range that is covered by continuous zones. Going back to our thermometer example, if we subtract 35 (lowest temperature zone) from 75 (highest temperature zone) we get a difference of 40 degrees. Therefore, one can conclude that the range of this zoned thermometer is 40 degrees. Of course this is the wrong conclusion since the original thermometer started at 30 degrees and went up to 80 degrees. Therefore, the original range was 80 - 30 = 50 degrees, or to be more exact, the temperature

range covered by these five zones is about 49.9 degrees. There are two methods of finding the range covered by a Zone System:

Method 1- Count the number of divisions or zones: In our thermometer case it was five divisions or 50 degrees, and in our Tone ruler case it was 5 stops.

Method 2- Add 1/2 unit to each end zone: This marks the actual beginning as well as the actual end of the scale. In this case, if we add 4.9 to 75, we get 80 (approx.), which is the upper limit of our scale. If we subtract 5 from 35 we get 30 that is the lower limit of out scale. By subtracting 30 from 80, we get 50 (5 units) which is the range of the thermometer. With this approach, we simply worked backwards to get to the original extremes that we started with.

In photography, we can apply the same logic to our Zone/Tone Ruler. In this system, our lowest number was 4.5% and the highest was 72%. Therefore our Zone/Tone Ruler covered a tonal range that is 1/2 stop darker than the 4.5% tone (3.18%) to a tone that is 1/2 stop brighter than 72% tone (101.82%). This makes our ruler a Five-Stop Tone Ruler.

In our thermometer, we have six markings creating five (always one less than the number of markings) temperature zones. In our Tone Ruler we also have six markings creating five tone zones.

6.8. Subject Brightness Ratio

Subject Brightness Ratio is another method of measuring the brightness range of a subject. I deliberately avoided this term because it is more mathematical and scares the average novice photographer away. It would not also add anything to what we learned so far except a different way of measuring the Subject Brightness Range (SBR). Since this is an introductory book, I will discuss it briefly. In Subject Brightness Range, to find the range, we counted the number of stops or EVs that a subject covered. With Subject Brightness Ratio (ratio means dividing one number into another), we divide the reflectivities at the two extreme edges of our subject tones. Let's start with our Tone Ruler. As illustrated on the next page, the lowest reflectivity that is represented is 3.18% and the highest is 101.82%. By dividing 3.18 into 101.82 we get 101.82/3.18 = 32 (approx.) Therefore the Brightness Range of our Tone Ruler is five stops and its Brightness Ratio is 32. The accepted standard for showing this Brightness Ratio is also 1:32, read "one to thirty two."

Now let's analyze a subject whose Brightness Range is four (4). To find the Subject Brightness Ratio, simply multiply 2 by itself 4 times, i.e., $2 \times 2 \times 2 \times 2 = 16$. Therefore a subject with SBR of 4 has a Subject Brightness Ratio of 16 or 1:16.

Another example? Assume a subject has a Brightness Range of 8. Using the same logic, if we multiply 2 by itself 8 times we get the Subject Brightness Ratio. In this case $2 \times 2 \times 2 \times 2 \times 2 \times 2 \times 2 \times 2 = 256$ or 1:256. A table showing how Subject Brightness Ratio and Subject Brightness Range are related is illustrated in Diagram 6.9.0.

6.9. Is a subject zone always one stop?

The standard **subject zone** in all different Zone Systems is *always* one stop. It follows the same design philosophy as the standard aperture openings and shutter speed settings (which doubles or halves with each full click) on your camera and the amount of light indicated by your spotmeter in EVs. **Image zones** in photography include "slide or transparency zones," "negative zones" and "print zones." Depending on how the subject is photographed and how the negative, slide or paper is processed, theoretically, these zones can be less than, equal to, or greater than one stop. The discussion of these image zones can become complex and are beyond the scope of this introductory text book.

6.10. Why do different Zone Systems have an odd number of zones?

When you look at different Zone systems, you will notice that the number of zones in each system is odd. Minor White's interpretation of Ansel Adams's Zone System has nine related zones, Phil Davis has seven, Glen Fishback in his classic literature also had seven, and our simplified version has only five.

The reason behind this is simple. The only way you can divide a number by 2 and have one left is if the number is odd. By the same reasoning, if you had six fingers, you would not have a middle finger. Therefore the only way that we can have a **middle gray** tone as our starting point is if we have an odd number of standard tones (zones) in our system.

6.11. Incident metering versus the Zone System -- Which one is better?

The major advantage of an incident meter is its ease of use by the unskilled. The best application of an incident meter is when you are photographing average subjects. An average subject, according to our definition, is a subject that does not contain any extremes of tones. Perhaps you can consider such a subject to have tones that are represented by 4.5% to 72% tone ruler. If your subject is black velvet, your incident meter fails and you will get a totally black image with no detail. If the subject is a super white snow with some glare, the reverse will happen and the final image will be washed-out.

Assuming a skilled photographer uses both incident and reflective techniques for the same average subject, both exposures will be very close if not identical.

The major disadvantage of incident metering is that the photographer has to be in the same light as the subject, or at least have access to the subject's light. The other disadvantage is that it cannot be used for manipulating tones and controlling image detail.

The beauty and the power of the *Zone System* of reflective light measurement, especially when using a spotmeter, is unlimited. This system allows the

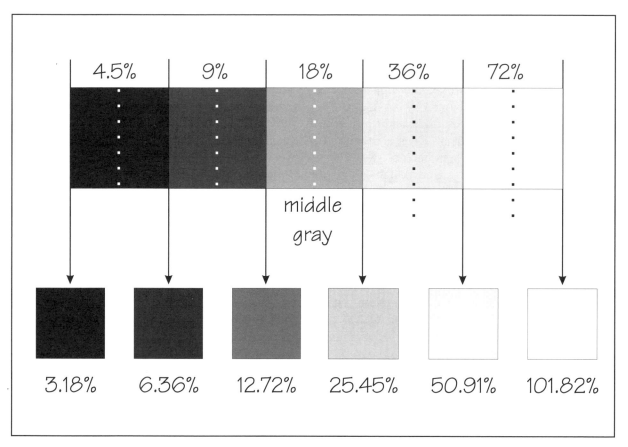

Diagram 6.9.0

Subject Brightness Range versus Subject Brightness Ratio
Diagram illustrating actual tones for the "middle gray (center)" zone as well as the actual tones for the edges of each tone. The Subject Brightness Range (SBR) of this Tone-Ruler is five stops since it has six markings. Its Brightness Ratio is the reflectivity of the darkest tone that it represents (3.18) into the brightness of the whitest surface that it represents (101.82%). This division (101.82 / 3.18) yields an approximate Brightness Ratio of 32. If you wonder where I got 3.18 from, it is [4.5 ÷ 1.41] where 1.41 is the square root of 2 [$\sqrt{2}$]. In other words 1.41 × 1.41 = 2.

Subject Brightness Range	1	2	3	4	5	6	7	8	9	10
Subject Brightness Ratio	2	4	8	16	32	64	128	250	500	1000

photographer to get accurate readings from the subject, and this in turn allows him or her enough control to construct and previsualize the tones of the final image.

6.12. How does our simplified Zone System compare with other classic systems?

Of all photographers of this century, Ansel Adams is the most known photographer who popularized the Zone System. The basis for the system used by Ansel Adams relates to large format cameras, black and white negatives and total control from the point of exposure to developing the negative and printing it on the paper. To understand the entire process, one has to have a good knowledge of light measurement, sensitometry (which in part includes analysis of the negative) and most important of all, to have creative darkroom skills. For this overview, we will use his zone numbering conventions, which were slightly modified by Minor White of MIT. As in any other Zone System, Ansel Adams started with 18% gray as the middle zone and built a Nine-Zone Tone Ruler. This ruler included 1.1%, 2.25%, 4.5%, 9%, 18%, 36%, 72%, 144% and 288% subject zones. He called the 1.1% subject zone ZONE-I, 2.25% subject zone ZONE-II, 4.5% subject zone ZONE-III, 9% subject zone ZONE-IV and the 18% (medium gray zone) subject zone ZONE-V and so on.

As in our Five-Stop Zone System, there is also one stop of difference between each of these related subject zones. Of course, since the contrast range of a negative is greater than slide film, this system has four more zones than what we covered in this book. The contrast range of nine is the contrast range that can be *theoretically* achieved when a large format camera is used to capture the image on black and white film. Currently, the most accepted version of the classic Zone System is the one perfected by Minor White, who used Ansel Adams's Zone System as its base. Minor Whites book is published by Morgan & Morgan, titled "The New Zone System Manual" that is co-authored by Richard Zakia and Peter Lorenz. Although the work of Ansel Adams and Minor White are classics, unfortunately they cannot be used by the everyday photographer carrying a 35mm or medium format camera.

The birth of spotmeters in the early to mid 60s, encouraged photographers and educators like Glen Fishback, to simplify the classic Zone System. Fishback's simplified Zone System had seven zones. In his literature that was frequently published in different photographic magazines in the mid-sixties to mid-seventies, he referred to these "Zones" as "Values." His tone Ruler ranged from Value-1 to Value-7 with the 18% gray tone (Value-4) in its middle. His first national article on this subject was published in 1968 in February/March issue of Camera 35, titled "A practical Zone System."

Another outstanding educator who has adapted the practical Seven-Stop subject zone as its base is Phil Davis. His system starts as ZONE V as the middle. The extremes of his system are ZONE II (black) and ZONE VIII (white). Books written by Phil Davis include "Photography by W.C. Brown Publishers" and "Beyond the Zone System by Focal Press."

Minor White's Nine-Stop Zone System (A simplified and a more streamlined version of Ansel Adams' Zone System)

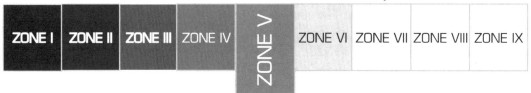

Glen Fishback's Seven-Stop VALUE System, also known as the Value/Range System

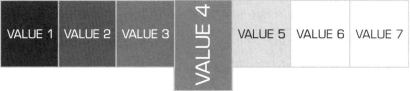

Phil Davis' Seven-Stop Zone Assignments

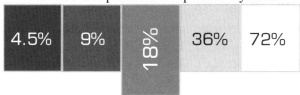

Farzad's Simplified 5-Stop Zone System

4.5%	9%	18%	36%	72%

Farzad's Simplified 5-Stop Zone System as it applies to Digital Photography with 256 Grayscale divisions of 000 (maximum black) to 255 (maximum white) with 128 in the middle. NOTE: These numbers are approximate and are *rounded* to 50 Grayscale divisions for simplicity.

-100	-050	0	+050	+100
28	78	128	178	228

Diagram 6.13.0

How does our simplified system compare with the classics?

Diagram illustrating *related* subject zones for more practical Zone Systems and their approximate relationship with one another.

Please Note: The shading density in this illustration does not represent their actual reflectivities. Please also note that this comparative analysis is approximate and is for illustrative purposes only.

6.13. How to use this simplified system when using black and white negatives?

Although I do not want to get too deep into this subject, the following are the most important differences between slide and black and white film.

6.13.1. The Film Contrast Range (FCR)

For practical purposes, the FCR of black and white films used by many photographers is around seven stops. This compares with the FCR of five that we used throughout this book with slide film.

6.13.2. The Reference Tone

In this book, with slide (positive) film, we selected the medium to brighter (whiter) portion of the subject to be used as our Reference Tone. With negative film, as the name implies, the selection is exactly opposite. In this case, we select the medium to darkest area of the subject (lowlight) that we are interested in capturing detail.

The logic behind this is simple. By choosing the lowlight portion of the subject as a Reference Tone, depending on the degree of the desired detail, we can place this tone into any of the darker zones of our Tone Ruler. These include 2.25% or 4.5% zones. While concentrating on the lowlights of the subject, for a subject with a long tonal range, there is a good possibility that we will produce overexposed highlights on the negative. The philosophy with this technique is that "overexposed highlights are better than underexposed lowlights" or simply said "with overexposed highlights, you have always something to show for, where with the underexposed lowlights you have nothing."

The following is a summary:

OVEREXPOSED HIGHLIGHTS:

Although overexposed highlight may go off the film's seven-stop FCR, they will have enough detail that can be forced out of the negative in the darkroom.

OVEREXPOSED LOWLIGHTS:

Lowlights that can be placed in the 2.25% or 4.5% zones of the ruler will record on the film and retain marginal detail so that they can be printed in the darkroom.

UNDEREXPOSED LOWLIGHTS:

This is perhaps the worst nightmare of a photographer. With underexposed lowlights (underexposing the black and white negative causes this), there is no recorded detail on the negative that a photographer can print.

These areas will be totally black and nothing a photographer can do to will bring back the original subject detail.

References

Although there are many books available on the subject of the Zone System, there is not a single book that covers it all. The advanced Zone System requires a good knowledge of black & white, darkroom skills, sensitometry, large format cameras and mathematics.

The following is a list of books and materials that I found to be helpful for light measurement, general photography and the Zone System reference.

Elementary Readings and reference

How to use a spotmeter -- Glen Fishback, Petersen's Photographic, January 1973

Glen Fishback Exposure System -- The Glen Fishback School of Photography Inc. 1978

Photography -- Phil Davis, Wm. C. Brown Publishers, 1990

The Encyclopedia of Advanced Photography -- Michael Freeman, Chartwell Books, 1985

Light and Film, Time-Life Books -- Library of Photography, 1970

The 35mm Handbook, Michael Freeman -- Ziff Davis Books, 1980

Minolta, Auto Meter III, Owners Manual -- Minolta Camera Co.

Pentax Digital Spotmeter -- Operating Manual, Asahi Optical Co.

Intermediate and advanced reading and reference

The Negative -- Ansel Adams, New York Graphic Society, 1983

The New Zone System Manual -- White, Zakia, Lorenz, Morgan & Morgan, 1989

Beyond The Zone System -- Phil Davis, Focal Press, Butterworth Publishers, 1988

Darkroom Book -- By the editors, Morgan & Morgan, 1980

Appendices

Appendix A: Neutral Density Filters and Their Corresponding Reduction Power

ND Filter Number	Filter Characteristics	Reduction Factor (Number of f-stops)
0.0	Allows 1/1 (100%) of incident light to pass through (clear glass)	0
0.3	Allows 1/2 (50%) of incident light to pass through	1
0.6	Allows 1/4 (25%) of incident light to pass through	2
0.9	Allows 1/8 (12.5%) of incident light to pass through	3
1.2	Allows 1/16 (6.25%) of incident light to pass through	4
1.5	Allows 1/32 (3.12%) of incident light to pass through	5
1.8	Allows 1/64 (1.56%) of incident light to pass through	6
2.1	Allows 1/128 (0.78%) of incident light to pass through	7
2.4	Allows 1/256 (0.39%) of incident light to pass through	8
2.7	Allows 1/512 (0.19%) of incident light to pass through	9
3.0	Allows 1/1024 (0.097%) of incident light to pass through	10
3.3	Allows 1/2048 (0.048%) of incident light to pass through	11
3.6	Allows 1/4096 (0.024%) of incident light to pass through	12
3.9	Allows 1/8192 (0.012%) of incident light to pass through	13
4.0	Allows 1/10000 (0.010%) of incident light to pass through	13-1/3

Diagram CHA.1.0

Appendix B: Color theory and correction

The light that should matter to a photographer

1) Ultraviolet (shortest wavelength) ⟶ Visible to film only
2) Blue ⎤
3) Green ⎥ ⟶ White light -- Visible to eye and film
4) Red ⎦
5) Infrared ⟶ Visible to infrared film only

Combining Primary Colors

As far as a photographer is concerned, white light is a combination of three primary colors, namely, Blue, Green, and Red. By combining (adding) two of these colors together, we produce three new colors. These are:

Primary or additive colors

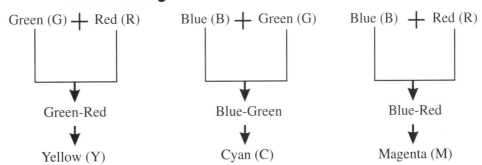

Green (G) + Red (R) Blue (B) + Green (G) Blue (B) + Red (R)

↓ ↓ ↓

Green-Red Blue-Green Blue-Red
↓ ↓ ↓
Yellow (Y) Cyan (C) Magenta (M)

Complementary or Subtractive colors

Properties of Complementary colors

 ## Yellow blocks Blue

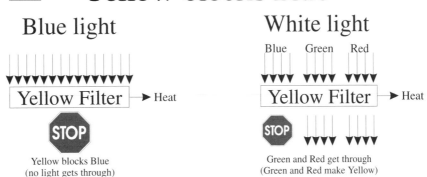

Blue light White light
 Blue Green Red

Yellow Filter → Heat Yellow Filter → Heat

STOP STOP

Yellow blocks Blue Green and Red get through
(no light gets through) (Green and Red make Yellow)

Diagram CHB.1.0

 # Cyan blocks Red

Red light

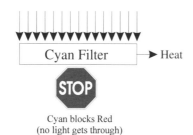

Cyan blocks Red
(no light gets through)

White light

Blue Green Red

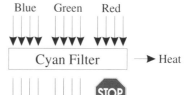

Blue and Green get through
(Blue and Green make Cyan)

 # Magenta blocks Green

Green light

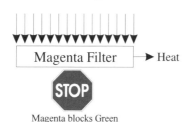

Magenta blocks Green
(no light gets through)

White light

Blue Green Red

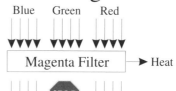

Blue and Red get through
(Blue and Red make Magenta)

Conclusions

Relationship between primary and complementary colors

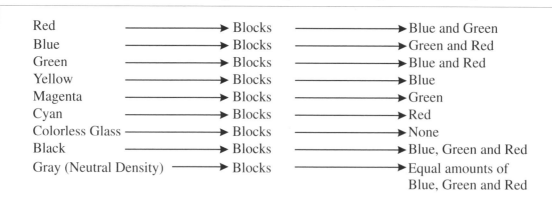

Red	Blocks	Blue and Green
Blue	Blocks	Green and Red
Green	Blocks	Blue and Red
Yellow	Blocks	Blue
Magenta	Blocks	Green
Cyan	Blocks	Red
Colorless Glass	Blocks	None
Black	Blocks	Blue, Green and Red
Gray (Neutral Density)	Blocks	Equal amounts of Blue, Green and Red

Diagram CHB.1.1

C.1 Digital Photography and Spotmetering:

The same technique that one uses with standard (analog) cameras also applies to digital cameras. When I bought my first digital camera, I very quickly realized that with this miracle of science, I still needed the skill to correctly expose my images. The little viewing screen on the back of the camera was not big enough (or accurate enough) to satisfy me. The only advantage of digital cameras was that the film was cheap and I could quickly correct my compositional errors.

The material covered here is **_not_** intended to be comprehensive. It is for photographers with digital cameras who have realized that even with digital cameras one needs to have exposure skills. In many cases the subject simply does not wait for the photographer to find its exposure by trial and error.

C.2 Gray making property of the Digital Metering:

What you learned about spotmetering in the book also applies to your digital cameras. What this means is that "the image tone (density) of a normally exposed simple subject will **_always_** have an 18% gray image tone!" The great feature of Digital Photography is that you can feed the results into your computer and analyze them quickly.

I assume that you have an image editing/manipulation software such as Adobe's Photoshop (or a less expensive software that does almost the same thing) on your Personal Computer. In my examples I will be using Adobe Photoshop for illustration purposes.

C.3 Digital Experiments:

Set your camera mode to Manual exposure. Please note that many cameras on the market do not have this feature. This includes some of the Nikon CoolPix cameras such as CoolPix 900 and CoolPix 950. If you do not have this feature, you can **_not_** use your camera to apply the spotmetering techniques that we discussed in this book. ***With the "M"anual exposure cameras, you can set the aperture opening and the shutter speed to anything that you wish and then take the picture.*** When performing the following experiment, please choose a sunny day (no clouds) and place your subjects to be photographed ***in the shade.***

1- Photographing an 18% Gray Card:

With your camera set to manual and your exposure mode set to [SPOT] take a photograph of a normally exposed 18% gray card.

2- Photographing a white card (white piece of paper):

With your camera set to manual and your exposure mode set to [SPOT] take a photograph of a normally exposed white card (white piece of paper).

3- Photographing a black card:

With your camera set to manual and your exposure mode set to [SPOT] take a photograph of a normally exposed black card.

C.4 Photoshop Color Picker Option exercise: 256 Grayscale divisions between black and white

Before downloading your images into your computer, start your image editing software (In my case Photoshop). Now click on the Foreground Color (a square box at the lower end of the Tool Box). The Color Picker menu will appear. Now type in 128 in Red (R:), 128 in Green (G:), and 128 in Blue (B:). Once you are done, depending on the version of Photoshop used, the magic number of 18% (or in this case 8%) will appear at the bottom of the Menu/Screen in front of BlacK (K:). If different numbers for different versions of Photoshop confuse you, do not worry. The most important feature is that the semi-circle on the left hand side of the illustration will appear exactly in the middle of the box (in the middle of black and white tones). The R:128, G:128, and B:128 numbers work very much like the 18% gray card. They are neutral and have no color bias. By definition, the darkest assignment on your monitor has a Grayscale value of "000" and the brightest (whitest) assignment on your monitor has a Grayscale assignment of 255 with 128 being the middle of 256.

C.5 Now download your three images to your computer and analyze their tones

Download your three images to your PC. Please edit each of these images and take away their color, and then save them! In Photoshop, this is done by clicking on Image ➤ Mode ➤ Grayscale options.

Now bring each image (one at a time), activate the Eyedropper tool, and click on the middle of the image. Now click on the foreground color (the rectangular box in the tool bar that has the same tone of gray as your image). Now the Color picker screen/Menu appears. If you have done your experiment correctly, a gray density value of RED:128, GREEN:128, and BLUE:128 will appear on the screen. If you did not get exactly 128, do not worry! Nobody does! Anywhere

Our 5-stop Tone Ruler (Standard Subject Tones)

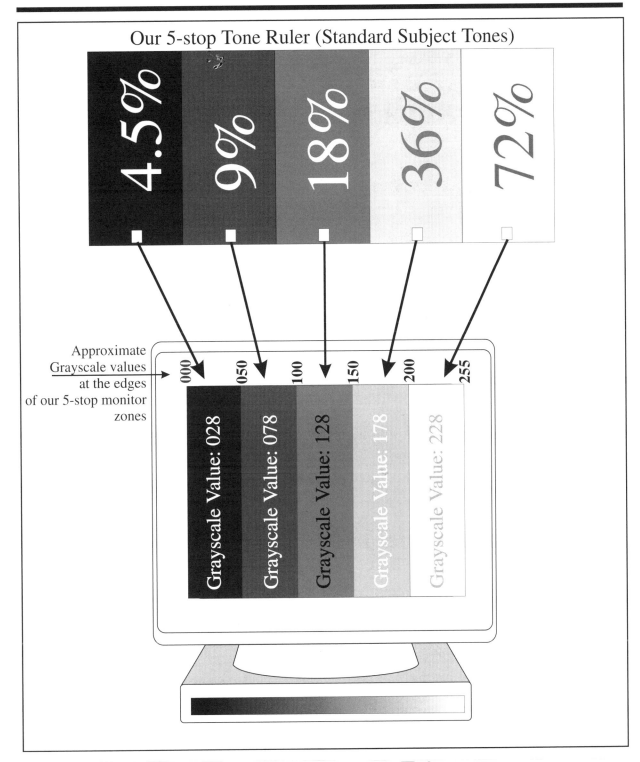

Approximate Grayscale values at the edges of our 5-stop monitor zones

Diagram CHC.1.0 Diagram

Illustrating Grayscale Values on your monitor corresponding to our 5-stop Tone Ruler. Please note that to make it easy to remember and understand, the lowlight tone (4.5%) has been oversimplified and approximated to a linear scale, i.e., "028" instead of "038".

around 128 should be good. Mine was 133. *You should get approximately the same number from each of your three experiments*.

C.6 How Gray Density Values relate to our 5-stop Tone Ruler?

Assume that in your experiment, the Normal Exposure for your gray card was 1/125@f-5.6. Now take five pictures of the gray card with the following exposures: 1/500@f-5.6, 1/250@f-5.6, 1/125@f-5.6, 1/60@f-5.6, and 1/30@f-5.6. If you convert these to Grayscale and measure their Grayscale Density, you will get the following *approximate* numbers:

1/500@f-5.6	1/250@f-5.6	1/125@f-5.6	1/60@f-5.6	1/30@f-5.6
038	078	128	178	228

If you forget this scale, each tone falls ___approximately___ 50 Grayscale division on each side of medium gray with a value of 128.

Therefore our Tone ruler values will translate into your monitor's brightness (image tones) as follows:

5-Stop Tone Ruler components	Your monitor's Grayscale value (approximate)
4.5% Black	028*
9% Dark Gray	078
18% Medium Gray	128
36% Light Gray	178
72% white	228

* In order to simplify these numbers, the 4.5% image tone has been assigned a Grayscale density of 028.

Now that you know the secret, you can fit any of the tones of your 5-stop Tone Ruler into the appropriate brightness of your monitor!

C.7 How to calibrate your Digital acmera's meter?

Due to the lack of consistent exposure standards in the digital world (manufacturers are still going through growing pains), we are experiencing a .5 to 1 stop of underexposure in some of the newer cameras. The discouraging part is that even the same camera manufacturer is not even consistent with exposure in their different camera models. On the other hand, some camera models (usually the less expensive D-Slr models) are dead on and produce a gray density of 128 from a normally-exposed simple surface.

If you have a camera that does not converge to 128, do not panic! You can calibrate it and learn to live with it. Having said that, there are a few things that you can do to overcome this! If your camera converges to say 103 instead of 128, there is a good possibility that almost all of your images are underexposed and you are not happy with them. Please do not blame yourself for this!

Using the Manual Exposure Mode to find the Correct "Normal Exposure"

When set to Manual Exposure Mode "M", let's assume when your camera is set to 1/60@F-9.5 , it produces a GrayScale Density of 103 from a normally exposed simple subject (as we know it should be 128), i.e., it underexposes the simple subject by ½ stop (1 stop is about 50 GrayScale Divisions). Knowing this, you can open-up your aperture by ½ stop (set it to F-8) and shoot. This will produce an image tone with a GrayScale Density of about 128. Any interpretation of the exposure setting must be done after this adjustment. For example if the subject is black, the correct exposure would be 1/60@F-16, if Dark Gray it would be 1/60@f-11, if Light Gray it would be 1/60@F-5.6, and finally if White, it would be 1/60@F-4.

Using Aperture or Shutter Priority modes to find the correct "Normal Exposure"

The other method (a longer method but easier for some) is by using the Exposure Compensation Dial on your camera. Please take a minute or two to read your camera's operational manual and learn how to set this dial to say +1/3, +1/2, +2/3, and so on.

The function of this feature, depending on your settings, is to overexpose or underexpose your exposure settings (in this case your Normal Exposure settings) by say 1/3, 1/2, 2/3 and up to 2 stops. Unfortunately, for many of today's digital cameras, the exposure compensation works only in Aperture Priority (A or AV), and Shutter Priority (S or TV). It will not work in the Manual Exposure Mode. In Aperture-Priority or Shutter Priority Mode, in order to make your camera to converge to a 128 gray scale density from for example a 103 gray scale density, set your Exposure Compensation to + 0.5 (1/2 of a stop increase corresponding to 25 GrayScale Divisions), point your camera at a simple surface, and then find its Normal Exposure. In the previous example with the exposure compensation set to +0.5 (1/2), it would read 1/60@F-8 (and not 9.5 that we obtained from exposing the subject Manually).

Now you MUST turn your exposure mode to "Manual", set your shutter speed and aperture to 1/60@F-8 and then interpret. When using this technique, please NEVER shoot in Aperture or Shutter Priority unless you are photographing an 18% gray card! Once you are in the Manual Exposure Mode, depending on your subject tone, you can interpret and then shoot.

For example if the subject tone is black, the correct exposure would be 1/60@F-16, if it is Dark Gray, it would be 1/60@f-11, if Light Gray it would be 1/60@F-5.6, and finally if White, it would be 1/60@F-4.

Special Note 1:

If your camera is set to 1/3 stop steps (i.e. three clicks of the wheel will change your aperture opening say from 5.6 to 8 or from 1/60 sec to 1/125 sec., instead of 25 (1/2 stop) GrayScale Divisions, you need to add 17 (1/3 stop comes from dividing 50 by 3) to get your normal exposure close to the 128 GrayDensity number.

Special Note 2:

If your camera does not allow you to get exactly to 128, do not worry. As long as you are around say 1/10 stop (123 to 133) you will be fine.

Special note 3:

If you are not using the technique (you are using the program mode or aperture/shutter priority modes) and your images are consistently dark, you can keep the exposure compensation dial to say +1/3 or +1/2 stop. There is a good possibility that your images will be brighter and better-exposed.
Just give it a try!

Guides to Manual Exposure and Spot Metering operations for some popular cameras

What is covered in this section?

This section covers manual exposure and spotmetering cheat sheets for some popular cameras with spotmetering or partial metering features.

Normal Exposure Shortcut:

In order to determine a surface's normal exposure using your on-camera spot meter, you can use the following short cut with many of the cameras featured in this section. Set your exposure mode to shutter priority "S" or "TV" (Time Value) and set the desired shutter speed. Now by pointing the spot circle (frame) at the desired simple subject and lightly pressing on the shutter release button, the corresponding aperture opening will appear on the screen. You must now go back to the Manual Mode "M" and after interpreting the normal exposure obtained, set the correct aperture opening and shutter speed and shoot. This technique is also useful when you want to determine the normal exposure of the palm of your own hand that is under the same light as your subject. Simply touch the shutter release button with one hand and obtain the exposure for your palm quickly. If Causian, after going back to Manual mode, open-up one stop and take the picture of your subject.

Please Note: It is almost impossible for me to evaluate and create a cheat sheet for every camera in the world and try to include them in this book! Having said that, I did try unsuccessfully to obtain more spot metering / partial metering cameras locally and/or through the manufacturer. Please e-mail me at cheatsheets@spotmetering.com with your camera's make and model (like Olympus E-20) and I will let you know as soon as it is ready.

1 How to set the ISO Manually	2 How to set the function to Manual mode	3 How to change the aperture Manually	4 How to change the Exposure Time (Shutter Speed) Manually	5 How to set the exposure function to Spot Metering	6 Using the Spot Metering feature of 5D to find the normal exposure of a simple subject?
a) Set the Quick Control *switch* (located on the back of the camera just above the Mode Dial) to [ON].					

b) Press and release the DRIVE·ISO button at the top of the LCD screen. The ISO will appear on the LCD screen.

c) By rotating the Quick Control Dial (a large notched circular wheel located on the back of the camera), you can set the dial to the desired ISO.

d) Press the SET dial at the center of the wheel to register the ISO. The ISO on 5D can be set to 100, 200, 400, 800, and 1600. An ISO of L/50 (Lo) and H/3200 (Hi) can also be set using the Custom Function setting of 08 with ISO Expansion Option set to 1:On. | a) Turn the Mode Dial to [M]. Your camera is now in the Manual Mode. The aperture opening and the shutter speed will now be displayed on the LCD screen. | a) By following the step 2, set your camera to the Manual Mode.

b) By turning the Power Switch on the back of the camera counterclockwise one notch after the [ON] position, the aperture can be manually changed by turning the Quick Control Dial. The Standard aperture opening values for a typical 28-135mm lens are: 4.0, 5.6, 8, 11, 16, and 22 and ½ stop values for this lens are: 4.5, 6.7, 9.5, 13, and 19. 5D also offers f-stop increments of 1/3 stop. | a) By following the step 2. set the camera to Manual Mode.

b) By rotating the Main Dial (located above the shutter release button), the value of the exposure time (shutter speed) can be changed.

c) The *standard* shutter speeds on 20D include Bulb, 30" (seconds), 15", 8", 4", 2", 1", 0.5" (1/2 second), 1/4, 1/8, 1/15, 1/30, 1/60, 1/125, 1/250, 1/500, 1/1000, 1/2000, 1/4000, and 1/8000 second. 5D also offers ½ stop as well as 1/3 stop divisions between these standard exposure times. | a) Press the Metering Mode button (please see diagram) once. Change the Main Dial until the spot metering symbol (a rectangle with a solid dot ⊡) appears on the LCD screen.

b) Your exposure mode is now set to partial metering. In this mode the camera's meter only reacts to the light that passes through the spot metering circle that is located at the center of the view finder. This circle (frame) 6mm in diameter) occupies about 3.5% of the entire viewfinder area. | a) Turn on the camera and following step 5, activate the spot metering function.

b) Set the Command Dial to [M] and for outside shots turn the main dial to choose a shutter speed that is close to the ISO of the film. For an ISO setting of 100, set the shutter speed to 1/100 or 1/125 sec.

c) To determine the normal exposure of a simple subject, point the spot/partial metering frame of the camera (at the center of the viewfinder) towards the desired *simple tone (say forehead in portrait photography)*. Now change the aperture opening by turning the Quick Control Dial so that the exposure level indicator in the viewfinder is positioned in the middle of [-2] and [+2]. |

CANON EOS 5D
(Full 35mm frame)
(D-SLR/12.8 MegaPixel)

23.9mm

35.8mm

6mm diametered Spot Metering circle (3.5% of the viewfinder area)

9.4mm dia/8% of VF area Partial Metering Circle Not outlined on the viewfinder

Canon EOS 5D
Exposure Cheat Sheet

35.8 X 23.9mm CCD (Full Frame)
partial 8% of ViewFinder
spot 3.5% of ViewFinder
12.8MP

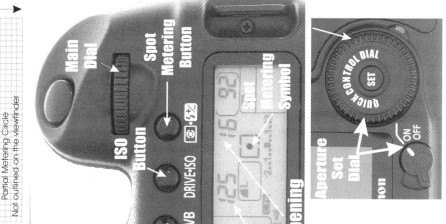

Main Dial

Spot Metering Button

Spot Metering Symbol

ISO Button

AF·WB DRIVE·ISO

Shutter Speed

Aperture Opening

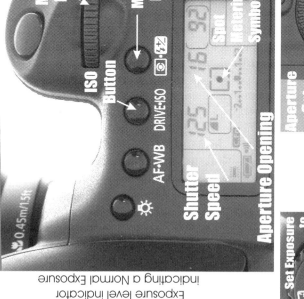

Exposure level indicator indicating a Normal Exposure

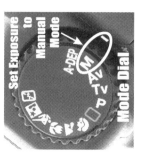

QUICK CONTROL DIAL SET

Aperture Set Dial

ON OFF

Set Exposure to Manual Mode

Mode Dial

A-DEP M Av Tv P

1 How to set the ISO Manually	2 How to set the function to Manual mode	3 How to change the aperture Manually	4 How to change the Exposure Time (Shutter Speed) Manually	5 How to set the exposure function to Spot (Partial) Metering	6 Using the SPOT function, how to find the normal exposure of a simple subject?
a) Set the Quick Control *switch* (located on the back of the camera just above the Mode Dial) to [ON]. b) Press and release the DRIVE-ISO button at the top of the LCD screen. The ISO will appear on the LCD screen. c) By rotating the Quick Control Dial (a large notched circular wheel located on the back of the camera), you can set the dial to the desired ISO. d) Press the SET dial at the center of the wheel to register the ISO. The ISO on 10D can be set to 100, 200, 400, 800, and 1600.	a) Turn the Mode Dial to [M]. Your camera is now in the Manual mode. b) Set the Quick Control *switch* (located at back of the camera just above the Mode Dial) to [ON]. The aperture opening and the shutter will now be displayed on the LCD screen.	a) By following the step 2, set your camera to the Manual Mode. b) By turning the Quick Control Dial on the back of the camera the aperture can be manually changed. The STANDARD aperture opening values for a typical 50mm lens are: 1.8, 2.8, 4.5, 8, 11, 16, and 22. 1/3 stop values include: 2.0, 2.5, 3.5, 4.0, 4.5 and 1/2 stop values include 6.7, 9.5, 13, and 19.	a) By following the step 2, set the camera to Manual Mode. b) By rotating the Main Dial (located above the shutter release button), the value of the exposure time (shutter speed) can be changed. c) The standard shutter speeds on 10D include Bulb, 30" (seconds), 15", 8", 4", 2", 1", 0"5 (1/2 second), 1/4, 1/8, 1/15, 1/30, 1/60, 1/125, 1/250, 1/500, 1/1000, 1/2000, and 1/4000 second. 10D also offers 1/4 stop divisions between these standard exposure times.	a) Press the metering mode button so that the shutter speed and the aperture opening dials disappear from the LCD screen and the exposure mode is displayed on the LCD screen (please see diagram). Change the Main Dial until the partial metering symbol (a rectangle with a hollow circle ⊙ inside) appears on the LCD screen.. b) Your exposure mode is now set to partial metering. In this mode the camera's meter only reacts to the light that passes through the partial metering circle that is located at the center of the view finder occupying about 9% of the entire viewfinder area	a) Turn on the camera and following step 5, activate the spot metering (partial metering) function. b) Set the Command Dial to [M] and for outside shots turn the main dial to choose a shutter speed that is close to the ISO of the film. c) To determine the normal exposure of a simple subject, point the spot metering/partial metering area of the camera, located at the center of the viewfinder towards the desired *simple tone*. Now change the aperture opening by turning the Quick Control Dial (a large notched wheel located on the *back* of the camera), so that the exposure level indicator in the viewfinder is positioned in the middle of [-2] and [+2] directly under [0].

CANON EOS 10D
(D-SLR/Digital)

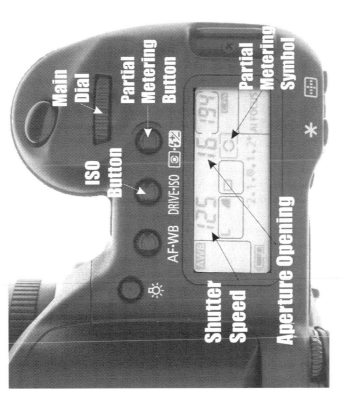

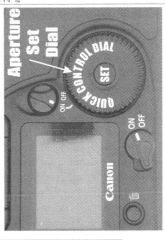

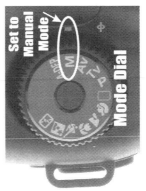

1 How to set the ISO Manually	2 How to set the function to Manual mode	3 How to change the aperture Manually	4 How to change the Exposure Time (Shutter Speed) Manually	5 How to set the exposure function to Spot (Partial) Metering	6 Using the Partial Metering feature of 20D to find the normal exposure of a simple subject?
a) Turn the switch on the back of the camera to the [ON] position. b) Press and release the DRIVE-ISO button at the top of the LCD screen. The ISO will appear on the LCD screen. c) By rotating the Quick Control Dial (a large notched circular wheel located on the back of the camera), you can set the camera to the desired ISO. d) Press the SET dial at the center of the wheel to register the ISO. The ISO on 20D can be set to 100, 200, 400, 800, and 1600. An ISO of 3200 can also be set using the Custom Function feature of the camera.	a) Turn the Mode Dial to [M]. Your camera is now in the Manual mode. The aperture opening and the shutter speed will now be displayed on the LCD screen.	a) By following the step 2, set your camera to the Manual Mode. b) By turning the Power Switch on the back of the camera counterclockwise one notch after the [ON] position, the aperture can be manually changed by turning the Quick Control Dial. The Standard aperture opening values for a typical 28-200mm lens are: 4.0, 5.6, 8, 11, 16, and 22 and ½ stop values for this lens are: 4.5, 6.7, 9.5, 13, and 19.	a) By following the step 2, set the camera to Manual Mode. b) By rotating the Main Dial (located above the shutter release button), the value of the exposure time (shutter speed) can be changed. c) The *standard* shutter speeds on 20D include Bulb, 30" (seconds), 15", 8", 4", 2", 1", 0.5" (1/2 second), 1/4, 1/8, 1/15, 1/30, 1/60, 1/125, 1/250, 1/500, 1/1000, 1/2000, and 1/4000 second. 20D also offers ½ stop as well as 1/3 stop divisions between these standard exposure times.	a) Press the Metering Mode button (please see diagram) once. Change the Main Dial until the partial metering symbol (a rectangle with a hollow circle ⊙ inside) appears on the LCD screen. b) Your exposure mode is now set to partial metering. In this mode the camera's meter only reacts to the light that passes through the partial metering circle that is located at the center of the view finder. This circle (frame) occupies about 9% of the entire viewfinder area.	a) Turn on the camera and following step 5, activate the spot metering (partial metering) function. b) Set the Command Dial to [M] and for outside shots turn the main dial to choose a shutter speed that is close to the ISO of the film. For an ISO setting of 100, set the shutter speed to 1/100 or 1/125 sec. c) To determine the normal exposure of a simple subject, point the spot/partial metering frame of the camera (at the center of the viewfinder) towards the desired *simple tone*. Now change the aperture opening by turning the Quick Control Dial so that the exposure level indicator in the viewfinder is positioned in the middle of [-2] and [+2].

CANON EOS 20D
(D-SLR/Digital)

15mm

22.5mm

Partial Metering circle (frame) (9% of the viewfinder area)

-2..1..●..1..+2

Exposure level indicator indicating a Normal Exposure

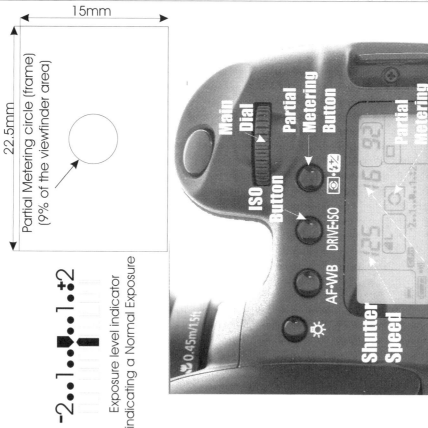

Main Dial

Partial Metering Button

ISO Button

DRIVE-ISO

AF-WB

Shutter Speed

Aperture Opening

Partial Metering Symbol

Set Exposure to Manual Mode

Mode Dial

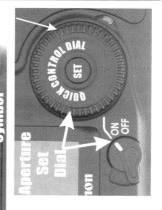

QUICK CONTROL DIAL

SET

Aperture Set Dial

ON OFF

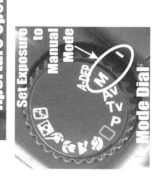

CANON EOS 30D
(D-SLR/Digital)

1 — How to set the ISO Manually	2 — How to set the function to Manual mode	3 — How to change the aperture Manually	4 — How to change the Exposure Time (Shutter Speed) Manually	5 — How to set the exposure function to Spot Metering	6 — Using the Spot Metering feature of 30D to find the normal exposure of a simple subject?
a) Turn the switch on the back of the camera to the [ON] position. b) Press and release the DRIVE-ISO button at the top of the LCD screen. The ISO will appear on the LCD screen. c) By rotating the Quick Control Dial (a large notched circular wheel located on the back of the camera), you can set the camera to the desired ISO. d) Press the SET dial at the center of the wheel to register the ISO. The ISO on 30D can be set to 100, 200, 400, 800, and 1600. An ISO of 3200 (H) can also be set using the Custom Function feature of the camera.	a) Turn the Mode Dial (located on the top left hand side of the camera) to [M]. Your camera is now in the Manual mode. The aperture opening and the shutter speed will now be displayed on the LCD screen. If the LCD screen is blank, gently press the shutter release button and the numbers will appear.	a) By following the step 2, set your camera to the Manual Mode. b) By turning the Power Switch on the back of the camera counterclockwise one notch *after* the [ON] position, the aperture can be manually changed by turning the Quick Control Dial. The Standard aperture opening values for a typical 18-55mm lens set at 1/3 stop / EV values are: 3.5, 4, 4.5, 5, 5.6, 6.3, 7.1, 8, 9, 10, 11, 13, 14, 16, 18, 20, and 22. The full stop values are 4.0, 5.6, 8, 11, 16, and 22 and ½ stop values for this lens are: 3.5, 4.5, 5.6, 6.7, 9.5, 13, and 19.	a) By following the step 2, set the camera to Manual Mode. b) By rotating the Main Dial (located above the shutter release button), the value of the exposure time (shutter speed) can be changed. c) The *standard* shutter speeds on 30D include Bulb, 30'' (seconds), 15'', 8'', 4'', 2'', 1'', 0.5'' (½ second), 1/4, 1/8, 1/15, 1/30, 1/60, 1/125, 1/250, 1/500, 1/1000, 1/2000, 1/4000, and 1/8000 second. By using Custom Functions, 30D offers ½ stop as well as 1/3 stop divisions between these standard exposure times.	a) Press the Metering Mode button (please see diagram) once. Change the Main Dial until the spot metering symbol (a rectangle with a dot inside) appears on the LCD screen. b) Your exposure mode is now set to spot metering. In this mode the camera's meter only reacts to the light that passes through the spot metering circle that is located at the center of the view finder. This spot circle (spot frame) that measures 3.88mm in diameter occupies about 3.5% of the entire viewfinder area.	a) Turn on the camera and following step 5, activate the spot metering function. b) Set the Command Dial to [M] and for outside shots turn the main dial to choose a shutter speed that is close to the ISO of the film. For an ISO setting of 100, set the shutter speed to 1/100 or 1/125 sec. c) To determine the normal exposure of a simple subject, point the spot metering frame of the camera (at the center of the viewfinder) towards the desired *simple tone.* Now change the aperture opening by turning the Quick Control Dial so that the exposure level indicator in the viewfinder is positioned in the middle of [-2] and [+2].

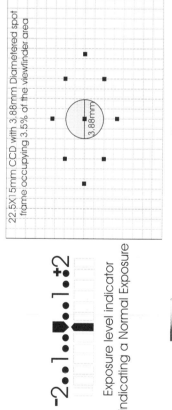

22.5X15mm CCD with 3.88mm Diametered spot frame occupying 3.5% of the viewfinder area

3.88mm

Exposure level indicator indicating a Normal Exposure

-2 . . 1 . . 1 . . +2

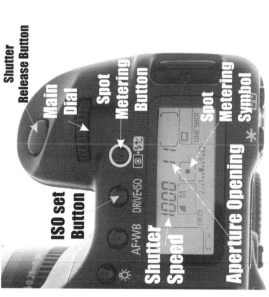

Shutter Release Button

Main Dial

Spot Metering Button

Spot Metering Symbol

ISO set Button

Shutter Speed

Aperture Opening

AF-WB DRIVE-ISO

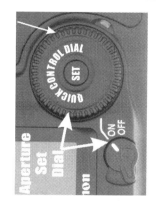

QUICK CONTROL DIAL

SET

Aperture Set Dial

ON OFF

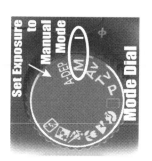

Set Exposure to Manual Mode

Mode Dial

-2 . . 1 . . 1 . . +2

1 How to set the ISO Manually	2 How to set the function to Manual mode	3 How to change the aperture Manually	4 How to change the Exposure Time (Shutter Speed) Manually	5 How to set the exposure function to SPOT	6 Using the SPOT function, how to find the normal exposure of a simple subject?
If you do not have a DX coded film (i.e., you roll your own film): a) While pushing down the Lock Release Button, turn the Command Dial to "M" b) Push and hold down the ISO Set Button (the function button marked [ISO-AEB] on the back of the camera. The ISO will appear on the LCD Screen. c) The ISO can be changed from 6 to 6400 by turning the Main Dial (a round notched wheel above the shutter release button). d) Press the shutter release button halfway to register the new ISO setting.	a) While pushing down the Lock Release Button, turn the Command Dial to "M" Now the Exposure Time (shutter speed) can be seen on the top (middle) of the LCD panel with the aperture opening to its right. The shutter speed/aperture opening shown in the photograph is 1/125@f-16.	a) Turn the Command Dial to be set to "M" (see step 2) while pushing down the Lock Release Button. b) Set the Quick Control Dial switch (a *small* round button located on the back of the camera just above the Aperture Set Control Dial to [1]. c) The aperture opening can now be changed by turning the Aperture Set Control Dial. The value of the aperture opening can be seen at the top right hand side of the LCD panel. Typical full-stop values are 4, 5.6, 8, 11, 16, 22, and 32. Typical ½ stop values are 4.5, 6.7, 9.5, 13, 19, and 27.	a) While pushing down the Lock Release Button, turn the Command Dial to "M". The shutter speed will appear at top center of the LCD Panel. b) The shutter speed can now be set by turning the Main Dial (a notched wheel located in front of the camera just above the shutter release button. Typical shutter speeds are 30" (30 seconds) to 8000 (1/8000 second). Standard shutter speeds are 30", 15", 8", 4", 2", 1", 2 (1/2 sec.), 4 (1/4 sec.), 8, 15, 30, 64, 125, 250, 500, 1000, 2000, 4000, 8000. Half stop shutter speeds are 20" (20 sec.), 10", 6", 3", 1.5"), 0.7, 3, 6, 10, 20, 45, 90, 180, 350, 750, 1500, 3000, and 6000.	a) While pushing down the Lock Release Button, turn the Command Dial to "M" b) While holding down the Metering Mode Set Button (located on the back of the camera) turn the Command Dial [•] until the [C] symbol appears at the bottom left hand corner of the LCD panel.	a) While pushing down the Lock Release Button, turn the Command Dial to "M". By following step 5, set your camera's metering mode to spot [C] b) For outside shots, turn the main dial to choose a shutter speed that is close to the ISO of the film. For example for a 100 ISO film, set the shutter speed to 1/90 or 1/125 sec. c) To determine the normal exposure of a simple subject, point the spotmetering area of the camera, located at the center of the viewfinder (a clear circle) towards the desired *simple tone*. Now turn the Aperture set Control Dial (Quick Control Dial, a large notched wheel located on the *back* of the camera), so that the exposure level indicator in the viewfinder indicates normal exposure. This is when the [⊕] symbols appear side-by-side in the viewfinder.

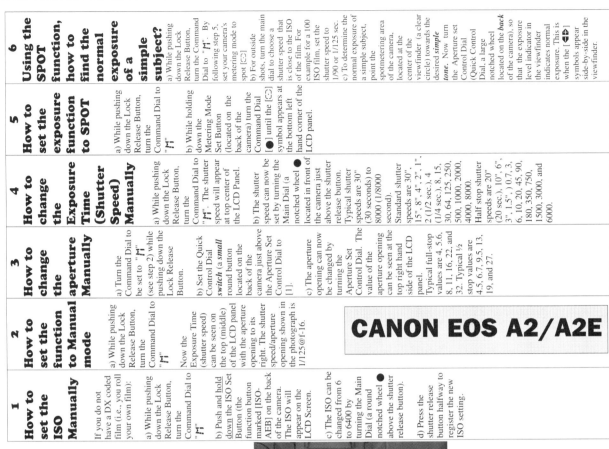

CANON EOS A2/A2E

Quick Control Dial Switch

Aperture Set Control Dial

Metering mode set button

ISO set button

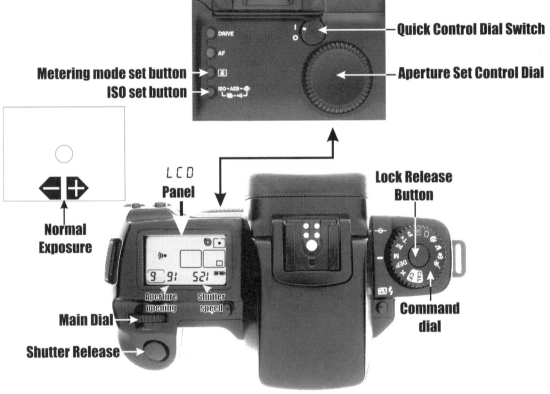

Normal Exposure

LCD Panel

Lock Release Button

Main Dial

Aperture opening

Shutter speed

Command dial

Shutter Release

1 How to set the ISO Manually	2 How to set the function to Manual mode	3 How to change the aperture Manually	4 How to change the Exposure Time (shutter speed) Manually:	5 How to set the exposure function to Partial Metering	6 How to find the normal exposure of a simple subject?
If you do not have DX coded film (i.e., you roll your own film): a) Press the "FUNC" button on the back of the camera until the arrow ">" points to the ISO icon. The ISO value now appears on the LCD panel. b) By turning the Main Dial (notched wheel located near the shutter release button), you can set the dial to your desired ISO. The ISO values on Rebel Ti can be set to 6, 8, 10, 12, 16, 20, 25, 32, 40, 50, 64, 80, 100, 125, 160, 200, 250, 320, 400, 500, 640, 800, 1000, 1250, 1600, 2000, 2500, 3200, 4000, 5000, and 6400.	a) Turn the Rotary Command Dial to [M]. Your camera is now in Manual mode. b) The shutter speed appears on the left hand side of your LCD panel, the aperture opening appears on the right, and the letter "M" appears at the top of the LCD screen.	a) Turn the Command Dial to [M] (see step 2). b) Push and hold down the "AV+/−" (the top button on the back of the camera) while rotating the "Main Dial". The aperture opening (Value) can now be set to different values. Typical Full-Stop values include 4, 5.6, 8, 11, 16, 22, and 32. Typical 1/2 stop values can include 4.5, 6.7, 9.5, 13, 19, and 27.	a) Set the camera mode to Manual [M] (see step 2). The shutter speed / Exposure Time now appears on the left hand side of the LCD screen and its value can be changed by rotating the Main Dial. b) By rotating the Main Dial (a notched wheel located near the shutter release button), the shutter speed (exposure time) can be changed by 1/2 stop each time from 30" (30 sec.) to 2000 (1/2000 sec.). Some typical shutter speeds include 15, 30, 60, 125, 250, 500, and 1000 and some midpoint shutter speeds include 20, 45, 100, 180, 350, and 750. Please remember that mostly used shutter speeds are in a fractions of a second.	a) Select an aperture opening. If there is a lot of light, choose a small opening (like f-11, f-16, or smaller). If the subject is dark, choose a large opening (like f-4, f-2.8, f-2, or larger). b) While pointing the center of the camera at the desired simple surface Reference Tone), press down the spot metering / partial metering button [*] referred to as "AE lock" or "Auto Exposure lock", the camera is in the spot / partial metering mode. As long as the [*] appears at the bottom of the viewfinder, the camera is in the spot / partial metering mode and its exposure is "locked" onto the surface that the camera was point at when the [*] was pushed down.	a) If the subject is bright, the aperture should have a small opening such as f-11, f-16, or smaller. If the subject is dark, the aperture should have a large opening such as f-4, f-2.8, f-2, or larger. b) Now point the center of the camera at the desired simple subject (Reference Tone) and press the partial metering button located on the back of the camera and marked with an [*]. An [*] will appear to the left of your display in the viewfinder. c) While [*] is showing in your viewfinder your exposure is locked to that specific surface. Now Turn the Main Dial until the exposure level indicator (index) in the viewfinder is positioned in the middle of [-2] and [+2] directly under [0]. If you change your Reference tone and the [*] is still in your viewfinder, press the [*] to re-expose.

CANON EOS Rebel Ti / 300V

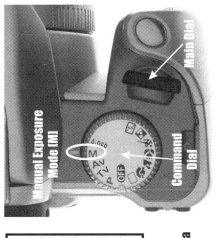

Canon EOS Rebel Ti (300V)
Partial Metering area (shaded)
Occupies 9.5% of the viewfinder area

⁻2.1.⚫.1.2⁺

Meter indicating a normal exposure

How to set the ISO Manually	How to set the function to Manual mode	How to change the aperture Manually	How to change the Exposure Time (Shutter Speed) Manually	How to set the exposure function to Spot (Partial) Metering	Using the Partial Metering feature of Rebel XT to find the normal exposure of a simple subject?
a) Turn the switch to ON position. b) Press the ISO (Upward arrow on the back of the camera). c) The ISO speed menu will appear on the screen. d) Use up/down arrows to set the desired ISO. e) Press the set button to register the new ISO. Canon Rebel XT's ISO can be set to 100, 200, 400, 800, and 1600.	a) Turn the Mode Dial to [M]. Your camera is now in the Manual mode. The aperture opening (in the middle) and the shutter speed (on the right) will now be displayed on the LCD screen.	a) By following the step 2, set your camera to the Manual Mode. b) By turning the Main dial while pressing the A/V (aperture/Exposure) dial you can change the aperture opening of the lens. The Standard aperture opening values for a typical 18-55mm lens in an Un-zoomed (wideangle, say 18mm) position are: f:4.0, 5.6, 8, 11, 16, and f:22 and 1/3 stop values for this lens are: f:3.5, 4.5, 5, 6.3, 7.1, 9, 10, 13, 14, 18, 20. For the zoomed position (say 80mm), these can range from f:5.6 to about f:36.	a) By following the step 2, set the camera to Manual Mode. b) By rotating the Main Dial (located above the shutter release button), the value of the exposure time (shutter speed) can be changed. c) The *standard* shutter speeds on Rebel XT include Bulb, 30" (seconds), 15", 8", 4", 2", 1", 0.5" (1/2 second), 1/4, 1/8, 1/15, 1/30, 1/60, 1/125, 1/250, 1/500, 1/1000, 1/2000, and 1/4000 second. Rebel XT also offers 1/3 stop divisions between these standard exposure times.	a) Press the Metering Mode button (please see diagram) once. Change the Main Dial until the partial metering symbol (a rectangle with a hollow circle inside) appears on the LCD screen. b) Your exposure mode is now set to partial metering. In this mode the camera's meter only reacts to the light that passes through the partial metering circle that is located at the center of the view finder. This circle (frame) occupies about 9% of the entire viewfinder area.	a) Turn on the camera and following step 5, activate the spot metering (partial metering) function. b) Set the Command Dial to [M] and for outside shots turn the main dial to choose a shutter speed that is close to the ISO of the film. For an ISO setting of 100, set the shutter speed to 1/100 or 1/125 sec. c) To determine the normal exposure of a simple subject (for a portrait the forehead), point the spot/partial metering frame of the camera (at the center of the viewfinder outlined by a dotted line in the illustration) towards the desired *simple tone*. Now change the aperture opening by turning the Quick Control Dial so that the exposure level indicator in the viewfinder is positioned in the middle of [-2] and [+2].

CANON Rebel XT
EOS 350D - (D-SLR/Digital)

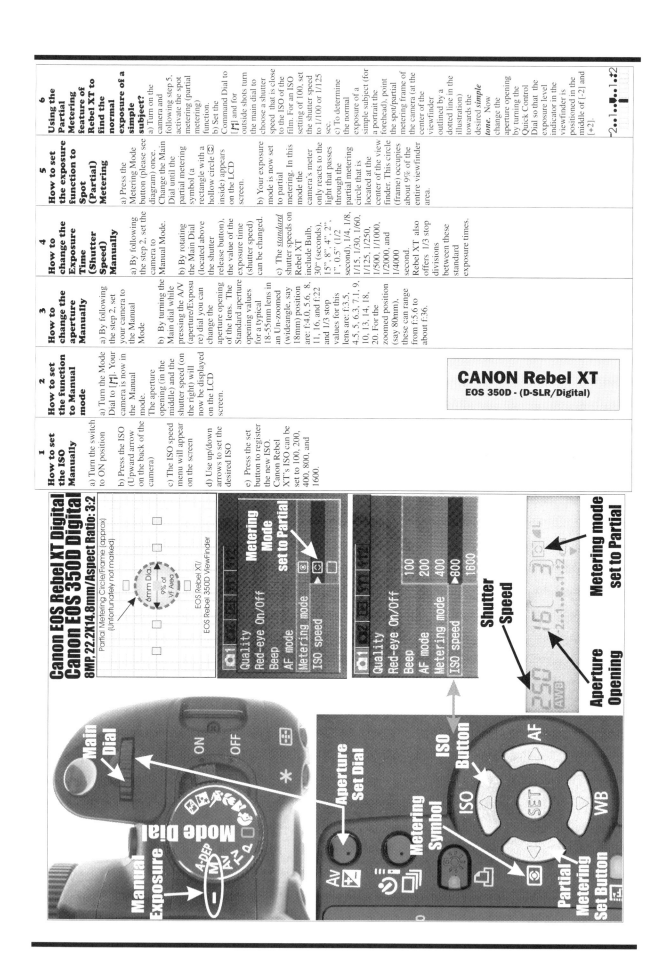

1 How to set the ISO Manually	2 How to set the function to Manual mode	3 How to change the aperture Manually	4 How to change the Exposure Time (Shutter Speed) Manually	5 How to set the exposure function to Spot (Partial) Metering	6 Using the Partial Metering feature of Rebel XTI to find the normal exposure of a simple subject?
a) Turn the switch to ON position b) Press the ISO (Upward arrow on the back of the camera) c) The ISO speed menu will appear on the screen d) Use up/down/left/right arrows to set the desired ISO e) Press the set button to register the new ISO. Canon Rebel XTI's Standard ISOs can be set to 100, 200, 400, 800, and 1600.	a) Turn the Mode Dial to [M]. Your camera is now in the Manual mode. The aperture opening (in the middle) and the shutter speed (on the left will now be displayed on the LCD screen on the back of the camera.	a) By following the step 2, set your camera to the Manual Mode. b) By turning the Main dial while pushing the A/V (aperture/Exposure) dial down, you can change the aperture opening of the lens. The Standard aperture opening values for a typical 18-55mm lens in an Un-zoomed (wide angle, say 18mm) position are: f:4.0, 5.6, 8, 11, 16, and f:22 and 1/3 stop values for this lens (Custom Function 06) are: f:3.5, 4.5, 5, 6.3, 7.1, 9, 10, 13, 14, 18, 20. For the zoomed position (say 80mm) these can range from f:5.6 to about f:36.	a) By following the step 2, set the camera to Manual Mode. b) By rotating the Main Dial (located above the shutter release button), the value of the exposure time (shutter speed) can be changed. c) The *standard* shutter speeds on Rebel XTI include Bulb, 30' (seconds), 15", 8", 4", 2", 1", 0.5" (1/2 second), 1/4, 1/8, 1/15, 1/30, 1/60, 1/125, 1/250, 1/500, 1/1000, 1/2000, and 1/4000 second. Rebel XTI also offers 1/3 stop divisions (Custom Function 06) between these standard exposure times.	a) Press the Metering Mode button (please see diagram) once. Use left or right arrow to highlight the partial metering symbol (a rectangle with a hollow circle ⬡ inside) appears on the LCD screen. b) Your exposure mode is now set to partial metering. In this mode the camera's meter only reacts to the light that passes through the partial metering circle that is located at the center of the view finder. This circle (frame) occupies about 9% of the entire viewfinder area.	a) Turn on the camera and by following step 5, activate the spot metering (partial metering) function. b) Set the Mode Dial to [M] and for outside shots turn the main dial to choose a shutter speed that is close to the ISO of the film. For an ISO setting of 100, set the shutter speed to 1/100 or 1/125 sec. c) To determine the normal exposure of a simple subject (for a portrait like the forehead), point the spot/partial metering frame of the camera (at the center of the viewfinder outlined by a dotted line in the illustration) towards the desired *simple tone*. Now by changing the aperture opening find the normal exposure for the simple subject so that the exposure level indicator in the viewfinder is positioned in the middle of [-2] and [+2]. -2..1.0..1.+2

CANON Rebel XTI
EOS 400D - (D-SLR/Digital)

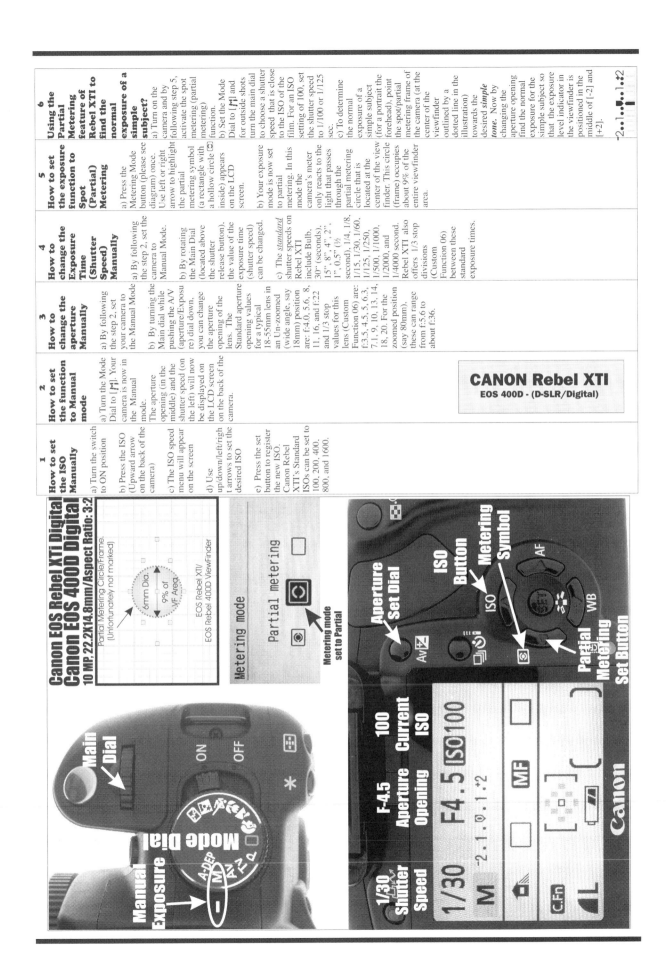

Canon EOS Rebel XTi Digital
Canon EOS 400D Digital
10 MP, 22.2X14.8mm/Aspect Ratio: 3:2

Partial Metering Circle/Frame. (Unfortunately not marked)

6mm Dia. 9% of VF Area.

EOS Rebel XTi/ EOS Rebel 400D ViewFinder

Metering mode Partial metering

Metering mode set to Partial

Main Dial

ON OFF

Mode Dial

Manual Exposure

Aperture Set Dial

ISO Button

Metering Symbol

AF WB

Partial Metering Set Button

1/30 Shutter Speed

F-4.5 Aperture Opening

100 Current ISO

F4.5 [ISO]100

M -2.1.0.1.+2

C.Fn

Canon

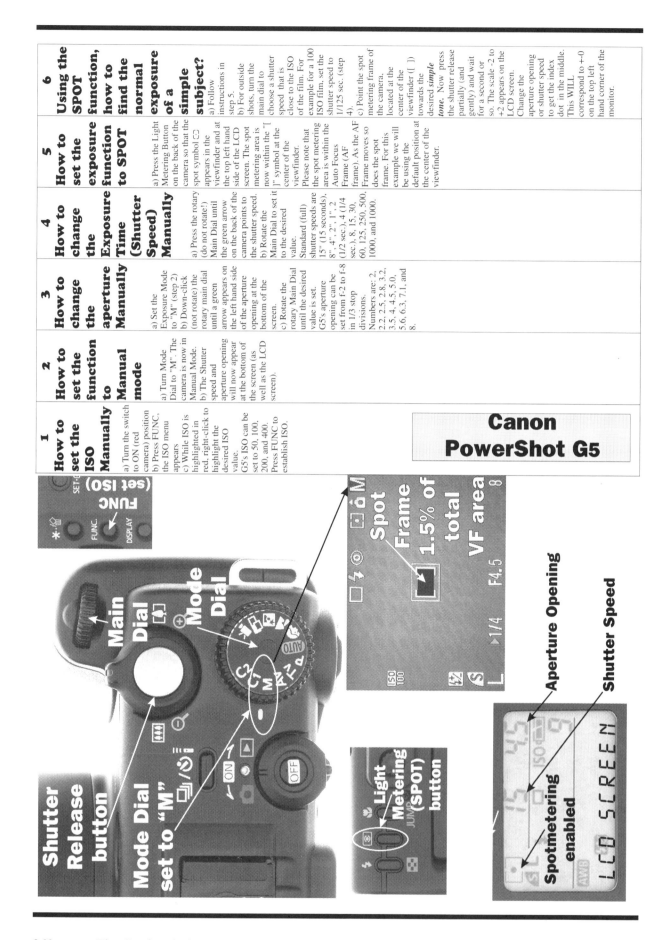

1 How to set the ISO Manually	2 How to set the function to Manual mode	3 How to change the aperture Manually	4 How to change the Exposure Time (Shutter Speed) Manually	5 How to set the exposure function to SPOT	6 Using the SPOT function, how to find the normal exposure of a simple subject?
a) Turn the switch to ON (red camera) position b) Press FUNC, the ISO menu appears c) While ISO is highlighted in red, right-click to highlight the desired ISO value. G5's ISO can be set to 50, 100, 200, and 400. Press FUNC to establish ISO.	a) Turn Mode Dial to "M". The camera is now in Manual Mode. b) The Shutter speed and aperture opening will now appear at the bottom of the screen (as well as the LCD screen).	a) Set the Exposure Mode to "M" (step 2) b) Down-click (not rotate) the rotary main dial until a green arrow appears on the left hand side of the aperture opening at the bottom of the screen. c) Rotate the rotary Main Dial until the desired value is set. G5's aperture opening can be set from f-2 to f-8 in 1/3 stop divisions. Numbers are: 2, 2.2, 2.5, 2.8, 3.2, 3.5, 4, 4.5, 5.0, 5.6, 6.3, 7.1, and 8.	a) Press the rotary Main Dial until the green arrow on the back of the camera points to the shutter speed. b) Rotate the Main Dial to set it to the desired value. Standard (full) shutter speeds are 15" (15 seconds), 8", 4", 2", 1", 2 (1/2 sec.), 4 (1/4 sec.), 8, 15, 30, 60, 125, 250, 500, 1000, and 1000.	a) Press the Light Metering Button on the back of the camera so that the spot symbol appears in the viewfinder and at the top left hand side of the LCD screen. The spot metering area is now within the "[]" symbol at the center of the viewfinder. Please note that the spot metering area is within the Auto Focus Frame (AF frame). As the AF Frame moves so does the spot frame. For this example we will be using the default position at the center of the viewfinder.	a) Follow instructions in step 5. b) For outside shots, turn the main dial to choose a shutter speed that is close to the ISO of the film. For example for a 100 ISO film, set the shutter speed to 1/125 sec. (step 4). c) Point the spot metering frame of the camera, located at the center of the viewfinder ([]) towards the desired *simple tone.* Now press the shutter release partially (and gently) and wait for a second or so. The scale -2 to +2 appears on the LCD screen. Change the aperture opening or shutter speed to get the index dot in the middle. This WILL correspond to +-0 on the top left hand corner of the monitor.

Canon PowerShot G5

FUNC (set ISO)

Main Dial

Mode Dial

Shutter Release button

Mode Dial set to "M"

Spot Frame 1.5% of total VF area

Light Metering (SPOT) button

F4.5 1/4

Aperture Opening

Shutter Speed

Spotmetering enabled

LCD SCREEN

1 How to set the ISO Manually	2 How to set the function to Manual Mode	3 How to change the aperture Manually	4 How to change the Exposure Time (shutter speed) Manually	5 How to set the exposure function to Spot	6 How to find the normal exposure of a simple subject?
a) Turn the camera to the [ON]/Red Camera icon position. b) Press the silver Photo Mode [f] located on the back at the bottom right hand side of the LCD screen. Once the Menu appears, right click ONCE so that the ISO option is selected. By up-clicking or down-clicking, the desired ISO can be selected. Press MENU/OK	a) Turn the camera to the [ON]/Red Camera icon position. b) Turn the Mode Dial to "M"anual Mode position. Depending on your EFT/LCD - DISP settings, the letter "M" in red will appear at the bottom left of the LCD panel or at the bottom left of the viewfinder. Your S7000 is now set to Manual Exposure Mode.	a) Turn the camera to the [ON]/Red Camera icon position. b) Turn the Mode Dial to "M"anual Mode position. c) While holding down the Exposure Compensation button [+/-] turn the rotary Command Dial until f-numbers such as F2.8, F3.6, F4, F4.5, F5, F5.6, F6.3, F7, or F8 appear in light blue at the left hand bottom of the LCD/Viewfinder screen. Please note that if you do NOT see an aperture opening such as F-2.8, chances are your camera's lens is fully zoomed.	a) Turn the camera to the [ON]/Red Camera icon position. b) Turn the Mode Dial to "M"anual Mode position. C) Turn the Command Dial until the desired shutter speed (exposure Time) appears in light blue between the letter M and the F# (Aperture opening) S7000's exposure times/Shutter speeds can be set to 15". (15 seconds), 13", 10", 8", 6.5", 5", 4", 3", 2.5", 2", 1.5", 1.3", 1", 1.3 (1/1.3), 1.6, 2, 2.5, 3, 4, 5, 6, 8, 10, 13, 15, 20, 25, 30, 40, 50, 60, 80, 100, 125, 160, 200, 250, 320, 400, 500, 640, 800, 1000, 1200, 1600, 2000, 2500, 3000, 4000, 5000, 7000, 8000, and 10000th of a second.	a) Turn the camera to the [ON]/Red Camera icon position. b) Turn the Mode Dial to "M"anual Mode position. c) Press MENU/OK button on the back of the camera once or twice until the Menu appears on the LCD screen. Right click MENU/OK dial until PHOTOMETER Y appears on your screen. By up-clicking or down-clicking highlight the SPOT option. Press the MENU/OK button to establish the spot metering function on your camera. A symbol [o] will appear at the bottom of the screen under PHOTOMETRY option.	a) Turn the camera to the [ON]/Red Camera icon position. b) Turn the Mode Dial to "M"anual Mode position. c) Choose a shutter speed. If you are not sure what to set your shutter speed to (for outside shots) set it to a number close to four times the ISO of the film. For example, if your film's ISO is 100, set it to 1/400 or 1/500 sec. (see step 4). c) Turn your metering to SPOT (step 5). Then by pointing the center of the viewfinder (a + symbol) at the desired simple subject and by changing the aperture and/or shutter speed, find the simple subject's normal exposure. This is when the small orange pointer at the bottom right hand side of the screen is positioned exactly in the middle of + and - signs on the sliding scale.

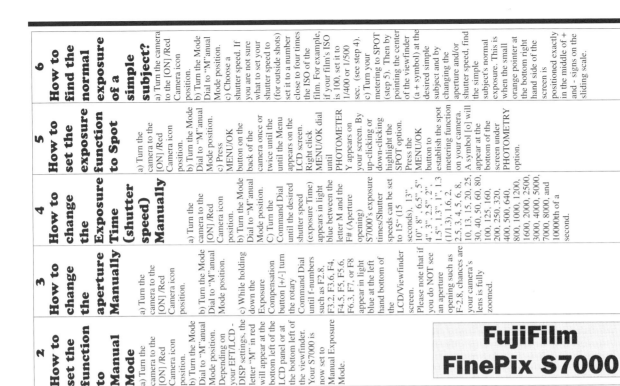

FujiFilm
FinePix S7000

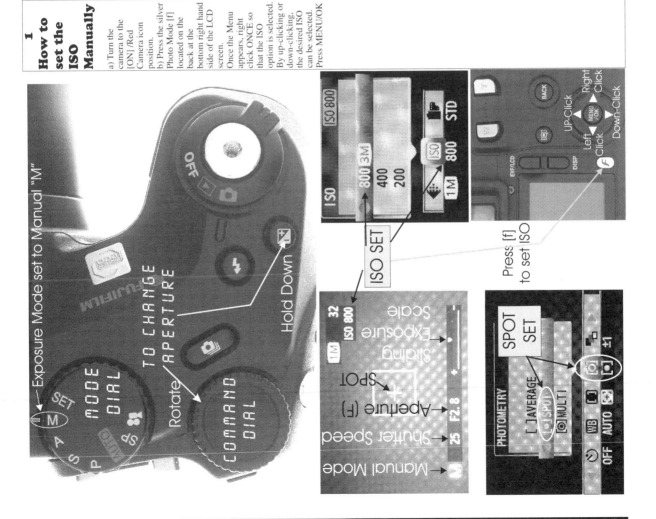

1 How to set the ISO Manually	2 How to set the function to Manual Mode	3 How to change the aperture Manually	4 How to change the Exposure Time (shutter speed) Manually	5 How to set the exposure function to SPOT	6 How to find the normal exposure of a simple subject?
If you do not have DX coded film (i.e., you roll your own film): a) Turn the power switch to the [ON] position. Please note that the power switch must be turned on for steps 1 through 6 of this cheat sheet. b) Turn the Function Dial to ISO c) Press and hold down the FUNC button. The ISO appears on the LCD screen d) Turn the control dial to set the desired ISO	a) Rotate the Function Dial so that the white index points to the PASM setting. b) Hold-down the FUNC button and rotate the Control Dial so that the letter "M" appears on the LCD screen. The shutter speed (exposure time) and aperture opening will appear on the LCD screen. Your camera is now in "M"anual exposure mode.	a) Set your camera mode to Manual [M] (see step 2). b) While the AV(+/-) button is pushed down, rotate the control dial to set the desired aperture opening, the value of which will be displayed in the viewfinder as well as the LCD panel. Typical values for AV (Aperture Value) are: 4, 5.6, 8, 11, 16, 22 and 1/2 stop values are: 6.7, 9.5, 13, and 19.	a) Set your camera mode to Manual [M] (see step 2). b) By rotating the front Control dial you can set your shutter exposure time. It will be displayed in the viewfinder as well as on the LCD panel.	a) Set the camera to Manual [M] mode. b) Push and hold-down the SPOT button on the back of your camera. The SPOT symbol [⊡] will now appear in the viewfinder. As long as the SPOT button is pushed down, the camera is in Spot metering mode.	a) Choose a shutter speed. If you are not sure what to set your shutter speed to, for outside shots, set it to a number close to the ISO of the film. For example if your film's ISO is 100, set it to 1/125 sec. (see step 4). b) Point your camera's spot at the desired SIMPLE subject so that the spot frame falls WITHIN the boundaries of this subject. c) Push and hold-down the [SPOT] button. This can be done by following directions in step 5. While the spot button is pressed press the AV (+/-) button. This will lock the exposure. Now release the spot button. The [⊡] will REMAIN in your viewfinder. While AV is pressed you can change the aperture opening until the pointer in your viewfinder is positioned exactly above the [0] mark.

Minolta Maxxum 5

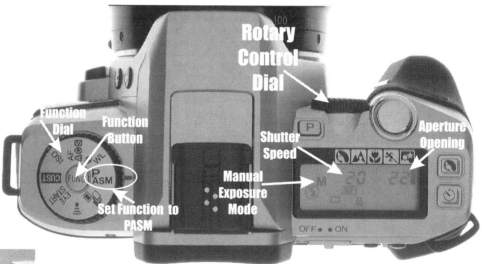

Rotary Control Dial
Function Dial
Function Button
Shutter Speed
Aperture Opening
Manual Exposure Mode
Set Function to PASM
OFF ● ON

-2.1.0.1.2+
EV / Exposure Scale indicating Normal Exposure

Push Down & Rotate Control Dial To set aperture

SLOW SYNC
AF SPOT
Spot Button

1 How to set the ISO Manually	2 How to set the function to Manual Mode	3 How to change the aperture Manually	4 How to change the Exposure Time (shutter speed) Manually	5 How to set the exposure function to SPOT	6 How to find the normal exposure of a simple subject?
If you do not have DX coded film (i.e., you roll your own film): a) Turn the power switch to the [ON] position. b) Open the Control-panel door in the back of the camera and press the ISO button. c) Turn the front or rear control dials to set it to the desired ISO.	a) Slide the main switch to the [ON] position. b) Press the lock-release button at the center of the exposure mode dial and set it to [M]. The shutter speed (exposure time) and aperture opening will appear in a small LCD panel located at the top right hand corner of the camera. At the top of the screen is the shutter speed and at the bottom of the screen is the aperture opening.	a) Slide the Main switch to the [ON] position. b) Set your camera mode to Manual [M] (see step 2). c) By rotating the rear Control dial you can set your aperture opening. The shutter speed (exposure time) and aperture opening will appear in a small LCD panel located at the top right hand corner of the camera. At the top of the screen is the shutter speed and at the bottom of the screen is the aperture opening.	a) Slide the Main switch to the [ON] position. b) Set your camera mode to Manual [M] (see step 2). c) By rotating the front Control dial you can set your shutter speed/exposure time.	a) Slide the Main switch to the [ON] position. b) Set the camera to Manual [M] mode. c) Turn the Metering mode switch (with letters AEL) in the back (top center) of the camera to [.] the spotmeter symbol [◌] will appear in the viewfinder.	a) Set the exposure mode to Manual [M] (step 2). b) Choose a shutter speed (exposure time). If you are not sure what to set your shutter speed to, for outside shots, set it to a number close to the ISO of the film. For example if your film's ISO is 100, set it to 1/90 or 1/125 sec. This can be done following directions in step 4. c) Turn your metering to [SPOT]. This can be done by following directions in step 5. Then by pointing the center of the viewfinder at the desired simple subject and by changing the aperture and/or shutter speed, find the simple subject's normal exposure. This is when the pointer in your viewfinder is positioned exactly above the [0] mark located in the middle of [-3] and [+3] signs.

Minolta Maxxum 7

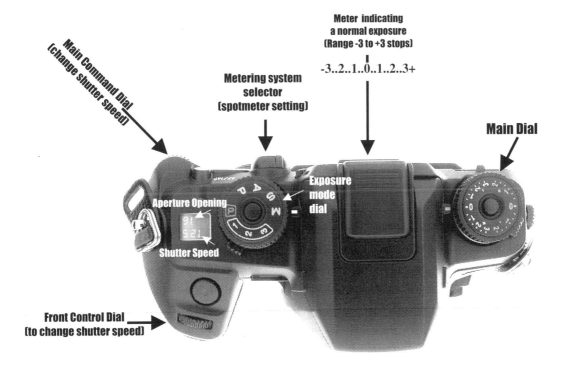

Main Command Dial [change shutter speed]

Metering system selector (spotmeter setting)

Meter indicating a normal exposure (Range -3 to +3 stops)

-3..2..1..0..1..2..3+

Main Dial

Aperture Opening

Exposure mode dial

Shutter Speed

Front Control Dial (to change shutter speed)

1 How to set the ISO Manually	2 How to set the function to Manual Mode	3 How to change the aperture Manually	4 How to change the Exposure Time (shutter speed) Manually	5 How to set the exposure function to SPOT	6 How to find the normal exposure of a simple subject?
If you do not have DX coded film (i.e., you roll your own film): a) Turn the power switch to the [ON] position. b) Open the Control-panel door located at the right hand side of the camera and press the ISO button. c) Turn the front or rear control dials to set it to the desired ISO. The ISO can be changed from 6 to 6400 in 1/3 stop increments. d) Press the shutter-release button partially down to register the ISO.	a) Slide the main switch from [lock] to [ON] position. b) Turn the exposure mode dial and set it to [M]. The shutter speed (exposure time) and aperture opening will appear in a small LCD panel located at the top right hand corner of the camera. At the top of the screen is the shutter speed and at the bottom of the screen is the aperture opening.	a) Turn the Main switch from [Lock] to [ON] position. b) Set your camera mode to Manual [M] (see step 2). c) By rotating the rear Control dial you can set your aperture opening. The shutter speed (exposure time) and aperture opening will appear in a small LCD panel located at the top right hand corner of the camera. At the top of the screen is the shutter speed and at the bottom of the screen is the aperture opening. It will also appear at the bottom of your viewfinder.	a) Turn the Main switch from [Lock] to [ON] position. b) Set your camera mode to Manual [M] (see step 2). c) By rotating the front Control dial you can set your shutter speed/exposure time. The Shutter speed will also appear at the bottom of your viewfinder. The shutter speed can be set from 30 seconds [30"] to 1 sec. [1"] through 1/12000 sec. In 1/2 stop increments.	a) Slide the Main switch to the [ON] position. b) Set the camera to Manual [M] mode. c) Turn the Metering mode switch (with letters AEL) in the back of the camera so that the index marker aligns with the spotmetering dot.	a) Turn the main switch from [Lock] to [ON] position. b) Set the exposure mode to Manual [M] (step 2). c) Choose a shutter speed. If you are not sure what to set your shutter speed to, for outside shots, set it to a number close to the ISO of the film. For example if your film's ISO is 100, set it to 1/125 sec. (see step 4). d) Turn your metering to [SPOT]. This can be done by following directions in step 5. Then by pointing the center of the viewfinder at the desired simple subject and by changing the aperture and/or shutter speed, find the simple subject's normal exposure. This is when the pointer in your viewfinder is positioned exactly above the [0] mark located in the middle of [-3] and [+3] signs.

Minolta Maxxum 9

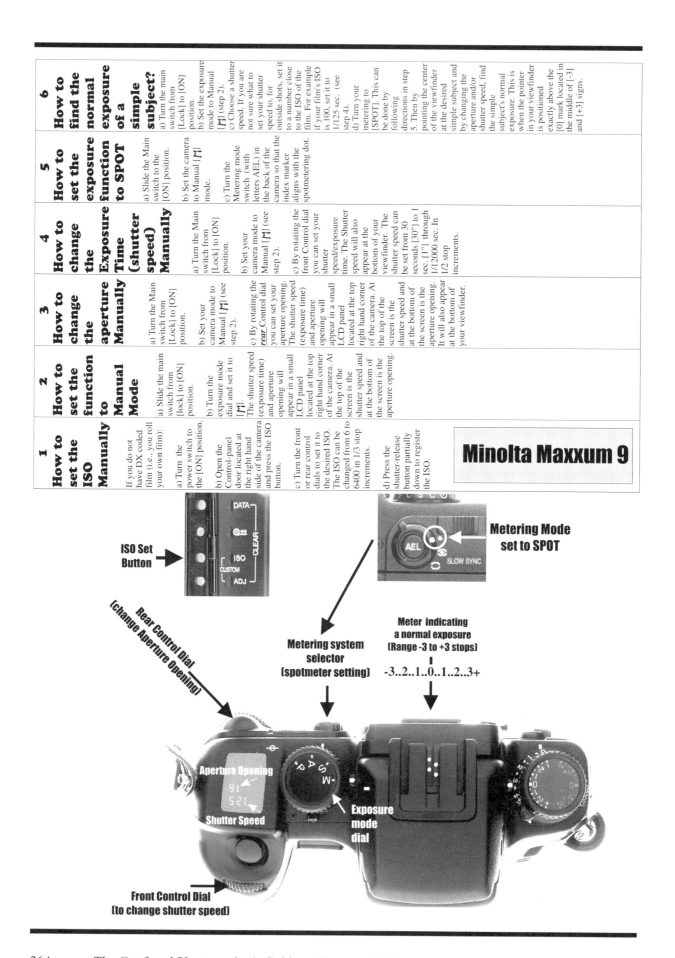

ISO Set Button

Metering Mode set to SPOT

Rear Control Dial [change Aperture Opening]

Metering system selector (spotmeter setting)

Meter indicating a normal exposure (Range -3 to +3 stops)
-3..2..1..0..1..2..3+

Aperture Opening
91
521
Shutter Speed

Exposure mode dial

Front Control Dial [to change shutter speed]

1 How to set the ISO Manually	2 How to set the function to Manual Exposure mode	3 How to change the aperture Manually	4 How to change the Exposure Time (shutter speed) Manually	5 How to set the exposure function to Spot	6 How to find the normal exposure of a simple subject?
If you do not have DX coded film (i.e., you roll your own film): a) Slide the power switch to the [ON] position. b) Turn the Function Dial to ISO c) Push the Function Button and hold down. The ISO value will appear on the LCD screen (Data Panel)	a) Turn the power switch to the [ON] position. b) Turn the Function Dial until the black mark points to PASM value. c) While holding down the Function button, rotate the Control Dial until the letter [M] appears at the center of the LCD panel. Now your camera is set to the Manual Exposure [M] mode.	a) Turn the main switch to the [ON] position. b) Set the camera mode to Manual [M] (see step 2). c) Now with your left thumb press and hold the round [AV button] located in front of the camera with symbols [+/-] and turn the control dial until the desired aperture is displayed. Typical full-stop aperture openings are 4, 5.6, 8, 11, and 16. Their typical 1/2 stop divisions are 4.5, 6.7, 9.5, 13, 19, 27, and so on.	a) Turn the main switch to the [ON] position. b) Set the camera mode to Manual [M] (see step 2).	a) Slide the main switch to the [ON] position. b) Set the camera to Manual [M] mode (step 2). c) Point the camera towards the subject and press the shutter release button partially down to focus.	a) Turn on the camera and set the mode to Manual [M] (step 2). b) Choose a shutter speed (exposure time). If you are not sure of your shutter speed setting, for outside shots, set it to a number close to the ISO of the film. For example if your film's ISO is 100, set it to 1/125 sec. This can be done following the directions in step 4.

Minolta Maxxum STsi

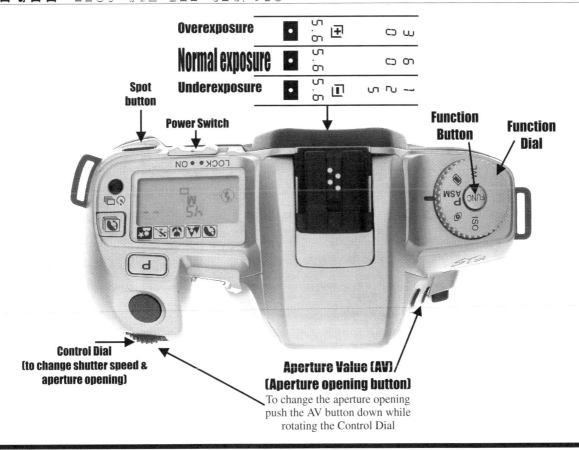

Overexposure

Normal exposure

Underexposure

Spot button

Power Switch

Function Button

Function Dial

Control Dial (to change shutter speed & aperture opening)

Aperture Value (AV) (Aperture opening button)
To change the aperture opening push the AV button down while rotating the Control Dial

1 How to set the ISO Manually	2 How to set the function to Manual Mode	3 How to change the aperture Manually	4 How to change the Exposure Time (shutter speed) Manually	5 How to set the exposure function to Spot	6 How to find the normal exposure of a simple subject?
a) Turn the Mode Dial to the [ON] /M-REC position. b) Push the ISO button and hold-down while rotating the Command Dial. The ISO changes from 100 to 200, 400, and Auto.	a) Turn the Mode Dial to the [ON] /M-REC position. The camera is now in Manual Mode. The letter M will appear at the bottom left of the LCD panel and the Menu screen.	a) Turn the Mode Dial to the [ON] /M-REC position. b) Press the "MODE" button until the aperture opening (the F number) such as F-5.0 appears at the top right hand side of the LCD screen or the bottom of the Menu Screen in the back of the camera. Depending on the zoom setting of your camera, the largest opening is F-2.5 and the smallest is about F-11. Please note that since the aperture opening of the CoolPix 990 increases or decreases by 1/3 stop, depending on its zoom/wide settings, you may not see the standard aperture openings such as f-4, f-5.6, or f-8.	a) Turn the Mode Dial to the [ON] /M-REC position. b) Press the MODE button until the letter "F" (aperture opening) disappears from the top right hand side of the LCD screen. Please note that shutter speed and aperture opening occupy the same location on the LCD screen. The number showing is the exposure time (shutter speed). CoolPix 990's exposure times range from bulb to 8" (8 seconds), 4", 2", 1", 2 (1/2 sec.), 4, 8, 15, 30, 60, 125, 250, 500, 1000 (1/1000 sec.)	a) Turn the Mode Dial to the [ON] /M-REC position. b) Press the MENU button on the back of the camera, the option #1/White Balance option will appear c) Down-Click the Multi Selector. Now you are in the METERING option. d) Right click the Multi Selector on the back of the camera. All metering options will appear. e) Down-click once and the spotmetering option [⬚] will be highlighted in red. f) Right click and your exposure mode is set on SPOT. g) Press the MENU button twice, the screen clears with the spotmetering symbol [⬚] appearing on the LCD and the Menu Screen.	a) Turn the Mode Dial to the [ON] /M-REC position. b) Choose a shutter speed. If you are not sure what to set your shutter speed to (for outside shots) set it to a number close to the ISO of the film. For example, if your film's ISO is 100, set it to 1/125 sec. (see step 4). c) Turn your metering to SPOT [⬚]. This can be done by following directions in step 5. Then by pointing the center of the viewfinder (a rectangle) at the desired simple subject and by changing the aperture and/or shutter speed, find the simple subject's normal exposure. This is when the small rectangle at the center of your scale is highlighted and is white-filled (please refer to CoolPix 990's illustration).

Nikon CoolPix 990

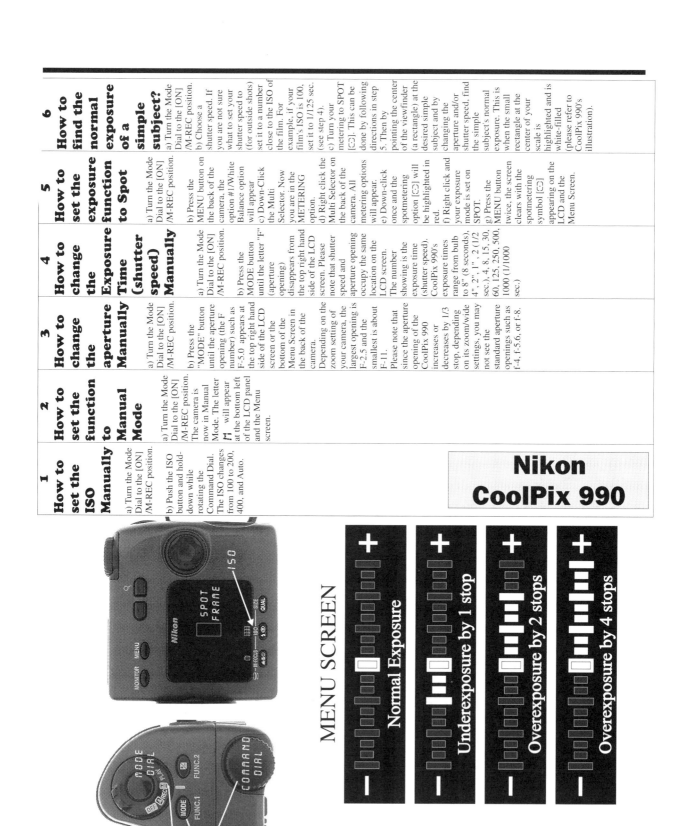

MENU SCREEN

Normal Exposure

Underexposure by 1 stop

Overexposure by 2 stops

Overexposure by 4 stops

LCD PANEL

0

-1

+2

+4

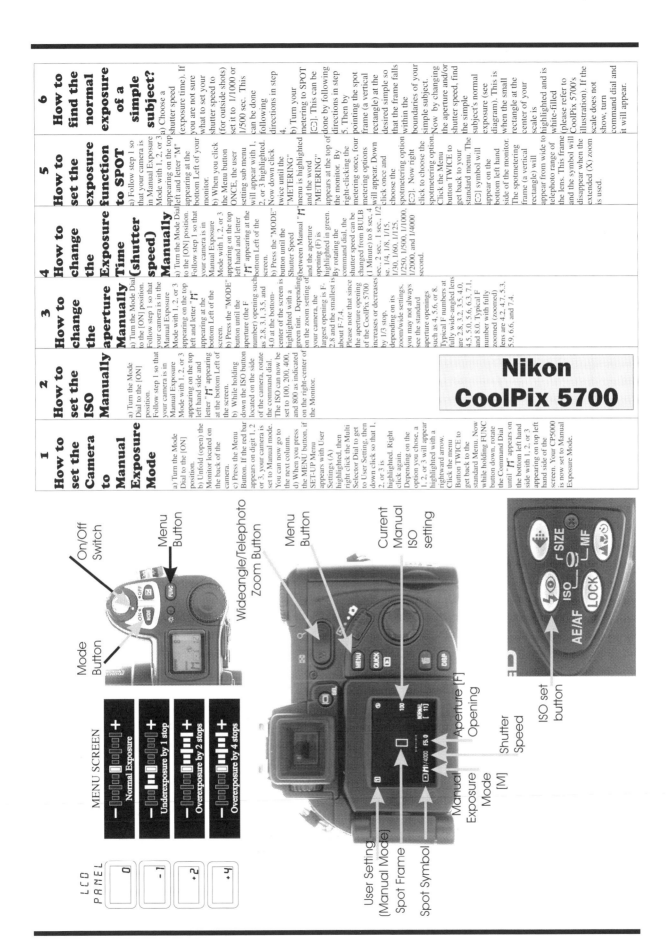

1 How to set the Camera to Manual Exposure Mode	2 How to set the ISO Manually	3 How to change the aperture Manually	4 How to change the Exposure Time (shutter speed) Manually	5 How to set the exposure function to SPOT	6 How to find the normal exposure of a simple subject?
a) Turn the Mode Dial to the [ON] position.	a) Turn the Mode Dial to the [ON] position. Follow step 1 so that your camera is in Manual Exposure Mode with 1, 2, or 3 appearing on the top left hand side and letter "Ϝ" appearing at the bottom Left of the screen.	a) Turn the Mode Dial to the [ON] position. Follow step 1 so that your camera is in the Manual Exposure Mode with 1, 2, or 3 appearing on the top left and letter "Ϝ" appearing at the bottom Left of the screen.	a) Turn the Mode Dial to the [ON] position. Follow step 1 so that your camera is in Manual Exposure Mode with 1, 2, or 3 appearing on the top left hand and letter "Ϝ" appearing at the bottom Left of the screen.	a) Follow step 1 so that your camera is in Manual Exposure Mode with 1, 2, or 3 appearing on the top and letter "M" appearing at the bottom Left of your monitor.	a) Choose a shutter speed (exposure time). If you are not sure what to set your shutter speed to (for outside shots) set it to 1/1000 or 1/500 sec. This can be done following
b) Unfold (open) the Monitor located on the back of the camera.	b) While holding down the ISO button located on the side of the camera, rotate the command dial. The ISO can now be set to 100, 200, 400, and 800 as indicated on the right-center of the Monitor.	b) Press the "MODE" button until the aperture (the F number) opening such as 2.8, 3.1, 3.5, and 4.0 at the bottom-center of the screen is highlighted with a green tint. Depending on the zoom setting of your camera, the largest opening is F-2.8 and the smallest is about F-7.4. Please note that since the aperture opening of the CoolPix 5700 increases or decreases by 1/3 stop, depending on its zoom/wide settings, you may not always see the standard aperture openings such as 4, 5.6, or 8. Typical F numbers at fully wide-angled lens are 2.8, 3.2, 3.5, 4.0, 4.5, 5.0, 5.6, 6.3, 7.1, and 8.0. Typical F number with fully zoomed (zoomed) lens are 4.2, 4.7, 5.3, 5.9, 6.6, and 7.4.	b) Press the "MODE" button until the Shutter Speed between Manual "Ϝ" and the aperture opening (F) is highlighted in green. By rotating the command dial, the shutter speed can be changed from BULB (1 Minute) to 8 sec, 4 sec., 2 sec., 1 sec., 1/2 sec. 1/4, 1/8, 1/15, 1/30, 1/60, 1/125, 1/250, 1/500, 1/1000, 1/2000, and 1/4000 second.	b) When you click the Menu button ONCE, the user setting sub menu will appear with 1, 2, or 3 highlighted. Now down click twice until the "METERING" menu is highlighted and the word "METERING" appears at the top of the monitor. By right-clicking the metering once, four metering options will appear. Down click once and choose the spotmetering option [⊡]. Now right click to choose the spotmetering option. Click the Menu button TWICE to get back to your standard menu. The [⊡] symbol will appear on the bottom left hand side of the monitor. The spotmetering frame (a vertical rectangle) will appear from wide to telephoto range of the lens. This frame and the symbol will disappear when the extended (X) zoom is used.	directions in step 4. b) Turn your metering to SPOT [⊡]. This can be done by following directions in step 5. Then by pointing the spot frame (a vertical rectangle) at the desired simple so that the frame falls within the boundaries of your simple subject. Now by changing the aperture and/or shutter speed, find the simple subject's normal exposure (see diagram). This is when the small rectangle at the center of your scale is highlighted and is white-filled (please refer to CoolPix 5700's illustration). If the scale does not show, turn command dial and it will appear.
c) Press the Menu Button. If the red bar appears on digit 1, 2 or 3, your camera is set to Manual mode. You can now go to the next column.					
d) When you press the MENU button, if SET-UP Menu appears with User Settings (A) highlighted, then right click the Multi Selector Dial to get to User Setting, then down click so that 1, 2, or 3 is highlighted. Right click again. Depending on the option you chose, a 1, 2, or 3 will appear highlighted with a rightward arrow. Click the menu Button TWICE to get back to the standard Menu. Now while holding FUNC button down, rotate the Command Dial until "Ϝ" appears on the bottom left hand side with 1, 2, or 3 appearing on top left hand side of the screen. Your CP5000 is now set to Manual Exposure Mode.					

Nikon CoolPix 5700

MENU SCREEN

- − |□|□|□|□|□|+ Normal Exposure
- − |□|■|□|□|□|+ Underexposure by 1 stop
- − |□|□|■|□|□|+ Overexposure by 2 stops
- − |□|□|□|■|□|+ Overexposure by 4 stops

LCD PANEL

0
-1
+2
+4

On/Off Switch
Menu Button
Mode Button

Wideangle/Telephoto Zoom Button
Menu Button
Current Manual ISO setting

User Setting (Manual Mode)
Spot Frame
Spot Symbol
Manual Exposure Mode [M]
Shutter Speed
Aperture [F] Opening

SIZE
MF
ISO
LOCK
AE/AF
ISO set button

1 How to set the Camera to Manual Exposure Mode	2 How to set the ISO Manually	3 How to change the aperture Manually	4 How to change the Exposure Time (shutter speed) Manually	5 How to set the exposure function to SPOT	6 Finding the normal exposure of a simple subject
a) Turn the Dial to [Mode]/[ON] position. b) Unfold (open) the Monitor located on the back of the camera. c) Press the Menu Button. If a [1] appears in a square on the top left hand side of the screen, you are almost there! Just go to step (d). However, when you pressed the MENU button if the Shooting Menu (Auto) appears, then by down-clicking the Multi Selector Dial (MSD) highlight the User Setting, then right click the MSD. The User Setting Menu will now appear. By down-clicking MSD twice, highlight the Custom 1 option, then right click. A [1] in a square will appear on the top left hand side of the screen. d) Now rotate the Command Dial while the Mode Button is held down until the letter " ⌐¹ " appears on the bottom left hand side of the screen and the number [1] appearing on top left hand side of the screen. The letter " ⌐¹ " must also appear on the LCD screen located on the top right hand side of the camera Your CP 8700 is now set to Manual Exposure Mode.	a) Turn the Dial to [Mode]/[ON] position. Follow step 1 so that your camera is in the Manual Exposure Mode with a [1] appearing on the top left hand side of the screen and the letter " ⌐¹ " appearing at the bottom left of the screen as well as on the LCD screen. b) While holding down the ISO button located on the lens of the camera, rotate the command dial. The ISO can now be set to 50, 100, 200, and 400 as indicated on the right-center of the screen.	a) Turn the Dial to [Mode]/[ON] position. Follow step 1 so that your camera is in the Manual Exposure Mode with the letter " ⌐¹ " appearing at the bottom Left of the screen. b) Press the "MODE" button until the aperture (the F number) opening such as F2.8, F3.1, F3.5, F4.0 at the bottom-center of the screen is highlighted with a green tint. Depending on the zoom setting of your camera, the largest opening is F-2.8 and the smallest is about F-8. Please note that since the aperture opening of the CoolPix 8700 increases or decreases by 1/3 stop, depending on its zoom/wide settings, you may not always see the standard aperture openings such as f-4, f-5.6, or f-8. Typical F-numbers for a fully wide-angled lens are F2.8, F3.2, F3.5, F4.0, F4.5, F5.0, f5.6, F6.3, F7.1, and F8.0. Typical F-numbers for a fully zoomed lens are 4.2, 4.7, 5.3, 5.9, 6.6, and 7.4.	a) Turn the Dial to [Mode]/[ON] position. Follow step 1 so that your camera is in Manual Exposure Mode with 1 or 2 appearing on the top left hand and letter " ⌐¹ " appearing at the bottom Left of the screen as well as the LCD screen. b) Press the "MODE" button until the Shutter Speed (between Manual " ⌐¹ " and the aperture opening (F)) is highlighted in green. By rotating the command dial, the shutter speed can be changed from BULB (10 Minutes) to 8 sec, 4 sec.. 2 sec.. 1 sec... 1/2. 1/4, 1/8, 1/15, 1/30, 1/60, 1/125, 1/250, 1/500, 1/1000, 1/2000, and 1/4000 second.	a) Turn the Dial to [Mode]/[ON] position. Follow step 1 so that your camera is in Manual Exposure Mode with 1or 2 appearing on the top left and letter " ⌐¹ " appearing at the bottom left of your monitor as well as your LCD panel. b) When you click the Menu button once, "MY MENU" screen will appear. Now down click MSD once and the metering menu will be highlighted. Right click MSD once and all metering options will appear. Choose spot and right click MSD. Press Menu button to exit. The spotmetering symbol ⊡ will appear on the back screen as well as on the LCD screen.	a) Choose a shutter speed (exposure time). If you are not sure what to set your shutter speed to, for outside shots, for ISO 50 set it to 5 times the ISO, i.e., 250. For 200 ISO it is 1/1000. b) Turn your metering to SPOT [⊡]. This can be done by following directions in step 5. Then by pointing the spot frame (a vertical rectangle) at the desired simple so that the frame falls within the boundaries of your simple subject. Now by changing the aperture and/or shutter speed, find the simple subject's normal exposure (see diagram). This is when the small rectangle at the center of your scale is highlighted and is white-filled (please refer to CoolPix 8700's illustration).If the scale does not show, turn command dial and it will appear.

Nikon CoolPix 8700

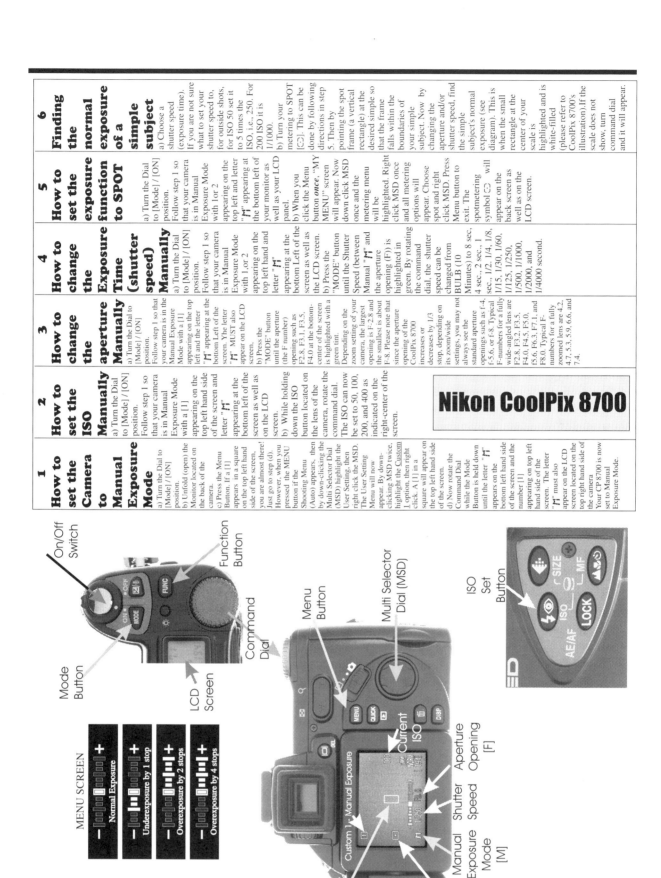

Nikon D50 Digital

1. How to set the ISO Manually	2. How to set the function to Manual Mode	3. How to change the aperture Manually	4. How to change the Exposure Time (shutter speed) Manually	5. How to set the exposure function to SPOT	6. How to find the normal exposure of a simple subject?
a) Turn the power switch to the [ON] position. B) Press down MENU on the back of the camera and highlight the camera icon (shooting menu / it has yellow tint) C) Down-click the MultiSelector button until ISO is highlighted D) Right-click the multi selector until the ISO menu appears E) Highlight the desired iso by up/down clicking the multi-selector F) Right-click the MultiSelector to establish ISO G) Click MENU twice to deactivate the monitor. D50's ISO can be set to 200, 400, 800, and 1600.	a) Turn the power switch to the [ON] position. b) Turn the MODE Dial to "M". The shutter speed and the Aperture opening will now appear on the LCD panel.	a) If you are NOT using type "G" lens, please make sure your aperture opening on your lens is set to its minimum, i.e., it is set to [f-22] or [f-32]. By pushing the minimum aperture lock (a lock with a little white dot on the lens) towards the camera, lock the lens in the minimum-aperture position so that the aperture ring can no longer be rotated. b) Set the camera mode to Manual [M] (see step 2). By rotating the Command Dial (the notched rotary dial in the back of the camera) WHILE THE EXPOSURE COMPENSATION BUTTON IS PRESSED DOWN, numbers such as 3.5, 4, 4.5, 5, 5.6, 6.3, 7.1, 8, 9, 10, 11, 13, 14, 16, 18, 20, and 22 in 1/3 stop divisions will appear on the LCD panel. Also 1/2 stop setting can be obtained using custom function (Pencil) on the menu.	a) Turn the main switch to the [ON] position. b) Set your camera mode to Manual [M] (see step 2). c) By rotating the rear Main-Command Dial you can change the shutter speed in ½ stop divisione from [bulb], [30"] (thirty seconds), [20"],... to [1"] second and from there to [1.5], [2], and finally to [4000]. ● PLEASE NOTE: after 1 second, all values are in fractions of a second or [1/]. For example 250 on the dial means 1/250th of a second and 4000 means 1/4000 sec. and so on. For 1/3 stop divisions please see Custom Function 11/Pencil icon on the MENU)	a) To simplicity, we will activate the center focus areas located at the center of the viewfinder. If the AF area mode on the LCD screen (on top? the camera has one [] at its center with no dots around it, your camera is set correctly. If the [] is not at the center, to activate the center focus area, click on MENU, then down-click once until the "PEN/Pencil" tool in the Custom Setting /CSM menu is highlighted. Now down-click 3 times until the '03 AF Area Mode" is highlighted. Now right-click and highlight Single Area, then right click to establish the single area focusing feature. Press menu twice to exit. You can verify this setting by checking the LCD screen (please see illustration). Also if shutter release is partially pressed, the center focus area in the viewfinder will be outlined in red.	a) Set the exposure mode to Manual [M] (step 2). b) Choose a shutter speed. If you are not sure what to set your shutter speed to, for outside shots, set it to a number close to the ISO of the camera. For example if your film's ISO is 200, set it to 1/250 sec. (see step 4). c) Turn your metering to [SPOT] and activate the center spot circle. This can be done by following directions in step 5. Now by pointing the *approximate* spot metering frame at the desired simple subject. By changing the aperture and/or shutter speed, find the surface's normal exposure. This is when only ONE line appearing under the [0] mark located in the middle of [+] and [-] signs. +..0..-

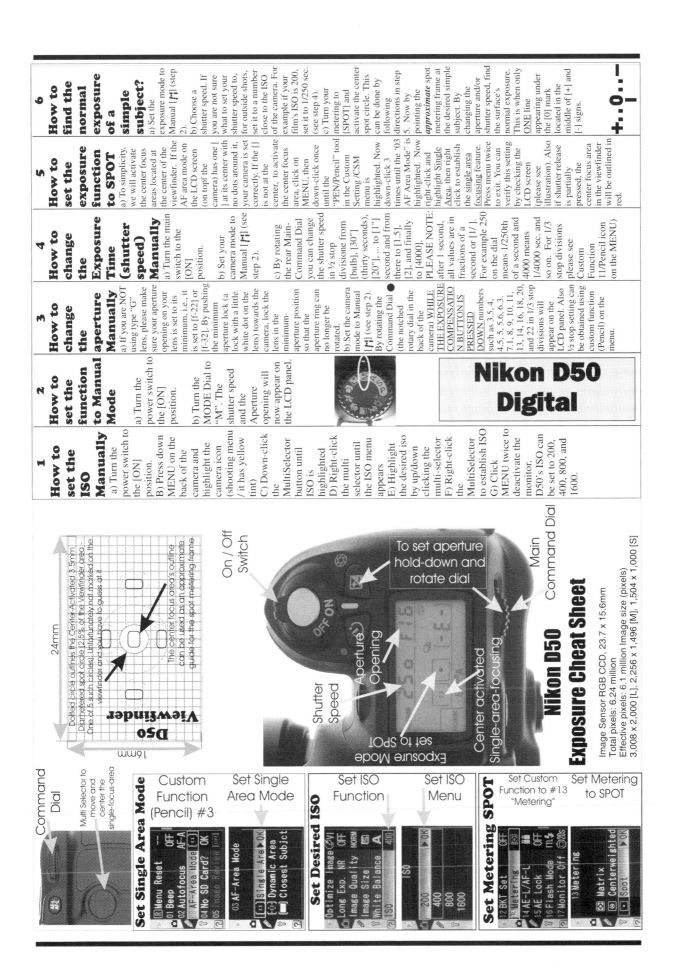

D50 Viewfinder

24mm / 16mm

Dotted circle outlines the Center Activated 3.5mm. Diametered spot circle (2.5% of the Viewfinder area). One of 5 such circles). Unfortunately not marked on the viewfinder and you have to guess at it

The center focus area's outline can be used as an approximate guide for the spot metering frame

On / Off Switch

To set aperture hold-down and rotate dial

Main Command Dial

Aperture Opening

Shutter Speed

Exposure Mode set to SPOT

Center activated Single-area-focusing

Nikon D50 Exposure Cheat Sheet

Image Sensor RGB CCD, 23.7 x 15.6mm
Total pixels: 6.24 million
Effective pixels: 6.1 million Image size (pixels)
3,008 x 2,000 [L], 2,256 x 1,496 [M], 1,504 x 1,000 [S]

Command Dial — Multi Selector to move and center the single-focus-area

Set Single Area Mode
Custom Function (Pencil) #3
Set Single Area Mode

Set Desired ISO
Set ISO Function
Set ISO Menu

Set Metering SPOT
Set Custom Function to #13 "Metering"
Set Metering to SPOT

1 — How to set the ISO Manually	2 — How to set the function to Manual Mode	3 — How to change the aperture Manually	4 — How to change the Exposure Time (shutter speed) Manually	5 — How to set the exposure function to SPOT	6 — How to find the normal exposure of a simple subject?
a) Turn the power switch to the [ON] position. b) While holding down the [ISO] button on the back, turn the rear Main Command Dial (notched wheel located near the LCD panel behind the camera ●) until the desired ISO appears on the screen. Release the ISO button and you are set! You can set the ISO on the D70 in 1/3 stop divisions to: **200, 250, 320, 400, 500, 640, 800, 1000, 1250, and 1600.**	a) Turn the power switch to the [ON] position. b) Turn the MODE Dial to "M". The shutter speed and the Aperture Opening will now appear on the LCD panel.	a) If you are NOT using type "G" lens, please make sure your aperture opening on your lens is set to its minimum, i.e., it is set to [f-22] or [f-32]. By pushing the minimum aperture lock (a lock with a little white dot on the camera, lock the lens in the minimum-aperture position so that the aperture ring can no longer be rotated. b) Set the camera mode to Manual [M] (see step 2). By rotating the Sub-Command Dial (the ● notched rotary dial in front of the camera right under the shutter release button) numbers such as 3.5, 4, 4.5, 5, 5.6, 6.3, 7.1, 8, 9, 10, 11, 13, 14, 16, 18, 20, and 22 in 1/3 stop divisions will appear on the LCD panel.	a) Turn the main switch to the [ON] position. b) Set your camera mode to Manual [M] (see step 2). c) By rotating the rear Main-Command Dial you can change the shutter speed from [bulb], [30"] (thirty seconds), [25"], ... to [1"] second and from there to [1.3], [1.6], [2], and finally to [8000]. NOTE: after 1 second, all values are in fractions of a second or [1/]. For example 250 on the dial means 1/250th of a second and 8000 means 1/8000 sec. and so on.	a) While holding-down the Metering Mode button, turn the Main Command Dial until ⊡ appears on the LCD screen. b) To simplicity, we will activate the center focus areas located at the center of the viewfinder. If the AF area mode on the LCD screen has one [] at its center with no dots, your camera is set correctly. If the [] is not at the center, use Multi Selector (with Focus Selector Lock button set to (.) to center it. When done, set it to "L" and you are done (see illustration). If not, set the focus selector lock to dot (.) and click on the menu button. Once menu appears, down-click twice until the "PEN" tool in the Custom Setting/CSM menu is highlighted. Now right-click once and down-click until "03 AF area mode" is highlighted. Now right-click again and highlight Single Area, then right click to establish the single area focusing feature. Press menu twice to exit. You can verify this setting by checking the LCD screen (please see illustration). Also if shutter release is partially pressed, the center focus area in the viewfinder will be outlined in red.	a) Set the exposure mode to Manual [M] (step 2). b) Choose a shutter speed. If you are not sure what to set your shutter speed to, for outside shots, set it to a number close to the ISO of the camera. For example if your film's ISO is 100, set it to 1/125 sec. (see step 4). c) Turn your metering to [SPOT] and activate the center spot circle. This can be done by following directions in step 5. Now by pointing the *approximate* spot metering frame (which fortunately with this Nikon model follows very closely the frame of the center-single-focus area) at the desired simple subject. By changing the aperture and/or shutter speed, find the surface's normal exposure. This is when only ONE line appearing under the [0] mark located in the middle of [+] and [-] signs.

+..0..-

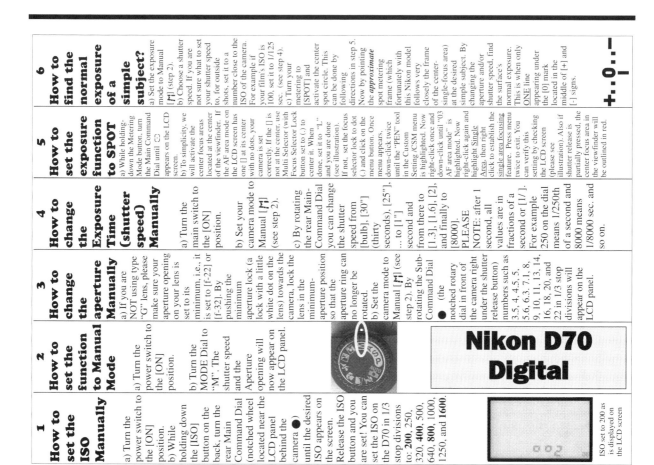

Nikon D70 Digital

ISO set to 200 as is displayed on the LCD screen

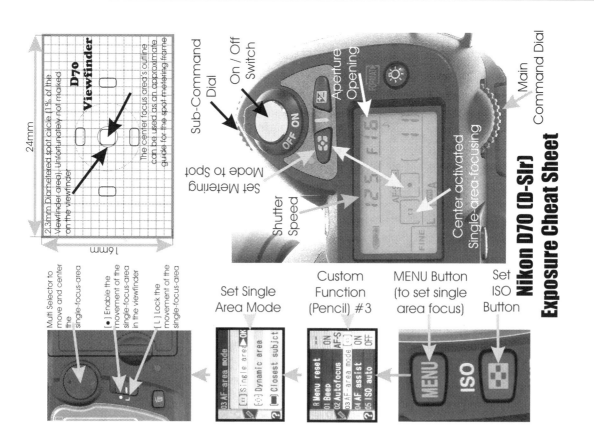

Nikon D70 (D-Slr) Exposure Cheat Sheet

D70 Viewfinder

24mm — 16mm

2.3mm Diametered spot circle (1% of the Viewfinder area). Unfortunately not marked on the viewfinder.

The center focus area's outline can be used as an approximate guide for the spot metering frame.

Sub-Command Dial — On / Off Switch — Aperture Opening — Main Command Dial

Set Metering Mode to Spot

Shutter Speed — Center activated Single-area-focusing

Multi Selector to move and center the single-focus-area

[●] Enable the movement of the single-focus-area in the viewfinder

[L] Lock the movement of the single-focus-area

Set Single Area Mode — Custom Function (Pencil) #3 — MENU Button (to set single area focus) — Set ISO Button

03 AF area mode — [□] Single area — [∷] Dynamic area — [∷] Closest subject

R Menu reset — 01 Beep ON — 02 Autofocus AF-S — 03 AF area mode [□] — 04 AF assist ON / OFF — 05 ISO auto

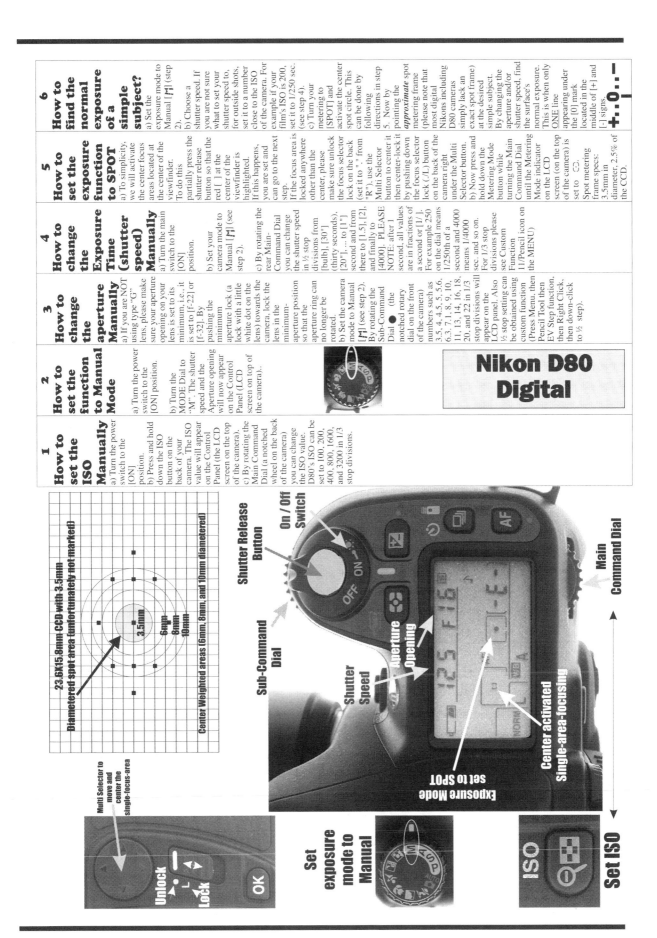

Nikon D80 Digital

1 How to set the ISO Manually	2 How to set the function to Manual Mode	3 How to change the aperture Manually	4 How to change the Exposure Time (shutter speed) Manually	5 How to set the exposure function to SPOT	6 How to find the normal exposure of a simple subject?
a) Turn the power switch to the [ON] position. b) Press and hold down the ISO button on the back of your camera. The ISO value will appear on the Control Panel (the LCD screen on the top of the camera). c) By rotating the Main Command Dial (a notched wheel on the back of the camera) you can change the D80's ISO value. D80's ISO can be set to 100, 200, 400, 800, 1600, and 3200 in 1/3 stop divisions.	a) Turn the power switch to the [ON] position. b) Turn the MODE Dial to "M". The shutter speed and the Aperture opening will now appear on the Control Panel (LCD screen on top of the camera)..	a) If you are NOT using type "G" lens, please make sure your aperture opening on your lens is set to its minimum, i.e., it is set to [f-22] or [f-32]. By pushing the minimum aperture lock (a lock with a little white dot on the lens) towards the camera, lock the lens in the minimum-aperture position so that the aperture ring can no longer be rotated. b) Set the camera mode to Manual [M] (see step 2). By rotating the Sub-Command Dial ● (the notched rotary dial on the front of the camera) numbers such as 3.5, 4, 4.5, 5, 5.6, 6.3, 7.1, 8, 9, 10, 11, 13, 14, 16, 18, 20, and 22 in 1/3 stop divisions will appear on the LCD panel. Also ½ stop setting can be obtained using custom function (Press Menu, then Pencil Tool then EV Step function, then Right Click, then down-click to ½ step).	a) Turn the main switch to the [ON] position. b) Set your camera mode to Manual [M] (see step 2). c) By rotating the rear Main-Command Dial you can change the shutter speed in ½ stop divisions from [bulb], [30"] (thirty seconds), [20"],... to [1"] second and from there to [1.5], [2], and finally to [4000]. PLEASE NOTE: after 1 second, all values are in fractions of a second or [1/]. For example 250 on the dial means 1/250th of a second and 4000 means 1/4000 sec. and so on. For 1/3 stop divisions please see Custom Function 11/Pencil icon on the MENU)	a) To simplicity, we will activate the center focus areas located at the center of the viewfinder. To do this partially press the shutter release button so that the red [] at the center of the viewfinder is highlighted. If this happens, you are set and can go to the next step. If the focus area is locked anywhere other than the center, please make sure unlock the focus selector lock on the back (set it to "R") use the Multi Selector button to center it then center-lock it by pushing down the focus selector lock (/L) button on the back of the camera right under the Multi Selector button. b) Now press and hold down the Metering Mode button while turning the Main Command Dial until the Metering Mode indicator on the LCD screen (on the top of the camera) is set to ⊙. Spot metering frame specs: 3.5mm in diameter, 2.5% of the CCD.	a) Set the exposure mode to Manual [M] (step 2). b) Choose a shutter speed. If you are not sure what to set your shutter speed to, for outside shots, set it to a number close to the ISO of the camera. For example if your film's ISO is 200, set it to 1/250 sec. (see step 4). c) Turn your metering to [SPOT] and activate the center spot circle. This can be done by following directions in step 5. Now by pointing the *approximate* spot metering frame (please note that most digital Nikons including D80 cameras simply lack an exact spot frame) at the desired simple subject. By changing the aperture and/or shutter speed, find the surface's normal exposure. This is when only ONE line appearing under the [0] mark located in the middle of [+] and [-] signs. +..0..-

23.6X15.8mm CCD with 3.5mm Diametered spot area (unfortunately not marked)

3.5mm

6mm
8mm
10mm

Center Weighted areas (6mm, 8mm, and 10mm diametered)

Multi Selector to move and center the single-focus-area

Unlock
L
Lock
OK

Set exposure mode to Manual

ISO Set ISO

On / Off Switch
Shutter Release Button
Sub-Command Dial
Shutter Speed
Aperture Opening
AF
Main Command Dial
Exposure Mode set to SPOT
Center activated Single-area-focusing

1 How to set the ISO Manually	2 How to set the function to Manual Mode	3 How to change the aperture Manually	4 How to change the Exposure Time (shutter speed) Manually	5 How to set the exposure function to SPOT	6 How to find the normal exposure of a simple subject?
a) Turn the power switch to the [ON] position. b) Press and hold down the ISO button on the top left hand side of your camera. The ISO value will appear on the Control Panel (the LCD screen on the top right side of the camera. c) By rotating the Main Command Dial (a notched wheel on the back right hand side of the camera) you can change the ISO value. D200's ISO can be set to 100, 200, 400, 800, 1600, and 3200 in 1/3 stop divisions.	a) Turn the power switch to the [ON] position. b) Press and hold down the MODE Dial located on the top right hand side of your camera and turn the Main Command Dial (a notched wheel on the back-right-side of the camera until the letter "M" appears on the top left hand side of the LCD panel. The shutter speed and the Aperture opening will now appear on the Control Panel (LCD screen on top of the camera).	a) If you are NOT using type "G" lens, please make sure your aperture opening on your lens is set to its minimum, i.e.. it is set to [f-22] or [f-32]. By pushing the minimum aperture lock (a lock with a little white dot on the lens) towards the camera, lock the lens in the minimum-aperture position so that the aperture ring can no longer be rotated. b) Set the camera mode to Manual [M] (see step 2). By rotating the Sub-Command Dial ● numbers such as 3.5, 4, 4.5, 5, 5.6, 6.3, 7.1, 8, 9, 10, 11, 13, 14, 16, 18, 20, and 22 in 1/3 stop divisions will appear on the LCD panel. Also ½ stop setting can be obtained using custom function (Menu, Pencil Tool, choose "b" for Metering/Exposure. By Right-clicking the Multi-Selector wheel and choosing sub menu "b3" and right clicking on the EV Step for exposure control	a) Turn the main switch to the [ON] position. b) Set your camera mode to Manual [M] (see step 2). c) By rotating the rear Main-Command Dial you can change the shutter speed in ½ stop divisions from [bulb], [30"] (thirty seconds), [20"],... to [1"] second and from there to [1.5], [2], and finally to [8000]. PLEASE NOTE: after 1 second, all values are in fractions of a second or [1/]. For example 250 on the dial means 1/250th of a second and 8000 means 1/8000 sec. and so on. For other divisions (1/3, and 1 stop) please refer to step 3 (Custom setting Menu, "b" Metering/Exposure, "b3" EV Step, then 1/3, ½, or 1 stop steps).	a) Turn the metering selector to spot "•". b) For simplicity, we will activate the center focus areas located at the center of the viewfinder. To do this set the AF-area mode selector to Single Area AF (as illustrated). Now partially press the shutter release button so that the red rectangle [.] at the center of the viewfinder is highlighted. If this happens, you are set. Simply turn the focus selector lock to "L" and go to step 6. If the focus area is pointing to anywhere other than the center, unlock the focus selector lock on the back (set it to " " from "L"), use the Multi Selector button to center it then center-lock it by pushing down the focus selector lock (/L) button on the back of the camera as illustrated. The spot metering area is an imaginary 3mm-diametered circle which occupies 2% of the viewfinder area.	a) Set the exposure mode to Manual [M] (step 2). b) Choose a shutter speed. If you are not sure what to set your shutter speed to, for outside shots, set it to a number close to the ISO of the camera. For example if your film's ISO is 100, set it to 1/125 sec. (see step 4). c) Turn your metering to [SPOT] and activate the center spot focus area. This can be done by following directions in step 5. Now by pointing the *approximate* spot metering frame (please note that most digital Nikons including D200 simply lack an exact spot frame. Please use the illustration as a guide) at the desired simple subject. By changing the aperture and/or shutter speed. find the surface's normal exposure. This is when only ONE line appearing under the [0] mark located in the middle of [+] and [-] signs. +..0..−

Nikon D200 Digital

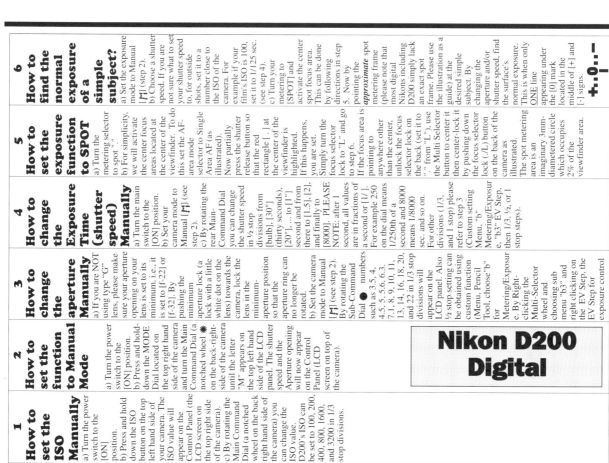

23.6X15.8mm CCD with 3mm Diametered spot area 2% of the frame.(unfortunately not marked and you have to guess at it!)

Center Weighted areas (6mm, 8mm, 10mm, and 13mm diametered)

3mm
6mm
8mm
10mm
13mm

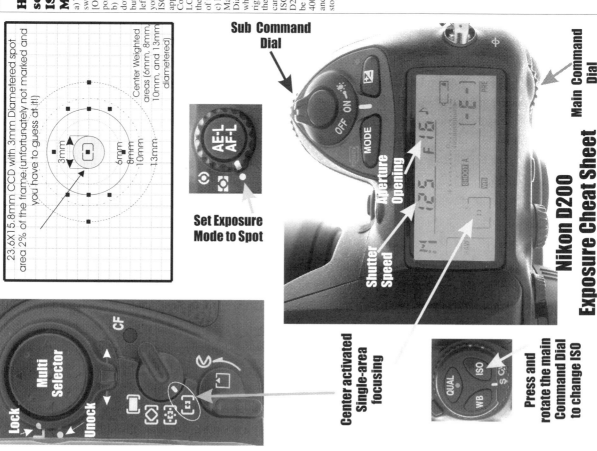

Sub Command Dial

Set Exposure Mode to Spot

Main Command Dial

Aperture Opening

Shutter Speed

Nikon D200 Exposure Cheat Sheet

Center activated Single-area focusing

Multi Selector

Lock

Unlock

CF

Press and rotate the main Command Dial to change ISO

Nikon F4

1 How to set the ISO Manually	2 How to set the function to Manual Mode	3 How to change the aperture Manually :	4 How to change the Exposure Time (shutter speed) Manually	5 How to set the exposure function to SPOT	6 How to find the normal exposure of a simple subject?
a) While holding down the ISO ring unlock button, turn the ISO ring until the white marker points at the desired ISO. The ISO for F4 can be set manually from 6 to 6400. b) To set the ISO back to DX, follow the step (a) until the marker points to "DX" symbol.	a) By setting the shutter speed dial to 4 (4 sec.) to 1/8000 sec.) (8000), your F4 will operate in the manual mode. If you can not turn the dial, there is a good chance that your dial is locked on "X" for flash synchronization. While holding-down the release button in the middle of shutter speed dial ring, turn the ring and it will be unlocked.	a) By rotating the aperture ring on the lens, the aperture opening can be set to the desired value. Depending on your lens these *could* include aperture openings of 1.4, 2, 2.8, 4, 5.6, 8, 11, 16, 22, and 32.	a) The Shutter speed ring can be set to exposure times ranging from 4 (4 sec.) To 8000 (1/8000 sec.) If you can not turn the dial, there is a good chance that your dial is locked on "X" for flash synchronization. While holding-down the release button in the middle of shutter speed dial ring, turn the ring and it will be unlocked.	a) Turn the metering selection dial located on the top of the camera close to shutter speed dial to the dot [.] symbol. Your camera's metering mode is now set to spotmetering.	a) While holding down the power switch unlock button, rotate the main switch so that it no longer points to "L". b) Set the exposure mode to Manual (step 2) by selecting any speed from 4 sec. To 1/8000 sec. c) Choose a shutter speed. If you are not sure what to set your shutter speed to, for outside shots, set it to a number close to the ISO of the film. For example if your film's ISO is 100, set it to 1/125 sec. (step 4) d) Turn your metering to [SPOT]. This can be done by following directions in step 5. Then by pointing the F4's exact spotmetering circle/frame at the desired simple subject and changing the aperture and/or shutter speed, find the surface's normal exposure. This is when the pointer in your viewfinder is positioned exactly under the [0] mark located in the middle of [+] and [-] signs.

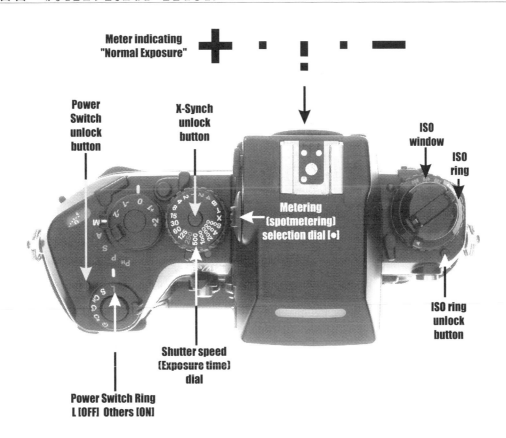

Meter indicating "Normal Exposure"

Power Switch unlock button

X-Synch unlock button

ISO window

ISO ring

Metering (spotmetering) selection dial [•]

ISO ring unlock button

Shutter speed (Exposure time) dial

Power Switch Ring L [OFF] Others [ON]

1 How to set the ISO Manually	2 How to set the function to Manual Mode	3 How to change the aperture Manually	4 How to change the Exposure Time (shutter speed) Manually	5 How to set the exposure function to SPOT	6 How to find the normal exposure of a simple subject?
If you do not have DX coded film (i.e., you roll your own film): a) Slide the power switch to the [ON] position. b) While holding down the [ISO] button, located on the back of the camera turn the rear Command Dial (notched wheel located near the LCD panel behind the camera ●) until the desired ISO appears on the screen. Release the ISO button and you are set! c) To set it back to DX, turn the rear Control Dial decreasing the ISO. The [DX] letters will appear after ISO 6 (the lowest ISO supported by the camera). PLEASE NOTE: The manual ISO will remain in effect indefinitely unless it is changed to another ISO or the dial is set back to DX for DX coded films.	a) Turn the power switch to the [ON] position. b) While holding down the [MODE] button, turn the rear Command Dial (notched wheel located behind the LCD panel ●) until letter [M] appears on the LCD screen. **Nikon F5**	a) Make sure your aperture opening on your lens is set to its smallest setting, depending on your lens, it is set to [f-22] or [f-32]. By pushing the minimum aperture lock (a lock with a little white dot on the lens) towards the camera, lock the lens in the minimum-aperture position so that the aperture ring on your lens can no longer be rotated. b) Set the camera mode to Manual [M] (see step 2). By rotating the Sub-Command Dial ● (the notched rotary dial in front of the camera right under the shutter release button) numbers such as **2.8**, 3.2, 3.5, **4**, 4.5, 5, **5.6**, 6.3, 7.1, **8**, 9, 10, **11**, 13, 14, **16**, 18, 20, **22**, etc. in 1/3 stop divisions will appear. The f-number will appear on the top right hand side of your LCD screen prefixed with letter [F].	a) Turn the main switch to the [ON] position. b) Set your camera mode to Manual [M] (see step 2). c) By rotating the rear Main-Command Dial you can change the shutter speed from [bulb], [30"] (thirty seconds), [25"],... to [1"] second and from there to [1.3], [1.6], [2],.... and finally to [8000]. PLEASE NOTE: after 1 second, all values are in fractions of a second or [1/]. For example 250 on the dial means 1/250th of a second and 8000 means 1/8000 sec. and so on.	a) Set the camera to Manual [M] mode (see step 2). b) Turn the Metering System Selector in the back (top center) of the camera to a white dot [.] so that ⊡ appears in the viewfinder. c) To simplify, set the Focus Mode Selector in front of the camera to "M"anual Focus. d) Choose Single AF Area by turning the Mode Selector on the back of the camera to []. e) If locked "L", unlock the Focus Area Selector to set to " ". Use thumb pad to activate the CENTER AF area so that the rectangle at the center of the viewfinder is lit (red). f) Lock the focus area selector to "L". g) The 4mm-diametered spot metering circle (frame) at the center is now active. Please note that you can NOT see the circle and have to guess at its approximate location!	a) Set the exposure mode to Manual [M] (step 2). b) Choose a shutter speed (exposure time). If you are not sure what to set your shutter speed to, for outside shots, set it to a number close to the ISO of the film. For example if your film's ISO is 100, set it to 1/125 sec. (see step 4). c) Turn your metering to [SPOT] and activate the imaginary center spot circle. This can be done by following directions in step 5. Now by pointing the *approximate* spot metering circle at the desired simple subject and changing the aperture and/or shutter speed, find the surface's normal exposure. This is when the pointer in your viewfinder is positioned exactly under the [0] mark located in the middle of [+] and [-].

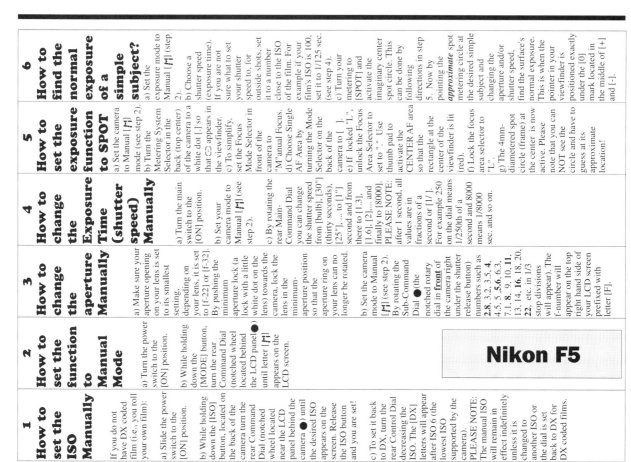

The 4mm-diametered invisible (fuzzy) center Spot Circle is activated when the center AF element is set to active (please see text)

12mm-diametered partial metering Circle

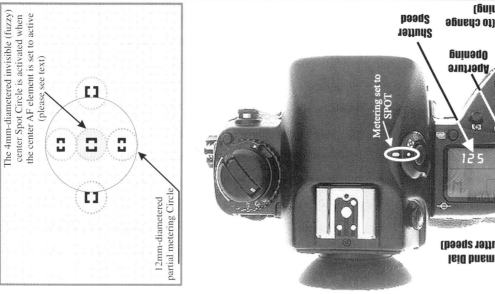
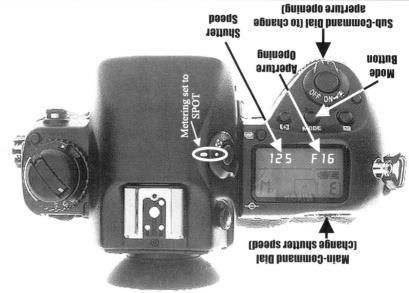

Shutter Speed

Sub-Command Dial (to change aperture opening)

Aperture Opening

Mode Button

Metering set to SPOT

Main-Command Dial (change shutter speed)

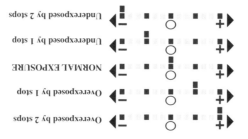

Underexposed by 2 stops

Underexposed by 1 stop

NORMAL EXPOSURE

Overexposed by 1 stop

Overexposed by 2 stops

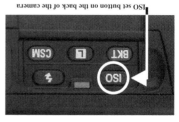

ISO set button on the back of the camera

ISO

1 How to set the ISO Manually by Hand	2 How to set the function to Manual Mode	3 How to change the aperture Manually	4 How to change the Exposure Time (shutter speed) Manually	5 How to set the exposure function to SPOT	6 How to find the normal exposure of a simple subject?
If you do not have DX coded film (i.e., you roll your own film): a) Slide the power switch to the [ON] position. b) While holding down the [ISO] button, turn the rear Command Dial (notched wheel located behind the LCD panel ●) until the desired ISO appears on the screen. Release the ISO button and you are set! c) To set it back to DX, turn the rear Control Dial decreasing the ISO. The [DX] letters will appear after ISO 6 (the lowest ISO supported by the camera).	a) Slide the power switch to the [ON] position. b) While holding down the [MODE] button, turn the rear Command Dial (notched wheel located behind the LCD panel ●) until letter [M] appears on the LCD screen.	a) Make sure your aperture opening on your lens is set to minimum, i.e., it is set to [F-22] or [F-32] on your lens. By pushing the minimum aperture lock (a lock with a little white dot on the lens) towards the camera, lock the lens in the minimum-aperture position so that the aperture ring can no longer be rotated. b) Set the camera mode to Manual [M] (see step 2). By rotating the Sub-Command Dial ● (the notched rotary dial in front of the camera right under the shutter release button) numbers such as **2.8**, 3.2, 3.5, **4**, 4.5, 5, **5.6**, 6.3, 7.1, **8**, 9, 10, **11**, 13, 14, **16**, 18, 20, **22**, etc. in 1/3 stop divisions will appear, the f-number will appear on the top right hand side of your LCD screen prefixed with letter [F].	a) Slide the main switch to the [ON] position. b) Set your camera mode to Manual [M] (see step 2). c) By rotating the rear Main-Command Dial you can change the shutter speed from [bulb], [30"] (thirty seconds), [25"],...to [1"] second and from there to [1.3], [1.6], [2]....and finally to [8000]. PLEASE NOTE: after 1 second, all values are in fractions of a second or [1/]. For example 250 on the dial means 1/250th of a second and 8000 means 1/8000 sec. and so on.	a) Set the camera to Manual [M] mode (see step 2). b) Turn the Metering System Selector in back (top center) of the camera to a white dot [.] so that ⊡ appears in the viewfinder. c) To simplify your metering set the Focus Mode Selector in front of the camera to "M"anual Focus. d) Choose Single AF Area by turning the Mode Selector on the back of the camera to []. e) If locked "L", unlock the Focus Area Selector to set to "." Use thumb pad to activate the CENTER AF area so that the rectangle at the center of the viewfinder is lit (red). f) Lock the focus area selector (set to "L"). g) The CENTER 4mm-diameated spot circle (frame) is now active. Please note that you can NOT see the circle and have to guess at its approximate location!	a) Set the exposure mode to Manual [M] (step 2). b) Choose a shutter speed. If you are not sure what to set your shutter speed to, for outside shots, set it to a number close to the ISO of the film. For example if your film's ISO is 100, set it to 1/125 sec. (see step 4). c) Turn your metering to [SPOT] and activate the imaginary center spot circle. This can be done by following directions in step 5. Now by pointing the *approximate* spot metering circle at the desired simple subject and changing the aperture and/or shutter speed, find the surface's normal exposure. This is when the pointer in your viewfinder is positioned under the [0] mark located in the middle of [+] and [-] signs.

Nikon F100

1 How to set the ISO Manually	2 How to set the function to Manual	3 How to change the aperture Manually	4 How to change the Exposure Time (shutter speed) Manually	5 How to set the exposure function to SPOT	6 How to find the normal exposure of a simple subject?
If you do not have DX coded film (i.e., you roll your own film): a) Slide the power switch to the [ON] position. b) While holding down the [FUNCTION] button (the large button labeled [FUNCTION] at the top left hand side of the camera), rotate the [Command Dial] (a notched black wheel located under the LCD screen●) until a small arrow appears in the ISO sector (the first sector from the right).	a) Slide the main switch to the [ON] position. While holding down the [FUNCTION] button, turn the circular command dial [●] until the arrow appears in the fourth sector from the right where one of these letters [A], [S], [P], or [M] will also appear. If the letter is anything other than [M], while holding down the [SET] button turn the control dial until the letter [M] appears.	a) Set the camera mode to Manual [M] (see step 2). b) Push the minimum aperture lock (a lock with a little white dot on your lens) forward and release the aperture ring so that it can be freely rotated. c) By rotating the aperture ring on the lens (the ring with numbers such as 4, 5, 6, 8, 11 etc.), the f-number will appear on the middle right hand side of your LCD screen. Please note that at times, when you are using zoom lenses, due to the lens extension the f-number engraved on the ring may not match the f-number that is displayed on the LCD dial. *The LCD dial always indicates the correct f-stop.*	a) Turn your camera on and set the camera mode to Manual [M] (see step 2). b) When rotating the Circular Control Dial (located behind the LCD panel), your exposure times (shutter speeds) will change. The new exposure time is indicated on the top left hand side of the LCD screen.	a) Slide the Main switch to the [ON] position. b) Set the camera to Manual [M] mode. c) While pressing the [FUNCTION] button, rotate the Command Dial so that the tip of the arrow appears in the metering sector (sector with a rectangular outline, fifth sector from right).	a) After sliding the main switch to the [ON] position set the exposure mode to Manual [M] (step 2). b) Choose a shutter speed (exposure time). If you are not sure of your shutter speed setting, particularly for outside shots, set it to a number close to the ISO of the film. For example if your film's ISO is 100, set it to 1/125 sec. This is done by following directions in step 4.

Nikon N70

Meter indicating a normal exposure

COMMAND DIAL

SET

FUNCTION

FUNCTION SECTORS

ISO/DX SECTOR

EXPOSURE SECTOR

METERING SECTOR

Spot Frame (circle) area

1 How to set the ISO Manually	2 How to set the function to Manual Mode	3 How to change the aperture Manually	4 How to change the Exposure Time (shutter speed) Manually	5 How to set the exposure function to SPOT	6 How to find the normal exposure of a simple subject
If you do not have DX coded film (i.e., you roll your own film): a) Slide the power switch to the [ON] position. b) While holding down the [ISO] button, turn the Command Dial (notched wheel located by the LCD panel ●) until the desired ISO appears on the screen. Press ISO button so that DX disappears from the LCD screen. c) To set it back to DX, turn Control Dial clockwise and decrease the ISO. The [DX] letters will appear after ISO 6 (the lowest ISO supported by the camera).	a) Slide the power switch to the [ON] position. b) While holding down the [MODE] button, turn the Command Dial (notched wheel located by the LCD panel●) until letter [M] appears on the LCD screen.	a) Set the camera mode to Manual [M] (see step 2). b) By pushing the minimum aperture lock towards the front of the lens, release the aperture ring so that it can be freely rotated. c) By rotating the aperture ring on the lens (the ring with numbers such as 4, 5.6, 8, 11 etc.), the f-number will appear on the top right hand side of your LCD screen prefixed with letter [F]. Please note that at times, when you are using zoom lenses, use the f-number that is displayed on the LCD dial. *The LCD dial always indicates the correct aperture opening.*	a) Slide the main switch to the [ON] position. b) Set your camera mode to Manual [M] (see step 2). c) By rotating the Command Control Dial (located on the bottom right hand side of your LCD panel●), your exposure times (shutter speeds) will change. The new exposure time is indicated on the top left hand side of the LCD screen. If you do not see the numbers, gently (and partially) press the shutter release button.	a) Slide the Main switch to the [ON] position. b) Set the camera to Manual [M] mode. c) Press and hold down the Metering Mode Selection Button, located to the top left of the camera and marked with ● and rotate Command Dial so that the spotmeter symbol appears on your LCD panel.	a) Set the exposure mode to Manual [M] (step 2). b) Choose a shutter speed. If you are not sure what to set your shutter speed to, for outside shots, set it to a number close to the ISO of the film. For example if your film's ISO is 100, set it to 1/125 sec. (see step 4). c) Turn your metering to [SPOT]. This can be done by following directions in step 5. Then by pointing the spotmetering circle at the desired simple subject and turning the aperture ring on the lens, find the surface's normal exposure. This is when the pointer in your viewfinder is positioned exactly under the [0] mark located in the middle of [+] and [-] signs.

Obtaining the Normal exposure automatically:

If you want to obtain the normal exposure of a simple surface (subject) quickly, while in "Manual Exposure" mode, you can set Shutter Speed to say 1/125 sec. Then change the exposure mode to Shutter Priority "S". This can be done by holding down the [MODE] button, turn the Command Dial until letter [S] appears on the LCD screen. In this mode, by partially pressing the shutter release button and pointing the spotmetering frame at the desired simple tone, the aperture opening for the "Normal Exposure" quickly appears in the viewfinder. Now you should take note of this aperture opening, change the exposure mode to Manual, interpret the reading, set the aperture to its interpreted value and then shoot.

Nikon N90s

METERING MODE

MODE

ISO

DRIVE

COMMAND DIAL

+ . . 0 . . —

Meter indicating a normal exposure

1 How to set the ISO Manually	2 How to set the function to Manual mode	3 How to change the aperture Manually	4 How to change the Exposure Time (shutter speed) Manually	5 How to set the exposure function to SPOT	6 How to find the normal exposure of a simple subject?
If you do not have DX coded film (i.e., you roll your own film): a) Slide the power switch to the [ON] position: b) While pressing the shift button, a round golden button marked with a square located at the top left hand side of the LCD display [⊙], press the ISO button so that DX disappears from the LCD screen.	After sliding the power switch to the [ON] position: a) While holding down the [MODE] button, turn the circular Command Dial, a large notched wheel located at the bottom right side of the LCD screen [●] until the letter [M] appears at the top left hand side of the LCD panel and in the viewfinder.	a) Set the camera mode to Manual [M] (see step 2). b) By pushing the minimum aperture lock (a lock with a little white dot on the lens) towards the front of the lens, then release the aperture ring so that it can be freely rotated. c) By rotating the aperture ring on the lens (the ring with numbers such as 4, 5, 6, 8, 11 etc.) the f-number will appear on the middle right hand side of your LCD screen. Please note that at times, when you are using zoom lenses, due to the lens extension, the f-number engraved on the ring may not match the f-number that is displayed on the LCD dial. *The LCD dial always indicates the correct f-stop.*	a) Slide the main switch to the [ON] position. b) Set your camera mode to Manual [M] (see step 2). c) By rotating the Circular Command Dial, located on the bottom left hand side of your LCD panel [●], your exposure times (shutter speeds) will change. The new exposure time is indicated on the left hand side of the LCD screen.	a) Slide the Main switch to the [ON] position. b) Set the camera to Manual [M] mode (see step 2). c) Press the metering system button (a four segmented button with a circle in the middle ⊛), then rotate the Command Dial [●] so that the spotmetering symbol (a rectangle with a small black dot ⊡) appears on your LCD panel.	a) Set the exposure to Manual mode [M] (see step 2). Then choose a shutter speed (exposure time). If you are not sure of your shutter speed setting, particularly for outside shots, set it to a number close to the ISO of the film being used. For example if your film's ISO is 100, set it to 1/125 sec. This can be done by following directions in step 4. b) Turn your metering to [SPOT]. This can be done by following directions in step 5.

Nikon N6006

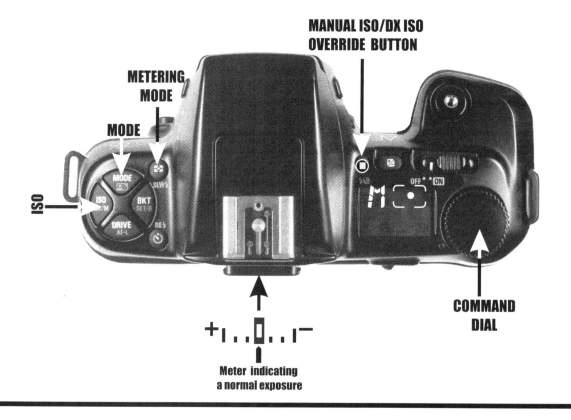

MANUAL ISO/DX ISO OVERRIDE BUTTON

METERING MODE

MODE

ISO

COMMAND DIAL

+₁..▯..₁−

Meter indicating a normal exposure

1 How to set the ISO Manually	2 How to set the function to Manual Mode	3 How to change the aperture Manually	4 How to change the Exposure Time (shutter speed) Manually	5 How to set the exposure function to SPOT	6 How to find the normal exposure of a simple subject?
If you do not have DX coded film (i.e., you roll your own film): a) Turn the power switch to the [ON] position. b) Push and hold down the ISO set button while turning the control dial. Release the button when the desired ISO is set. c) To turn back the ISO to DX, follow step (b) and turn the Command Dial until DX appears on the LCD Panel. It is before [6] ISO and after [6400] ISO.	a) Slide the main switch to the [ON] position. b) While pushing and holding down the Exposure Mode button, turn the Command Dial until letter [M] appears on top left hand side of the LCD panel.	a) Slide the Main switch to the [ON] position. b) Set your camera mode to Manual [M] (see step 2). c) By rotating the aperture ring on the lens, the aperture opening will appear on the LCD Panel. If the LCD reading does not reflect the same value as is indicated on the ring, The LCD reading indicates the correct aperture opening.	a) Slide the Main switch to the [ON] position. b) Set your camera mode to Manual [M] (see step 2). c) By rotating the Command Dial, the shutter speed (exposure time) will change from Bulb, 30" (30 seconds) to 1" (1 second) and to 8000 (1/8000 sec.)	a) Slide the Main switch to the [ON] position. b) Set the camera to Manual [M] mode. c) While pushing down the Metering mode button [⊙] turn the Command Dial until the spotmetering symbol [⊡] appears on the LCD panel.	a) Set the exposure mode to Manual [M] (step 2). b) Choose a shutter speed. If you are not sure what to set your shutter speed to, for outside shots, set it to a number close to the ISO of the film. For example if your film's ISO is 100, set it to 1/125 sec. (see step 4). c) Turn your metering to [SPOT]. This can be done by following directions in step 5. Then by pointing the approximate spotmetering circle at the desired simple subject and changing the aperture and/or shutter speed, find the surface's normal exposure. This is when the pointer in your viewfinder is positioned exactly under the [0] mark located in the middle of [+] and [-] signs.

Nikon N8008s

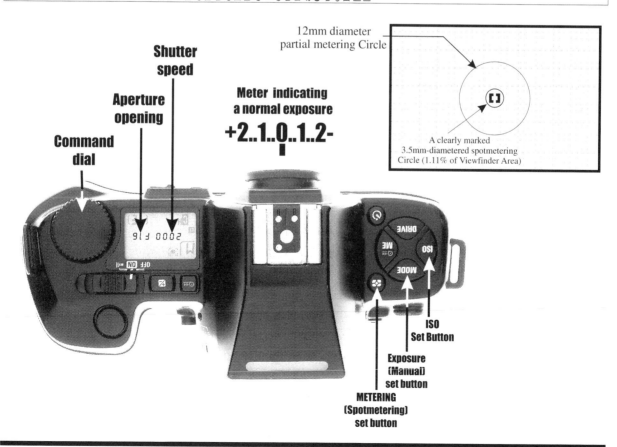

Command dial

Aperture opening

Shutter speed

Meter indicating a normal exposure

+2..1..0..1..2-

12mm diameter partial metering Circle

A clearly marked 3.5mm-diametered spotmetering Circle (1.11% of Viewfinder Area)

ISO Set Button

Exposure (Manual) set button

METERING (Spotmetering) set button

1 How to set the ISO Manually	2 How to set the Exposure to Manual Mode	3 How to change the aperture [Av] Manually	4 How to change the Exposure Time (shutter speed / Tv) Manually	5 How to set the exposure Mode to SPOT	6 Finding the normal exposure of a simple subject
a) Turn the Main Switch to [ON] position. b) Set the Mode Dial to ISO. The Mode Dial is a notched wheel located on the top left of the camera. c) Now turn the Tv Dial (a notched wheel located right under the On/Off switch) to change the film sensitivity (ISO). *Ist-D's ISO can be set to 200, 400, 800, and 1600.	a) Turn the Main Switch to [ON] position. b) Set the Mode Dial to letter [M]. The Mode Dial is a notched wheel located on the top left of the camera. Your *ist-D is now set to Manual Exposure Mode. The shutter speed (exposure time) and aperture opening will now appear on the LCD panel located on the top right hand side of the camera.	a) Turn the Main Switch to [ON] position. b) Set the Mode Dial to letter [M]. The Mode Dial is a notched wheel located on the top left of the camera (step 2). c) Turn the dial on your lens to [A] and leave it there. d) The aperture opening can be changed using the Av (Aperture Value) dial located on the back (top right hand side) of the camera. Depending on the lens used on the camera the aperture opening can be changed say from f-4 to f-22. Full stop values are 4, 5.6, 8, 11, 16, and 22. The half-stop values in this case are (yours may be different) 4.5, 6.7, 9.5, 13, and 19.	a) Turn the Main Switch to [ON] position. b) Set the Mode Dial to letter [M]. The Mode Dial is a notched wheel located on the top left of the camera (step 2). c) The Shutter Speed (exposure time now appears on the LCD screen prefixed by letters [Tv]. The shutter speed can now be changed manually by turning the Tv (Time Value) dial located on the front (right under the On/Off switch). The exposure times in seconds can be set to: 30", 20", 15", 10", 8", 6", 4", 3", 2", 1.5", 1". This dial can be set in fractions of a second to: 0.7, 0.5, 0.3, 4, 6, 8, 10, 15, 20, 30, 45, 60, 90, 125, 180, 250, 350, 500, 750, 1000, 1500, 2000, 3000, and 4000.	a) Set the Main Switch to [ON] position. b) Turn the Metering Mode Select Lever (located right under the mode dial on the top left hand side of the camera) to spot metering symbol [□].	a) Set the Mode Dial to letter [M] (step 2). b) Choose a shutter speed (exposure time). If you are not sure what to set your shutter speed to (for outside shots) set it to a number close to the ISO of the film. For example, if your film's ISO is 200, set it to 1/250 sec. This can be done following directions in step 4. c) Turn your metering to SPOT [□]. This can be done by following directions in step 5. Then by pointing the center of the viewfinder "()" at the desired simple subject and by changing the aperture and/or shutter speed, find the simple subject's normal exposure. This is when only one small dot is appears exactly in the middle of the "+" and "-" sign on the right hand side of your viewfinder.

PENTAX *ist-D

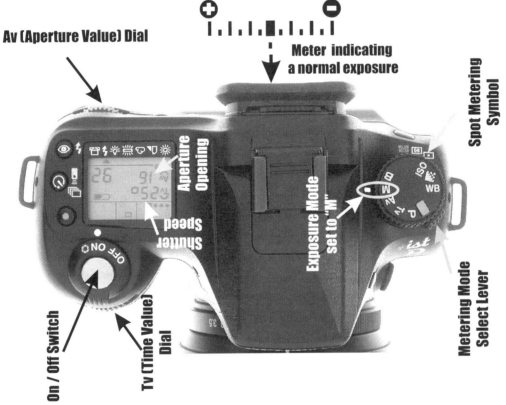

Av (Aperture Value) Dial

⊕ Meter indicating a normal exposure ⊖

Spot Metering Symbol

Aperture Opening

Shutter Speed

Exposure Mode Set to "M"

On / Off Switch

Tv (Time Value) Dial

Metering Mode Select Lever

1 How to set the ISO Manually	2 How to set the function to Manual	3 How to change the aperture Manually	4 How to change the Shutter Speed Manually	5 How to set the exposure function to SPOT	6 How to find the normal exposure of a simple subject?
a) Slide the power switch to the [ON] position.	a) Press the shutter speed release button and turn the shutter speed dial so that it is NOT set to "A".	a) Change the aperture opening ring on your lens to set the aperture to the desired value. It could be 2.8, 4, 5.6, 8, 11, 16, or 22. If the aperture opening is set on "A" and the ring can not be rotated, press the aperture lock release (a small black button on the ring) and then change the aperture opening.	a) Push the shutter speed release button so that you can turn the shutter speed rotary dial to the desired value. Shutter speeds (exposure times) range from Bulb [B], 4 seconds [4s] to 1000 (1/1000th of a second).	a) Turn the metering mode selector until it is set to spot [⊡].	a) After sliding the main switch to the [ON] position set the exposure mode to Manual (step 2).
b) While pushing (and holding) the ISO-set lever in the arrow's direction, align the white squared index mark with the ISO mark (a small circle).					b) Choose a shutter speed (exposure time). If you are not sure of your shutter speed setting, particularly for outside shots, set it to a number close to the ISO of the film. For example if your film's ISO is 100, set it to 1/125 sec. This is done by following the step 4.
c) Use the Increase/Decrease ISO arrows to set the desired ISO, the value of which will be displayed in the small LCD panel.					

Pentax 645N

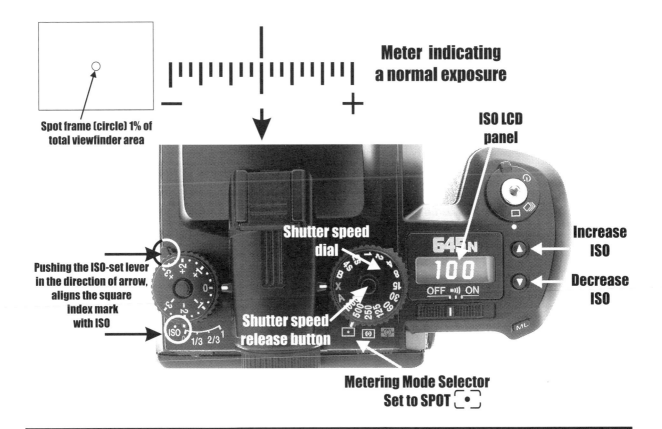

Spot frame (circle) 1% of total viewfinder area

Meter indicating a normal exposure

ISO LCD panel

Increase ISO

Decrease ISO

Shutter speed dial

Pushing the ISO-set lever in the direction of arrow, aligns the square index mark with ISO

Shutter speed release button

Metering Mode Selector Set to SPOT ⊡

1 How to set the ISO Manually	2 How to set the function to Manual Mode	3 How to change the aperture Manually	4 How to change the Exposure Time (shutter speed) Manually	5 How to set the exposure function to SPOT	6 How to find the normal exposure of a simple subject?
If you do not have a DX coded film (i.e., you roll your own film)		a) Turn on the camera and set your exposure mode to [M] (see step 2).	a) Set your camera to Manual mode (see step 2).	a) Turn the main switch to [ON] position.	a) Turn the main switch to [ON] position.
a) Turn the main switch to [ON] position.	a) Turn the main switch to [ON] position.	b) If the lens aperture ring is set to [A], while holding down the aperture lock button, turn the aperture ring so that the pointer [♦] no longer points to [A]. Now the letters [M] or [Av] will appear on the top right hand side of your LCD screen. By turning the aperture ring on your lens, you can set the aperture to the desired value. If instead of the aperture opening you see [F- -], gently touch the shutter release button and the aperture opening will appear again. Aperture values on a typical lens may include: 2.8, 4, 5.6, 8, 11, 16, and 22. When using zoom lenses, if the aperture value on the lens is different than the LCD reading, LCD indicates the correct number.	b) While [M] is showing on the top right hand side of the LCD screen, by turning the [Select Dial] you can set the shutter speed to the desired value. Shutter speed settings range from Bu (Bulb), 30 seconds (30"), to 1/6000 second in ½ stop increments. Typical sequence is: 30", 20", 15", 10", 8", 6", 4", 3", 2", 1.5", 1", 0.7", 1/2, 1/3, 1/4, 1/6, 1/8, 1/10, 1/15, 1/20, 1/30, 1/45, 1/60, 1/90, 1/125, 1/180, 1/250, 1/350, 1/500, 1/750, 1/1000, 1/1500, 1/2000, 1/3000, 1/4000, and 1/6000 second.	b) Turn the metering mode until it points to SPOT (◻).	b) Set the exposure mode to Manual (see step 2). Then choose a starting shutter speed (exposure time). If you are not sure of your shutter speed setting, particularly for outside shots, set it to a number close to the ISO of your film.. For example if your film's ISO is 100, set it to 1/125 sec. This can be done by following the directions in step 4.
b) While pressing the lock release button, turn the exposure compensation dial until gray index mark (right under the flash pop-up button) points to "ISO". Now the film's ISO will appear on the LCD screen. By turning the [select Dial] the desired value can be set. The ISO range of MZ-S is from 6 to 6400.	b) If lens aperture ring is set to [A], while holding down the aperture lock button, turn the aperture ring so that the pointer [♦] no longer points to [A]. Now the letters [M] or [Av] will appear on the top right hand side of the LCD screen.				

PENTAX MZ-S

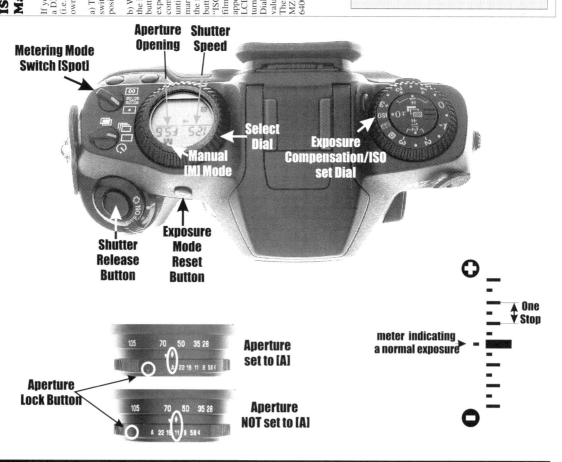

Metering Mode Switch [Spot]

Aperture Opening

Shutter Speed

Select Dial

Manual [M] Mode

Exposure Compensation/ISO set Dial

Shutter Release Button

Exposure Mode Reset Button

Aperture set to [A]

Aperture NOT set to [A]

Aperture Lock Button

One Stop

meter indicating a normal exposure

1 How to set the ISO Manually	2 How to set the function to Manual mode	3 How to change the aperture Manually	4 How to change the Exposure Time (shutter speed) Manually	5 How to set the exposure function to SPOT	6 How to find the normal exposure of a simple subject?
If you do not have DX coded film (i.e., you roll your own film):	a) Turn the Mode dial so that the mode set dial points to [MODE].	a) Set the camera mode to Manual [Hy M] (see step 2).	a) Set the camera mode to Manual [Hy M] (see step 2). If the shutter speed does not appear on the LCD screen, press the shutter release button partially to activate the LCD screen.	a) Slide the main switch forward to the [ON] position.	a) Set the exposure mode to Manual [Hy M] by following directions in step 2.
a) Slide the power switch forward to the [ON] position.	b) While pressing the Mode set button, turn the [Tv] direct dial (a notched wheel located above the shutter release button) until [Hy M] appears on the LCD screen. If the [Hy M] does not appear on the LCD screen, chances are you have set the main switch to [USER] rather than to the [ON] position!	b) By rotating the aperture ring on the lens (the ring with numbers such as 4, 5.6, 8, 11 etc.) the f-number will appear on the bottom right hand side of your LCD screen. Please note that at times, especially when you are using long zoom lenses, due to the lens extension the f-number engraved on the ring may not match the f-number that is displayed on the LCD screen or the viewfinder. *The LCD dial always indicates the correct f-stop.*	b) By rotating the Time value [Tv] direct dial (a notched wheel located right above the shutter release button) the shutter speed (exposure time) can be changed. Sample exposure times are: 30" to 1", then .7, 1/2, 1/3, 1/4, 1/6, 1/8, 1/10, 1/15, 1/20, 1/30, 1/45, 1/60, 1/90, 1/125, 1/180, 1/250, 1/350, 1/500, 1/750, 1/1000, 1/1500, 1/2000, 1/3000, 1/4000, 1/6000, and 1/8000.	b) Set the camera to Manual [Hy M] (see step 2).	b) Choose a starting shutter speed (exposure time). If you are not sure of your shutter speed setting, particularly for outside shots, set it to a number close to the ISO of the film being used. For example if your film's ISO is 100, set it to 1/125 sec. This can be done by following the directions in step 4. Now turn your metering to [SPOT]. This can be done by following directions in step 5.
b) Turn the Mode dial (notched wheel on the left of the camera) so that the mode is set to [ISO].				c) Press and hold down the spot button on the back of the camera (a small dot in the middle of a rectangle) while rotating the [Tv] dial (a notched wheel located above the shutter release button). When the spotmetering symbol appears at the bottom right hand side of the external LCD screen, your camera's meter is set to [SPOT].	

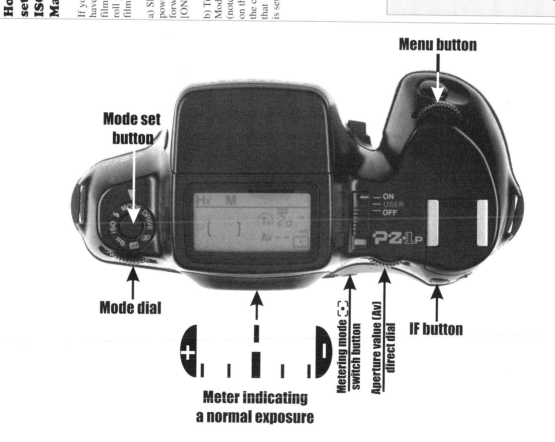

PENTAX PZ1p

Menu button

Mode set button

Mode dial

Meter indicating a normal exposure

Metering mode switch button

Aperture value [Av] direct dial

IF button

The Confused Photographer's Guide to Photographic Exposure and the Simplified Zone System 283

1 How to set the function to Manual Exposure Mode:	2 How to set the ISO Manually	3 How to change the aperture Manually	4 How to change the Exposure Time Manually	5 How to set the exposure function to SPOT	6 How to find the normal exposure of a simple subject?
a) Slide the power switch to [ON] position. b) Turn the [MODE Dial] to [M] position. Shutter speed and aperture opening settings now appear on the right hand side (towards the middle) of the screen with a yellow arrow pointing towards one of them.	a) Slide the power switch to the [ON] position and set the mode dial to "M" (step 1). b) Press the [MENU] button on the back of the camera. If the ISO scale at the bottom of the screen is not highlighted, left-click the [Control Button] until it is highlighted. Now the ISO values will appear on the screen. c) By up-clicking or Down-clicking the [Control Button] place the pointer over the desired ISO. d) Establish the ISO by pushing down the center of the [Control Button]. DSC-F717 can be set to 100, 200, 400, and 800 ISO.	a) Follow step 1. b) If the arrow's color is white push-down the Jog Dial until the arrow is Yellow (active). If the Yellow arrow does not point at the aperture opening (a letter "F" followed by a number such as 4.5, 5.3, or 5.6) then rotate the Jog Dial until it does. c) Once the yellow dial points at the aperture opening, Down-Click the Jog Dial. The arrow becomes white and the letter "F" and the number becomes yellow. By "Rotating" the Jog Dial the desired aperture values can be set. Typical values are: 2, 2.2, 2.5, 2.8, 3.2, 3.5, 4.0, 4.5, 5.0, 5.6, 6.3, 7.1, and 8.0. These values are obtained when the lens is set to its maximum wideangle position. Press Jog Dial to establish the desired aperture opening.	a) Follow step 1. b) If the arrow's color is white push-down the Jog Dial until the arrow is Yellow (active). If the Yellow arrow does not point at the shutter speed value (a number such as 60, 80, 100, or 125) then rotate the Jog Dial until it does. c) Once the yellow dial points at the shutter speed (exposure time), Down-Click the Jog Dial. The arrow becomes white and the shutter speed value becomes yellow. By "Rotating" the Jog Dial the desired shutter speed can be set. DSC-F717 exposure time values are prefixed with letters "NR" if the exposure time is longer than 1/30 second. Typical values are: NR30" (30 seconds), 25", 20", 15", 13", 10", 8", 7", 5", 4", 3", 2.5", 2", 1.6", 1.3", 1"(1 second), 1.3, 1.6, 2, 2.5, 3, 4, 5, 6, 8, 10, 13, 15, 20, 25, 30, 40, 50, 60, 80, 100, 125, 160, 200, 250, 320, 400, 500, 640, 800, and 1000. Press Jog Dial to establish the exposure time.	a) Slide the power switch to [ON] position. b) Turn the [MODE Dial] to [M] position. Shutter speed and aperture opening settings now appear on the right hand side (towards the middle) of the screen with a yellow arrow pointing towards one of them. e) Repeat pressing the spotmetering button until [⊡] appears on the middle left hand side of the screen on the back of the camera. Your exposure mode is now set to SPOT.	a) Set your camera to manual exposure (step 1) and set the metering feature to Spot (step 5). b) Turn the shutter speed. If you are not sure what to set your shutter speed to (for outside shots) set it to a number close to the ISO of the film. For example, if your film's ISO is set to 100 or 125, set it to 1/125 sec. (see step 4). c) Now by pointing the center of the viewfinder (a cross +) at the desired simple subject and by changing the aperture and/or shutter speed, find the simple subject's normal exposure. This is when the exposure dial (on the top of the aperture value) shows "0EV". PLEASE NOTE: Any other number with a prefix of "-" or "+" indicates underexposure or overexposure.

Sony DSC-F717

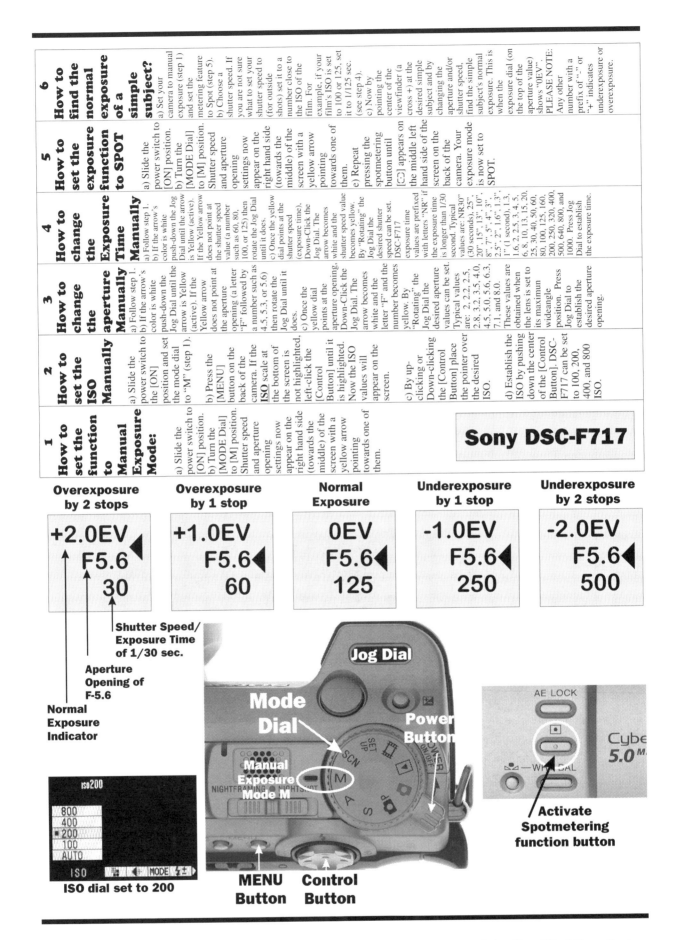

Overexposure by 2 stops
+2.0EV F5.6 30

Overexposure by 1 stop
+1.0EV F5.6 60

Normal Exposure
0EV F5.6 125

Underexposure by 1 stop
-1.0EV F5.6 250

Underexposure by 2 stops
-2.0EV F5.6 500

Shutter Speed/ Exposure Time of 1/30 sec.

Aperture Opening of F-5.6

Normal Exposure Indicator

Jog Dial

Mode Dial

Power Button

AE LOCK

Cybe 5.0 M

Manual Exposure Mode M

NIGHTFRAMING • NIGHTSHOT

ISO200
800
400
200
100
AUTO
ISO MODE

ISO dial set to 200

MENU Button Control Button

Activate Spotmetering function button

Book Index